FIRST CAST
Teaching Kids to Fly-Fish

FIRST CAST
Teaching Kids to Fly-Fish

Phil Genova
Director of the Fly Fisher Apprentice Program

STACKPOLE
BOOKS

Published by
STACKPOLE BOOKS
5067 Ritter Road
Mechanicsburg, PA 17055

Printed in the United States

First Edition

10 9 8 7 6 5 4 3 2 1

Cover photograph by Tim McKinney
Line drawings by Louisa Meltzer Sandvik
Photographs by Tim McKinney, Paul Roberts, Mike Parkhurst, Lee Multari, Dr. Philip
 Brunquell, and Phil Genova
Flies tied by Lee Multari and Phil Genova

Library of Congress Cataloging-in-Publication Data

Genova, Phil.
 First cast : teaching kids to fly-fish / Phil Genova. — 1st ed.
 p. cm.
 Includes bibliographical references.
 ISBN 0-8117-2761-0
 1. Fly fishing. 2. Fly fishing—Study and teaching. I. Title.
SH456.G45 1998
799.1'24'071—dc21 97-38936
 CIP

This book is dedicated
to Judy, Cosmo, and Dante—the inspiration for all I do,
and to Eric—my friend and mentor.

Contents

Acknowledgments

There are as many ways to teach fly fishing as there are fly fishers. More than anything, *First Cast* is a community effort. The following five folks were instrumental in making *First Cast* a reality. I'd like to extend a special thanks to them:

Joe Cambridge is the multitalented instructor of fly fishing, public speaking and English at Tompkins County Community College. A dedicated Fly Fisher Apprentice Program (FAP) mentor and conservationist, Joe lent me his invaluable expertise in editing and "touching up" the manuscript and in putting together a useful bibliography.

John Kirk, famed international environmental educator and longtime director of the New Jersey School of Conservation, has been a sincere and enthusiastic champion for youth fly-fishing education and a great friend of FAP. I'm honored that he consented to do the Foreword for *First Cast*.

Tim McKinney arrived on the scene late in production but had a profound impact on the entire project. Tim travels the U.S. photographing auto races and other big, exciting events. He put in yeoman's duty over the last two months and helped capture on film some of the essence of these young fly fishers.

Paul Roberts and I have worked as the one-two punch of FAP since the beginning. Paul has been a major influence in many young people's lives and is the most enthusiastic and thorough fly-fishing educator I know. His tireless dedication to helping our young people and protecting our environment is inspiring.

Louisa Meltzer Sandvik is not only responsible for the illustrations in *First Cast*, but also takes credit for raising (along with her spin-fisher husband Gil) two very competent, enthusiastic young fly fishers. Her warm sense of humor and true friendship have added great depth and sincerity to the entire program.

I've called on many of my friends from around the world to help make

this project a reflection of the spirit that draws us to the sport and keeps us with it for life. I'd like to give my sincerest thanks to the following folks who have contributed original written material and photographs to *First Cast:*

Cathy Beck from Benton, PA, co-owner, with her husband Barry, of Raven Creek Travel, is a respected fly-fishing instructor and author of *Cathy Beck's Fly Fishing Handbook* (1996).

A. K. Best, from Boulder, CO, professional fly tier and designer, is owner of A.K.'s Tools and author of *A. K.'s Fly Box* (1996).

Jim Belfan, from New York, NY, is Executive Director of the Photographic Center of Harlem, a youth apprenticeship program.

Gary Borger, from Wausau, WI, is an innovative fly tier, lecturer, university professor, and author of *Presentation* (1995).

Phil Brunquell, M.D., from Glastonbury, CT, is a doctor of pediatrics at Newington Children's Hospital (CT) and author of *Fly Fishing with Children* (1994).

Bill Catherwood, from Tewksbury, MA, is a pioneer saltwater fly designer, creator of the "Giant Killer" fly series, and a genuine character.

Leon Chandler, from Homer, NY, is fly fishing's legendary "international ambassador" and a fly line designer, and was named *Fly Rod & Reel* magazine's Angler of the Year in 1994.

Larry Dahlberg, from Brainard, MN, is a globe-trotting fisherman, fly designer, and host of "The Hunt for Big Fish."

Katie Donahue, from Union Springs, NY, is a sixteen-year-old fly-tying instructor who has been with FAP since she was eleven.

Karen Edelstein, from Ludlowville, NY, is author of *Pond and Stream Safari—A Guide to the Ecology of Aquatic Invertebrates* (1993).

Mike Fong, from San Francisco, CA, is a longtime angling writer and lecturer who, along with his wife Chris, has published the *Inside Angler* since 1992.

D.L. Goddard, from Easton, MD, is a custom fly tier, fly-casting instructor, fly designer for Umpqua Feather Merchants, and dedicated friend of FAP.

Pete Van Gytenbeek, from Seattle, WA, is editor and publisher of *Fly Fishing in Saltwaters* magazine.

George Harvey, from State College, PA, is a legendary fly-fishing innovator who was the first to teach fly fishing as an accredited course in a major university (Penn State, 1947).

Henry Hoffman, from Warrenton, OR, is the originator of the genetic hackle and the "Super Grizzly."

Diallo House, from Ithaca, NY, now twenty years old, is one of the original FAP members. He was the first Junior inductee to the N.Y. State Sportsman's Hall of Fame and is pursuing a career in fisheries research.

Joe Humphreys, from Boalsburg, PA, is the author of *Trout Tactics* (1993), a former fly-fishing instructor at Penn State, and apprentice to George Harvey.

Charles Jardine, from Dunkirk, Faversham Kent, U.K., is a noted fly tier, a fly-fishing historian, and author of *The Classic Guide to Fly Fishing For Trout* (1991).

Stefan Jirka, from Ithaca, NY, has been a member of FAP from the beginning, and is now, at age twenty, a fly-tying and casting instructor and a student at Cornell University.

Karl Johnson, from Ithaca, NY, will soon receive his Ph.D. in leisure studies from Cornell University.

Ed Koch, from York Springs, PA, is a pioneer small fly and short fly rod innovator and author of *Fishing the Midge* (1972).

Mel Krieger, from San Francisco, CA, is a noted fly-casting instructor and author of *The Essence of Flycasting* (1987).

Gary LaFontaine, from Deer Lodge, MT, is the acclaimed author of *Caddisflies* (1981) and a fly-tying innovator, and was named *Fly Rod & Reel's* Angler of the Year in 1996.

Hannes Maddens, from Aspen, CO, is, at age fifteen, a capable and dedicated fly-tying and casting instructor and an enthusiastic young writer.

Bruce Matthews, from Lansing, MI, is a former director of SAREP, a national authority on outdoor ethics, and presently Director of Information and Education for the State of Michigan DNR.

Walt Maslowki, from Lima, OH, is a retired dentist and born-again fly fisher.

Charles Meck, from Pennsylvania Furnace, PA, is a well-respected fly tier, educator, and author of *Patterns, Hatches, Tactics and Trout* (1995).

Lee Multari, from Spencer, NY, is a local fly-fishing legend, photographer, and fly-fishing instructor at Cornell University.

Bill Peabody, from Portsmouth, RI, is a longtime Rhoddy fly rodder, fly designer, and saltwater fly-fishing historian.

Mike Parkhurst, from Brooktondale, NY, is a photographer, FAP mentor, small fly enthusiast, and almost a local legend.

John Randolph, from Harrisburg, PA, is an international fly-fishing authority and editor and publisher of *Fly Fisherman* magazine.

Page Rogers, from Middle Haddem, CT, is a minister, Northeastern saltwater fly-fishing authority, and Umpqua Feather Merchants fly designer.

Steve Rajeff, from Woodlawn, WA, is a long distance casting world champion and fly rod designer for G. Loomis.

Carl Richards, from Rockford, MI, is coauthor with Doug Swisher of *Selective Trout* (1971), one of the most influential and popular fly-fishing books of the twentieth century.

Ryan Rosalsky, from Dumont, NY, is a fifteen-year-old saltwater fly-fishing enthusiast and budding author.

Jesse and Ely Sandvik, from Ithaca, NY, ages sixteen and fourteen, are enthusiastic and skilled writers and fly-fishing instructors with FAP.

Dick Stewart, from North Conway, NH, is a respected fly-tying authority, prolific author, and publisher of *Fly Fish America* magazine.

Lou Tabory, from Ridgefield, CT, is the "dean" of Northeastern saltwater fly fishing, a noted instructor, and author of *Inshore Fly Fishing* (1992).

Dick Talleur, from Manchester, NH, is author of *The Versatile Fly Tyer* (1990) and is considered one of the top fly-tying instructors in the world.

Mike Terepka, from Ithaca, NY, is, at fifteen, one of the local landlocked salmon hot shots and a fly-tying instructor with FAP.

Kelly Warren, from Madison, WI, is an Environmental Research Specialist with the University of Wisconsin-Extension.

Jonathan Woodcock, from Essex, U.K., is an environmental education student and recent convert to saltwater fly fishing.

Joan Salvato Wulff, from Lew Beach, NY, is one of the world's most respected and innovative fly-casting instructors, owner of the Wulff School of Fly Fishing, and author of *Joan Wulff's Casting Techniques* (1987).

I'd also like to thank the following:

- The entire dedicated staff at the Tompkins County (NY) Cooperative Extension and 4-H of Ithaca, New York, for their enthusiastic support and encouragement over the last nine years and, especially, for putting up with me over the last few months!
- The members of the fly-fishing industry and fly-fishing show producers who have generously supported our efforts in so many ways.
- The parents of our apprentices who have trusted our judgement and stood behind us.
- The many wonderful, dedicated volunteer instructors who have given generously of their time and helped pass on the tradition to so many new fly fishers.
- And of course Judy, my best friend and companion through life, who has encouraged and supported me through it all.

Foreword

The sport of fly fishing, as we have come to know it, has a long and fascinating history dating back to the third century. Today, fly fishing is growing in popularity among all ages, sexes, and levels of the socioeconomic scale.

Two of the factors which hindered the growth of fly fishing in the past were the cost of equipment and the level of skill necessary to become proficient. Today both of these problems are somewhat resolved. Equipment can now be purchased at a modest cost, and improvements have made fly fishing a possibility for even those with limited motor skills.

The author of this text has mastered the skills of fly fishing, and his great love of the out-of-doors, combined with his love and concern for our children, led him to establish one of the most unique fly-fishing programs in the United States, the Fly Fisher Apprentice Program (FAP). For his work with FAP, Phil Genova was given the 1994 National 4-H Fisheries and Wildlife Adult Volunteer of the Year Award; he received this honor from the late Mollie Beattie, who was then Director of the U.S. Department of Fish and Wildlife.

Today the FAP model is being emulated across the U.S. As a result, many children who otherwise would never have known the thrill of tying a fly, constructing a leader, and casting a fly line into a beautiful mountain stream, lake, or along the seashore are now able to enjoy the excitement and joy of this lifetime sport. These young anglers have developed a keen interest in protecting the waters they love and are sure to go on to be the future stewards of our resources.

The Fly Fisher Apprentice Program is special because it serves all levels of the socio-economic spectrum. The only requirement for participation in the program is the desire to learn and the self-discipline to pay heed to the instruction.

In this book, the author explains and analyzes every segment of youth fly-fishing education. For the beginner, it will open a whole new world. For

the experienced, it will provide new insights into this extraordinary sport. There has never been a more thorough and accurate text for those wishing to learn the methodology of organizing material in segments that are understandable and enjoyable for children.

Although there have been more books published on fly fishing than on any of the other angling sports, none has ever provided the depth, scope, and coverage found in this one. When these factors are combined with the detailed analysis of the techniques used in presenting the materials to children, you have a reference book which is a must for anyone wishing to teach fly fishing to young people.

The motto of the Fly Fisher Apprentice Program is, "Pass on the Tradition!" From this book many adults will learn the special techniques of teaching fly fishing that will make the sport interesting for children. This will enable the youngsters to acquire the many necessary skills without the frustration and anxiety often connected with learning the proper techniques of casting and fly tying.

Future generations of fly-fishing instructors who use this text as a guide will feel a great sense of gratitude to the author for providing them with the wisdom and knowledge to organize fly-fishing information in a manner that will reach all children. For countless generations of youngsters, the thrill of feeling the tug of a trout in a mountain stream, a bass in a mirrored lake, or a bluefish in the surf will become a reality. These are experiences they may never have known if it were not for the dedicated fly fisher who will use this book and who, like Phil Genova, is anxious to "pass on the tradition" which opens a whole new world of activity for children.

Those who choose to add this book to their collection of fly-fishing literature invest wisely. I feel certain that, in the not too distant future, this outstanding text will take its place among the classics in the extensive collection of reference books dedicated to providing readers with the opportunity to discover the magic and wonder of fly fishing.

—Dr. John J. Kirk
Director of the New Jersey School
of Conservation

Introduction

Dante was not happy.

It was 11:30 P.M. and his first night of being weaned from Mom. He wanted no part of me or the bottle of warm milk I offered him. I wandered slowly around the house, whispering in his ear, rocking him back and forth, singing a few tunes he normally enjoyed. The volume of his complaint only increased. Sitting down, rocking, walking. Nothing worked.

After about thirty minutes with Dante at full volume, I decided to swing into my office. I remembered that his brother had a fascination for furs and feathers at a young age. It was worth a try.

We sat at my fly-tying table. I picked up a piece of bucktail and began stroking his arm. Dante calmed down a bit and focused on my actions. He took the bucktail into his hand and became quiet. We began to explore some of the wonderful shapes, colors, and textures of the other materials. I would stroke him with each one and let him hold it as I explained what each was and related a story about the animal it came from.

It was landlocked salmon time in our area, so I figured I'd attempt to tie a fly or two. We developed a game where I would lay out several different materials and he would pick one out. I would slowly clip off a piece and tie it into the salmon hook that was clamped in my vise. An orange squirrel tail wing combined nicely with the other materials to form the Orange Weaner, a pattern I fish enthusiastically each fall.

We worked together quietly for two and a half hours until he nodded off in my arms. At fourteen months of age, Dante was introduced to fly tying on his first night away from Mom.

Over the last nine years I've watched thousands of kids bend a feather and cast a fly line for the first time. It is a magic moment that never loses its appeal and newness. All types of fishing link us to the natural world. Fly fishing offers the angler something different. Twelve-year-old Peter Binkiewitcz put it this way, "Fly fishing is more complicated, but in a better way."

Peter has put his finger on the reason fly fishing appeals so strongly to so many people. It is truly an activity that has evolved from early human history when a successful hunt meant survival. Through fly fishing we can satisfy this primordial urge in a creative way, fulfilling a multitude of human needs. In this wonderful lifetime sport there is always more to learn.

Fly fishing has shown itself to be the ideal vehicle for introducing youngsters to the importance of environmental respect and the principles of resource stewardship. Fly fishers must possess an intimate understanding of the waters they fish to be successful. This understanding breeds respect. This respect fosters an awareness and cultivates a need to defend these resources from exploitation.

First Cast contains step-by-step instructional information along with a wealth of interesting facts and stories that will inspire you and your students to learn more. I've included chapters on every phase of a complete youth fly-fishing education program. You'll find practical advice that can be used whether working with one young angler or 100.

Use this book as a guide and reference to become a successful mentor. It may save you time and energy while you are getting started and will provide lots of helpful tips along the way. Don't make the experience academic. Have fun!

1

The Mentor
and the Apprentice

"When I was a little boy, I had a friend who was a colonel." So begins my favorite piece of angling literature, "The River God," by Roland Pertwee. Pertwee goes on to chronicle his longtime relationship with a fly fisher he met when he was ten years old while on vacation with his family near a salmon river. The tale tells of their friendship, which continued until the colonel's death.

It is a powerful story that outlines in beautiful detail how the "shaggy maned" old-timer befriended the lad, who had just lost his rod and line to the first salmon he'd ever hooked. As if by magic, the colonel spotted the line bobbing in the current and retrieved it with a cast that made the "line whistle to and fro in the air with sublime authority." After retrieving the boy's line, the colonel cut his own line just above the leader.

> "Can you tie a knot?" the colonel asked.
> "Yes," I nodded.
> "Come on then; bend your line into mine. Quick as lightning."
> Under his critical eye, I joined the two lines with a blood knot.
> "I guessed you were a fisherman," he said, nodded approvingly and clipped off the ends. "And now to know the best or the worst."
> I shall never forget the music of that check reel or the suspense with which I watched.

[The salmon was still on the boy's line, and they went on to land the fish together. However, the boy's rod was gone, and they returned to the hotel.]

> "We got the fish," said he, "but we lost the rod and a future without a rod doesn't bear thinking of. Now," and he pointed at a long wooden box on the floor that overflowed with rods of different sorts and sizes,

3

"*rummage among those. Take your time and see if you can find anything to suit you.*"

I have the rod to this day and I count it among my dearest treasures. And to this day, I have a flick of the wrist that was his legacy. I have too a small skill in dressing flies, the elements of which were learned in his company by candlelight after the day's work was over.

"The River God" is one of the countless tales in fly-fishing literature that extol the virtues of the mentor-apprentice tradition. In fly fishing, this special relationship, bred out of mutual caring and respect, finds an ideal venue. I believe that the soul of the sport of fly fishing lies in this relationship. There is a value and an importance about things that are shared in such circumstances that transcend knowledge.

The philosophy we've adopted at Fly Fisher Apprentice Program and the methods and principles discussed in this book have their origins in the mentor-apprentice approach to youth fly-fishing education. Each chapter describes in detail a segment of the fly-fishing education experience. The steps are laid out with the novice in mind and contain a great deal of information on how to conduct a class and encourage the learning adventure. Experienced teachers who are used to working with adults will find helpful tips on making fly-fishing skills more accessible to youngsters.

Mastering the sport of fly fishing is, after all, only a matter of perfecting the basics. We all can become more proficient anglers by relearning the foundational skills.

I have tailored each chapter for use by the mentor or a single apprentice. The youth program leader will benefit from some of the special advice I've included for dealing with large groups of diversified youngsters.

Throughout I have also included brief tales written especially for this book by some of the greats of the sport. These autobiographical works will lend some human insight and relevance to the topics covered in each chapter. I have also sprinkled in essays and thoughts written by some of the youngsters I've worked with over the years, as well as a few who were mentored by other program leaders.

Giving a bit more thought to why you've chosen to be a fly-fishing mentor, how you will proceed, and what you have to offer these budding anglers and conservationists will allow you to be a positive influence and leave a lasting and profound effect on your charges.

In a lunchtime discussion one afternoon, my friend Karl Johnson, a doctoral candidate in the philosophy of leisure (!) and director of Team Building Programs at Cornell's Outdoor Education Department, talked about how fly fishing fit with the work he was doing with youngsters. To elaborate, he came up with "The Virtues of Fishing."

Μy total obsession with the sport of fly fishing began when I was around twelve years old. I can recall going to my school library to find books explaining the natural history of salmon and trout. I was so interested in fish that I became known around the neighborhood as the "Fish Boy." I learned a lot about fish and their natural history.

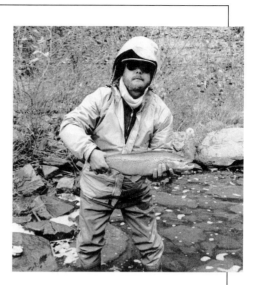

The season was early fall, a great one at that! Trees were painted in brilliant shades of golden yellow and red. I had just gotten out of school for the day and I wanted to show off my new fly reel. To whom. . . I

The late Eric Seidler with one of his beloved Finger Lakes' landlocked salmon.

don't know. But I knew that someone would be there, to teach me something about my new toy. My expectations of finding someone who knew how to fly-fish were high, so right after I returned home from school, I was gone again. I rode my bike all the way across town to Fall Creek, with on a fly reel in my pant pocket.

I arrived at around four o'clock on the Black Iron Bridge (a spot of infamy in the community). Under this large railroad bridge, there is a long gravel bed, where salmon spawn in the fall. In the spring giant schools of smelt spawn on the beds. Salmon and trout follow the smelt on their spawning routes to take advantage of an easy meal.

I remember a red-haired man fly-casting under the Black Iron. I was standing above. From here I had a perfect view of the greatest caster of all time (to me anyway). I watched each casting stroke unfurl as if it were part of a movie. To me this was all new. I remember yelling down to the man, saying, "How do you do that?" He replied simply (as if I already knew), "keep up your backcast."

—Diallo House is now 20 years old and studying fisheries management at Cobleskill (NY) College.

[The red-haired man, who was to become Di's mentor, was Eric Seidler, my mentor.]

"THE VIRTUES OF FISHING" BY KARL JOHNSON

Some people simply have not caught on to the comforts and conveniences of modern life. Forsaking the convenience of securing fresh fish in an air-conditioned grocery, many favor the old ways, squandering untold hours during the fishing season and raising some serious questions about this pastime and the sanity of those who participate. Why bother? Consider the hassle of a typical fishing expedition. Get up at 4 A.M., don a musty vest and clown pants even baggier than current fashion allows, stumble through mud and brambles to a mosquito-infested stream, tie fake flies fashioned from feathers lifted off dead birds to belligerent nylon line using one hand and a few teeth, and then myopically stare at them as they float on the water. Surely these people have way too much time on their hands. A closer look, however, suggests there is more going on, much more, in fact.

Several years ago I ran an after-school recreation program for at-risk youth. Students often missed the program because of detention for smoking, threatening, stealing, and nearly everything else under the sun. One personable but toughened knife-toting fifteen-year-old missed out regularly because of his fondness for fighting. It wasn't long before I began to doubt my efforts. Why take Joey fishing when he would rather be beating up his classmates? Why teach kids fly tying when they can't read or write? Isn't recreation far less important than education?

Sympathetic to the "studies before sports" approach to education, I did question this conventional wisdom. My after-school program, I realized, had become a reward—teachers used it as a bribe to extract good behavior from otherwise bad students. Although consequences for bad behavior are important, this seemed to me to be an illogical consequence. Students are not kept from math or science as a punishment, not only because the threat would fail to serve as a deterrent, but also because students *must* learn math and science. As I pondered this strange activity of pursuing cold-blooded aquatic vertebrates with primitive technologies, I became convinced that there is much more to fishing than mere fun—it is a pastime with benefits, some of which are downright educational.

To those who see fishing as a waste of time—a mere recreation—I offer the following virtues of fishing.

1. *Fishing engages the mind.* As Norman MacLean wrote in *A River Runs Through It,* the art of fishing consists of "looking for answers to questions"—finding the right bait, the right hole, the right timing.

2. *Fishing engages the whole self—body, mind, and emotions.* The streamside has far more potential to civilize the passions than does the classroom, for our most deeply rooted emotions—love, hate, joy, sorrow, fear, and anger—can be harnessed only when they have first been aroused.

3. *Fishing teaches ethics.* The rules of self-restraint collectively known as "sportsmanship" require integrity, for the primary referee in fishing is one's own conscience.

4. *Fishing thwarts delinquency.* As Teddy Roosevelt astutely observed, delinquency is born of boredom. "Every child has inside him an aching void for excitement," he said, "and if we don't fill it with something which is exciting and interesting and good for him, he will fill it with something which is exciting and interesting and which isn't good for him."

5. *Fishing initiates the young into culture.* The stories and traditions associated with fishing serve to socialize youths into the norms and mores of their family and community.

6. *Fishing unites people across barriers.* A common interest in fishing creates a bond that can bridge cultural, economic, and even linguistic barriers. Most notably, mentoring relationships transcend the generation gap.

7. *Fishing encourages humility.* In contrast to "self-esteem" activities, which often serve only to make children more self-centered, fishing is a contemplative activity that confronts us with the fact that we are not ultimately in control of every aspect of our lives.

8. *Fishing encourages a commitment to quality and excellence.* The secret of fishing is to learn to define success as something other than productivity—to value the means and process of one's efforts at least as highly as the end product of those efforts.

9. *Fishing fosters an appreciation of nature.* Fishing requires knowledge of fish, stream ecology, weather, worms, and bugs.

10. *Fishing is fun.* This reason to go fishing is at once the simplest and most profound. It may sound like heresy to parents and educators concerned with the betterment of children, but it's not. "Fishing begins in delight and ends in wisdom," to paraphrase Robert Frost. One fishes simply to fish. The lessons are by-products, not the goal, though they are no less real.

In fact, fishing is likely to be most productive when pursued purely for pleasure. Unfortunately, when it comes to play, adults are far less expert than children. Adults tend to justify their recreation—

for the health and fitness they confer—and turn play into work. But notice children at play. They do not have to be told to count their Monopoly money or to calculate Cal Ripken's batting average. They do it for fun—"just because." Play captures the imagination and focuses attention so intently that learning happens without effort. Fishing may build character, but no child is fool enough to be duped by the idea of fishing in order to build character.

Which brings us back to Joey. Is it a waste of time to take our kids fishing? And if not, what about kids like Joey who still have to work on their reading and writing, not to mention their manners? Not simple questions, to be sure, but ancient wisdom offers some advice. Paradox though it may seem, the ancient Greek word for *leisure* is *schole,* the word from which we derive the English word *school.* In other words, the ancient Greeks considered education and learning as games of sorts—activities that are *fun*—erasing the sharp distinction we often make between recreation and education.

The popular religious philosopher C. S. Lewis wrote that the devil himself hates innocent pastimes because they generally promote charity, courage, and contentment. In an age of performance anxiety, impending deadlines, immediate gratification, conspicuous consumption, compulsive achievement, obsessive productivity, competition without sportsmanship, and keeping up with the Joneses, an age of bored kids and overcommitted adults, the simple pleasure of fishing may be just the antidote to our collective neuroses. For kids like Joey, who not only suffer through school by day but also try to burn it down at night, starting with something fun may be the only hope. Fishing may not be "productive"; in that sense it is a waste of time. But it is, all things considered, time very well wasted.

Fly fishing is more than just catching fish. We each make the sport our own and, as fly fishers, are the product of all our experiences and skills, good and bad. One of the great attractions of fly fishing is the very personal nature of the sport. We are offered a wide range of possibilities and are free to make our own choices of rod, reel, line, fly, hook, materials, species of fish, and so on. We each form our own fly-fishing behavior based on what we as individuals wish to gain from the sport.

ETHICS AND PROTECTING OUR RESOURCES
As fly fishers we have an obligation, steeped in tradition, to actively look after and protect the resources we use in the enjoyment of our sport. Respect for our resources is the key to becoming a competent and caring steward, and this is built on the firm foundation of ethical behavior.

The landlocked salmon is a freshwater form of the fish that many expert fly fishermen consider the greatest game fish of all time: the Atlantic salmon. I'm lucky enough to live on one of the greatest landlocked salmon fisheries in the United States: Cayuga Lake. Fall Creek, the tributary that probably gets the most intense run of salmon from Cayuga, runs right behind my school. When school is over, I can literally step out the door and begin casting.

I can't even begin to explain how my proximity to this fishery and fly fishing in general have helped me. I have always loved nature and loved to fish since I was a small child on Echo Lake in Maine, a treasured family place that we visit every summer. During middle school, I was getting into some trouble and was sent to a rehab wilderness program in the wild mountains of Idaho, where I again felt a oneness with nature. Soon I began fishing every weekend, then almost every day, at every chance I could. *And then I was introduced to fly fishing!* To make a long story short, I'm now feeling great about myself and doing much better in school, and much credit goes to my number one passion: fly fishing.

—Mike Terepka, age fourteen,
Ithaca, New York

We humans all use the planet's resources and we all should share in their protection. True enough. As fly fishers, we share a special intimate relationship with the creatures that live in the fresh and salt waters of our world.

Part of our attraction to the sport is that it allows us to become intimate for a short time with nature. In today's world, fly fishing can be seen as the civilized way of the predator. With catch-and-release fishing, we can be nonconsumptive predators participating in the hunt, being successful, and then releasing our prey unharmed.

What fly fisher hasn't enjoyed the thrill of the hunt? And what fly fisher hasn't enjoyed the peacefulness and contentment that go with the total immersion into the experience?

In *The Compleat Angler,* published in 1653, Izaak Walton captured the fly fisher's life:

No life is so happy and so pleasant as the life of a well governed angler, for when the lawyer is swelled up in business and the statesman is preventing or contriving plots, there we sit on cowslip banks,

hear the birds sing, and possess ourselves in as much quietness as these silent silver streams which we now see glide so quietly by us. Indeed, we may say of angling as Dr. Boteler said of strawberries: "Doubtless God could have made a better berry, but doubtless God never did"; and so (if I may be the judge) God never did make a more calm, quiet, innocent recreation than angling.

To be a successful fly fisher, the angler must know the quarry: where it lives, what it eats, where it feeds, why it's there. He or she must know the tackle and how to use it to present the fly in a manner that will entice the animal to take this feathered offering in its mouth, out of hunger of curiosity.

To enjoy the sport to the fullest, the fly fisher needs clean water, a healthy population of creatures inhabiting it, and stimulating surroundings. Familiarity with the natural world breeds respect. Out of this understanding comes a true concern for the health of the natural environment. Fly fishing encourages and creates the future stewards of our resources. This is reason enough to start a youth fly-fishing program or encourage a youngster to take up the long rod.

What is ethical behavior? It is often said that ethics is what you do when no one is watching. Difficult-to-define concepts such as integrity, character, sportsmanship, moral development, values, compassion, humility, courtesy, fairness, and respect all come into play.

When teaching ethics to the young fly fisher, many questions will come to mind: Whose ethics are taught? What authority prescribes the ethical code to be followed? Should an adult set the ethical standards for a teen? In the outdoors, is the game warden the ultimate ethical authority? Why should we care about the ethical behavior of others? Do our ethical decisions affect

While fly fishing has been a wonderful sport and career for me, I am concerned about the future of this sort of fishing. I don't see the same type of people growing up in American society today— people who understand and love the outdoors. Economic priorities seem to overshadow everything these days. In order to keep what we have, and hopefully bring some of our waters back, young people are going to have to switch off their computers and go out and experience nature. That's a tall order. Maybe it's impossible. I hope not.

—Dick Talleur, author and fly tier

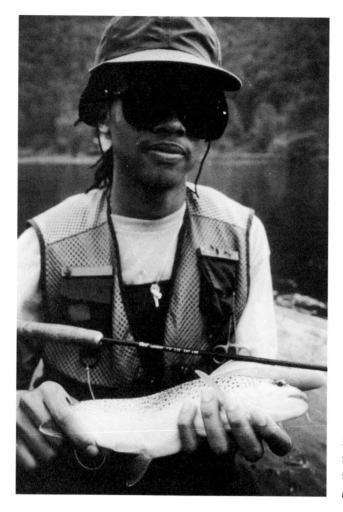

Diallo House knew where to find this wild brown trout and what fly to use.

others? How far does our ethical responsibility go? Is there one code of ethics for all of us? How does ethical behavior begin? Who makes the final decision on what is ethical behavior?

When we take on the responsibility of helping educate a youngster in an activity such as fly fishing that involves matters of life and death, respect for the resource, fair chase, and environmentally and socially correct behavior, we must not purport to be the final authority of what is ethically correct or incorrect. We are not the judges or enforcers of ethical behavior.

The mentor has the important but troublesome duty of posing ethical questions, which are not always as simple as whether to keep an extra fish over the limit, and they may not have such simple answers.

"This is the biggest trout I've ever seen! That was going to be my last cast. I have my limit already. I'm alone. Should I slip this little dinky trout that might survive back into the water and bring home this prize?"

"Wow! This fish is big enough to take first place! Oh no, my hook caught around a piece of monofilament attached to someone else's fly that broke off in the fish's mouth! Did he really take my fly after all? What should I do?"

"We know the game warden is out of town today and nobody will see us. That stretch of stream if full of huge spawning rainbows that will grab our flies in a second. We'll release them all, of course. They'll only be caught and killed next week when the season opens, anyway. My best friend is over there fishing right now. What should I do?"

Ethical questions may lead to even more questions. These questions will involve issues we'll face constantly throughout life as users of the outdoors.

For several years the training team from New York State's 4-H Sport Fishing and Aquatic Resource Education Program (SAREP) encouraged trained instructors to guide their students in forming personal ethical codes, asking the young anglers to consider what ethical responsibility they had to the following:

- Other anglers they met.
- Their fishing club.
- Other users of the resource.
- Landowners.
- The local community.
- Administrative or regulatory agencies.
- The sport or tradition of fishing.
- The individual fish and other aquatic organisms.
- The aquatic agencies as a whole.

If ethics is a subject that you wish to explore further and include as a regular part of a youth fly-fishing education program, I suggest that you obtain a copy of *Teaching and Evaluating Outdoor Ethics Education Programs* from the Educational Outreach Department of the National Wildlife Foundation, 8925 Leesburg Pike, Vienna, VA 22184-0001, telephone (703) 790-4055.

To become competent, effective stewards of our resources, young anglers must develop a sound code of ethics. We cannot create integrity and strong moral character in these youngsters, but we can encourage and help develop it. In the subjective, personal world of outdoor ethics, we as mentors must be careful to act not as the authority figure, but as the guide.

In the traditional role, the mentor functions as a guide, assisting the apprentice in developing an individual code of ethical behavior and enlightened respect for the resource. The mentor helps the apprentice acquire the needed skills and equipment to be a successful angler and also becomes a valued companion.

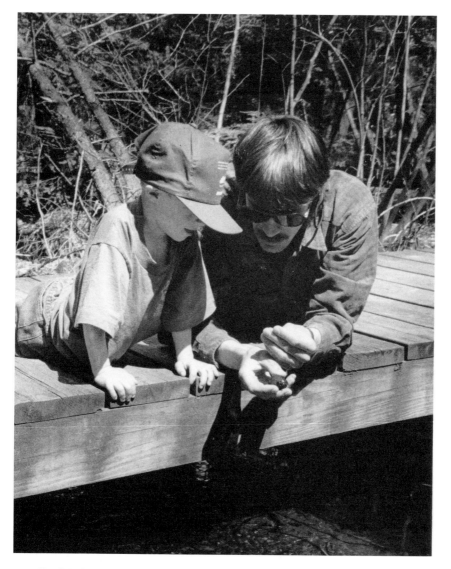

Paul Roberts and Cosmo Genova do some impromptu stream sampling.

If a child is to keep his inborn sense of wonder, he needs the companionship of at least one adult who can share it, rediscovering with him the joy, excitement and mystery of the world we live in.
—Rachel Carson, *The Sense of Wonder*

Page Rogers shares her secrets with some of the young Fly Fisher Apprentice Program instructors.

My father taught us how to take care of ourselves in every way. I remember watching with intense wonder as he opened up a trout and we saw how clean and efficient and well designed the fish was. It was mystery and miracle, and I knew I wanted to know more.
—Page Rogers, minister and saltwater fly designer

It is a difficult task to be a companion and a role model to a youngster. But the thoughtful mentor welcomes the challenge, for the personal rewards are great, and seeing your apprentice blossom and go on to become a true leader and mentor to his or her own apprentice is a thrill.

THE MENTOR'S DUTY
The job of a mentor in a youth fly-fishing education program begins with understanding that there is a responsibility to the apprentice. This is the key point that distinguishes the Fly Fisher Apprentice Program's traditional

approach to fly-fishing education from the one-shot fishing derby "seduce and abandon" mentality of many youth sportfishing efforts.

For the most part, these one-time derbies serve as feel-good events for the instructors, leaving them convinced they've done something great for the kids. Many of the youngsters who participate return home excited, stimulated, and wanting more but have no one to turn to for help. If such events could be combined with a long-term program, they would provide a real service.

The mentor-apprentice approach begins a long-term, quality interaction between two "brothers (or sisters) of the angle." And as often happens in a true apprentice-mentor relationship, both learn valuable life lessons.

As the adult in the relationship, the mentor must keep the welfare of his or her apprentice in mind at all times. Safety issues are, of course, most important. The mentor must also be vigilant in providing opportunities for growth. When learning opportunities for the apprentice present themselves, the mentor must be sure to take into account the apprentice's readiness to learn. Don't force the issue. It's often best to let the apprentice ask for more. Take the time to show the possibilities. Every fly-fishing experience takes place in a rich world of natural beauty. Don't rush the adventure!

Becoming a mentor forces us to look at ourselves. In order to present ourselves as proper role models for young people, we must examine our own behavior and code of ethics.

THE TEACHABLE MOMENT AND THE THRESHOLD EXPERIENCE

The teachable moment and the threshold experience are two very important events that all educators should be aware of. Look for these in each activity; learn to recognize them. Young people are constantly growing intellectually, and it will make a major difference in the development of the budding young angler and conservationist if these events are recognized and exploited.

The *teachable moment* occurs when something unplanned happens that captures the youngsters' attention. For example, you may be trying to teach a youngster an upstream mend when, off to the side, she sees a dead fish floating by. Or on a well-planned insect safari on a local stream, there's a chorus of oohs and aahs and "Oh, gross!" when the kids discover a water snake slowly swallowing a hapless toad in the grass nearby.

It's useless to try to drag kids back into a planned lesson when they've discovered something *really* interesting. Instead of fighting it, use it. You have their attention, *big time;* think fast and come up with what might be the most important lesson that day. Ask questions that get them thinking: "What kind of fish do you think that is? Why do you think it died?" "How do you suppose that snake got that big toad in his mouth in the first place? How will he

chew it?" This event may be a true turning point in someone's life. For some, it may be a *threshold experience.*

We all have had a few threshold experiences in our lives, life-changing events that we are exposed to; afterwards, we are never the same. In the case of fly fishing, the first time we see a good fly caster effortlessly lay out a beautiful line may be a threshold experience. For many, it's the first time a fish takes a self-tied fly. I have yet to run into a fly fisher who could not pinpoint the event that turned on his or her switch and, in the case of many, dramatically changed the rest of their lives.

Hannes Maddens discovers some of the wonders of a trout stream that will lead to successful fishing.

I suppose if anyone was blessed with every opportunity to be a fly fisherman, it was me. Call me lucky—it would have been strange if I didn't end up a fly fisherman. My stepfather, John Gandreau, was a wonderful, caring man. He not only took me fishing every weekend, but he also answered my continual barrage of questions.

Gary LaFontaine hams it up with Patrick Sodums.

I grew up in Connecticut. By age nine, I was a catch-and-release poacher on the Windsor Gun & Rod Club private trout stream, Mill Brook. All summer I'd fish this local water every weekday; on the weekends we'd drive to the classic trout rivers up and down the East Coast.

It wasn't just the fishing that made me a fisherman; two other aspects of the sport consumed all my time. I had access to some of the best private fly-fishing libraries in the East, and I read all the great English and American books. Also, our basement was filled with aquariums (my stepfather raised Jack Dempseys for pet shops), and there were always extra tanks where I could raise and study trout, bass, and bluegills.

My future was set. I didn't want to just fish—I wanted to write about fly fishing, after all that reading and I wanted to seriously study fish, after all that early observation. I've been fortunate enough to spend my life doing both of these things.

—Gary LaFontaine, fly-fishing author

For most, this experience was supported and encouraged afterward by a caring adult who helped them along after this major event, enabling them to pursue their interest, acquire the needed equipment, and learn the necessary skills. The role of caring, aware, and concerned mentors is to help their apprentices along the road that will help them fulfill their dream and then, in turn, become mentors themselves and help another do the same.

A teachable moment or threshold experience can occur at any time. If you are aware that this wondrous chemistry is taking place, take advantage of it. This will make each trip a memorable one and will help your young anglers become more aware and well-rounded individuals.

My approach to youth fly-fishing education has the threads of resource stewardship and ethical behavior running throughout. The mentor and the apprentice weave these threads into the fabric of a life well lived.

Inspired fly-fishing education can be a powerful tool for building and strengthening important character traits like self-confidence and self-worth in a youngster. The education that builds these traits will lead to a feeling of empowerment, the feeling that he or she can, in fact, make a change!

Intimate interaction with the resource will help the young fly fisher realize an all important sense of place. He or she will feel an ownership and have a stake in the future of the resource. Knowing he or she has the power to make a positive change can't help but lead the young fly fisher to the path of stewardship.

THE FUTURE OF FLY FISHING

The world is changing rapidly, growing and becoming more urban every day. As fly fishers we can accept the challenge and use the sport we love to ensure a positive future for the resource. We can do all the stream improvement, pass all the environmental protection laws, and clean up all the trout habitat in the country, but it will do no good if there isn't a generation of educated, concerned, and dedicated stewards of the resource to keep it that way. If we expect the sport of fly fishing to thrive, if we expect our resources to continue to have strong champions, we must offer fly-fishing education to children.

If we are to safeguard our rights as fly fishers from the attack of other rights groups, we must educate *all* segments of society. If we are to protect our precious wild lands from the bulldozer of the uncaring developer, we must educate and empower the urban dweller as well as the country gentleman.

The fact is that pressure from a growing population on our already over-stressed waterways will increase. The challenge of the fly fisher is not to load the already crowded streams with more anglers, but to educate these anglers and make them a caring, committed, and powerful force for positive environmental change.

You can make a significant contribution to the future of our natural resources while enjoying and passing along this lifetime sport. By offering the gift of fly fishing to a youngster, you are beginning a process that is sure to create a competent, educated, and dedicated steward of our resources.

Along the way something wonderful will take place. The young fly fisher

A gentleman by the name of Koke Winter had a great influence on my fly-fishing life. In fact, he was the trout bum who caused me to become one as well. We would come from Detroit to Alpena each summer, and we'd camp on the banks of Hunt Creek and fish all day every day for a week. It was at one of these camps that I hooked and landed one of the biggest I'd ever seen. The trout was 22 inches long and must have weighed at least 4 pounds. Koke was standing next to me when I netted the fish, and as I knelt in the shallow water and reached into the net to take the fly from the trout's jaw, he said, "Man, what a magnificent fish. I've never seen such a perfect trout!" He paused, then continued, "Of course, you're going to release it, aren't you?"

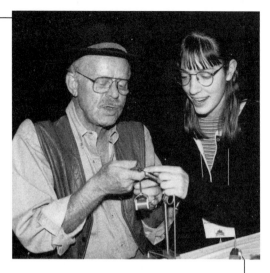

A. K. Best and Katie Donahue share fly-tying tips.

It wasn't a question, but a statement. The only choice I had was to free the biggest trout I'd ever caught on a fly rod. I held it in the current a few moments, and then with a flip of its tail, it was gone.

Koke put his hand on my shoulder and said, "Feels real good, doesn't it?"

I had to admit it *did* feel good. Until that time, I had always kept the big fish and always tried to keep my limit each time I went fishing. I grew up fishing for food. It just never occurred to me to release the fish I caught until I had my limit.

Fresh trout is still my favorite meal. However, I haven't had my favorite meal more than half a dozen times in the past twenty years! Each time I go fly fishing, I remember that big brown trout. And I silently thank Koke for teaching me that catching trout is only half the enjoyment of fly fishing. The other half is releasing.

—A. K. Best, author, fly tier,
and owner of A. K.'s Tools

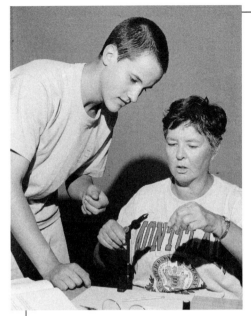

Jesse Sandvik at work at the New Jersey School of Conservation women's fly-fishing clinic.

Fly fishing is an art that touches every aspect of my life in some way. It isn't just casting a fly for a fish, but much more. A fly fisher must cope with surroundings and investigate the environment to find a way to catch the fish, and this is teaching me how to deal with obstacles, stay focused, and solve my problems. With the role models I meet fishing, I steer clear from the trouble many kids my age get into.

In addition to being one of the most enjoyable arts, I find fly fishing to be the best way to take my mind off anxieties and annoyances, as I focus on the stream, the fish, and the wildlife.

With my fly-fishing experiences, I get to witness and participate in many cycles. I learn the art that I will someday pass on, I realize the cycle of nature and role I play in it, and I have a better understanding of the cycle of nature in general and how everything grows to a peak and then passes its experiences on. There is no better way to observe nature than to enter a stream, catch a fish, release it, and become part of the cycle. I find values and qualities in fly fishing that will make me a better person in the future. A recent value I've learned is preserving. This is extremely important in fly tying, and it also has taught me to work hard for my goals, not to be sidetracked, and to accomplish every task I accept.

—Jesse Sandvik, age fifteen, Ithaca, New York

will mature and become an ethical and thoughtful citizen. The seeds of stewardship and ethical responsibility that you planted will grow. Your apprentice will go on to plant his or her seeds in the rich new life of another budding angler. Your legacy, and that of all fly fishers before you, will be seen in the "flick of the wrist" of future generations.

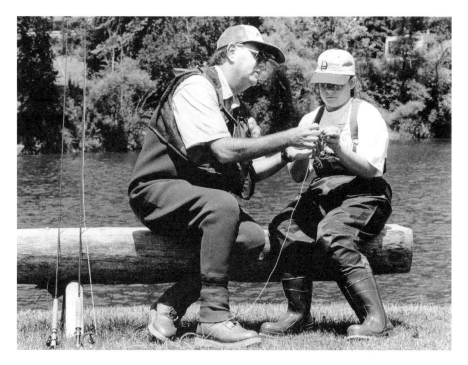

The mentor is there to show the way at each step.

So he was no more—my river god—and what was left of him they had put into a box and buried in the earth.

But that isn't true; nor is it true that I never saw him again. For I seldom go a-fishing but that I meet him on the river banks.

The banks of a river are frequented by a strange company and are full of mysterious and murmurous sounds—the cluck and laughter of wind in the willows. What should prevent a man in such a place having a word and speech with another who is not there? So much of fishing lies in the imagination, and mine needs little stretching to give my river god a living form.

"With this ripple," says he, "you should do well."

"And what's it to be," says I—"Blue Upright? Red Spinner? What's your fancy, sir?"

Spirits never grow old. He has begun to take an interest in dry-fly methods—that river god of mine, with his seven-league boots, his shaggy head and the gaff across his back.

2

Fly Tying: Tools and Materials

Fly fishing by its very nature is an act of faith. The feathered, hairy, or gaudy creation we secure to the end of our line and offer to the fish represents an inspired choice we hope will bring success.

When this offering is a fly we have designed and constructed ourselves, it is the ultimate act of faith. We are relying on our own talents in creating it and our good sense in choosing it. We are not counting on the work of a professional fly tier, asking a local expert, or even consulting with a good friend.

Tying on your own fly and then casting it into the water and presenting it to a fish is a powerful experience and remains so over the course of a lifetime. The first time you drift one of your own flies in the proper fashion and have a fish choose to take it is a true turning point.

For a young fly fisher, collecting a sample of the fish's food from a stream, be it an insect or baitfish, and creating an original pattern, tying it, and using it successfully to fool a native fish is graduation day. It also shows the mentor that this young angler has truly made the connection between the resource and the sport.

WHEN TO START

One of the most common questions I'm asked by folks interested in beginning a youth fly-fishing program is "How young can we get kids started, and what's the best way to start?" My answer to this question is always the same: "When they are ready, when their interest is piqued and you're not forcing them, then start with fly tying."

Most folks seem puzzled, thinking that the art of fly tying with all its mysterious materials and intricate patterns would be too great a challenge for a young angler. Don't matching the hatch and bending a hackle around a hook shank require great dexterity and fine motor skills? Isn't fly tying the pinnacle of the fly fisher's sport and not an appropriate introduction to it?

If you've made the decision to help a youngster begin the fly-fishing jour-

It soon became apparent to me that the flies I was buying at the local gas station (the only place in 30 miles that sold trout flies) weren't a very close match to the naturals I was seeing on the stream. So I bought a fly-tying kit and taught myself how to tie by untying the flies I had purchased at the gas station. It's a pretty hard way to learn, but it worked. I soon learned that I needed better materials than those provided in the kit, and after months of searching, I managed to find some fly-tying necks and dubbing that were the quality and colors I thought I needed to tie some Adams and March Brown dry flies.

My first trout on a dry fly was caught on a March Brown I'd tied the night before. It was one of the most thrilling experiences of my life. I had fooled the trout, starting the night before at my fly-tying bench. It changed my life and my family's as well!

—A. K. Best

ney, I have found there is no better place to start than at the fly-tying vise. Children can construct a fly long before they can cast one safely or successfully. These fly creations, even though they are not exactly fishable, are works of art, and in building them, a child's innate curiosity and creativity can be used to the fullest. They are sharing something very special with you at an early age.

Flies can be tied in good weather or bad, day or night, and usually at a moment's notice. Each "masterpiece" is something to be proud of and will make a great gift for aunts, uncles, other family members, and friends.

WHERE TO START

If you are new to fly tying, it will be helpful to pick up a good book on the subject and familiarize yourself with some of the tools, materials, and procedures before equipping yourself and a youngster with all the paraphernalia needed to begin. I highly recommend the *Universal Fly Tying Guide* by Dick Stewart (Countryman Press, 1979), or the *American Fly Tying Manual* by Dave Hughes (Frank Amato Press, 1986). We use both in our classes and find them very helpful

The world of fly tying is a very accessible and truly wondrous one for any youngster—or anyone for that matter. The fly tier's materials include an incredible diversity of shapes, colors, textures, and smells. There are few other

activities in which kids can touch and inspect such a variety of animal furs and feathers. Pheasants, geese, elk, deer, bears, moose, partridge, foxes, and squirrels all become familiar to the young tier, these creatures now more than just pictures in a book. Each animal has its own place in the system; each should be given the respect it deserves for supplying us with food and making the world a richer place.

If you are starting with a very young child (three is not too early to begin) who shows a keen interest in this discipline, a browse through your fly-tying materials can be a real adventure and a learning experience. Select less-than-perfect pieces of a few types of fur, feathers, and chenille, and help your budding fly fisher start his or her own collection of goodies. Make very clear the distinction between his or her materials and yours. You will find in time that this distinction becomes very important.

Buy a bunch of snap-top, stackable, transparent containers (plastic shoe storage boxes work well). Help your apprentice label and put together a system for his or her materials. Secure each box with a rubber band to prevent spills.

A trip to the local craft or sewing store can be lots of fun and will help your new tying buddy discover some inexpensive materials on his or her own, and you may also find some economical alternatives for your own creations. A selection of colored feathers, tinsel, thread, doll's hair, and every conceivable type of item that can be secured to a hook shank may be found at such stores.

It is important to give a little time and thought to a space where the novice tier can set up shop and call his or her own. Take into consideration that hooks, feathers, hair, and whatnot will be scattered around in a creative flurry and then must be gathered back up to keep it from being dragged throughout the house. Try to make the area as pet- and sibling-proof as possible.

If you need advice, there's no better resource for fly-tying and fishing assistance than your local fly shop. Avoid mail-order and bargain stores. Develop a relationship right from the start with the shop you feel will best serve your needs, offers you the most reliable and courteous service, and makes you feel at home. You may pay a little bit more than catalog prices, but it will be well worth it in the long run to help support and keep in business the folks who share the same waters as you, who can meet your day-to-day angling needs, and who will, over time, help you become a better angler. Most of your personal angling habits and traditions will be spawned in these places. You'll meet new, interesting fly-fishing acquaintances, and the fly shop will provide a friendly, accessible place for your apprentice to learn.

That being said, unless you are passing along your old tools, it's time to head to the local shop and pick out a vise and some tools for your emerging

fly fisher. Depending on the age of the new tier and your budget, you'll have to decide whether to buy tools that may cost more but will last a long time or "cheapies" that can be used, abused, and tossed out after a year or two. Decisions also must be made as to whether the youngster can be trusted with sharp scissors, needles, and so on. It may be more prudent to start with less expensive tools that can be modified for safety or to use temporary stand-in tools you've found around the house.

FLY-TYING TOOLS

In recent years the selection and variety, along with the price range, of tools have expanded dramatically. Inexpensive, imported tools have become widely available and offer the tier an opportunity to get started at a very reasonable cost. For under $30 the novice can usually pick up a vise and several necessary tools, along with a few basic materials.

On the other end of the scale, premium, top-of-the-line, full rotary vises (the jaws may be turned 360 degrees, with the hook shank remaining parallel to the table, allowing complete access to all sides of the fly), manufactured by A. K.'s Tools or Renzetti Inc., may cost over $400.

Tools that are poorly constructed and don't work well will lead only to frustration. Don't purchase every new tool that catches your eye. Grow into the tools you have, and after gaining some expertise, pick up other tools that may help speed up your tying or make a difficult task easier.

Basic Tools

A good beginning selection of tools should include the following:

Vise. Good quality is important here. This will be the "workhorse" tool used in creating every fly and will probably be the most costly item on the fly-tying bench. There are several styles to choose from, with the lever type, made famous by the D. H. Thompson Company, being the most popular. A well-stocked fly shop should carry several models and will afford you and your apprentice the opportunity to try each type firsthand. It's important that the new tier feel comfortable with the vise and be able to open, close, and adjust the jaws with minimal effort. The fewer moving parts and adjustments the better. Be sure he or she is able to tighten a hook in the jaws securely.

Many vises have the option of changing jaws in order to accommodate very small or very large hooks. This can be handy, but don't make your decision based solely on this fact; chances are, you'll seldom use this feature. Height should be easily adjustable. The vise should be able to slide up and down through the table clamp. If a pedestal type stand is chosen, be sure the working height of the vise is not too high for the young tier. You should be able to move the fly around while in the vise so that you can access all sides.

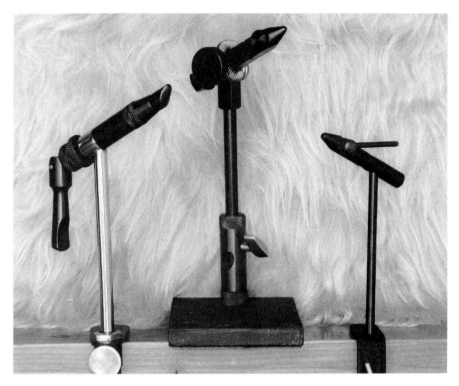

Common vise styles left to right: A lever-type imported vise which clamps on to the edge of the table and has easily adjustable jaws and height; the Griffin, an easily adjustable screw-type model, shown here in the pedestal version; an economical imported vise which is serviceable but should be considered only if higher quality is not affordable.

Expect to pay somewhere between $18 and $80 for a decent-quality entry-level vise, or between $30 and $150 for a full kit.

Scissors. There are many kinds of scissors made especially for fly tying. Each tier eventually finds a style that he or she prefers. Start with moderately priced tools and work into the more expensive precision models. While searching the local fly shop, have your apprentice try several pairs. Usually the low-end models (under $4) will be just fine to start out with. The high-end models will feel really nice and handle well. However, there is absolutely no reason to get a pair of these—some of which cost $150 or more—for a beginner. Scissors have the highest mortality rate of any of the fly tier's tools. Several pairs may be lost, broken, or severely dulled over the course of a year, and an inadequate or dull pair of scissors that will not make fine cuts is use-

less on the fly-tying bench. Keep your own good pair hidden or lay down the law right away in no uncertain terms: "Hands off my scissors!"

Here are some hints to keep your scissors usable longer:

- Try to cut as far back into the blades as possible for most materials. Use the tips for only easy-to-cut materials, such as hackle tips or thread.
- Avoid dulling the blades on the shank of the hook.
- Keep another, inexpensive pair around to do much of the heavier cutting. Finger- and toenail clippers can also be used for the heavy work.

Bobbin. This handy item is used to hold your tying thread. Bobbins range in price from $2 imports to $30 for the best domestically made models. Most are in the $9 to $16 range. In purchasing lower-priced models, be sure that the bobbin has a flanged tip and does not cut the thread when pressure is applied. Even minor imperfections that cannot be detected upon casual inspection will abrade and eventually slice through the thread. If you end up with one that cuts the thread, take it back to the fly shop for immediate exchange. Better yet, try it out before buying. There's nothing more annoying

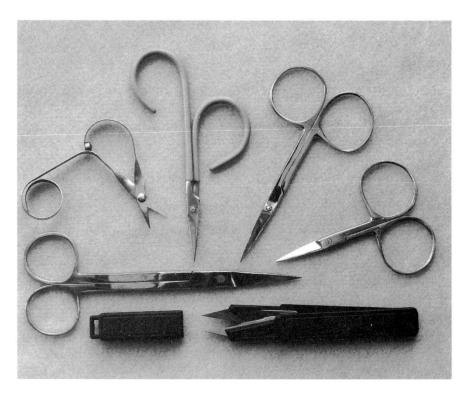

Fly-tying scissors come in a variety of shapes and styles.

than having to constantly rethread the bobbin! Quality models have ceramic tubes to reduce thread abrasion, and all types should have spool holders that adjust for thread tension easily. Once again, start with a moderate-to-low priced model.

Bobbin Threader and Tube Cleaner. A 6-inch-long piece of thin wire or stiff monofilament can be bent in half and inserted into the tube of the bobbin to pull out the thread after it has broken or to start a new spool. A small piece of dowel can be lashed to the wire, or a bright plastic bead or small painted cork can be attached to the cut ends, making it easier to find and to handle. Gudebrod and a few other companies make a little mono loop gadget that is used with dental floss and makes a fine, inexpensive threader.

As you tie more and more flies, you will notice a buildup of wax from the thread coating your bobbin tube. It's a good idea to clean it periodically with a bobbin tube cleaner, which is simply a straight, stiff, square-ended piece of wire. Very fine pipe cleaners will also work.

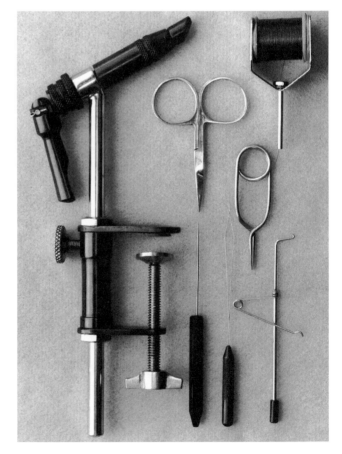

A basic tool kit, left to right, top to bottom: lever operated vise; scissors; bodkin/half hitch tool; hackle pliers; bobbin threader and bobbin. Bottom right is an old-style whip finish tool often included in beginner kits.

Commercial bobbin threaders are usually under $2 and will often have a bobbin tube cleaner attached to the other end. If you can find one of these multipurpose tools, I recommend them highly.

Hackle Pliers. Hackle pliers are used to hold hackles and other materials when adding them to your fly, and there are endless versions. These tools can be clumsy and awkward for young hands to use. Be sure to choose one that's easy and comfortable for the youngster to open and control. Choose a light-weight version that will not snap the fragile hackle if it is accidentally dropped while winding. In our classes we offer a thin, flat model that's about ¼ inch wide, is easy to open, and has small rubber pads on the ends to secure the hackle tips. Mini test clips found at electrical supply houses can also make very light, useful, inexpensive hackle holders. (Archer brand at Radio Shack is a good one). Hackle pliers range in price from $1 to $6.

Bodkin. Bodkins are used for various tasks such as applying cement, teasing dubbing, and picking at hackle. A needle attached to a dowel or pushed through a cork can make a serviceable bodkin. Commercial bodkins have handles of plastic, aluminum, brass, hardwood, or even deer antler and cost from $1 to $15.

Light. Good lighting is essential. Your apprentice needs a good, adjustable, desk-type lamp that can handle a 100-watt bulb and be placed close to his or her work. *Hint:* A piece of light-colored paper hung behind the work will silhouette the fly and make it easier to work on.

Small Needlenose Pliers. These come in handy for a variety of tasks on the fly-tying bench, including crushing hook barbs and handling heavy materials.

Additional Tools

As your apprentice's tying improves and the range of patterns he or she can make expands and becomes more complicated, a few other tools should be added.

Hair Stacker. This handy device can be designed in a number of ways but will usually consist of two short tubes (about 2 inches or so) of slightly different lengths and diameters. The longer tube is open on both ends and fits into the shorter one, which is closed on one end. The tier places a clump of trimmed hair into the open end of the tool (tips first), and the entire tool is tapped a few times on the bench. The hair is then removed, the tips having become even. A hair stacker costs from $2 to $25, or you can make one of these contraptions from an old lipstick container (be sure to remove all the lipstick first).

Tweezers. These common tools are very useful on the bench for picking up individual hackles or small bits of materials and holding flies that have

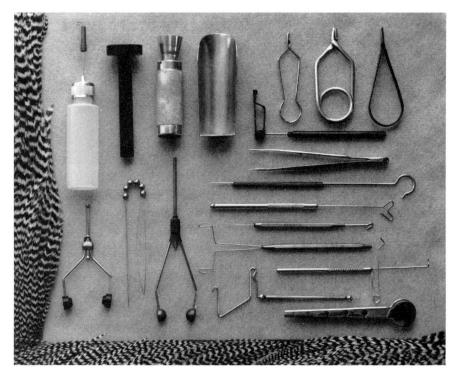

A variety of fly-tying tools, left to right, clockwise: cement applicator; three hair stackers; four hackle pliers; tweezers; four dubbing twisters; two whip finishers (Matarelli, bottom); hackle gauge; ceramic bobbin; bobbin threader; and short-nosed bobbin.

just been cemented. Purchase tweezers that are made for the commercial fly-tying market; these have flat ends and specially designed tips. Prices range from $2 to $20.

Material Clip. This simple, inexpensive tool keeps materials out of the way until the tier is ready to use them. A material clip is usually just a short spring wound around the shaft of the vise. It is used to hold long materials after they've been secured to the hook shank and await their turn to be added to the fly body. Material clips cost from 50 cents to $5.

Whip Finisher. A whip finish is used by many tiers to put the final knot in the head of the fly. The tier can do this manually, using only the fingers, or with any number of different tools. The most popular of the commercially made models is the Matarelli. This ingenious device, which sells for about $11, makes tying a whip finish a snap (after a little practice, or course). Cheaper, imported knockoffs can be found for a lot less; however, if you can afford the real thing, get it.

You can make your own whip-finish tool from a matchstick or dowel and a short piece of monofilament. Simply lash the mono to the stick in a loop. Lay the loop over the head of the fly. Run several turns of tying thread over the loop. Clip the thread, run it through the loop, and pull it out from under the wraps, snugging up all the threads. Not as slick as the Matarelli, but with a little practice it works fine.

MATERIALS

The young fly tier can initially obtain basic materials from you, other fly tiers, or craft stores. Eventually, however, it will be time for your apprentice to choose and purchase his or her own special materials. Many fly-tying materials are produced for the trade and are found only in a well-stocked fly shop. The hackles, feathers, and hair that are offered have been selected especially for fly tying, and have the properties that make them desirable to the tier. Venture out with a basic idea of what is required and the amount you are willing to spend. Be forewarned: There is no easier way to spend money than on fly-tying materials. Here is a general guide for your outing to the fly shop.

When choosing materials for fly tying, try to obtain the best you can afford. There is no substitute for quality. Look them over and purchase only the ones that will be most useful.

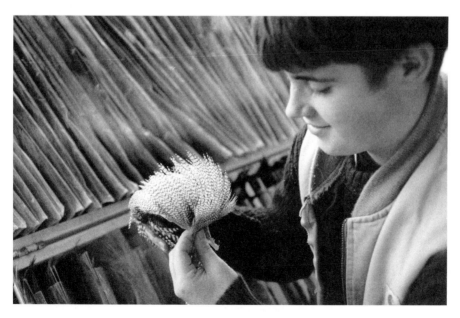

Eric Sincebaugh inspects a premium dry-fly neck from Baker's Hackles, Cortland, NY.

Inspect each item carefully. *Dry-fly necks* should contain plenty of hackles of the size needed. To check this, pick up the neck with the bottom (shortest hackles) in your right hand between your thumb and index finger. Stroke the rest of the neck back with your other hand into an arch so that each row of hackles pops up in line. The quills should be flexible, the barbules stiff, even, and separate. The higher-quality hackle will have grades printed on the package and on the back of the neck. Half necks can be a thrifty alternative if your apprentice will be tying a variety of flies. Start with a light cream, a dun, and a grizzly.

Wet-fly hackle is usually lower priced and will be found in greater variety than dry-fly hackle. When choosing a wet-fly neck, look for an abundance of the kind and size of hackles needed. Avoid very short, wide feathers, severely bent or cupped necks, and poorly dyed or unevenly colored hackles. Wet-fly hackles are more "webby" than dry-fly hackles and should have a thin, flexible quill.

Select *deer or elk body hair* with the intended use in mind. Avoid crinkled hair. Body hair is referred to as being "hollow," or filled with air. Softer hair is used for spinning a floating body. Harder, slicker, shorter "coastal" deer hair may be the best for dry-fly wings.

Bucktail, calf tail, and squirrel tail should have long, straight hair. Avoid hair that is curly or heavily crinkled. Long, soft bucktail makes the best streamer wings. The most usable, best-quality hair is on the tip of the tail. Purchase the tail with the longest tip section, straightest hair, and the most white (or colored hair, in the case of dyed tails).

Most materials can be found in variety packs containing smaller pieces dyed in several colors. This may not be the best quality or offer the exact colors you are looking for; however, the price is usually right, and it may turn out to be a good investment. Be sure the dye job on any natural material is satisfactory.

Basic Fly-Tying Materials
Before going out and buying a pile of miscellaneous materials that may never be used, concentrate on getting the ingredients for the flies your apprentice will be tying the most of. It will be helpful and fun (and maybe even save some money) for the two of you to make a list of the most popular flies in your region and the materials needed to tie them. Some fly shops may offer kits that contain the materials needed to assemble several flies of a specific pattern. This may be an economical alternative to get the youngster producing flies while keeping storage problems to a minimum.

When acquiring materials from different locations, especially if they are

Hannes Maddens is fourteen and lives in Aspen, Colorado. He has his own method of gathering inexpensive materials:

I'm a fly tier. That means I need fly-tying materials, and those cost money. To solve this problem, I work at the Sodumses' farm. The Sodums are a nice family, and Mark (the father) is a fly tier and good friend.

Working on the farm, I earn money that goes into savings for college, as well as some spending money for fly-tying and fly-fishing materials. I also get some of my fly-tying materials at the farm, such as feathers from dead chickens. Sometimes Mark hunts for woodchucks, which dig holes in the pastures. That's where I get my chuck skin. When the Sodumses shear their sheep, I get some wool. This wool is great for dry flies because it's very buoyant. Recently I caught three rainbows on a dry fly made out of this wool. Another day, while I was grooming the horses, I plucked some tail hairs, which are an excellent substitute for striped peacock quills.

Even though I get a lot of materials from the farm, most of my materials come from friendly fly tiers. I hope someday I can pay them back for all the help and support they gave me so that I could tie flies and fly-fish.

This proves that you don't need to spend a lot of money on fly-tying materials. Even if you don't know any friendly farm folk like the Sodumses, there are many sources of materials all around you, such as roadkill, plastic bags for wings, old radios or clocks that contain lots of fine wire, old beach sandals that can be used for poppers, and old paintbrushes for tails.

Hannes Maddens teaches a group at the New Jersey School of Conservation (NJSOC).

of dubious origin, it's wise to store them away from the rest of your materials. (Folks are always giving me feathers and fur from their latest hunting expedition or presenting me with the remains of a "fresh" roadkill they kindly retrieved for me and the kids!) Pack these items in heavy Ziploc plastic bags along with mothballs or moth crystals. A quick shot in the microwave or some time in the deep freeze will get rid of any unwelcome parasites. Fresh skins need to be deboned, cleaned, and cured in salt or borax.

It's good to know a little about the properties of the materials you may need ahead of time. The following list will help familiarize you and your budding angler with the basic materials before you shop.

Thread. Fly-tying thread comes in a variety of sizes, shapes, and colors. The larger the number the thinner the thread. The 12/0 is used for very small flies; 6/0 is larger in diameter and the most useful size. The 3/0 and A nylon thread are used for large flies and may be the first choice when constant breaking is a problem. Black and white are the most common colors used. The available color selection is endless, and having a variety around helps keep things interesting.

Head Cement. Head cement is applied during the tying process to strengthen the fly and keep materials in place. It is also used in the last step to seal the head and help secure the final knots. Clear nail polish (Sally Hanson's Hard as Nails, for example) can also be used. I don't recommend using cement until "serious" flies are tied and your young apprentice has achieved some organization and maturity at the tying bench. Mishandled head cement can make quite a mess!

If head cement is used, be careful not to slop it over into the hook eye. It will dry there and have to be removed in the field. While still wet, it can be cleanly removed by simply running a small hackle, with the butt fluff cleaned off, through the eye.

Before the young tier begins to use cement regularly, establish a rule that the bottle remains closed unless being used. Pinpoint applicators (Loon Products makes a great one) can also be used but are not foolproof. Also, consider nontoxic head cement. Again, Loon Products has some good ones to choose from.

Dubbing and Dubbing Wax. Dubbing can be made from any number of different materials (natural or synthetic) that have been chopped up or combined together to fasten to the tying thread and wound around the hook shank to form a buggy- or hairy-looking body. Dubbing wax is used to make the thread sticky and receptive to any fur or synthetic dubbing. A dubbing rope or "noodle" can be made nicely without this stuff (many tiers never use it), but it does help. A number of brands at a variety of prices are available.

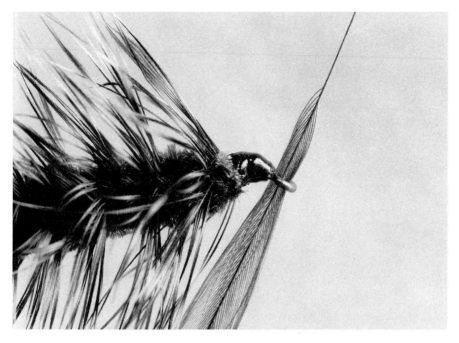

Be sure to clean the head cement from each hook before it dries.

We use a toilet ring wax, available at plumbing supply shops for about 80 cents. It's very sticky, so use it sparingly. If you are passing it out to a bunch of young tiers, break off chunks into film canisters so that the wax is about flush with the rim of the container, and put the lids on.

Chenille. Chenille is constructed of furry-looking material (synthetic or natural) spun on a thread core. It is the most popular and easy-to-apply wet-fly body material. It comes in an endless variety of diameters, colors, and sparkles and is usually sold in 10- to 20-foot lengths wrapped on a small card. If you intend to use very large quantities of a single color for a large program's activities, look for a source where you can purchase a skein or buy it by the pound.

Yarns. Wool and synthetic yarns are inexpensive and easily obtained. They are very useful for a variety of flies and may prove to be the most reliable source of body materials for the novice tier.

Tinsel. Used to add flash to bodies, tags, and ribbons, tinsel is usually available in silver and gold and composed of metal or mylar. It can be found in various widths, flat, oval, or round, or may be braided or embossed. Variety packs are available and include several colors, sizes, and shapes.

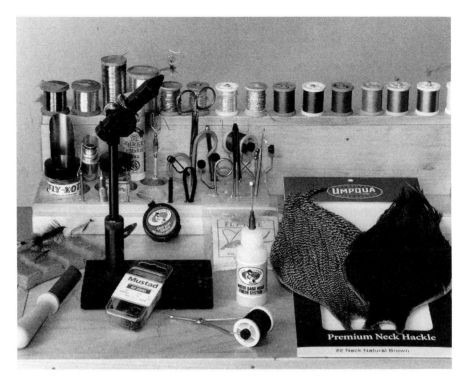

Tools and materials can be stored neatly and used safely on this easy-to-construct plywood tying platform.

Krystal Flash. This relatively new and very versatile synthetic is used to put flash in all sizes of wet flies and streamers. It is available in many colors.

Flashabou. Long, thin mylar strips called Flashabou are tied into streamers or used for ribbing. The most popular colors are pearl, silver, blue, and gold.

Floss. This is a thick thread usually made of rayon or silk. It comes in one, two, or four strands and is used mainly for wet fly bodies. Floss can be colored nicely with a permanent marker.

Wire. Wire may come in silver, gold, or copper and can be used for bodies on small wet flies or ribbing along a fly body to show segmentation, add a bit of flash, or aid in protecting delicate materials.

Lead Wire. This is wrapped on the hook shank when weight is desired, before adding the rest of the materials to a fly.

Permanent Marker. Waterproof colored markers can be used to add accents to wings and bodies. Be careful, especially when very young kids are involved.

Natural Materials

Hackles

Hackle. This usually refers to the feathers of a chicken (hen or rooster) specifically bred for fly tying. Fluff found on the butt or base of the feather is usually removed before attaching the hackle. Of interest to the fly tier are the size and flexibility of the *quill* (center shaft of the individual feather) and the length and flexibility of the *barbule* (the small, thin part attached to the quill).

Saddle Hackles. These are feathers found on the bird's rump in front of the tail. These are usually long, slender feathers. A few varieties of genetically selected roosters are being raised especially for their superior-quality saddles that make excellent dry-fly wings. Strung saddle hackles (sewn together along the stems) from low-quality skins are usually inexpensive and are often used for tying large streamers.

Neck. This area offers a wide variety of hackle sizes. Fine-quality dry-fly hackles have a thin, even, flexible quill and stiff, easily separated barbules. Rooster necks are usually preferred for dry flies.

Hen Hackles. These tend to have stubbier, very flexible barbules. They are usually preferred for use in tying streamers and wet flies. These may be referred to as soft hackles and are sold in both natural and dyed colors.

Hackle Colors. Standard popular hackle colors include badger, a cream color with a black or brown tapered stripe running through the center; furnace, similar to badger but darker; blue dun, a bluish gray; ginger, a light tan, golden, or cream color; grizzly, which has black and white stripes running the length of the feather (probably the all-around most useful color); white; black; and cream. An endless variety of dyed colors are also available.

Dry-fly hackle

Wet-fly hackle.

Examples of premium hackles top to bottom: saltwater saddle; grizzly streamer neck; brown dry-fly neck; white dry-fly neck; and dark badger dry-fly neck (hackles courtesy Umpqua Feather Merchants).

Interested in raising your own hackles? Here's how Henry Hoffman got started back in 1951:

In those days there were few fly fishermen, and with spinning reels starting to come over from France, it was hard to get interested in fly casting. I used to hitchhike 15 miles to the Russian River (in California) for shad and steelhead. A couple times I got rides with fly fishermen. They got me interested, and I tried tying some flies like I'd seen in the magazines.

I did the first ones Lee Wulff style, holding the hook

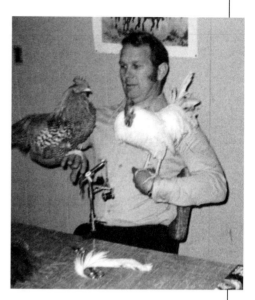

Henry Hoffman and friends (1975).

between my fingers and wrapping cotton sewing thread on with the other hand. After someone shared a Herter's catalog with me, my flies improved.

That spring I went out and caught a dozen or so shad on some of them. The next winter I met the late great Grant King. He looked at my flies and said, "For a beginner, you do a good job." He told me he could sell some of my flies at his News and Tackle shop. On visits to his shop, he gave me many tips on tying flies and how to use them.

I read a 1955 article about Harry Darbee and his famous flies and the blue dun roosters he raised. Before the year was up, I had started raising roosters in five colors for my own use.

By 1970 Orvis started to sell our feathers and came up with the term "super grade grizzly." We adopted the term "Super Grizzly."

Henry's "Super Grizzlies" revolutionized the fly-tying hackle industry. In 1989 Henry sold twenty-three thousand hatching eggs to Dr. Tom Whiting and has returned to fly tying and working on some new "super" chickens.

Other Feathers

Quills. Quills are the primary or secondary wing feathers of many birds. Duck, turkey, and goose quills are popular for tails, wings, and wing cases.

Pheasant. Pheasant saddles (for wet flies and legs) and tails (for nymph bodies and legs) are used. Golden pheasant crests (the feathers on top of the head) are popular for use as toppings and highlights.

Grouse. Grouse body and flank feathers are used for soft-hackle wet flies.

Peacock. Peacock herl (long, wavy barbules) and the eye of the tail are used for bodies and streamer toppings. Peacock herl is one of the most useful, inexpensive, and popular fly-tying materials. It is delicate; several should be twisted together to form a "rope" or should be reinforced with thread or thin wire when wound on the shank.

Turkey. Turkey tail and wing feathers have many uses, including wet-fly wings and nymph wing pads.

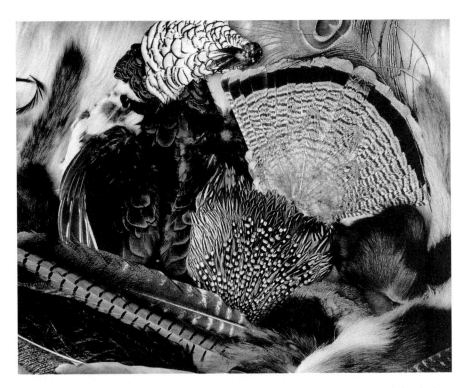

The fly tier's world is filled with many colors and textures, starting top left, clockwise: squirrel tail; full silver pheasant skin; peacock tail; partridge; calf tail; jungle cock neck; deer body hair; bucktail; peacock sword; pheasant tail; turkey tail.

Teal, Partridge, Mallard, Wood Duck, Guinea, Starling. Body and flank feathers of these birds are popular winging materials for wet flies, nymphs, and small streamers.

Marabou. Originally, the plumes of the marabou stork were used to add "breathing" action to streamers and wet flies. Turkey has become an excellent substitute and can be found in a wide variety of dyed colors.

Ostrich. The individual herl is used from the ostrich plume to construct a wide variety of flies. Ostrich herl is used primarily on wet-fly bodies.

Hair and Fur

Deer. This is probably the most useful hair to the tier. Almost any part of a deer hide can be used. Body hair makes the best hair bodies (for bass bugs, bombers, and so on), and quality bucktail makes the best streamer and wet-fly wings.

Rabbit. Rabbit has become very popular in the last few years. Dyed or natural rabbit strips are used in everything from Bonito Bunnies to Zonkers. The Gold-Ribbed Hare's Ear (tied from the hare's mask or face hair) is arguably the most popular nymph in use. Guard hairs (the longest hairs) are used for tails and legs.

Black Bear. The underfur of the black bear makes good dubbing. The longer hair is used for wet- and dry-fly wings.

Squirrel and Calf Tail. These are very popular wing materials for streamers and wet flies. They are often found dyed in various colors.

Sheep and Goat. The longest hair of sheep or goats is especially useful for large saltwater streamers. Shorter types are used to make a variety of bodies and heads.

Fox. Fox tail hair is used for wings, body hair for dubbing.

Elk, Antelope, Moose, Caribou. The stiff, hollow hair of these animals is generally used for wings, tails, and spun bodies.

Beaver, Badger, Muskrat, Otter, Opossum, Skunk, Woodchuck, Mink, Cow, Camel, Mole, Ermine. The fur of mammals can be handy for dubbing, tails, wings, and many other uses. Each type of fur has different properties, and thus each is better for some uses than others.

Synthetics
Dubbing

Antron. This is used for nymph and dry-fly bodies. Its sparkly look makes it great for many patterns. It can be easily separated for small bodies. It is often used blended with rabbit for hare's ear bodies.

Polypropylene (Poly). Lighter than water and excellent for dry-fly bodies

and even wings, poly can also be used for nymph bodies if tied on a heavier hook or weighted. It is found in an almost endless variety of colors and thicknesses, indicated by denier.

Wings

Fish Hair. One of the original long, bucktail-type synthetic hairs, fish hair is available in many colors and thicknesses (denier). Thinner fish hair is popular for Pacific salmon and steelhead flies; thicker and longer fish hair is used for large saltwater patterns.

Ultra Hair. This very popular translucent and kinky material is effective for epoxy flies and Clouser minnows. It is very tough, comes in a variety of colors and several thicknesses, and is marketed under many names.

Craft Fur. Easily and cheaply obtained in craft or fly shops, craft fur can be used in endless ways for wings and bodies.

Long, synthetic streamer wings often get matted and tangled with use. Keep a metal pet comb handy, and run it through the flies often while using them. Plastic combs will cause static electricity and make a mess of the wing.

Chenille

Crystal Chenille. This sparkly, translucent, and colorful material is used for steelhead, salmon, and saltwater fly bodies.

Estaz. Estaz is similar to crystal but is strung more sparsely on the thread.

Ice Chenille. Similar to crystal chenille, ice chenille is available in very bright colors.

Eyes for Flies

Dumbbell-Type Nontoxic and Lead Eyes. Made popular by the Clouser Deep Minnow, these dumbbell- or hourglass-shaped eyes are usually tied in near the eye of the hook, resulting in a jigging motion when retrieved.

Bead Chain Eyes. Chrome bead chain of the kind found in plumbing stores is cut into pairs of eyes and attached in a similar way to the dumbbell eyes.

Stick-on Eyes. Stick-on eyes are made from adhesive-backed mylar and are individually cut for easy removal. It's a good idea to put a dot of adhesive under the eye before applying to reinforce it or to cover the eye with epoxy or nail polish after it's in place.

Bead Heads. Small, heavy beads with holes specially drilled in the center fit easily onto hook shanks. Bead-head flies have become very popular in recent years. While not really eyes, they do add flash to the head of the fly and aid in weighting it.

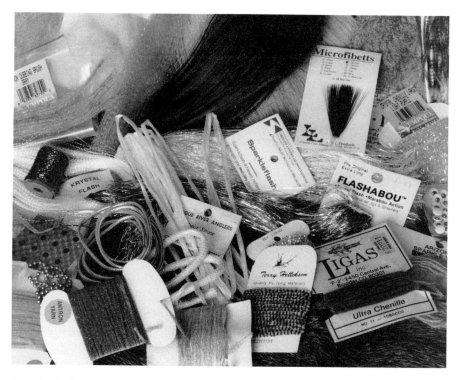

The fly tier's choices are not limited to natural fur and feathers. Synthetic yarns, chenille and a wide variety of materials can be used by the creative tier.

This should not be considered a complete listing of possible fly-tying materials. It is meant to be a beginning and has been designed to answer most of the basic questions before they arise. The properties of these materials are discovered by working and experimenting with them.

Encourage the budding tier to be creative and find new and unique materials to use in each session. Be sure thought is given to the properties of the material so that the fly will function correctly when used.

Acquiring and looking after one's fly-tying tools and materials is a life-long process. It is good to start out as organized and flexible as possible. Always allow for the enthusiasm of youth, and be sure to enforce a cleanup system from the start.

FLY-TYING HOOKS

When I first started tying flies, it was difficult to find any real fly hooks at the local bait and tackle shop. We used whatever we could get our hands on.

If we were lucky enough to find a fly shop in an area where we were fishing, the hook variety was limited and the quality left something to be desired. But who cared? They were still far superior to the bait hooks we typically used.

The selection of quality fly hooks today is staggering, and thorough coverage is beyond the scope of this book. Modern fly-tying hooks have a wonderful combination of qualities that make each a specialized tool. It's important to have a good overall idea of what makes each hook design unique in order to teach their use effectively. It's also kind of fun to know what a "Kirby" or "2X stout" label means on a box of hooks. The following pages include some of the history, basic terminology, and characteristics of modern fly-tying hooks. Use this section as a teaching reference and an aid to choosing the proper hook for each fly.

History

The first devices used to catch fish on a line were gorges. A gorge was a piece of wood, bone, or stone sharpened on both ends, with a groove carved in the middle. This was then fastened to a line, covered with bait, and tossed into the water. A fish would swallow this offering, swim away, and cause the line to tighten, turning the gorge sideways and impaling the fish in the gut.

About 5,000 B.C., man first started using metal. His initial creations were copper clothing pins and fish hooks. Bronze hooks with eyes were invented around 3,000 B.C.

The fourteenth century saw the beginning of more modern hook construction in Europe. Hook making as a trade started around 1650 with Charles Kirby in London, England. Limerick (Ireland), Aberdeen (Scotland), and Carlisle (England) each developed hook-manufacturing industries, lending their names to styles of hooks used to this day. Hook designers Kirby, Sproat, and Bartlett have been similarly remembered.

By the early 1800s, the town of Redditch, England, known for its fine steel and needle production, became the undisputed hook-manufacturing center of the world. Today, only the A. E. Partridge & Son Hook Company remains.

Sheriff Ole Mustad started producing hooks in Norway around 1876. O. Mustad & Son soon became the largest fish hook manufacturer in the world, and it remains so today, producing more than 30,000 different types sold in over 130 countries.

Construction

Modern fish hooks are usually made from high-carbon steel (or other steel alloy) wire that is cut, bent to shape, and tempered for strength. Part of the shank may be then forged or hammered to give it even more strength.

Hooks

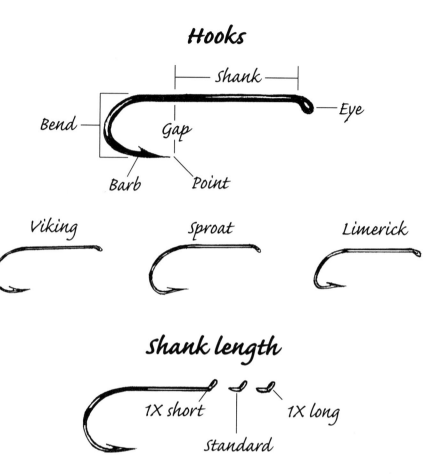

Hook terminology important to the tier.

Hooks are available in several finishes, including bronze, which is the color of the hook after it has received a few coats of clear or tinted lacquer; black, or japanned, with black lacquer applied to the hook; gold or silver, with a coating electroplated to the wire; stainless steel, made from stainless steel wire; and cadmium (or other saltwater-proof metal), which is electroplated to the wire to prevent rust.

Design
Most fish hooks have the same basic parts.

Eye. The eye is the beginning of the hook where the line is tied. There are several eye types of interest to fly tiers. The most common is the ball type, which is round with the wire diameter the same as that of the shank. Tapered

eyes are common in dry flies. Here the part of the shank that makes up the eye is tapered to reduce weight. Looped eyes are common in salmon fly hooks. In these hooks, the part of shank making up the eye runs back for a short distance along the shank, tapering out flat against it.

The eye position relative to the shank is believed to influence hook penetration. The eye is turned down in most fly designs, but it can also be turned up, as in many salmon and steelhead flies, or parallel to the hook shank, known as straight, or ringed.

Shank. The shank is the section of the hook between the eye and the bend. Differences in shank diameter, and therefore weight, are indicated by the use of the letter X and the words *fine* or *stout*. For example, 1X Fine indicates a hook made from standard-diameter wire of the next *smaller* size hook, and 1X Stout indicates a hook made from standard-diameter wire of the next *larger* size hook. 1X Fine wire is thinner than the standard size and 1X Stout is thicker.

Light wire means easier penetration and a slower sink rate, but it bends more easily and may wear a hole in the fish's jaw and pull out more quickly. Heavy wire doesn't penetrate as easily, sinks faster, is stronger, and won't "spring," or straighten out.

Hook length is indicated by the use of an X along with L for *long* or S for *short*. For example, 2XS indicates a hook the length of the standard shank, two hook sizes *smaller,* and 2XL indicates a hook the length of the standard shank, two sizes *longer*. For example, a 2XS #8 is the length of a standard size #10; a 2XL #8 is the length of a standard size #6.

Short shanks are used on smaller-bodied flies when a larger hook gap is desired. Long shanks are used for long-bodied flies. They afford some protection from sharp teeth, but longer shanks can act as levers to work the fly from the fish's mouth.

There are several shank types of interest to fly fishers. *Straight* shanks, the ones used most often in tying flies, are straight from eye to bend. *Humped* shanks are used for poppers to keep the body in place. *Keel* shanks bend down dramatically to the eye to form a keel. These flies tend to ride point up and remain mostly weedless. *Bendback* shanks have a slight backward bend to help prevent the fly from snagging. These are tied so that the point rides up. There are also several specialized types of shanks designed for specific flies.

Bend. The bend is the curve at the end of the shank. It is a distinctive part of the hook that identifies the type, such as a Sproat bend or a Kirby bend. It can be offset, but it is usually straight in fly-tying hooks. The bend determines the profile and, therefore, the hooking characteristics and fly appearance.

Spear. Spear is a seldom-used term describing the final length of hook from the end of the bend to the point.

Point. The point is the sharpened penetrating end of the hook. The method used to sharpen hooks in manufacturing varies with each company and the desired effects, but it is usually accomplished by grinding. Chemical sharpening refers to a final acid bath given to hooks to clean and smooth the surface and thereby improve hooking qualities.

There are several types of points of interest to fly tiers. *Needle* points are ground on all sides. They are straight and have good penetrating qualities. *Hollow* points are needle points that are ground out between point and barb for fast penetration. *Knife-edge* points are sharpened on four sides to form a

A variety of hook types of interest to the fly tier:
 19/0 shark hook (Mustad) for demonstrations
Row 1: *#4 kink shank (Mustad) for poppers; #4 stainless steel (Eagle Claw) for
 saltwater; #4 stainless steel bendback (Eagle Claw) for saltwater; #6
 salmon (Mustad); #8 Dry fly—upturned eye (Mustad).*
Row 2: *#6, #8 streamer/nymph (Mustad); #10, #12 streamer/nymph (Tiemco); #10
 nymph—short shank (Mustad); #10 nymph—Sproat (Mustad); #10
 nymph—special (Eagle Claw).*
Row 3: *#18, #14 dry fly (Mustad); #12, #10 dry fly (Tiemco); #8 dry fly (Mustad).*
Row 4: *gold novelty pin hook (Mustad).*

knife-blade-like edge. These points are popular for use with bigger fish, especially saltwater species.

Barb. The barb is a sharp projection extending backward from the point of the hook. It functions to keep the hook from slipping out. Barbless hooks have become popular in recent years, however, because they both facilitate penetration and make it easier to release landed fish unharmed. They also are easier to remove from snagged clothing or fingers.

Throat. The throat refers to the distance from the tip of the point to the farthest curve of the bend. It is important for holding properties and the appearance of the fly. The width of the bend and length of the throat form the *bite* of the hook.

Gape, or Gap. Gape, or gap, refers to the distance between the hook point and the shank and is a major factor in determining hook size.

Hook Sizes
Although hook manufacturers use a number system for sizing and identification purposes, there is no uniform system of hook sizing, and actual sizes vary among manufacturers. The best you can do is to get a good general idea of sizes. This is usually sufficient. As numbers *decrease* from 32 to 1, hook size *increases*. After size 1 begin larger sizes, from 1/0 up to 19/0. Here, as the numbers *increase,* the size *increases.*

Sharpening
Crushing the barb and sharpening the hook before putting it in the vise is an important habit to form early on. It's much easier to put a fine, even, sharp point on a hook while relaxing at the tying bench. Don't wait till you've arrived at the stream and are ready to fish. If you're going to tie a quantity of the same size flies, it's good to sharpen several hooks before beginning the tying process so that you won't have to pause after each fly.

Small files made especially for hooks work well, as do hook hones and stones. You can also use nail files for very small hooks and hardware store files for very large ones.

Step 1. If you're not using a barbless hook, start by crushing the barb. This will make for quicker penetration and facilitate the release of fish, not to mention clothing and fingers. Fish will not be lost if played correctly, and it's always a good safety precaution.

To do this, squeeze the hook point between the jaws of a pair of pliers or a vise. Crush the barb flat with as little damage to the shank as possible. Don't hold the pliers crosswise, as this will weaken the metal and may cause it to break.

Step 2. Clamp the hook into the vise with the bend up and point fully

SHARPENING HOOKS PROPERLY

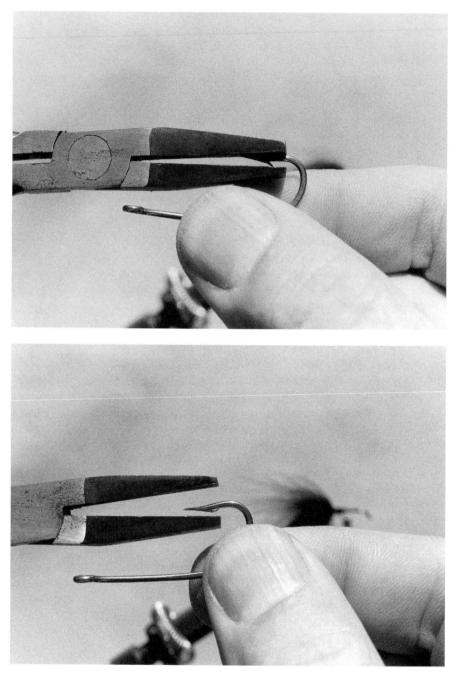

Step 1—Crush barb from the correct angle.

Step 2a—Run the file on the two inside edges under the point.

Step 2b—Run the file on the two outside edges on top of the point.

Step 3—Check point for sharpness by dragging it over your thumb.

exposed, or hold the hook between the thumb and index finger of the right hand. Run the file or hone a few strokes on either side *under* the point (2a) and a few strokes *on top* of the point (2b), creating four cutting blades on the point. Be sure to run the file *from the point back toward the bend.* Running it toward the point will weaken the metal.

Step 3. Check for sharpness by running the hook point down your thumbnail slowly. If it catches and sticks, it's sharp. If it just glides over, keep filing.

Fly Tying: Flies and Instruction

FLY TYPES

Many terms are used to describe the type of fly that is being tied or used. Here's a brief glossary to help the novice understand what that old-timer is talking about. Flies are categorized by the type of forage they're imitating, whether they're used on or under the surface, and where in the water column they're fished.

What They're Imitating

Aquatics. These flies imitate insects, baitfish, nymphs, crayfish, or other life forms that live in the water.

Terrestrials. These flies imitate creatures that live on land and end up as fish food in the water, such as mice, beetles, or ants.

Attractors. These flies imitate nothing in the natural world but still catch fish. Salmon flies are good examples.

How They're Used

Dry Flies. These flies float on the surface. They are tied on thin wire hooks with buoyant materials.

Classic dry flies. Made with a hackle or hair wing. Can be aquatic, terrestrial, or attractor.

Poppers. These are large-bodied dry flies, usually made of cork.

Hair Bodies. These are dry flies tied with deer body hair and clipped to imitate a type of bait, such as frogs.

Wet Flies. These flies are used under the surface. They are tied on heavier hooks and are made of materials that take on water readily.

Classic wet flies. Made with a soft hackle or hair wing. Can be aquatic, terrestrial, or attractor.

Streamers. These are baitfish imitations usually tied with feathers.

Bucktails. These are baitfish imitations tied with bucktail.

Nymphs. These imitate the aquatic stage of some insects.

Streamer/Wet Fly

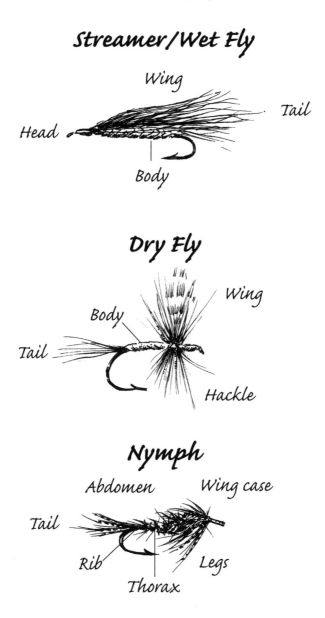

Wing

Tail

Head

Body

Dry Fly

Body

Wing

Tail

Hackle

Nymph

Abdomen

Wing case

Tail

Rib

Legs

Thorax

Three fly styles and their parts.

Where They're Fished

High Water. These are fuller-dressed flies tied on heavy hooks made to sink fast and deep.

Low Water. These flies have sparsely dressed bodies on thin wire hooks made to ride high in the water column in low, clear conditions.

HOW TO TEACH FLY TYING

The basic method of fly-tying instruction presented here is geared specifically for the beginning mentor. Because of this, it is different from most other fly-tying instruction you'll see. Points, procedures, and techniques that should be emphasized throughout the teaching process are highlighted. Each tier will come to prefer certain techniques and will develop his or her own style.

Early Instruction

Depending on your relationship with your apprentice and his or her age and skill level, the actual initiation and procedure of fly-tying instructions may vary. Wait until the child shows a lot of interest and insists on learning.

In an informal setting with your own very young child (three-to-five years old), sit the child on your lap and show him or her how to make a few wraps and attach a few materials in whatever combinations please you both. Move along slowly, consistently teaching the right way to proceed. Form good habits early on without taking the fun and creativity out of it.

With very young children, it's wise to use big hooks—the bigger, the better. The larger the hook, the easier it is for the child to use and for you to find if it's lost. For these initial lessons, any sort of hooks will work; use the cheapest and most easily obtained. Crush the barbs and clip the points. Supply the hooks a few at a time, not allowing too many in the activity zone at once. Include a variety of precut materials to tie on the hooks.

Gradually switch over to smaller, pointed hooks, teaching safety and responsibility along the way. I believe the sooner the youngster learns to handle the real thing, the better. When to do so depends on the individual child and is up to your own judgment.

Adjust the vise so that hooks can be easily put in and securely tightened. Insert the hook so that the point is hidden within the jaws of the vise. This will keep your young tier from severing the thread or impaling a finger on the sharp point. As time goes on, each individual tier develops his or her own preference as to how the hook should rest in the vise.

Before the actual tying takes place, tape a sheet or two of paper on the work surface in front of the vise. This will help the tier locate various items easily. A simple device consisting of a 1-foot-square piece of plywood fastened to four pieces of 2 x 2, with various-size holes drilled in them, makes a handy tray for materials and tools. An egg carton is an easier alternative that will also serve nicely. Weigh it down or secure it somehow to prevent spillage. When we're doing a big weekend show, during which four hundred beginning tiers construct some eight hundred flies, we use several 16-inch-square trays.

Supply the child with good, strong thread that will withstand abuse,

A two-foot-square plywood tray will keep a lot of materials organized during a group instruction.

a pile of body materials in various lengths and colors, miscellaneous colorful hackles, and a supply of "doctored" hooks, and let your young fly tier have at it!

If the parents show sincere interest, encourage them to learn along with their kids. Make it a family experience, and include both parents whenever you can. This doesn't always work with older children (especially teenagers), but with the very young ones, it's important.

Excitement and creativity (along with mess!) will be boundless. Be sure to save some of the early creations for posterity. Specific patterns are not as important at this point as general categories—tarpon flies, salmon flies, and so on—the more exotic the better. Praise the child's efforts, and make accommodations for storing the flood of flies that is sure to follow. Film canisters will serve nicely to hold a few flies. Inexpensive plastic boxes with compartments, found at most hardware stores, will work when the quantities increase. Secure the boxes with rubber bands to prevent spillage. Actual fly boxes cost too much, will fill up too quickly, and are just not up to the task.

As children get a little older (age seven and up) and gain some experience, they'll be ready for fly-tying lessons and actual patterns. It will then become necessary to read fly "recipes." These list the suggested hook size, the

parts of the fly, usually in the order they are attached to the hook, and describe the technique, kind and color of materials, and anything special that applies to the pattern. Most beginner manuals also provide full instruction for the patterns.

Basic Fly-Tying Instruction

Before attempting to tie a specific pattern, it's important to know some of the basic steps involved in the process and to learn the skills needed to complete a fly. Detailed, step-by-step instructions for tying specific fly patterns will be included later in this chapter.

If you don't know how to tie flies, consider taking a fly-tying course with your youngster. This may be a little difficult to find. Check with your local fly shop, sportsmen's clubs, Trout Unlimited, 4-H, Boy Scouts, or community colleges, or call the Federation of Fly Fishers national office for information on possible programs in your area. Another alternative is to find a friend who is willing to help you get started. Faced with the prospect of doing it all yourself, get hold of the *Universal Fly Tying Guide* or *American Fly Tying Manual* and start reading.

General Guidelines

There are some general rules or procedures that help keep flies neat and strong. Keep these in mind while teaching the beginner:

- Put down a sheet or two of light colored paper on the tying table before beginning. It makes a good background to help make materials easier to identify, protects the surface, and keeps things neater.
- Keep only the materials needed for the fly you are tying on the table in front of you.
- Prepare by placing the hook in the vise, threading the bobbin, and choosing the fly pattern and "recipe."
- Maintain tension on the thread at all times.
- Start with a good even base of thread across the length of the hook shank. Flies are almost always tied from the end of the shank, at the bend, forward toward the eye.
- Make all wraps away from you over the top of the hook shank.
- All thread wraps, except the head, must be covered and hidden by the materials.
- Keep the number of thread wraps to a minimum. Excess thread will only bulk up the fly and detract from its appearance and effectiveness. Use only the wraps needed to make it strong.
- Stop and fix mistakes; don't try to tie around them.
- Keep all materials securely tied and even to avoid making a sloppy, uneven body.

- Avoid crowding the hook eye. Leave at least ⅛ to ¼ inch behind the hook eye for the *red zone,* the area where the head is to be tied. Leaving insufficient space or crowding the eye is one of the most common mistakes of beginning tiers.
- Use the natural end tapers of the materials; trim the butts, not the tips.
- Sparse is better. Less material will usually cause a fly to appear more lifelike and last longer.
- Follow the recipe and suggested proportions.
- Keep bodies even and symmetrical along the hook shank.
- Always cut materials from the top to avoid cutting thread.
- Trim off materials at an angle. The clipped ends will be easier to secure and will look more even when covered with thread or other materials.
- Finish the head of the fly by clipping off materials and winding the thread in an even manner. Tie off the head with a half hitch knot. Avoid using head cement with beginners.

A portion of my son Cosmo's original fly patterns, tied when he was five years old.

Teaching a Group

Instructing a group of beginning fly tiers is mostly an exercise in damage control. We use two methods of running group classes. One method involves one main instructor teaching a pattern at a workshop series or special event. The instructor ties the first example while everyone in the class gathers up close to watch. The students then return to their seats and tie a fly along with the instructor. Apprentice instructors are available to pass out materials and help anyone who needs assistance while tying. In this way, a very large class can be easily accommodated, and each participant gets individual attention.

In the other method, there are several instructors. Our young apprentices teach at several events each year. We usually team them in pairs and have one instruct while the other helps the students. They can then switch occasionally. One pair can handle up to four students effectively. If there are four pairs (eight apprentices), sixteen students can be taught at a time effectively. Damage control is handled by the mentors at the large shows. They keep tabs on everything, cleaning up and directing the traffic flow. All students sign in with name, age, and address. This gives us a mailing list and the total number of students served. Each new tier gets a film canister (available at camera shops) for his or her first flybox. This keeps the flies out of clothing and us out of trouble!

The class gathers around Bud LaRocque as he demonstrates a hairwing Rusty Rat.

Katie Donahue works as the roving instructor, helping students tie their first Woolly Buggers.

SPECIFIC PATTERNS

After you've gotten down the basics of attaching thread and materials to the hook, start practicing some specific patterns. The beginning tier should concentrate on learning a few effective fly patterns that will consistently catch the most fish in the most situations and are easy to tie. I recommend starting with the ones known as the Fabulous Five: the Woolly Bugger, which can be used in a variety of colors and sizes; the Gold-Ribbed Hare's Ear, the generic nymph that's sure to be found in every serious fly fisher's vest; the Mickey Finn, the classic bright-colored bucktail; the White Marabou Streamer, a simple but deadly baitfish imitation; and the Adams, a superb dry fly.

Specific tying instructions for the Fabulous Five flies and the Big Three Saltwater patterns are included. All the procedures outlined will be for right-handed tiers. I have chosen these flies because they are consistently effective with a variety of gamefish, and each represents a category and style of fly used extensively by fly fishers the world over. Once learned, these patterns can be used successfully in a number of sizes throughout the new tier's angling career. Each fly can be constructed with a minimum of common, easily acquired materials and the tying instructions include at least one specific, basic fly tying procedure that can be learned and perfected by tying several of each pattern.

The instructor should sit directly across from the student in a well lit area. A narrow table fitted with two lamps is ideal. Attach a few sheets of light colored paper to the surface to help silhouette the fly, protect the table top, and keep the area neat.

Choose a simple pattern. Keep the area uncluttered. On the fly-tying table in front of the vise lay out the materials to be used in the fly in order of their attachment to the hook. Place all needed tools to the right of the tier.

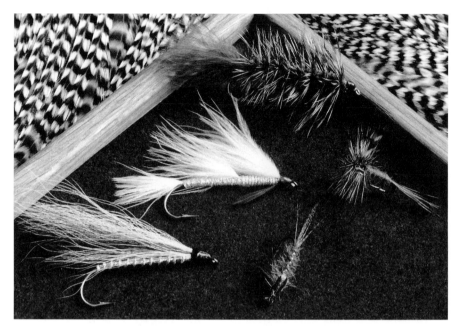

Five great flies for most situations, from top: Woolly Bugger; White Marabou Streamer; Adams dry fly; Mickey Finn bucktail; Gold-Ribbed Hare's Ear nymph.

Select a hook. Inspect it to see that there are no deformities in the construction. Be sure the eye is fully closed. An open eye will catch the fine tippet mono and cause problems when the fly is used. Crush the barb. You may wish to sharpen the point at this time. Install it in the vise.

Begin the lesson with a simple description of each tool and its uses. The information in this chapter should be of great help. Always provide the best quality materials that you can. No amount of skill can make up for poor materials.

Demonstrate the full tying procedure for a single fly, from start to finish. While tying, describe each step. After the fly is completed the student and instructor can tie one together, step-by-step. Encourage the student to practice and learn the pattern by tying several in a variety of sizes.

The Woolly Bugger

This pattern is probably the most widely used and taught fly in the world. Its construction includes most of the basic skills needed to tie a simple fly. I've presented the steps in a fashion that will cover problems most often encountered with teaching beginning tiers, while highlighting simple techniques and tips that will help the student master the basics.

White is used here to highlight the thread's position.

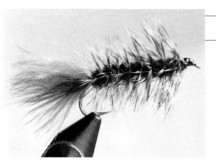

PATTERN: Wet Fly—Woolly Bugger

HOOK: 1X to 3X long streamer or nymph hook, sizes 14–2

THREAD: Black (or body color) 6/0 for most applications

TAIL: Marabou to match body (color is the tier's choice)

BODY: Chenille (wool, fur dubbing, etc., may be substituted), about three inches

HACKLE: Color (tier's choice)

COMMENT: The Woolly Bugger doesn't imitate any specific insect or other specific fish food. Its design causes it to be very animated in the water, mimicking a number of different creatures' movements. It can be tied in a variety of colors and sizes. All black, olive, brown, white, and gray are the most popular. Grizzly is used frequently for the hackle. It is often weighted with lead wraps under the body material, a bead head or bead chain, or dumbbell eyes.

PROCEDURE:

1. Insert the bobbin threader into the top of the bobbin tube. Run the thread through the loop and pull it up the tube. Adjust the tension on the thread by spreading or squeezing the bobbin legs. The spool will be held tightly by the legs. The thread must be able to be pulled out smoothly without breaking. Lift the bobbin up by the thread. It should have enough tension to hold its own weight. The bobbin should be held loosely in the palm of the right hand with the tube protruding between the thumb and index finger. Thread can be shortened by

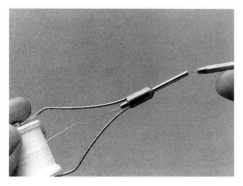
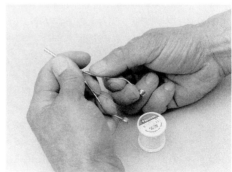

Step 1

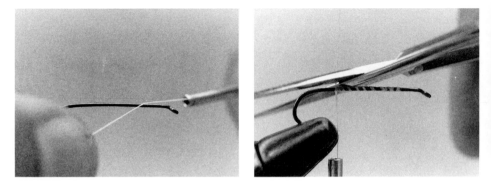

Step 2

holding the bobbin upright in the palm and moving the spool with the thumb while keeping tension on the thread with the left hand.

2. Pull off 6 to 8 inches of thread. Hold the bobbin loosely in the right hand. The tag end is held in the left. Place the thread at an angle across the hook about mid-shank. The left hand will remain against the vise behind and below the hook. The right hand will move the bobbin down and around the hook shank, always winding away from the tier with tension on the thread. Throughout the tying process, keep the distance between the end of the bobbin and the hook shank to an inch or less. This simple habit will allow the tier to keep constant tension on the thread and to reduce winding effort. Wrap three turns toward the eye, then reverse direction and wrap at least eight turns back over the thread and the tag end, stopping just before the bend. This will form a secure base on the hook shank for the rest of the materials. Allow the bobbin to hang freely below your work on a few inches of thread. This is standard bobbin position between each step and will keep it out of your way. Be sure to keep tension on the thread at all times during the process. This is the key to a well tied fly. All materials must be securely fastened from the start if the fly is to hold up. Hold the tag end up straight over the hook shank with the left hand. Trim it close to the shank. All materials are trimmed in this fashion to prevent the thread leading to the bobbin from being cut.

3. Select a plume of marabou for the tail. Hold it on the shank of the hook with the right hand, tip facing to the rear (bend) of the fly. The Woolly Bugger tail should be a little longer than the length of the hook shank. Grasp the plume with the thumb and index finger of the left hand, touching those of the right. This exchange of materials from one hand to the other is a standard way of measuring and handling mate-

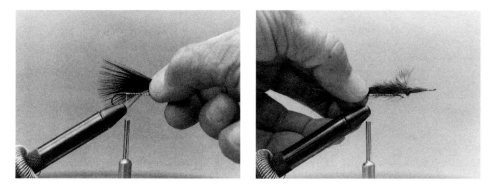

Step 3

rials before tying them into the hook. Place the tail in position just before the bend of the hook shank. The natural taper of materials is usually pointed to the rear of the fly giving it a sleek look when wet. Avoid cutting or trimming this taper. Try always to trim for length from the butt end of all materials.

4. While keeping tension on the tail with the fingers of the left hand, grasp the bobbin in the right and pull the thread to the rear at a sharp angle between the thumb and index finger. Pinch the thread tightly. Move the bobbin to the other side of the shank. Pull the thread down tightly, freeing it from the pinch and fastening the materials to the shank. Repeat two more times. The marabou plume is now ready to be tied in completely. The pinch method is the basic technique used for tying in materials on most flies. Unruly materials are stroked back out of the way of the thread throughout the tying process. You may even wish to wet the hackle or hair slightly to keep it under control.

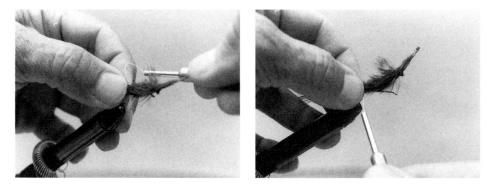

Step 4

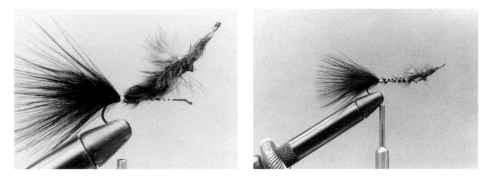

Step 5

5. Wind about eight wraps of thread tightly up the hook shank to within ⅛ inch of the eye, securing the feather. Return the thread to the base of the tail with five or six tight wraps. Trim off the excess plume. If the feather is tied in neatly and uniformly it will give an even base for the chenille body and hold the tail firmly in place. Use only the number of wraps that will secure the material to the shank. Always avoid excess thread wraps. Too much thread will make the fly bulky and result in a poorly tied fly. Choose a hackle with barbs about one and one-half times the length of the hook gape. To determine this, bend it around the hook shank and compare the barb length to the gape.

6. Hold the top inch of the tip of the hackle in the left hand and stroke the barbs on the remaining feather down gently, flaring them to the side. This simple procedure will separate the barbs and allow the hackle to be tied in more neatly and evenly. Tie in the tip at the base of the tail and secure it along the hook shank. Return the thread once again to the base of the tail. Tying the hackle in this fashion will place

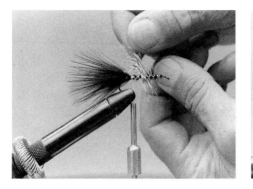
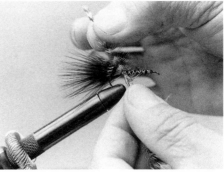

Step 6

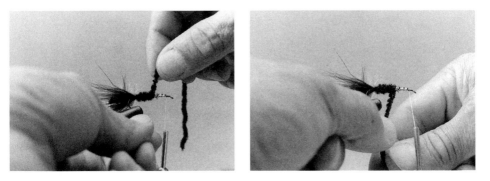

Step 7

the shorter barbs to the rear of the fly and the longer barbs toward the head, giving the fly a nice, naturally tapered appearance. Extend the butt of the hackle back behind the rear of the fly to keep it out of the way until needed.

7. Grasp the tip of the chenille in the left hand and pull off about ¼ inch of the fluff from the end, exposing the thread core. This step will help eliminate useless bulk and keep the body even. Hold the chenille at the base of the tail and tie in securely to the shank using the pinch method. Continue to wind the thread along the body to within ⅛ inch of the eye and hang the bobbin. Hold the end of the chenille directly over the hook with the left hand and, while keeping constant tension, bring it down under the shank and transfer it to the right hand, which will be waiting by the side of the vise to receive the chenille. Check to see that all thread wrappings at the base of the tail are covered by this first wrap of chenille. The left hand will release the chenille back to the right hand. Grasp it again in the left hand. Repeat the process, always keeping tension and always winding away from the tier. This technique will keep the chenille from twisting while making a firm and even body. It is used while winding any material on any part of the fly.

8. Wrap the chenille to the hook eye. Hold it straight over the shank with the left hand. Pick up the bobbin with the right hand and place it over the top and behind the chenille about ⅛ inch from the eye. Repeat three or four times. Trim the excess chenille. Make a few more wraps to secure it. If this is done properly the body will be fastened to the shank about ⅛ inch from the eye. Then grasp the butt of the hackle with the fingers of the left hand or hackle pliers. The hackle will be wrapped the length of the hook shank in five evenly spaced turns using the same technique as that used with the chenille. This method of wrapping a hackle along the length of the shank is called palmer-

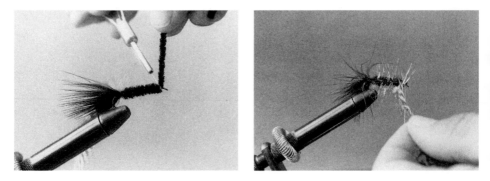

Step 8

ing. Each turn will bury the hackle into the grooves between the chenille wraps. This is accomplished by keeping constant tension on the hackle (being careful not to break it) and moving it in a front-to-back motion while forcing it into the grooves. This simple operation will help protect the fragile hackle and produce a much neater fly. Tie off the hackle ⅛ inch from the eye, using the same technique as with the chenille. Trim the excess hackle. At this point the thread should only be visible at the eye of the fly.

9. Place the thumb, index, and middle finger of the left hand around the eye of the hook and pull back gently, holding the hackle fibers out of the way. Build a neat, tapered head with several wraps of thread and finish with a whip finish (see page 31). Or use several half hitches: Hold eight inches of thread tightly with the left hand at a right angle to the fly. Place a soda straw or your finger about half-way between the bobbin and the eye of the hook and wrap the thread around it once. Then slide the thread up snugly behind the hook.

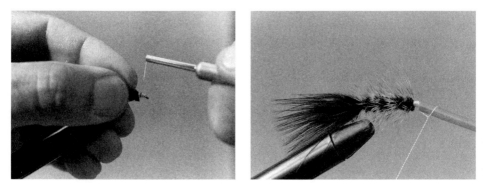

Step 9

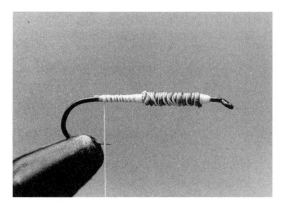

Wire weight applied to the hook waiting to be covered with materials.

Additional Skills and Concepts

To become more proficient, the beginning tier will need to master basic skills such as *tying in wire weight,* which is done by starting the thread and forming a base along the hook shank. Then select the diameter wire that is about the thickness of the hook shank. Break off a 3- to 4-inch piece with your fingers or use an old pair of scissors. Secure one end about halfway down the hook shank and wrap evenly and tightly to where you plan to begin the head (usually a little more than ⅛ inch from the eye). Wrap several turns of thread around the coils and on the back end to make a smooth, tapered "stop". This will keep the wire from twisting around the shank or moving back and forth.

Tying in weighted eyes is another important skill. Tie in thread ¼ inch or so (depending on hook size) back from the hook eye. Form a small ball of thread and move the thread over (towards hook bend) about ⅟₁₆ inch. Form another ball. Trim the tag end. Place the eyes on top of the hook shank between the balls of thread and place a few wraps of thread in a figure eight

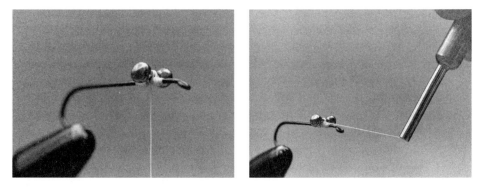

Fasten weighted eyes between thread balls with a few figure eights. Finish by wrapping securely underneath.

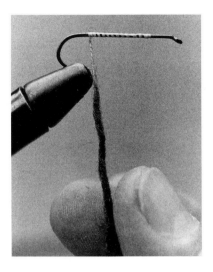

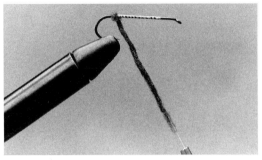

When applying thread to make a dubbing noodle, be sure to twist in one direction.

Start by sliding the noodle up to the shank and covering the thread wraps.

around it. Snug up the thread and begin winding it tightly around the base where the dumbbell meets the shank; do not use a figure eight motion here. Keep the wraps tight as the bobbin moves in a slight up and down motion surrounding this base. After several turns, make a few more figure eights over the top of the eyes. Check to be sure eyes are secure. Make a half hitch with thread on the hook shank to keep the thread in place. Cover the wrappings with the body as the fly is finished.

To form a dubbing noodle, start the thread and run it to the hook bend. Pull 3 to 4 inches of thread from the bobbin. Apply a small amount of dubbing wax, if you choose to use it. Keeping the thread tight with the left hand, press a small amount of loose dubbing material evenly along the thread. It is a very common error to use too much dubbing material. While tension is still applied on the thread by the left hand, use the thumb and middle finger of the right hand to gently but firmly twist the materials on the thread in one direction. In essence you are making a piece of chenille or yarn to use for the body. Slide this sparse noodle up along the thread to where it meets the hook. Wind it on evenly along the shank, adding more dubbing if needed, forming a uniform body. Clean off any excess.

Repairing a broken thread is another basic skill. If the thread breaks at any time during the fly-tying process, grasp the thread end and materials as quickly and neatly as possible to prevent unwrapping. Attach a hackle pliers to the broken thread and allow it to hang free, keeping tension on it. Restart the thread and clip the tag ends. This is a common problem at fly-fishing shows. Keep a bobbin threader and a few already threaded bobbins nearby. Breaking the thread occasionally on purpose and repairing it is recommended practice for beginners.

Proportion is an important consideration when tying flies. Fishing flies are

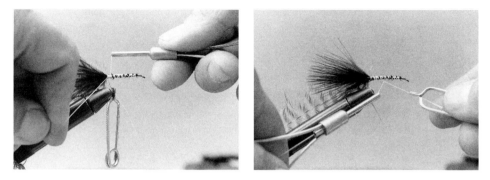

Catch the broken thread in a hackle pliers and begin again. Wrap the broken end in securely.

designed either to sink or float in a true-to-life manner with all the parts working together. The fly fisher's job is to present the fly in the proper fashion so that it will perform as desired.

The fly tier constructs the fly by adding the specified materials to the hook shank in the correct amount, clipped to the proper length, and secured in the appropriate place to make the fly perform as intended. A dry fly should float upright; a streamer should ride up while being retrieved and its wing should not wrap around the hook shank when cast.

Tying each fly in the proper proportion will allow it to function correctly and look pleasing to the eye. Always review the individual recipe and, if possible, see an example of the pattern while tying to be sure to achieve the correct proportions.

Over time, a tier will develop a natural sense of proportion and learn the basic rules that help their flies perform as intended. Proportions for some specific patterns will vary, but there are a few traditional rules that are usually followed.

When cutting hair from a patch or flash material from a bunch, clip it close to where it is attached to the skin or packet. Then trim to desired size. This will keep all the remaining materials the same length and organized, resulting in less waste and more efficiency.

For a wet fly, the tail is the length of the hook shank (eye to beginning of bend), and the wing is the length of the entire hook (eye to outermost bend). For a dry fly, the tail is the length of the hook shank (eye to beginning of bend), the hackle wing will equal about 1¼ times the width of the hook gape, and the body will take up about ¾ of the hook shank, the wing the remaining ¼.

With practice the young tier will move along steadily, learning how to identify and handle materials. Flies will gradually change from impromptu creations to more anatomically correct versions of insects and even standard classic patterns.

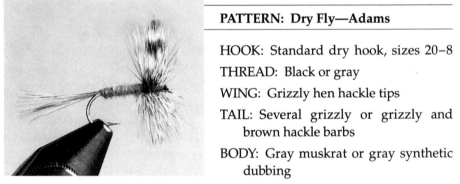

PATTERN: Dry Fly—Adams

HOOK: Standard dry hook, sizes 20–8

THREAD: Black or gray

WING: Grizzly hen hackle tips

TAIL: Several grizzly or grizzly and brown hackle barbs

BODY: Gray muskrat or gray synthetic dubbing

HACKLE: Grizzly or grizzly and brown dry fly hackle

COMMENT: The Adams is probably the most popular dry fly in use today. It does not represent any specific insect, but can be used as a buggy looking offering that will attract many species. In large sizes it is effective on river smallmouth bass; when tied on a tiny number 18 or 20, it can fool even the wariest spring creek brown trout.

The wing is tied in first on many dry flies, unlike most other types of flies. This allows it to be more firmly attached and easier to work on.

SKILL LEARNED: Installing dry fly wings.

PROCEDURE:
1. Secure thread to the front quarter of the hook shank. Select two matching grizzly hen hackles. Hold them front (shiny) sides together in left hand. Measure a hook shank length, from hackle tips to finger tips.
2. Switch hackle to the right hand by placing finger tips to finger tips. Place hackle tips on the hook shank, pointing them toward the eye. Tie in at tip of fingers, securing them about ⅓ of the distance back

from the eye. Point the butts back toward the bend and secure along the shank with a few turns of thread. Trim the butt ends.

3. Pull up the wings so they are perpendicular to hook shank, then grasp with the fingers of the left hand.
4. Pull down a few of the barbs from the back of the base of the wing and tie in along the shank. Run a few figure eight turns of thread around the wing pair. This should support and separate them nicely.
5. Measure the tail to be about shank length and tie in at the bend. Wind thread over the secured wing barbs and tail to make an even underbody. Return thread to bend of hook.
6. Form a sparse dubbing noodle to use for the body.
7. Slide this sparse dubbing noodle up along the thread to where the thread meets the hook. Wind it on evenly along the shank from the tail to the base of the wings forming a uniform body. Clean off the excess.
8. Select two dry fly hackles, whose barbs are about as long as the hook gape is wide. Clean off the lower barbs and fluff, leaving only some stubble to catch the thread and hold the hackle securely behind the wing base. Bring thread to the eye.
9. Wind in hackles evenly behind wings. Grasp the wing in the finger tips of your right hand and pull it back out of the way, then wind in the hackle in front of the wing. Tie off and trim.
10. Finish the head.

PATTERN: Nymph—Gold-Ribbed Hare's Ear

HOOK: Standard nymph hook, sizes 16–8

THREAD: Black or brown

TAIL: Rabbit guard hairs or mallard flank barbules

THORAX & ABDOMEN (Body): Hare's mask fur or commercially prepared hare's ear dubbing mix

RIB: Round thin gold tinsel or wire

WING CASE: Turkey tail

COMMENT: The Gold-Ribbed Hare's Ear can usually be found in the fly box of nearly every serious nymph fisherman and for good reason. One of the most effective and easily tied nymphs, the Hare's Ear is used in all sizes and nearly all trout waters. Not a specific imitation, this popular nymph

is buggy looking enough to be mistaken for a number of different aquatic insects.

SKILL LEARNED: Making a wing pad.

PROCEDURE:
1. Tie in thread and form a base along the hook shank.
2. Select diameter wire that is about the thickness of the hook shank and install.
3. Select a tail and tie in a bushy clump equal to about half the length of the hook shank.
4. Tie in the rib.
5. Make a dubbing noodle on the thread. Wind in dubbing to about half way up the shank.
6. Secure and tie in. Wind the rib up the abdomen in an opposite direction (so that it doesn't slip between the dubbing wraps) three or so turns and secure along with dubbing. Trim.
7. Clip out the wing case section from turkey tail feathers. Tie in with dubbing and rib. The shiny front part of the wing will be facing up on the finished fly. Lay the wing pad back flat on the already tied abdomen of fly.
8. Form another noodle on the thread, which should be at the base of the wing pad. Wind it to within ⅛ inch or so of the eye. Tie off.
9. Pull the wing case over the dubbed thorax and snug up. Tie off, trim, and finish head. Pick out guard hairs and other material along the body to give the fly a buggy appearance.

HINTS:
- Before cutting the wing case from the turkey feather, apply a coat of cement to harden and strengthen it.
- A variation of the fly can be tied using Krystal Flash for the wing case, creating a "flash back" hare's ear.

PATTERN: Bucktail Streamer—Mickey Finn

HOOK: Streamer hook, sizes 12-2

THREAD: Black

BODY: Flat silver tinsel (can be overwound with an oval tinsel rib) or other reflective body material

WING: Alternating yellow and red bucktail

COMMENT: An ancient streamer design that has been a staple trout, salmon, bass, and panfish fly for generations. A classic example of an attractor type pattern, it is still in wide use and very popular today.

SKILL LEARNED: Constructing a bucktail wing.

PROCEDURE:

1. Tie in thread and make a base along the entire hook shank, stopping at the bend.
2. Tie in flat tinsel body and wind up to the head. Tie off and trim.
3. Select a wisp of yellow bucktail about 1½ times the length of the hook shank. Clip off at base of patch.
4. Hold bucktail firmly and clean off excess fluff and shorter hairs.
5. Tie in just behind head. Be sure the last few wraps toward the back of the wing are loose. If they are too tight the hair will flair out. Trim off at an upward angle being sure the eye is clear of material.
6. Select another wisp of red bucktail, the same length. Tie in and trim off as before. Top off with a final wisp of yellow. The angle of the trimmed bucktail should be the base for a nicely tapered finished head.

PATTERN: Streamer—White Marabou

HOOK: Standard streamer hook, size 10 and up

THREAD: Black or white

TAIL: White marabou (optional)

BODY: Silver tinsel, braided mylar or similar material

WING: White marabou, mallard (optional)

COMMENT: Easy to tie, very effective streamer used for many species of freshwater fish. Can be modified for saltwater if rust-resistant hook is used.

PROCEDURE:

1. Tie in thread and form base ending at the bend of the hook. If a tail is to be used, select a clump of marabou about half the length of the shank and tie in.

2. Tie in tinsel and wind thread to ⅛ inch from the eye.
3. Wrap body around the shank of the hook and tie off near the eye.
4. Select a marabou plume with barbules that are about the length of the hook shank. Tie off at the head. Trim, tie off, and form an even head.

HINTS:

- A midwing (see photo) may be used on longer flies or for a variation.
- If using white or other light colored thread, you may make an eyeball with a pointed permanent marker and cement over it to seal it.
- You may add one turn of mallard flank around and over the marabou to give the fly a little color or variation, or a wisp of red hackle under the head for a throat.

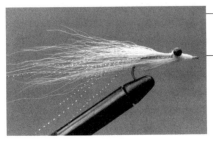

**PATTERN: Clouser Deep Minnow
(Saltwater Fly)**

HOOK: Straight eye, standard length saltwater

THREAD: Monocord or similar, usually white or fly body color

EYES: Dumbbell type (lead, nickel, bead chain, or other)

WING: Bucktail, ultra hair, foxtail, or other; Krystal Flash midwing (a few strands of color to suit)

COMMENT: The Clouser Deep Minnow was developed by Susquehanna River guide and fly shop owner Bob Clouser. Originally designed for smallmouth bass, this style of tying has been used to create flies from one inch to over a foot in size. They are used all over the world for practically every species of fish in fresh and saltwater.

The lead eyes tied in on top of the hook shank cause the fly to invert, making the wing and the hook point ride up. This makes the fly very snag resistant when retrieved over rocky terrain or weedy flats.

Match the size fly to the fish sought. Color combinations and material choices are up to the tier. Two very popular combinations for saltwater include bucktail, which has a chartreuse top, white bottom, and silver Krystal Flash, and ultra hair, which has a blue top, green bottom, and pearl Krystal Flash.

Paint eyes on dumbbells using lacquer. Coat with epoxy. Black on red and black on yellow are the most popular combinations.

PROCEDURE:

1. Place hook in vise in usual position (shank up). Tie in dumbbell eyes of desired size.
2. Select a small clump of light color bucktails (or preferred material) and measure desired length. Keep the amount of material on the sparse side. Too much will prevent a natural appearance of the fly and impede its fast sink quality. Clip butt ends even. Dab ends with cement and tie in behind the hook eye. Place so that they will not need to be trimmed.
3. Tighten up windings. Hold bucktail over the dumbbell and along the shank of the hook. Wrap a few lengths of thread evenly along the length of the hook shank, securing the bucktail. Stop just about at the hook bend. Wind a few extra wraps, apply a dab of cement, and return thread to just in front of the dumbbell. Secure thread with a half hitch or two.
4. Take the hook from the vise and invert it with the point on top and shank below. Push the bucktail out of your way.
5. Tie in Krystal Flash (desired amount). Select a clump of darker bucktail (or preferred material), clip butt ends to a length equal to or shorter than the other bucktail, apply a dab of cement, and tie in (placing so that trimming is not needed).
6. Finish off with a nice even head. Apply cement. Allow to dry, then apply some five-minute epoxy to the head for added strength (avoid the eye of the hook).

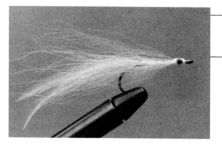

PATTERN: Lefty's Deceiver (Saltwater Fly)

HOOK: Straight eye, standard length saltwater

THREAD: Tier's choice

COLLAR: Bucktail (color is tier's choice)

BODY: Thread or tinsel (wound under collar)

THROAT: Red Krystal Flash (rabbit fur, wool, etc.)

WING: Four to ten matched saddle hackles (color is tier's choice), a few strands of Krystal Flash or flashabou (color is tier's choice), a single grizzly hackle both sides (optional)

TOPPING: Several peacock herl (optional)

EYES: Optional

COMMENT: The Lefty's Deceiver is probably the single best known and most widely used fly in all of saltwater fly fishing. Developed by Bernard "Lefty" Kreh in the 1960s, the Deceiver has been used to catch countless fresh and saltwater species throughout the world.

Making a Deceiver involves a method or style of tying a fly, rather than a specific pattern. The finished product can be simple or elaborate, bright or dull, large or small. The fly size, however, should match the size of the baitfish found locally and be tied to the preferences and demands of the species sought.

Eyes can be put on the finished head or applied to a cheek tied in along the sides behind the head. Peacock toppings can be added to give the fly extra appeal, imitating the dark shiny back found on many baitfish.

An all-white Deceiver is the fly of choice for many anglers. All-black Deceivers have taken as many striped bass at night as any fly ever developed.

PROCEDURE:
1. Start thread and build a base, stopping at about the bend of the hook.
2. Select four to ten hackles of the desired length. Clean some of the down off the end of the quills. Lay one half of the quills on the tying table curving side up, stacked on top of each other. Take the other half and lay them on the top of the other hackles, curve down. All hackles should fit together lying straight.
3. Grasp the ends of the quills and secure them with a few wraps to the top of the hook shank at the rear of the hook, at the bend, so that they point straight out, tips facing away from the eye on top in line with the shank.
4. Dab a few drops of cement onto the quills and thread. Now wind several wraps, saturating the thread with cement (a few strands of Krystal Flash can be added if desired for added flash.)
5. Bring thread to within ⅛ inch of eye. Select a clump of bucktail (amount based on the size of fly). Check length and trim so that the tapered ends run well beyond the bend of the hook. This part of the design helps prevent the hackles from turning back and fouling or twisting around the bend of the hook. This is probably the single most important feature of this fly.
6. Trim the butt ends of the bucktail to length, dab on some cement and tie in to the side of the hook shank. Do the same to the other side of the hook, forming a collar of bucktail around the shank.

The fly can be finished off now if desired or you can tie in a throat (a short, small clump under the hook eye), tie in a few strands of Krystal Flash to the top of the shank for flash, tie in a sparse clump of darker bucktail to the top of the fly, tie in a few strands of peacock herl topping (about the length of the bucktail or a little longer), or finish the head and put on an eyeball. Or you can do all of the above.

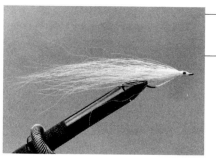

PATTERN: Bendback Streamer (Saltwater Fly)

HOOK: Straight eye, regular length saltwater

THREAD: Tier's choice

BODY: Chenille or mylar or nothing (color and size are tier's choice)

WING: Bucktail, Krystal Flash, peacock topping (optional)

OTHER: Painted eyeballs

COMMENT: The Bendback Streamer was developed in the early 1900s for use in weedy situations when seeking bass in lakes and ponds. In recent years, saltwater fly fishing expert Chico Fernandez popularized this style for use on shallow saltwater flats and anywhere weeds are present.

The design of the fly allows it to ride hook point up. The wing covers the point and bend, making it relatively weedless.

Among the simplest of all saltwater patterns, the Bendback is nevertheless one of the most effective and useful of all fly designs and deserves a place in any saltwater outing.

PROCEDURE:

1. The secret of this pattern's effectiveness is the hook shape. Place the eye and about ⅓ of the shank of the hook into the jaws of a pliers. Hold the pliers tightly and push down on the hook to bend the shank slightly. Do not overbend the shank; this will interfere with hooking efficiency.

2. Place the hook in the vise, point up. Start the thread just behind the eye and wind it to the bend of the hook. Tie in the body. Return thread to ⅛ inch of the hook eye. Wrap the body in evenly to the thread and tie off.

3. Select a clump of bucktail (size and color tier's choice). Trim butt end

so that the tips will lie past the bend, covering the point of the hook and extending at least half the hook shank length past the bend. Tie off.

The fly can be finished here or a few strands of Krystal Flash can be added, darker bucktail can be tied in, a few stands of peacock herl topping can be added, eyeballs can be put on the head, or all of the above.

Once again, the bucktail wing will cause the fly to ride hook point up and be virtually weedless. Design the fly with this in mind.

Store-Bought Flies

Many fly fishers buy all their flies or bum them off their buddies. I think fly tying is at least half the fun of the sport, however, and should be done yourself in order to enjoy fly fishing to its fullest. Nevertheless, you may have occasion to pick up a few commercially tied flies while visiting a fly shop. You may have lost all your flies to the riverbottom or left them at home, need a few good patterns to duplicate, or want to pick up a "hot" local pattern while on a trip. The flies offered by a quality fly shop are sure to be well tied and worth the purchase price. Always sharpen the hooks of any new flies before using.

Poppers. Poppers can be used as effective imitations of grasshoppers or beetles blown into the water from a nearby field or fallen from an overhanging tree or bush. Panfish (which includes bluegills, pumpkinseeds, and others) and small largemouth bass love to feed on these insects on the surface.

Most popping bugs are constructed with a long shank hook, small painted cork body, and a few hackles wound around the hook near the cork

Like Dick Stewart, noted author and fly tier, you can create your own original patterns:

"A Japan-made fly rod affixed with a skeleton reel and level fly line provided my first fly fishing, which was for little bluegill sunfish that lacked the brainpower to refuse the simple flies tied with hackle-barb tails, a chenille body, and a few turns of hackle in front. These nameless flies were tied by the dozens in red, yellow, white, gray, brown and black—whatever colors I accumulated in my materials collection."

When I was about seven years old, I read *Just Fishing*, by Ray Bergman. He made fly fishing sound a lot more fun than bait fishing, so I started hanging around Hall's Hardware, a store that was the equivalent of today's fly shop. I would sit and listen to the owner, Harold Hessler, and all the other experts as they talked about what they caught, where and when they caught them, and what fly they used. I absorbed much more from them than I could have learned on my own.

In addition to hammers and nails, Hall's sold fly-tying materials, and I would buy some every week, teaching myself how to tie flies. After a while Harold asked me if I'd like to tie some flies for the store. He told me he'd give me a dollar a dozen. That sounded pretty good to an eight-year-old. I delivered a dozen McGinty wet flies the following week, but I'm sure he threw away that first dozen, and probably the next six dozen after that.

Harold must have seen a potential fly tier in me, however, and thanks to his patience, I finally learned to tie well enough to see my flies in the cases with the others at Hall's Hardware.

—Dr. Carl Richards, dentist and fly-fishing author

body. Making these flies correctly can be difficult. Glues and paints can make a real mess. The cork body must be the right size and must be properly secured to the appropriate hook in the correct position with the proper adhesive for the whole business to work effectively.

I found that it is much easier and, in the end, more productive to purchase a few popping bugs from your local sporting goods store. They are usually inexpensive and readily available. Pick up the smallest you can find. The color doesn't matter as long as you can see them clearly on the water. Crush the barbs before using.

Almost any weight rod will work. A floating weight-forward line and a basic leader tapered down to a six pound test tippet or so will be fine. Find a pond full of willing bluegills and you are ready to go. Simply get the fly out there and dapple and giggle it around docks, logs, lily pads, and submerged weeds, and you will probably be successful.

Bring along a pair of hemostats or small needlenose pliers to aid in removing the hooks. Hold the fish gently around the middle in the palm of your hand, folding the pointed spines of the dorsal (top) fin down safely against the fish's back. Grasp the hook—not the popper body—to remove it.

One advantage of this fly is that it floats high on the water and won't tangle in the submerged weeds and branches that are so often prime habitat of panfish. Even though a woolly worm fished slowly beneath the surface may be more productive and attract larger fish, the floating popping bug will keep the hook from getting tangled in vegetation and allow you to see the fish grab the fly. A large Adams dry fly will also be effective, but will not float as readily as the popper after extensive use.

If you want to try to make some popping bugs from scratch, pick up *Bug Making* by Boyd Pfeiffer (Lyons and Burford, 1993). This thorough text will guide you step-by-step through the process.

4

Tackle and Equipment

We've all heard tales of youngsters fishing with poles cut from willow branches, complete with shoestrings for lines and safety pins with grasshoppers or worms attached. The giant trout and bucketmouth bass that were lured to these crude offerings helped hook the youngsters on the sport for life.

Today, such rigs are used rarely, and fishers seldom have the opportunity to catch those huge, legendary lunkers so easily. Fishing tackle has become mass produced and is stocked in every chain store. Some sort of gear is available to every angler with even the most modest budget. Instead of the idyllic farm pond, young anglers may seek their first angling experience in a much more urban setting, and a Donald Duck spin-casting outfit has replaced the willow pole and safety pin.

SPIN FISHING

Closed-face spin-casting outfits are one of the simplest systems for getting even the youngest child out on the water. A little assistance with knot tying and baiting a hook, a quick casting lesson, and he's fishing! It's hard to argue with the efficiency or the results of this method. There's no better way to satisfy a child's desire to catch a fish. I recommend it as a truly fun, low-maintenance, almost foolproof way to introduce a youngster to the sport and spend some time together on the water.

Each year the Fly Fish Apprentice Program sponsors a Learn to Fish Day at the Ithaca Farmers' Market on Cayuga Lake in Ithaca, New York. We invite the entire community and have a ball teaching young kids to tie a good knot and to use spin-casting outfits. Then we provide an opportunity for them to catch giant carp on corn from the shoreline. For sheer basic sportfishing excitement, you can't beat the combination of young kids and big fish.

Spin-fishing equipment can be used to deliver a fly tied by the young apprentice. Simply fasten the new creation to the end of the monofilament and attach a very small float. When fishing deeper water, include a split shot

I started angling in a very basic way. Not knowing anyone who fished very much, we started out with some light cord wrapped on a short piece of stick. With this and a sinker tied on one end, and snelled hook and bait, we had ourselves a pair of throw lines. No rod. No reel. We caught just enough fish to encourage us to buy $2 Calcutta cane poles and some used reels. With these we would fish a jetty at Bodega Bay in California, where in 1963 Alfred Hitchcock made the movie *The Birds.*

Two years later, after getting washed off a reef into rough water and nearly getting drowned, I decided to try freshwater fishing.

—Henry Hoffman, originator of the genetic hackle

placed a foot or so above the fly; the weight will allow for easy casting and control of the lure. Floats made especially for this purpose are inexpensive and can be found in most tackle shops.

This system has been consistently effective on bluegills and bass in shallow water. Here is where the small woolly worms and Mickey Finns will shine. It is the best way I know to wean budding anglers from bait, enable them to actually use their own creations in an easy, effective manner, and most important have them succeed in catching a fish while having some great fun!

SELECTING FLY TACKLE

The youngster's age and genuine interest both must be considered in determining when it's time for him or her to move on to fly casting. Using the long rod requires a different set of skills and generally a different mindset from spin casting. I've seen enthusiastic seven-year-olds who handled a fly rod like it was part of their anatomy from day one and, conversely, many older folks who were ready to return to their spin rods after the first instructional session.

Fitting youngsters with their first fly tackle can be accomplished in several ways. The most obvious place to start is by allowing the new angler to try some of your tackle or that of a friend. Under proper supervision, allow him or her to cast several outfits and get a feel for a suitable rod length and line weight. A trip to the local fly shop to sample its tackle is also helpful.

Before running out to invest in an outfit or searching local garage sales or pawn shops for a used bargain, you need to know some basics on how the

entire fly rod, reel, and line system works. There is no surer way to discourage someone from pursuing the sport of fly fishing than to start him with an outfit that is not balanced, difficult to cast, too heavy, too light, or just plain wrong for his purposes and physical limitations.

To make a sound decision on tackle, it is wise to consider where most of the angling will be done and to seek counsel from a knowledgeable local expert and the local fly shop. Do some research into how fly tackle operates and what it's made from. Learn the terms most often used. Understand hook and line sizes.

Balance

Fly fishing differs from all other types of angling in one important aspect: the weight of the line carries the lure (fly) to the fish. To achieve this, the fly outfit must be properly balanced. The line, rod, and reel must be correctly matched so that they will work together to help make casting effortless.

Over the last few decades, fly tackle manufacturers have standardized the weights of fly lines and matched them to specific rods and reels. The final system is easy to understand and makes putting together a balanced outfit a snap.

The young angler should be allowed to grow into a fly outfit. Begin by choosing a good-quality rod and reel. As time passes, this equipment will still

The world of angling is like a sphere with an infinite number of keyholes punched in its skin, through which an angler can view what's inside. Two anglers can be side by side, each with his eye pressed so tightly to his keyhole that he has a perfect view. But one will say, "Oh yes, I see the world of angling . . . it's green." The other will say, "You're crazy. I have a perfect view, and it's bright yellow." The truth is that they are both correct, but each has only a two-dimensional view. To get the most out of angling, it's critical to be looking through as many keyholes as possible simultaneously. Only then can one get a 3-D view.

The fly fisher, if he will listen, can learn much from worm or live bait dunkers about catching fish with flies. The most important requirement to becoming a great fly fisher is careful observation of the world around you.

—Larry Dahlberg, professional sport fisherman

be serviceable and have its place. However, faster rods, premium lines, and expertly machined reels will gradually take its place as the main outfit.

Prepackaged outfits that contain all the needed components are a convenient way for a novice to obtain a well-balanced outfit. If you have the time to research the parts individually, however, you may be able to help your youngster find tackle that is a little more personalized, and you'll learn some valuable lessons and may even save money in the process!

Fly Rods

The fly rod market seems to be in constant flux, with new, more powerful designs continually being developed. With a few exceptions, bamboo and fiberglass rods have been relegated to the realm of the collector. Graphite is now the material of choice for most fly fishers and manufacturers. It is light, strong, and can be combined with other materials and a variety of compo-

I first started fly-fishing fifty-one years ago. I can still remember the first rising trout I attempted to catch. That brown trout rose several times near the far shore. I tied on a size 16 Black Gnat dry fly and attempted to cast it upstream a foot or two from the trout. My dad gave me my first "fly rod"—one of those telescoping metal rods that had three or four guides and expanded to a length of 7 or 8 feet. I used an old Pflueger reel with a level line.

My dad sat back and watched me make several casts over that lunker. On the second or third cast over that trout, it took the Black Gnat and headed under the bank on the far shore. My dad cautioned me not to apply too much pressure and eagerly landed the 15-inch brown trout with his landing net. I was hooked for life.

For the next few years, I alternated between spinning and fly-fishing gear. Then, in my junior year of high school, I was elected to go to a conservation camp conducted by Penn State University. At this camp, all the kids spent a day fly-tying and fly-fishing with George Harvey. George taught us during the day and then took all of us to Fisherman's Paradise in the evening on a fishing trip. I caught a brown trout that evening on a fly I had tied at class that morning. I'm still hooked for life. That camp occurred in 1950, and from that time on I was a devoted fly fisher.

—Charles Meck, author, educator, and fly tier

nents to produce an almost endless selection of actions and prices. This flexibility makes graphite the ideal choice for a beginning fly rod.

In choosing a rod, you need to consider four factors: length; action, the relative flexibility or stiffness of the rod; the components that make up the rod; and the intended use.

An 8- to 9-foot rod is generally best for young beginners. Shorter rods (under 8 feet) and longer rods (over 9 feet) are more difficult for the novice fly fisher to handle efficiently. Only if the youngster lacks the strength to handle a longer rod should he or she use a rod less than 8 feet.

Choosing the correct action of the fly rod is considered by some to be even more important than length. This is a very subjective determination, and the final verdict on a specific rod's action will be different for each angler who tries it. For the purpose of the beginner, the feel of a rod will play the biggest part in final selection and eventually in final successful use. To make an accurate judgment of a rod's action, pick it up by the grip, hold it straight out at about waist height, and—being very careful not to hit anything—give it a sharp snap and stop quickly.

There are several terms that anglers use to describe action. For general purposes, use the following terms to make it easier to "talk shop" with the sales clerk and other anglers:

- *Fast-action, or stiff-action, rods* will flex evenly over the length and stop almost instantly. They are usually the highest-priced and most difficult to cast, but in the hands of an expert they are very efficient tools.
- *Medium-action rods* will tend to bounce once or twice and stop. Most quality rods fall in this category, and they are popular because of their design, ease of casting, and price.
- *Slow-action rods* will bounce a few times, describing an arc. This is the easiest type of rod to cast. Fiberglass rods usually fall into this category and are favored by many as a good rod for the beginner. I still prefer graphite, however, because of its lightness and availability. Slow-action rods are very forgiving of casting errors and are usually low-priced.

Avoid rods that bounce and wobble several times, sending shock waves into the handle. Such rods are more trouble to use than they are worth, regardless of the price.

A slow- to medium-action graphite rod of 8½ feet built to handle 5- to 7-weight line is an ideal place to start most beginners. The manufacturer's suggested line weight for the rod will be on the blank near the handle. Pay attention to the components. Look for a good, easy-to-operate reel seat, a cork handle that's not too large for your young angler to grip, and large, closely spaced guides that enable the line to flow smoothly on the cast and will allow

Fly Rod

Fly Reel

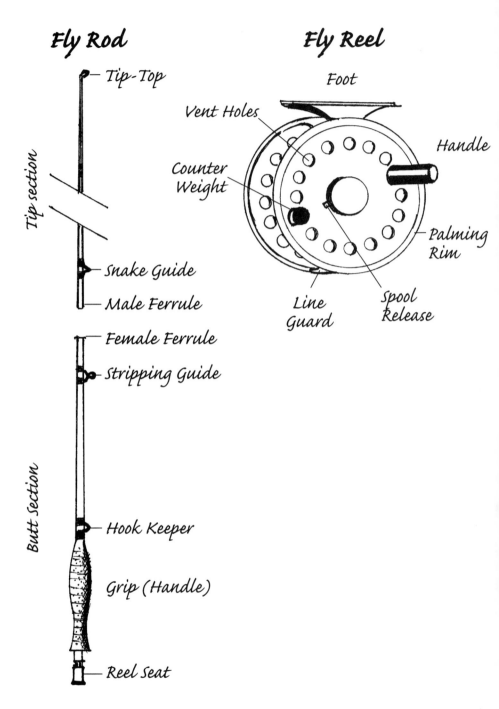

- Tip-Top
- Tip section
- Snake Guide
- Male Ferrule
- Female Ferrule
- Stripping Guide
- Butt Section
- Hook Keeper
- Grip (Handle)
- Reel Seat

Foot

Vent Holes

Counter Weight

Handle

Palming Rim

Line Guard

Spool Release

Rod and reel parts

the line to form an even arc with the rod under tension. Uplocking reel seats are usually preferred because the lock screws are less likely to be loosened by the casting action and a handy short "fighting butt" is formed on the end of the rod.

For youngsters, it's generally a good idea to overweight the line to the rod for easier casting. Your young fly fisher will handle the combination of a 6-weight line on a 5-weight rod better than a lighter line. Always go with the heavier line if your rod is rated for two weights; for example, go with the 7 on a 6/7.

Expect to pay upward of $60 for a good-quality beginner-level graphite rod. Choose a rod that really looks good. Rods that have a quality look, a nice solid cork handle, and attractive windings are usually designed with some thought and can be used with pride. Avoid cheap junk. Reel seats will crack, guides will rust and pull out, and the action will be poor. Treat the fly rod as the heart of the beginner's outfit. When teamed with the proper line, it will almost cast itself!

Many youth fly-fishing programs include classes in rod building. This is indeed a fascinating discipline and will make the final outfit even more personal. Hand-built rods may also be an effective way to provide inexpensive angling tools for your apprentices.

Rod blanks and components can often be found as imperfect or cosmetically not salable at full retail price. As long as you are fairly certain they are not junk, these may be real bargains.

Fly Reels

Unless your apprentice will be angling for large trout on a very light tippet, fishing in salt water, or pursuing powerful game fish that make extended runs, the choice of a fly reel will be less critical (and less expensive) than the rod and line. In most situations, the reel is used merely for the convenient storage of line and as a balance weight in the total outfit. Decent serviceable reels can be inexpensive and easy to obtain. There are three main types to choose from:

- *Single-action reels.* With single-action reels, the recommended choice for the beginner, one revolution of the reel handle will turn the spool once. As the line goes off the spool, the handle turns with it. This is the most common, simplest, and usually least expensive design. The wider the diameter of the spool, the wider the area that will turn and the faster the line will be retrieved.
- *Multiplier reels.* With multiplier reels, a single revolution of the handle will turn the spool several times. Constructed with a system of gears, the multiplier is designed to retrieve line quickly.

It required great boldness on my part because I had to "borrow" my father's fly rod and automatic reel—he used them for his rare opportunities to fish and then used them to fish worms or minnows. Nonetheless, with care and a bit of stealth, I could get the rod and reel from the rear of the gun cabinet and be out the back door before anyone noticed I was gone.

And, oh, the lessons I learned with that rod and reel! For one thing, I learned that I could catch more vegetation on my pathetic backcast that I could on a forward cast. I also learned the joys of mechanics.

My great safaris often took me to sandy reaches of the stream where a boy could wade in bare feet. And it was on one of these sandy stretches that I laid the rod and reel while taking off my shoes. Much to my horror, I discovered that sand does strange and awful things to the guts of an automatic fly reel. Knowing, from the absolute certainty that comes with guilt, that my father would come home from work that night and immediately search out and try his fishing gear (which he hadn't used in at least two months), I raced home and began to explore the inner mechanisms of the reel. Shortly, I discovered the immense, coiled spring that had been cleverly concealed behind the reel's back plate. Perhaps discovered is not the right word, let us just say that before I was aware that it was there, it had escaped into the room and stretched itself full length across my lap. Some hours, filled with great dread, passed before I was able to incarcerate that totally uncooperative strap of metal behind the back plate of the reel.

Soon after, I took an advance against my next year's allowance and purchased an inexpensive fiberglass, level fly line, and a single action reel.

—Gary Borger, university professor
and fly-fishing author

- *Antireverse reels.* Usually of single-action design, the antireverse reel is built with a clutch and drag system that allows the line to be pulled from the spool without moving the reel handle. This design eliminates the "knuckle-busting" trait associated with the quickly spinning single-action reel handle. Antireverse reels are usually in the upper range of reel prices and are of no real use to the beginner.
- *Automatic reels.* Automatic reels have no handle and are spring loaded.

The spring is tightened by cranking a round handle on the side of the reel. Fish are played directly on the line. Slack is drawn up into the reel by pulling a small lever with a finger from the rod hand and starting the reel spool spinning.

Fly reels are made from graphite or lighter metals, such as aluminum. The housing and frame on the less expensive reels are assembled from several parts, which are screwed or riveted together. Easily tightened screws are preferable to unadjustable rivets. High-end reels are usually individually turned on a lathe from a single piece of bar stock metal.

Drags apply pressure to the spool as line is released. They range from the simple pawl type (wedge-shaped metal), attached to the housing, to the disk drag, where a pair of flat surfaces (one on the spool, one on the housing) made of heat-resistant materials press on each other when adjusted to regulate the pressure on the turning spool A palming rim—an exposed rim of the spool used to apply drag pressure with the palm of the hand—can be helpful but is not mandatory for most situations. The added expense of a good drag system is warranted only if large fish will be a regular target.

Before purchasing a reel, know which hand your angler will be reeling with. Some brands work properly only when turned in one direction. Most reels, however, can be changed from right- to left-hand operation by a simple adjustment. Read the enclosed manual for instructions. Be sure to save any paperwork included with the reel purchase should replacements be needed or other problems occur.

Extra spools are handy, but they're not really necessary for the beginning freshwater angler. Many times the more inexpensive, entry-level reels do not have the extra spool option, simply because spare spools would cost as much to manufacture as the entire reel.

New cassette-type reels have become popular among some fly fishers. Cassettes are inexpensive plastic spools that can be easily changed when a different line is needed. This essentially cuts the price of an extra spool by about a third. It's an option worth noting, but it shouldn't influence the choice of a beginner's reel.

A simple reel with few parts is preferable to a complicated one with many parts. Choose a good name-brand reel with a smooth reeling action and pleasant-sounding, even clicker—the device that prevents the spool from running over and tangling the line. The first fly reel should be inexpensive (about $30 to $70), of good quality, and provide good balance with the rod and line.

Fly Lines

Early fly lines were made of silk and had to be greased before each day's angling in order to keep them afloat. They became saturated and sank after

It was during my early indoctrination to the Cortland Line Company that I first learned about fly fishing—and that fish could be caught with special equipment that involved the use of artificial flies designed to imitate the real food fish like to eat. Cortland was the leading producer of fly lines, a most important component of the equipment used in presenting artificial flies. At that time, fly lines were produced by braiding silk threads into a tapered design, then impregnating the tapered braid with a formula of oils including linseed oil, tung oil, and perhaps other special oils that I can't remember. Fly lines were an important part of the Cortland product line in 1941, as they still are today.

—Leon Chandler, legendary fly fisher

a short time. Usually another reel with a freshly dressed line was substituted while the first line was hung out to dry. This cut deeply into fishing time. After World War II, materials became available that drastically changed the sport.

The modern fly line is specifically designed for efficient fly casting and is made up of a combination of materials. The core is level and usually braided and is composed of dacron, monofilament, or nylon. Vinyl in various thicknesses is molded around this core. The lines are manufactured to be thick and heavy, providing needed weight to cast the usually light fly.

Types of fly lines are identified on the package by a system of capital letters and numbers. They are usually about 30 feet (shooting tapers) or 100 feet (full lines) in length. The numbers run from 1 (lightest) to 15 (heaviest) and identify the weight of the first 30 feet of line in grains (a very small measure of weight). The letter or letters before the number indicate the design of the line, and the last letter indicates whether the line sinks or floats. For example, a fly line box labeled DT9F is a double-taper 9-weight floater and WF8S is a weight-forward 8-weight full sink line.

Fly Line Design. Today's fly lines are the products of hundreds of years of design evolution. Weight is distributed along the length of the line by changing the diameter of the coating. This gives the line a profile called a *taper*. Each taper is engineered to help the caster achieve a specific goal. Many of today's fly lines are designed with specific situations and even individual species in mind. Most companies have steelhead tapers, bonefish tapers, tarpon tapers, and even pike tapers. It is not necessary to get that specific about line use with your young apprentice, but you should have a good, solid

knowledge of basic taper design and an understanding of how they are designated and labeled. Here is a list of the standard tapers, the letters that identify them, and their characteristics:

- *Level line (L).* These lines have the same diameter from beginning to end. They're usually the least expensive, but they're more difficult to cast than the other tapers and are not recommended for casting instruction. A level line is often used for bait fishing with a fly rod or when using large amounts of weight to fish deep or fast waters.
- *Double taper (DT).* These lines start thin, get thicker, then become thin again. They are designed for more delicate presentation. They can be roll-cast nicely and can be reversed and used in either direction. Many anglers prefer this taper for dry-fly and small-stream fishing.
- *Weight-forward (WF).* These lines start thin, have a shorter, thicker belly than the DT, and taper to a long, thin running line. They are the most versatile and easiest to cast, are very good for casting larger flies and making longer casts, and are the hands-down favorite for saltwater, lake, or river angling. The WF taper is preferred by most casting instructors and is ideal for the young beginner.
- *Shooting tapers (ST).* These are shorter lines (usually about 30 feet) used for making extra-long casts. The shooting taper has a thin belly and thick head and is attached to a running line, usually made of monofilament, braided monofilament, or thin level fly line. The design is primarily used for distance casting and for facilitating quick line changes. These are specialty lines and are not appropriate for the young beginner. After the basics have been learned, casting shooting tapers can be great fun and will widen any angler's horizons.

Sink Rate. Fish can be found feeding at depths throughout the water column and in a great variety of current speeds. In order to present a fly successfully in all of these circumstances, without the addition of lead weight, lines of various sink rates must be used.

The beginning angler need not acquire a variety of lines; a good floating line will be the line of choice in most situations. Still, it's a good idea to familiarize yourself with sinking lines, the sink rates available, their specific characteristics, and identifying features. As you go along in the sport, more and more exciting opportunities will present themselves, and it will be to your advantage to know the possibilities that exist. Here is a list of standard lines, their sink rates, their characteristics, and the letters that identify them:

- *Floating (F).* These lines float on the surface when cast. They are by far the most popular type of line and an ideal starting point for any angler. Floating lines are usually lighter in color (depending on manufacturer and use) and are constructed with a nylon core coated with

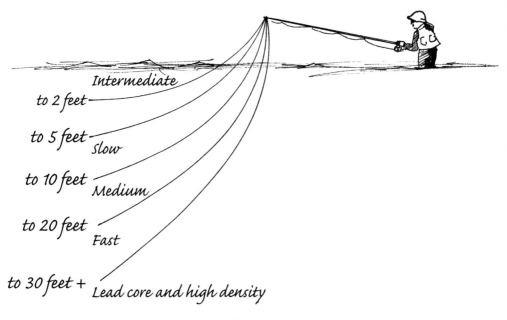

to 2 feet — *Intermediate*

to 5 feet — *Slow*

to 10 feet — *Medium*

to 20 feet — *Fast*

to 30 feet + — *Lead core and high density*

Fly line sink rates

vinyl that is filled with tiny, air-filled, glass balls. With proper care and cleaning, a floating line should last for several years.

- *Intermediate (I).* These are very slow-sinking lines designed to be retrieved just below the surface. They are particularly handy in choppy or rough water, as they tend to cut through the waves and make it easier for the angler to keep a tight line.
- *Sinking (S).* Full sinking lines are designed to sink at a rate—slow, medium, or fast—determined by an amount of lead dust included in the vinyl coating. Weight in grains, the line weight, suggested use, and sink rate in feet per second are usually printed on the line box. These lines become darker colored as the sink rate increases—black will be faster-sinking than light brown. Full sinking lines are difficult to handle, even for experienced casters, and are not recommended for beginners.
- *Floating line with a sinking tip (F/S).* Also known as sinking-tip or wet-tip lines, these are floating lines with a weighted tip that is 5 to 20 feet in length. The lines are available in many different sink rates. In the last few years there has been a tremendous increase in the use and the number of different designs of these very useful lines. A sinking-tip line facilitates fishing at greater depths yet still maintains the advantages of easy pickup and line control that the floating line affords. The

sinking section of the tip is a darker color, designating the sinking speed, and the floating section is lighter for easier detection. F/S lines tend to be fairly easy to cast but a little tricky to control. A young caster who can handle a rod and line well should have no problem with these tapers.

The following are general recommendations for line weights and the conditions they'll be used under:

- *1 to 3.* Very light fresh water, usually small streams, small fish.
- *4 to 6.* Average fresh water; suitable for most freshwater conditions and fish sizes.
- *7 to 9.* Freshwater lakes, larger streams, rivers, windy conditions, large flies, big fish, light to average salt water.
- *10 and up.* Heavier salt water, very heavy fresh water.

Helping Students Understand Fly Lines. It is important that young anglers become familiar with the identification system and the properties of a fly line. Sketch the exaggerated profiles of the different styles of line tapers on a blackboard and explain the advantages and limitations of each. Have a few tapers on hand, and allow the students to run the lines through their fingers so that they can feel the change in line diameter.

Go over the letter and number system that describes each line and have a quick quiz. Don't spend an inordinate amount of time on this, but make sure everyone understands.

Choosing a Line. The best line for a young beginner is a weight-forward (WF) floater (F), which is the easiest to cast and most widely used. Avoid level lines, which are difficult to cast. Line weights 5, 6, and 7 are the most popular and will fit the greatest variety of fly-fishing situations. They are the ideal place for the young angler to begin.

Several levels of line quality are available, at a variety of prices. It's okay to start with inexpensive lines at first; however, the premium lines are worth the extra cost as skill levels and competence increase. Good-quality, medium-priced fly lines cost about $20. Premium lines usually start at about twice that.

Care of Fly Lines. Treat fly lines with care, and clean them often. Frequently coat them with Armor All vinyl treatment or Glide by Umpqua to help them remain supple, slick, and easy to cast. After each outing, clean lines by running them through an old sock or cotton rag soaked with vinyl cleaner or specially made line treatment. Store them over long periods of time on loose coils. Keep them out of direct sunlight and away from high heat (bright sunlight through car windows and closed trunks on hot days are line destroyers).

Help your apprentice form good habits early. A good fly line will last several seasons and give hundreds of hours of service if it's properly cared for.

Fly Line

Fly lines are composed of a braided core and vinyl coating. The coating is varied to determine taper.

Fly line profiles

Level Fly Line

Double Taper Fly Line

Weight-Forward Taper Fly Line

The Three Basic Fly Line Designs
For the level and double taper, the leader can be attached to either end. On the weight-forward, it must be attached to the shorter end of the taper, which is usually about two feet in length.

Backing

The first component to be attached and loaded onto the fly reel is the backing. It performs two functions: It fills up the spool, making it easier to reel in the line and it serves as a fighting line when a large fish makes a long run.

Add 50 to 100 yards of 20-pound-test (depending on reel recommendations) braided Dacron backing to the reel. Do not use monofilament; it will coil and tangle while lying under the fly line and become an awful mess when being pulled off the spool.

Leaders

The weight of the fly line casts the fly. In order to do this, the fly line by design is big, fat, and round. As a consequence, it is easily seen by the fish. Fly

line is too thick to fit through most hook eyes, and even if it could be attached, it would not allow the fly to act naturally. In order for anyone to use the fly-fishing system and successfully catch a fish, a proper link must be made between the fly line and the fly. This link must lay out evenly on the cast, placing the fly on the water in a delicate fashion, and be flexible enough to work in a variety of conditions yet strong enough to hold up to the demands of fly fishing. Such a link is called the leader.

In the early days of fly fishing, horsehair was used. More recently, thin pieces of gut were cured, dried, and fastened to the fly line. Gut leaders had to be soaked overnight in water to soften them for use, and then carefully cared for afterward. With the invention of nylon, a new type of leader material known as monofilament, or mono, revolutionized the sport of fishing. Mono can be made in a variety of diameters and colors and can be braided to form many versatile products.

Hand-tied leaders are constructed by tying several sections of different diameter mono together, starting with the heaviest, the *butt.* The butt is connected at one end to the fly line, and the other end to the first *midsection.* Depending on the type and desired length of the leader, there may be one or more midsections, each of a different diameter. The final and lightest section of the leader is the *tippet.* This is usually 18 to 20 inches long and of a diameter small enough that it easily fits through the eye of the fly and generally suits the type of fishing being done.

Leaders tied in this fashion are called *tapered leaders.* When the leader is constructed properly, it will follow the fly line on the cast, distributing itself on the surface in a smooth, even, quiet manner.

Most fly fishers today use one-piece, factory-tapered leaders. The monofilament is tapered as it is extruded, emerging from the machine perfectly balanced for optimum casting. Factory tapers are available in a wide variety of lengths and diameters. Each is tapered to the end of the tippet. When the first foot or so is used up from changing flies and the leader diameter has become too large for optimum use, a section of level tippet material in the desired diameter and pound-test can be knotted onto the midsection. Usually the only part that has to be changed is the tippet section.

For all practical purposes, the length of the leader should not exceed the rod length by more than a foot or so. In some special circumstances, increased length is needed, as when a combination of especially wary fish and extremely clear calm waters is encountered. A leader that is too long may be difficult to cast, and the knot connecting the leader butt and fly line will also have to come inside the rod guides when the angler is landing a fish. This presents a problem when the tired fish decides to make one last try for freedom and the knot jams in the guides, resulting in a broken tippet. A

leader that is too short, however, may not allow for proper presentation of the fly.

When sinking lines are used, a short leader of 3 feet or less, made of tippet material only, is attached directly to the line. The target of the fly fisher using a sinking line is far beneath the surface, and the presence of a fly line close to the fly probably will not put a feeding fish on guard. The sinking line and short leader will drag the more buoyant fly along, enabling the presentation to take place in a more natural manner at the desired depth. If a long leader is used, currents will push the fly toward the surface and away from the fish, defeating the whole purpose of using a sinking line.

Specially designed trout, bass, saltwater, and panfish leaders are readily available and will take the guesswork out of choosing a leader. A few spools of tippet material should also be purchased along with the leader.

Tippet Diameters, Breaking Strength, and Fly Size

Some thought must always be given to matching the right diameter tippet to the size of the fly being used. The final choice of tippet comes after the angler has looked over the fishing situation and factored in the size and species of the target fish, the size and type of fly needed, and the water clarity and general conditions. The brighter the day, the calmer the water, and the warier the fish, the finer the tippet needed. If cloudy conditions, murky waters, and aggressive fish are present, then heavier tippet is in order.

The letter X is used to describe tippet diameter. It originally referred to the number of lengths of silk gut that could be drawn through a certain diameter hole or holes. The X measurement now describes the diameter of a tippet relative to that of other tippets. To make this whole system a little more understandable, the accompanying table lays out a simple system that will give you a good idea of how the diameter, pound-test, and suggested fly size combine for a balanced cast and presentation. Actual breaking strengths of monofilament vary with each manufacturer.

Diameter (inches)	Size	Pound-Test	Fly Size Range
.004	7X	1–2	14–28
.005	6X	2–3	10–22
.006	5X	3–4	8–18
.007	4X	4–6	6–16
.008	3X	5–8	6–14
.009	2X	6–10	6–10
.010	1X	8–12	1–8
.011	0X	10–14	1/0–2

My buddy Joe Cambridge suggests the "rule of four" for use in practical applications: Divide the hook size by four to derive the best tippet match. For example, a #16 hook would work best with a 4X tippet (16 ÷ 4 = 4).

ASSEMBLING THE OUTFIT

The entire fly-fishing system consists of several components that must be balanced and assembled properly to work successfully. Whether the new fly outfit is in a prepackaged box with all the parts or each component has been individually chosen, it all has to be put together before use. Avoid having the fly outfit preassembled for convenience. It might seem like a lot of trouble to have to go through all the steps needed to put it together properly, fill the reel, and tie the knots, but here's where the complete fly-fishing education begins.

To balance the outfit, be sure to match the corresponding weight rod and line together with a reel that will be the proper size to hold the line and sufficient backing. Proper leader dimensions and fly size must be chosen to complete the rig.

Place all the components on a table with plenty of space. Look over printed materials that came with the tackle. They may indicate the number of yards and test of backing recommended for the reel and other tips. If this is a class, students should be divided into pairs and given strict orders not to take the parts (especially the fly lines) out of their containers until instructed.

A few basic tools are needed for assembling the fly outfit (give a set to each pair of students in a classroom situation):

- *One or two pencils or chopsticks* to hold the line spools.
- *Line clipper* for trimming knots (nail clippers also work well).
- *Pliers* to grasp tag ends of line while securing knots.
- *Fly-tying bobbin, thread, safety glasses, 6-pound-test mono (a foot or so), and Pliobond* (or other rubber cement) if a loop is to be tied in the end of the fly line.
- *Several large, heavy books* are needed if this is going to be a solo effort.
- *Line winder tool* (optional), a specially made tool for handling fly line while loading and unloading reels. Angler's Image makes a great model for about $50.
- *Hair dryer* (optional) to heat shrink-wrap tube on braided mono loop or dry Pliobond quickly.

Rod and Reel

The first step is to attach the reel to the rod. Using the rod butt *only,* put the reel in the reel seat, being sure that the handle is on the correct side. Tighten it securely in place.

Knots from Reel to Fly

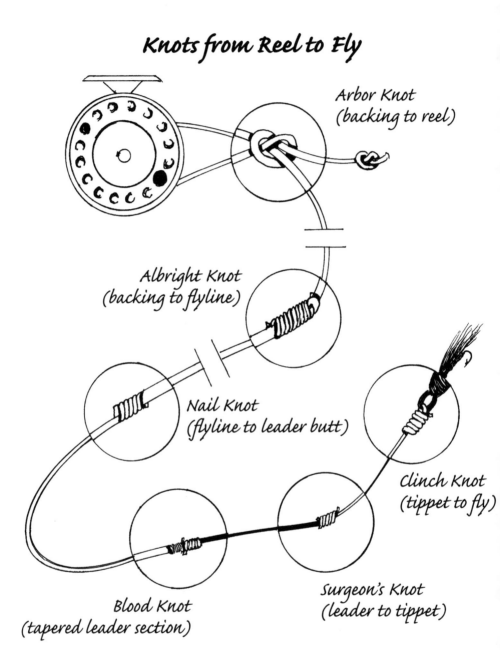

Arbor Knot
(backing to reel)

Albright Knot
(backing to flyline)

Nail Knot
(flyline to leader butt)

Clinch Knot
(tippet to fly)

Surgeon's Knot
(leader to tippet)

Blood Knot
(tapered leader section)

Connections from reel to fly

The line will be coming out at the bottom front part of the reel and will be cranked onto the spool in a forward, down, back, and up motion. Check to be sure that the drag is set for use in the proper direction.

Backing and Line

For the beginning angler, the final level of the fly line on the reel should come within ½ inch or so of the rim of the spool. Most fly fishers fill the spool of the reel to the top in order to maximize the amount of backing, allow them to retrieve faster, and keep the coils in the line larger and thereby less likely to tangle. For the beginner, however, this space will allow for a margin of error if the fly line is not fed back onto the reel in an even manner. It will also keep tangles to a minimum and allow the spool to be easily removed.

There are two methods for loading the backing and fly line onto the reel:

- *Install the backing first.* Estimate the amount of backing needed to fill the spool. This may be easy if the reel is a familiar model that you've used before or if there are explicit directions in the package. If too much backing is installed, the complete fly line will not fit onto the reel. The line must then be removed (in a neat fashion) and the backing trimmed to the proper length.
- *Install the fly line first.* Two reels of the same kind are usually used with this method. The fly line is wound onto one reel first, followed by the backing. When it is filled to the proper level, it is cranked onto the second reel, filling that reel to the exact level.

The first method is the best choice when beginners are involved. A good educated guess will usually result in a spool filled to an acceptable level. The other method may lead to a mess and confusion, and it takes a lot of time. We'll use the first method in this section.

If the reel has a very large capacity (over 100 yards), the backing will often be purchased in 100-yard connected spools. These must be placed together front to back and attached so that they will turn together. If several reels are to be filled, a bulk spool is a better deal and easier to use. Most reels, however, will require only one 100-yard spool or less to fill them to capacity.

The backing should *always* be installed by pulling it off a revolving spool. If the spool is laid flat on the ground and the backing coiled off (as when filling an open-faced spinning reel), it will twist and become tangled and weakened.

Place the backing spool on the pencil or chopstick, find and loosen the end, and run it through the stripping guide of the rod butt. This *tag end* will be tied to the reel with an *arbor knot*. Remove a few feet of line from the spool of backing. Run the tag end through the front of the reel, around the spool, and out again. Tie a simple overhand knot in the tag end, tighten, and trim

it. This will be the *jam knot*. Using the tag end (with the knot), tie another overhand knot around the *standing* part (leading to the spool) of the backing. Tighten this knot so that it will slide down the standing part onto the reel. A good, firm pull will drag the jam knot up against the second overhand knot, securing it to the reel spool and completing the arbor knot.

Installing the Backing. The backing can now be installed onto the reel spool. Have one person hold the spool on the pencil for the other, putting a moderate amount of pressure on the sides with the thumbs as the line is cranked evenly onto the reel. If this is a solo venture, prop the spool between two stacks of books on the table and run the backing through the middle of another book placed in between the rod, reel, and spool. A few more books may be added on top to increase tension.

It's important to always have tension on the line while filling the spool. Loose line can cause a tangled mess inside the reel. It's also a good idea, especially with large-capacity reels, to occasionally zigzag a few diagonals across the spool to prevent backing that is under the stress of a battle from slicing in between the even rows, fouling, causing a tangle, and breaking the stressed tippet.

Installing the Line. Once the desired amount of backing has been installed, the line can be attached and added to the reel. Most fly lines usually come from the factory in loose coils secured with two twist-ties. They are often packed on plastic or cardboard spools. The end that goes onto the reel first and is to be tied to the backing will be on the outer layer of the coil and should have a tag attached to it. Save the spools that the lines come on for storage.

When working with students and new fly lines, always be very careful and proceed slowly. Nothing can become tangled more quickly and more hopelessly than a fly line.

Taking care not to make a mess, remove the twist-ties and uncoil a few feet of line slowly and evenly. Replace the twist-ties before the next step.

The end of the fly line and the backing can be connected easily using an *Albright knot*. Developed by famed Florida Keys guide Jimmy Albright, this is the perfect knot for attaching very large-diameter lines to smaller ones.

Bend about a 3-inch loop into the end of the fly line. Secure it between the thumb and index finger of the left hand, leaving about an inch or so of loop open. With the right hand, slip the tag end of the backing and about 6 inches through the loop. Secure it, along with the fly line, with the left hand. Allow the tag end and 6 inches to hang free. Taking the tag end of the backing in the right hand, wrap it once around itself at the tips of the left-hand fingers where all three pieces meet. Continue to make eight or so even wraps (when using small mono to large mono, use about twelve wraps) toward the

Albright knot

loop, keeping them snug and even but not tight. Run the tag end out of the loop *on the same side it came in on.* Slide the coils toward the loop, pulling the tag with a pair of pliers and tightening the knot as the gap in the loop closes. Tighten the whole thing up by firmly pulling on both sides of the knot before trimming closely. Pull firmly and be sure it will not pull loose.

Place a pencil into the fly line spool and load the fly line slowly and evenly onto the reel. If a tangle occurs, don't panic! Stop the action and assess the situation. Slowly, carefully, and with a great deal of patience, try to straighten things out.

Attaching the Leader. The fly line should be fully loaded except for 4 or 5 feet. The leader must now be attached. A loop in the end of the fly line is the best, most practical way of fastening the leader butt. There are three methods of building a loop in the fly line while producing a connection that will easily and smoothly pass through the rod guides:

- *Whipped loop* (suggested in *Practical Fishing Knots* by Kreh and Sosin). Strip the first ½ inch of coating off the end of the fly line, exposing the braided Dacron core (do not use this method with monofilament). Fold about 3 inches back on itself to form an inch-long loop. The core produces a fine taper at the end of the splice. Ready the fly-tying bobbin (filled with at least 6/0 thread) by wrapping the thread around the leg a few times. Test it for resistance to be sure the thread will pull off only with a hard tug that will free the thread but not break it. Start the end of the thread on the double section of the line, below the loop. Make a few hand-wound wraps to secure the thread, and pull about 6 inches off the bobbin. Safety glasses should now be worn. Hold the loop in the right hand and the tag end and standing portion of the fly line in the other; the bobbin should be handing on about 6 inches of thread down from the line. Now, with a sort of rocking motion, swing

the bobbin around the fly line and work it back and forth, covering the entire splice with two layers, pushing the thread into the soft vinyl coating. Place a loop of mono paralleling the fly line loop over the splice, and cover it with two more layers of thread. Clip the thread, put it into the mono loop, and pull it under the other wraps, securing it with a whip finish. Give it a few coats of Pliobond or other rubber-type adhesive.

- *Braided mono loop.* Monofilament can be braided into a hollow line that can be handy for a variety of fly-fishing uses. Mono in this design is very flexible, strong, and limp. If a short section is cut and run back into itself to form a loop, it can be inserted over the tip of a fly line. When it is pulled on in this position, it will grasp onto the fly line in Chinese finger-locking fashion. Commercial line manufacturers discovered this fact and now produce braided mono loops especially for attaching to fly lines. Several sizes are available to fit a variety of fly line diameters. These loops are snaked up onto the line, and when they are installed to their maximum, a heat shrink tube is snugged up on the frayed end, toward the reel, heated, and used to secure the loop to the line. The loop can also be attached with thread and Pliobond, whipped loop style, if the tube seems a little risky.

- *Nail knot.* The nail knot has been the knot of choice to attach mono to fly line for many years. Heavy mono (25- to 40-pound-test) can be attached, then a loop is put in it, or a tapered leader butt can be nail-knotted directly to the fly line. It can also be used to attach Dacron backing to fly line. The nail knot is difficult to tie and not recommended for beginners. It is, however, a valuable knot and should be considered an important part of every fly angler's arsenal.

The easiest way to tie the nail knot, originally done with a nail, is with a small tube. An ink pen refill or a small, short, hollow bar straw works nicely. With the standing part of the leader leading out to the right and the standing end of the fly line running to the left, place the tube, the tip of the fly line, and a section of leader butt in the left hand. Allow a tag end of 8 to 10 inches of butt material to extend past the tube. Grasp the three pieces tightly with the left hand, and with the right hand, bring the tag up to wrap around itself and the other two pieces (fly line and tube). Wrap about eight neat, even turns right next to each other along the tube, keeping them all in line and snug. On the last wrap, grasp the knot coil securely with the left hand, keeping everything in place. Insert the tag end in the right hand into the tube, with the tag facing down the standing end of the fly line, in the opposite direction from the leader. Grasp the tag end of the leader with

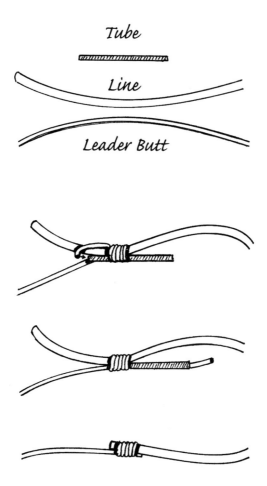

Tube-nail knot

your teeth and the standing end of the leader in the right hand and pull tight, keeping a secure grip on the coils and tightening slowly as you remove the tube and the mono tightens up on the fly line. Use a pair of pliers on the tag end to finish the tightening job. Be sure the coils are in line, and grasp the fly line *tightly*. If the coils of mono are over the tops of each other, keep pulling harder; if they don't tighten into order, clip and try again. Trim the tag of the leader and the fly line closely. This is not an easy knot to tie. Don't get discouraged; it takes practice.

The easiest, fastest, and most efficient method—and the best for the general purpose of getting a youth fly-fishing workshop moving along—is

the braided mono loop. It can be done quickly with a minimum of effort and looks great. If there are many lines to be done at once for several practice outfits, however, the whipped loop is less expensive (braided loops are a bit pricey). For good looks and the feeling of satisfaction that comes from a well-tied knot, my favorite is the nail knot.

Attaching the Leader. Now that the loop is in place, the leader can be looped on. A note of caution when removing a factory-tapered leader from its package: Proceed slowly and carefully! I've seen youthful enthusiasm destroy many a tippet section of a new tapered leader. The wispy mono of the tippet will knot and kink very easily if care is not taken from the start.

Knotless tapered leaders are packaged in a coil with the tippet on the innermost level and the first foot or so of the butt wrapped around the entire leader to hold it together. Inspect the whole coil carefully. Find the end of the butt section, and slowly and carefully unwrap it from the rest of the leader until it begins to follow the winding of the coil. Then—and only then—start pulling it away from the rest of the leader, allowing the mono to uncurl.

If this is done correctly, the leader will look like a giant spring. Grasp the end of the butt, and run the entire leader smoothly through the thumb and index finger of the other hand. The resulting warmth and pressure will straighten it nicely. Do this each time the mono gets coiled.

Four ways to attach a leader to a line, top to bottom: nail knot and mono loop to loop with leader butt; braided mono loop to loop with leader butt; whipped loop in line loop to loop with leader butt; nail knot leader butt directly to fly line.

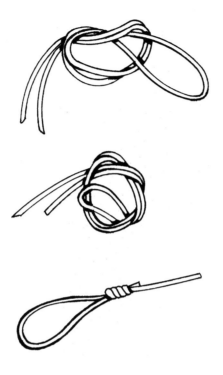

Surgeon's loop

Tie a surgeon's loop in the end of the leader butt, and the leader is ready to be looped onto the fly line loop. The surgeon's loop is the easiest way to put a strong loop in the end of a piece of monofilament. Simply bend over about 8 inches of so of the tag end of the leader, forming a loop. With the doubled line, make one half hitch and then another. Moisten the knotted area thoroughly and tighten, forming a loop of the desired size. Finished loops are usually no larger than ¾ to 1 inch in length. Put the loop over a pencil or other object and pull tight again. Trim the tag end close. Be sure they are connected, with one being the mirror image of the other. If they are not properly arranged, one will cut into the other, making the connection weak.

Strike Indicators. The take of a wary trout may be very delicate and almost undetectable to the fly fisher. A simple device called a strike indicator will help the young angler follow the progress of his fly on an overcast day and relay the message when a fish has taken it. This brightly colored fly-fishing version of the bait fisher's "bobber," attaches easily to the line and is available in a variety of designs from most fly shops.

To create your own indicator, begin by selecting a bright fluorescent colored synthetic yarn. Clip off about two inches. If it is the thick variety, split it

Loop-to-Loop Connection

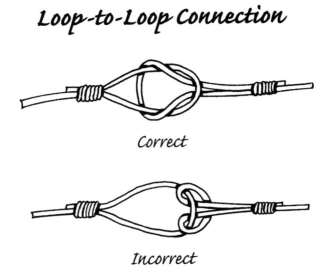

Correct

Incorrect

Proper seating of a loop-to loop-connection.

into narrow diameter, easy-to-cast pieces. Before tying on, determine at about what depth you wish to fish. Using a piece of fine tippet material, secure a piece of the yarn to the leader with a clinch knot at the proper knot. Hold the ends together and clip to about ¼ inch. An application of dry fly floatant will help keep the indicator on the surface in plain sight.

Your young students may want to use these devices as they advance in their skill levels and especially while learning the slack line, dead drift nymphing technique. Strike indicators are not necessary when using the wet fly swing. The line is always tight and the strike will be readily felt.

OTHER EQUIPMENT

Individual fishing habits and inclinations determine what other goodies an angler needs for a trip astream. Keep the gadgets and accessories to a minimum. A list of what I would consider essential looks like this:

- *Vest.* You'll need a fly-fishing vest with pockets to carry stuff around in. When buying a vest, spend a few dollars more and get bigger pockets, better closures, comfortable fit, and a nice big pocket in the back.
- *Fly boxes.* Kids fill these fast, and they usually aren't cheap. Start out with the hardware store type with the snapping plastic lids, and later move on to the nice, one-piece foam jobs. A handsome, quality fly box is a dandy gift or reward for an accomplished young tier.

- *Tippet spools.* You need several diameters and sizes to match conditions. Get a bag of elastic ponytail wraps at the local drugstore to put on the spools once they get started to keep the mono on them. At first, plain old mono is fine for tippet material. As skills increase, quality tippet is worth the price.
- *Line clipper.* Either a commercial line clipper or a fingernail clipper will work. Attach it to the vest somehow.
- *Small flashlight.* This will pay for itself over and over again. The best fishing is just at dark, and it's much easier to get out with a flashlight.
- *Hemostats.* This tool can be used to clamp on a fly and remove it with the least harm to fish, angler, and fly.
- *Split shot.* Whether to use split shot is a matter of personal preference. Use the nontoxic types, which are getting better and less expensive.

Wyatt Golding is properly dressed and ready for action at the annual River God Fly Fishing Camp held at the West Branch (Delaware River) Angler Resort.

Typical contents of a trout fisher's vest, top, left, clockwise: leader material holder; foam clip-on patch for dry flies; sunglasses; fly floatant; insect repellant; thermometer; line clipper (attached to retractor); forceps; lead-free weight; flashlight; and hook hone.

- *Thermometer.* Available at most fly shops.
- *Fly patch.* This can be used to dry flies.
- *Polarized sunglasses.* These cut the glare on the water and protect the eyes.

CAMERA AND FILM

Every leader and instructor should carry a camera on field trips and to classes. Anytime you take a youngster fly-fishing, you should have a camera on hand at all times to capture some of life's great moments as they occur.

There are many very serviceable, reasonably priced, and easy-to-use point-and-shoot autofocus cameras on the market today. Avoid the instant-developing type and select a good-quality 35mm SLR. Get as many practical features as affordable, but be sure the camera is compact and easy to carry and can be operated with one hand. Look for one with an auto zoom lens, built-in flash, and fill-in flash or macro capabilities. Water resistance is

another valuable feature. Make a list of the type of situations you'll be photographing most often, and visit the local camera shops and call the mail-order houses for advice and product comparison. Take the owner's manual along for easy consultation, and be sure to store the camera so that it is protected from extreme heat or cold. Before choosing the film, give some thought to the use the photos will be put to. Color prints are fine for general purposes. Kids love to get photos of their exploits, and a nice album is a great public-relations tool for a program. Photos can also be sent to supporters and folks who have helped out. Use lower ISO film (100 to 200) for brightly lit, exterior situations and higher ISO (400 to 1000) for indoors and low light. If publication is a possibility, black and white prints or color slides (transparencies) are usually preferred by publishers. Shoot a roll of each at events to cover all bases. Color prints can be made from slides for a modest fee; slides can be made from color negatives for a little bit more. It is best to store photos, negatives, and slides in plastic archival sheets that can be purchased at most camera shops. Clip them into a three-ring binder for easy storage and reference.

Put together a shoot list before each trip. Think about the possibilities, and consider which types of photos would be most desirable; plan to take a variety of photos, not just fish shots. Just shooting randomly, without any prior planning, may leave you with a bunch of uninspired shots that miss the real energy and beauty of the moment.

Compose each photo carefully. Zoom in and out, shooting at several different focal lengths. Take both vertical and horizontal shots.

When deciding how to compose your shot, learn and use the "rule of thirds." As you look at your subject, imagine that the scene to be photographed is divided into thirds, horizontally and vertically. Be sure that something important or interesting is featured at one of the points where these imaginary lines would cross in the frame of your shot.

Set up each shot to get the most out of the subject and the surroundings. Use live or freshly killed, wet fish; avoid using ones that are dead, dry, bloody, colorless, or generally unappealing. Include the rod, reel, and fly in the photo, as well as some sort of background that will add to the natural effect and serve as a reference. Be sure distractions such as cars, telephone poles, garbage cans, and so on are not included in the frame. Place the subject so that sun glare won't reflect off the water or cause a person to squint or appear uncomfortable. Be sure the fish is held in a proper manner and clothing is not in the way. Have the angler push his or her cap back to help eliminate shadow on the face. The angler's eyes should be visible and expression pleasant. Use fill flash whenever necessary to eliminate shadows and light up interesting areas. Hazy days are often best because there are few shadows.

Don't overstress a fish that is to be released. Keep it in the water until the

Each section of this photo tells us part of the story.

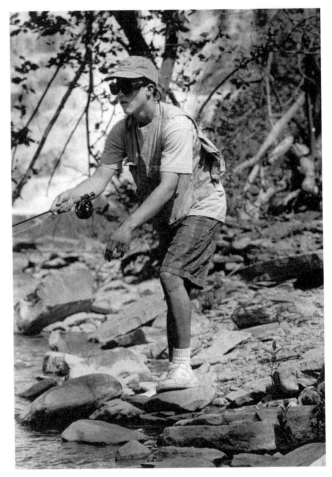

shot is ready, and support it firmly and gently. If the shot can be done with the fish in the water, so much the better! Try to keep the fish's comfort in mind.

TACKLE CARE

In order to present a fly successfully and fight a powerful game fish, all parts of your fly-fishing tackle must function correctly and do the job they were designed to do. Fly tackle can also be a significant investment. Consequently, it should be treated in a manner that will keep it serviceable and in top condition for as long as possible.

Good habits should be formed early on. Teach your students to handle fly-fishing equipment with respect while transporting it and using it afield, as well as when cleaning and storing it at home. Let's examine some good

tackle-handling habits by following a fly rod and reel through a day's fishing.

The morning of the year's last fly-fishing trip was chilly and clear. Eric had taken the 8½-foot, 6-weight rod, 7-weight line, and matching reel out of the closet the night before. Keeping them in their protective cases, he placed them in the car along with his fishing vest, emergency pack, waders, extra clothes, and other essential items.

After breakfast, we picked up the other young anglers and loaded their gear into the back of the station wagon. Rods and reels were put on one side, waders and bags on the other. I put any heavy or hard gear on the bottom so that it wouldn't slide around or fly forward and hurt passengers or equipment if the car stopped abruptly.

We reached the local stream after a short drive, and the excited anglers hopped out and grabbed their gear. The kids put on their waders, taking turns sitting on the rear bumper and standing on the small pieces of carpet brought along to help keep stocking feet clean and dry.

Anticipation was building as the young anglers pulled their rods out of the cases, attached their reels, and laid the rods carefully on the roof, safely off the ground. Rod cases were stashed in the car. The anglers gave each other plenty of room as they fished out the leaders from the reels and pulled out several feet of line. To protect the reels from damage, they placed the rod butts in the hats they had set on the ground nearby. Each angler doubled the line just above the leader and pulled it through the guides and out of the tip-top, until the leader and tippet were free.

Everyone had prepared his or her own leader the night before. A few firm pulls through the fingers along its length warmed up and straightened the coiled mono and made it limp and ready to go. It was an easy matter then to tie on a fly, clip the tag end of tippet, reel in the slack line, and slide the hook firmly into the side of the reel seat by the base of the handle. This concealed the point and made it easy to wrap the fly line around the length of the rod blank a few times, securing it along the side of the stripping guide. The rod, reel, line, and fly were now ready to be carried through the bushes that lined the creek.

Todd led the way, with the other young anglers spaced at safe intervals a little over a rod's length apart. They were now wearing sunglasses and hats, following each other single file down the narrow, well-worn path along the stream. They held the rods with the butt ends facing forward and the tips to the rear, line secured snugly along the length and safe from the many branches that reached out to snag it.

When the youngsters reached the destination, they checked to be sure they were each in sight of one of their fellows. Eric carefully unwrapped his outfit, freed the fly, and pulled off several feet of fly line, while adjusting the

Tips up! Just above head height and facing back.

drag on the reel. Three-foot sections of the line were pulled tight, straightening the coils (the line's memory), making the line limp and easy to cast. He wiggled the rod tip back and forth at waist height, working the line out into a pile on the edge of the water. After a quick inspection of the area for snags and backcast room, he made the first presentation of the day, with a flip of the tip and a short roll cast.

Eric's bead-head hare's ear drifted through the run several times, once becoming lodged under a rock. After a few upstream mends failed to free the fly, he walked upstream. With the rod out at arm's length across the stream and above the fly, he was able to pull it free with a tug.

When the fly caught on a 12-foot-high branch he had overlooked during his backcast inspection, he reeled in the line and walked over. Under the branch, he tightened up until the fly was inside the tip-top, gave a careful

Easy does it and the fly should be saved.

shake, and the fly came free. He checked the tippet for damage and, just to be safe, clipped the fly and retied it on a fresh piece of tippet.

An errant cast cost the young angler that hare's ear a while later, when it wrapped around a root on the far side of the stream. He tried aiming the rod at the snag, pulling the line tight and releasing it toward the fly several times. This maneuver had popped many a fly free for him, but it didn't work this time. Unable to free the fly, and faced with water too deep to safely wade, Eric tightened up the line, wrapped it a few times around his hand, and, making sure his sunglasses were in place, aimed the rod directly at the tangle. He turned his head away and walked out of the water slowly, until the tippet snapped. The fly line and leader sprang safely free into the water, and his fly disappeared below the surface, firmly attached to the root.

He lost a second fly when a feisty rainbow picked it up and headed

Always look away when freeing a snag.

downstream. The leader parted when he applied pressure, and upon close inspection, he realized that an undetected wind knot in the tippet had caused the mono to slice into itself.

At the appointed time, everyone returned to the parking lot with many tales to tell. A broken rod tip was the result of Don's improper attempt at freeing his snagged fly. Luckily, it was broken close enough to the end that a pair of pliers and a match were all that was needed to hold the metal tip-top, heat it, and pull out the broken piece of graphite. The trimmed-off end of the blank was inserted back into the tip-top shaft while twisting it to line it up with the other guides. A single tug after it cooled showed that there was enough ferrule cement left in the tip-top to make it secure.

We decided to try one more stretch of stream before calling it a day. Each outfit—fly securely in place, line wrapped around the blank—was carefully fed through the back hatch of the station wagon, with the tips resting near the rearview mirror. It was Todd's job to hold on to the rods to steady them as we traveled to the spot I felt sure would reward us with a big brown.

Everyone sat on the old blankets I always carried along to help keep the seats dry for the ride home. I took off my waders and stashed them neatly

in the back. We arrived at the parking area, hopped out, and headed for the water. Don was into a fish before the rest of us had our flies in the water. The big brown danced around the pool and tested Don's knots as well as his fish-fighting skills.

As the fish tired, Don eased out of the water and onto the bank. Eric put his net in the water, and Don led the fish over to it headfirst. The prize was his!

Photos were taken quickly and the fly was freed while we removed the fish briefly from the water. A gentle release into stillwater after the fish was fully recovered assured us that this great fish was none the worse for wear.

Don's fish proved to be the best for the day. We all returned to the car, where we clipped off our flies and reeled in the line, leaving a foot or two of leader free from the reel. We put the tackle in its cases, washed the mud from our boots, folded them neatly, and stashed them in the back.

Once at home, the anglers set to the task of preparing their tackle for winter storage. They filled the boots on the rubber waders with newspapers, wiped them clean, and hung them by the straps to facilitate air movement. In a day or two the newspapers would be removed, and the boots would be dry inside. Waders would then be neatly hung upside down by the boots in a safe place. If there was no room to do this, they would be rolled up carefully, avoiding creases, which could create a leak, then placed away from direct heat or electrical motors, which would tend to break down the rubber.

The anglers opened their fly boxes to dry and inspected the contents for rusty or broken hooks. Monofilament pieces, trash picked up from stream-side, candy wrappers, and old socks were removed from fishing vests, along with an assortment of other items. Pockets were cleaned and the vests washed, dried, and hung up on hangers till next season.

The fly rod, reel, and line were next to be worked on. Eric clipped off his leader at the knot and stripped large coils of line into a dishpan. When he reached the backing, he reeled the line back onto the spool after running it through a clean old sock saturated with vinyl cleaner or fly line cleaner made especially for this purpose.

Eric knew that the line should be stored off the reel in loose loops, similar to the way it is stored when purchased. This would keep the line from having too much memory (forming tight coils) and give the backing a chance to dry thoroughly. Some of his friends made line winders from old coffee cans or wooden frames. Others used devices specifically designed for this purpose. Eric used the plastic case the line came in when purchased. He wound the line in loose, even loops, with the leader end going on first. He clipped the backing knot and left it on the end of the line to avoid confusion

next year. He slipped a twist-tie around the coil to hold the wraps in place, returned the line to its original box, and stored it out of sunlight and away from excessive heat.

Next he washed the reel with a quick spray of warm water and gave it a light scrubbing with an old toothbrush; then it was lightly rinsed and allowed to dry. He popped off the spool and wiped clean the rim of the spool and reel. He inspected the interior of the reel for damage, wiped it clean with a rag, and sprayed a shot of reel oil on the moving parts. The loose screw that had given Eric trouble all season received a touch of Lock Tight to keep it snug, and all the other screws were checked and tightened. He turned the drag back to its slowest setting and placed the reel in an old, clean cotton sock for winter storage.

Eric washed his fly rod with soap and water and rinsed it clean. After it dried, he checked the guides and all components for wear or sharp edges that could harm the fly line. None were found, so he next checked and lightly oiled the reel seat. Eric put the rod back in its sack and then slid it into the tube slowly, circling the open end of the tube with his thumb and index finger to guard the rod from damage.

Fishing season was over, and all the gear was properly stored till spring. Eric knew it would be in good working order and ready to go when the time came.

It was time to start making new memories; fly-tying season had just begun!

5

Fly Casting

Fly casting is merely a means to an end, the end being presenting a fly successfully to a fish. In order to achieve this goal—and have fun along the way—the entire process must be put into perspective. Always follow two basic rules: *Keep it simple and keep it relevant to fishing.*

The surest way to put a damper on a youngster's enthusiasm for fly fishing is to make the whole process seem too complicated. Stick to the basics. Remember, the kid is learning to cast a fly rod so that he or she can catch a fish.

No matter what your skill level, when you are teaching a youngster, you must start at the beginning. Along the way you'll discover a marvelous surprise: Breaking fly casting down to its simplest components and starting from scratch, teaching a youngster each step—the right way—will make *you* a better caster.

In order to teach fly casting to youngsters, you need to have some casting experience. However, it's okay to be new at the game. Your desire to help these young anglers will be an inspiration, and you'll set a proper example to follow. If you're a beginner yourself, seek proper instruction and practice. If you still don't feel up to the task, find someone who is willing to work with both you and the youngsters, and become his or her apprentice. If the instructor does not feel comfortable about teaching young people, assure him or her that it's easy and fun and that you'll provide plenty of assistance! Also suggest that he or she read this chapter.

Throughout this chapter, I've borrowed liberally from the techniques and styles of the three great fly-casting instructors of our time, Bernard "Lefty" Kreh, Joan Wulff, and Mel Krieger. These three fly fishers have crafted fly casting into a fine art and made it accessible to thousands. Their influence can be seen in the design of nearly all fly tackle produced today and in the casting strokes of most fly fishers.

My father was my first fishing companion and owner of an old, three-piece bamboo fly rod. I fished this rod with a bobber, split shot, and night crawler for bluegill and perch at Gardner's Pond. My dad showed me that if I stripped out a modest amount of line upon a flat rock, I could then "cast" (sling!) the entire mess into the pond. This procedure worked quite well. He told me that in time I would learn to cast flies for trout in the manner that the rod was designed to perform.

I had a vague idea of the casting procedure required to deliver a fly to the water. I remember once trying to imitate a series of false casts that I imagined a fly fisher used to propel a fly to a hungry fish . . . only I still had a bobber, sinker, and worm on the leader. Needless to say, my performance was not a pretty sight.

—Bill Peabody, saltwater fly tier

Master fly-casting instructor Nancy Zakon breaks up her classes with a "reading the water" demonstration. She uses balloons and flags as boulders and fish.

FLY-CASTING CLASSES

In this section, I've laid out the general techniques we've used over the past few years at the Fly Fisher Apprentice Program to successfully teach hundreds of youngsters the fundamentals of fly casting. The overall approach presented here can be used while working with one youngster or a hundred. It may include all the suggested equipment I describe or just a fly outfit. The basic steps and examples are tailored to young students from ten to sixteen years of age and are designed to lay a solid foundation for an ongoing youth fly-fishing education program.

For class situations, group together youngsters of similar skill levels. The

In comparison with other sports, fly fishing has many fewer participants. When I'm fishing on a beach, stream, or lake, I rarely see anyone else fly-fishing. When there are local fly-fishing shows in my area, usually the people I see there are the only people in my area that participate in this wonderful hobby. To me fly fishing is only a hobby, but for some it is an occupation. I think it's great to earn a living doing something you love.

I mostly saltwater fly-fish in the Long Island area. While I'm out on a secluded beach all alone with my father, I feel as if I'm in heaven. Sure, I become frustrated when my line gets tangled or I lose a fish, but those are problems I adore. Sometimes while I'm fishing I forget where I am altogether. My only worry is when the fish will take my fly.

Before you do anything else in fly fishing, you must learn how to cast. This is probably the most challenging aspect of fly fishing. Some beginning fly fishers don't catch a fish until a year after they start. This just shows that fly fishing is only meant for the most dedicated people. Once you're able to cast pretty well, the next step is to tie the perfect fly to match the bait. This is definitely my favorite thing to do.

I believe fly fishing is one of the greatest things life has to offer. This is why I choose to spend most of my free time fly-fishing and tying flies. I wish everyone out there can feel the way I do when I fly-fish.

—Ryan Rosalsky, age fourteen,
Dumont, New Jersey

fewer variables, the more effective the group instruction will be. It's important to be aware that each youngster is different and has different physical abilities, different frustration levels, and different reasons for learning to fly-fish in the first place. With young students, do not force the issue. Start only when the youngster is ready, and finish the lesson well before anyone reaches the frustration or exhaustion limit. Remember, this is supposed to be fun!

Preparation
Start by making sure your young caster has appropriate equipment (see chapter 4). The casting tool should fit his or her physical stature. The grip should be comfortable, the rod and reel combination of a manageable weight, and the line weight a size or so above that recommended for the rod. An 8½-foot, 5/6 fitted with a weight-forward floating line is the standard for the average young beginner. Stock a few lighter outfits with thinner grips for smaller students and those who may not have the strength to handle the heavier rod

Ed Koch passes on a few casting tips at the New Jersey School of Conservation.

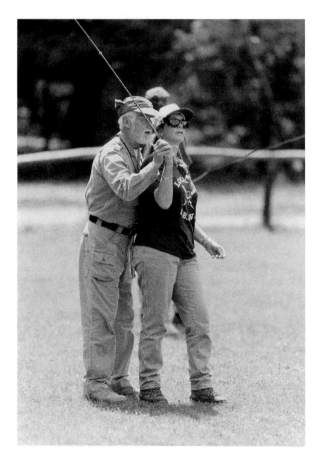

My first fly rod was a 9-foot, two-piece Heddon that cost all of $3, purchased sometime in the mid-1940s. It was a rather hefty sum for a dad who made under $15 a week. To me it felt like it weighed 3 pounds! What I did with that rod in an effort to get my line and fly where I wanted it was anything but casting. Again, the good Lord must have wanted me to make some kind of progress. I was out behind my grandmother's house one Saturday trying my best to get some kind of control over my arm, my rod, and my life—still without success.

Unknown to me, a neighbor had been watching me for some time. He went into his house, rigged up his fly rod, returned to the backyard, and continued to watch me. I never knew he was there.

Quietly he asked, "Would you like some help?" He surprised me and I almost dropped the rod.

"Sure could use some, I'm just getting started in this fly casting," I answered.

He walked over and began to explain the techniques of the fly rod, reel, and line. Next he demonstrated the proper casting technique. It was beautiful to watch what he could do with his fly rod. After a short time he reeled in some line, handed me *his* rod, and said now it was my turn.

He held my hand and walked me through his technique, thumb on top, wrist locked, elbow tight against my side. He guided my movements as the rod moved smoothly through the air, the line going out perfectly straight in front of me, staying high in the air on the backcast, rod stopping at 1 o'clock. I couldn't believe it. It was easy.

Vince spent about another hour with me. Over the next few years, before I graduated from high school, Vince must have spent hundreds of hours with me. We fished together from time to time. More importantly, he took me with him whenever he could. His knowledge, advice, and companionship were invaluable to this teenager.

Had it not been for the interest he took in me and the countless hours he spent with the young lad of twelve, I'm certain I wouldn't have stuck it out. I have fifty-plus wonderful years of passing on to others what I was so fortunate to have had passed on to me in those very early years.

—Ed Koch, pioneer small-fly tying innovator

and reel. All outfits should be properly balanced so that they can be used for an extended period of time (an hour or so) without tiring your students.

Handling Rods and Reels

If the youth fly-fishing education program involves hauling around several rod and reel combos, number the blanks with colored nail polish or lacquer. For temporary labeling, use masking tape. Mark individual rods with a number on the base of the blank by the grip and the same number at the base of the tip. This will help keep the correct butt with its corresponding tip. I always write our program's initials, "FAP," on the cork of the handle with a marker for further easy identification.

If the rod does not have a case or sleeve, the butt and tip sections should be bound together. Hold the two sections together in one hand with tip-top up and butt down. Wrap a stout rubber band or twist-tie sideways around the sections several times, using the stripping guide as an anchor. This holds the rod together securely and makes it easy to carry several at a time without any problem. Wrap rubber bands around the rod butt when not in use.

Be very careful how and where rods are stored when they are not in use. Rods should be taken apart before being taken indoors or put in a car. Screen doors, car trunks, and car doors eat rod tips! Rods easily fall when placed against an upright surface. Individual rods laid flat on the ground, especially

A properly wrapped rubber band will hold a rod together surprisingly well.

These rods are safely piled on the break in the fence rail to prevent them from sliding off onto the ground.

on grass, are likely to be stepped on and broken. There's safety in numbers. Piles of rods are easier to carry and are much more visible. The lightweight graphite rods are very strong when properly used, but the walls are thin and easily crushed.

When walking with a rod, it's best to hold the rod by the handle with the butt end facing forward and the tip of the rod facing to the rear. A tip waving around in the air may catch on a person or a tree limb, and one that is facing forward and down may catch on the ground and snap.

Reels used primarily in casting practice should be outfitted with a whipped loop in the end of the fly line. Leaders will take a tremendous beating in the classes, and the loops facilitate easy changing. They are also handy to use when fishing.

With a permanent marker, mark the 30-foot length on the fly line. This is

the standard taper length in fly line design. It will load the rod correctly, help familiarize the students with this distance and enhance their casting and fishing judgment, and will serve as a reference point which will be used often during instruction. Write the weight of the line on a piece of masking tape and place it on the side plate of each reel.

Loop on a basic tapered leader and, for beginners, secure a short piece of yarn or pipe cleaner to the tippet.

Head and Eye Protection
Outfit your budding casters comfortably in caps and safety glasses or sunglasses for protection. Safety glasses in smaller sizes are difficult to find, and large glasses tend to slip from small heads, especially on warm days. A simple trick suggested by Lefty Kreh can help cure this problem.

Purchase adhesive-backed Velcro strips, available at craft and hardware stores; 3 inches for each pair of glasses should be enough. Secure a short piece of backing or fly line to the stems of the glasses. Fold one side of the Velcro strip back on itself over one of the lines and tie it off. Fold the corresponding piece of Velcro on the other line, tying it off. The two sides of Velcro will then fasten to each other securely. A bit of adjustment will make the glasses fit nicely, holding them in place through a day's casting.

Velcro strips are handy. Here two strips are used to hold sunglasses on a small, sweaty head.

Targets

Get a supply of targets to use for the class. Anything that will lie flat on the ground, is easy to see, and will not blow away should work fine. Three-foot sections of white rope make highly visible targets and can also be used as starting lines for the caster to stand behind. Rope is inexpensive, and the quantities can be easily stored and carried. Set up the targets 30 feet from the starting lines.

Choosing the Site

For the initial practice sessions, select a well-mown lawn with lots of casting room. If you can, choose a day when there is little or no wind. Short grass offers resistance similar to that which occurs when the line is dragged through water, tugging on the rod, bending it, and causing it to flex, or load. The rod then springs up, pulling the line with it, giving the whole casting stroke more power. It's difficult to make a good cast without this initial tug on the line. A gym or similar glossy floor is not recommended, as the slick surface will not allow the fly line to grip and help load the rod. Don't use an area covered with blacktop or dirt; repeated casting on this type of surface will destroy the lines.

Strive to have about 50 feet of safe area in either direction. Be sure there are few diversions and even fewer observers, and be careful to avoid power lines and tree limbs. The idea here is to provide a learning situation that will allow the young fishers to focus on the task at hand. Noisy crowds and a pond full of fish will distract both you and your students.

The Lecture

After arriving at the practice site, gather the students into a group, being sure they are positioned so that the sun is not in anyone's eyes. Keep the rods off to the side in a pile and out of everyone's hands until it is time to use them. *Do not* distribute the outfits before the lecture and demos are completed.

Introduce the assistant instructors, who should be wearing name tags. Give the students a brief description of the day's schedule and explain the rules they must follow. My favorite way to start a class is to ask "What makes fly fishing different from every other type of fishing?" Then hold up a fly outfit along with spinning, bait-casting, and spin-casting outfits. Be prepared to get every conceivable answer under the sun. Sooner or later someone will come up with the astute observation that the line is fatter. "Aha!" I say, pointing excitedly at the lucky winner. In fly casting, it is the weight of the *line*, not the weight of the lure, that carries your offering to the fish. It is from this point that we start our fly-casting education.

Where the whole thing goes from here is up to you. A quick explanation

of fixed spools and revolving spool reels may be in order. Get the whole class involved, and encourage the students to share their knowledge.

Be sure to include lots of examples. Try to put concepts into terms that the youngsters can understand. Explain that the line is like a long weight that you throw like a ball or a spear. Explain that you can probably throw a spinning lure with your hand about as far as you can cast it with a rod. But a little fly is a different matter.

The visual image of throwing a line can be very effective when speaking to kids. Youngsters respond well to the use of images, which are a great aid to their understanding.

Assembling the Outfits

If it's a casting-only class and time is a factor, it's a good idea to preassemble the outfits. However, if the casting instruction is part of a full fly-fishing educational workshop, in which the youngsters will be instructed in various skills throughout the day, it's good to have them assemble the outfits themselves.

In a workshop situation, each youngster should be assigned a rod and reel at the start and use it throughout the day. Mark down the name of the angler and the number of the outfit. Make it clear to the students that they are responsible for the rods and reels they've been assigned.

While doing the assembly demonstration, allow the students to participate as much as possible. Have them answer questions, and if they've just had a class in assembly, let them demonstrate what they've learned. This will help reinforce the lessons.

As you assemble the outfit, give the relevant information along the way:

1. *Explain why the reel is at the end of the rod:* to balance the entire outfit. The butt is very short to help make casting easier and to keep the line from jumping up and wrapping around it during each cast.
2. *Identify the parts of the rod.* Start with the *reel seat* and *grip.* Explain that the cork is shaped to fit into the caster's hand. A two-piece rod has two parts: the *butt* section and the *tip* section. The first metal loop right next to the handle is the *hook keeper.* The fly can be hooked onto this loop after the line has been pulled through the guides and is tied to the tippet. A safer option, especially with larger flies, is to slide the hook point under the front part of the reel seat. This will cover the point completely and hold the fly securely.

 The first, larger guide is called the *stripping guide.* The word *strip* describes the act of retrieving the line by pulling it over the index finger of the rod hand after a cast. The larger diameter of this guide aids

in better control of the line while doing this and also helps reduce friction on the line when it is cast, allowing it to *shoot* through the rod more easily. The other thin, metal guides, which have a twist in them, are called *snake guides.* They are designed to offer as little resistance to the fly line as possible on the cast and the retrieve. The very top guide is called the *tip-top.*

3. *Point out the male and female ferrules.* The male ferrule can be on either the butt section or the tip section, depending on the manufacturer's design. It is made specifically to fit into the female ferrule of that particular rod blank. It's important to keep the individual parts for each rod together. Although some tips and butts may interchange, it is best to keep the originals together.

4. *Explain how to assemble the rod and reel.* Find the end of the leader or line loop on the reel. Running the end of the line through a ventilation hole on the side of the reel before storage will help keep it accessible. Be sure the line does not go under itself; the tangle this creates will not take care of itself as line is pulled from the reel. Push the end of the line back under itself and out of the bottom of the spool.

 Note which direction the line comes off the spool. Position the reel on the reel seat so that the line will exit the reel from the *bottom* of the spool directly to the stripping guide. Snug up the lock screws on the reel seat.

 Explain the simple function of the reel as a line holder. Note that the *clicker* keeps the line from backlashing and making a mess. Demonstrate how to reel the line back onto the reel in an even fashion: Grip it between the thumb and index finger of the rod, or casting, hand, putting the palm on the top of the rod handle, and crank in the line, using the remaining fingers of the rod hand to guide the line evenly onto the spool.

 Slide the male and female ferrules together, with the last guide on the butt and the first on the tip being slightly out of line. Sighting down the rod blank, twist the two halves into alignment while pushing them together snugly. This will keep them more secure during a day's casting than if they are just shoved straight together.

5. *Explain how to string the rod.* First put a hat on the ground. Pull several feet of line from the reel and place the rod butt and reel in the hat, explaining how this will protect the tackle and keep everything clean. Bend the fly line just above leader. Run this loop through the stripping guide first. Stop and explain that the line *does not* go through the hook keeper. Also explain that if you lose your grip on the line, the loop will

prevent it from falling back through the guides. Continue up through the guides and out through the tip-top. Make a final check to see that you haven't missed any of the guides and that the line does not wrap around the blank at any point.

The Casting Stance

Before the casting demo, go over the three main elements that make up the fly-casting stance. Stress that your students must be sure to follow all of these steps *before each cast*. Soon this will become a habit and a regular part of their casting form.

Step 1. The Grip. Each youngster must determine which arm to cast with. This is personal preference. Some casters like to cast with their stronger arm and reel with the weaker. Others prefer to use their stronger hand to reel and weaker arm to cast. Still others will use the same arm for both, switching the rod back after the cast.

Have the student grasp the rod firmly toward the front of the handle with the *rod hand.* The grip should be comfortable but not too tight (white knuckles are a sure sign of an overtight grip). The thumb should be on top,

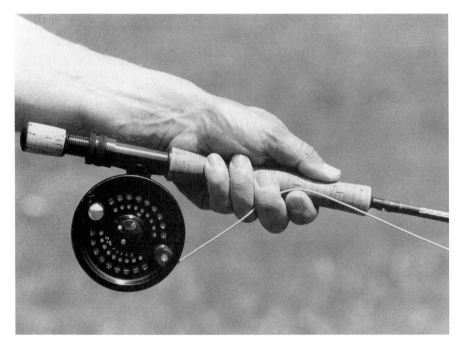

Typical thumb-on-top grip

A comfortable beginning position

with the rest of the hand wrapped firmly but not too tightly around the handle. It's sort of like shaking hands with the rod handle.

The other hand, called the *line hand*, will eventually be used to control slack between the reel and the first guide, and to retrieve and feed line into the cast. For the first lesson the line hand will not be used; the line will be held under the index finger of the rod hand on the grip.

Step 2. Foot Position. Feet should be placed apart about shoulder width or less. The foot on the same side as the line hand should be slightly forward, aiming at the target. The foot on the rod hand side should be positioned with the toes across from the front of the arch of the other foot. This position will allow for easy turning to watch all phases of the cast. Comfort and ease of movement are paramount here. Allow for individual needs and preferences.

Step 3. Point the Rod Tip Down. The rod should be held out at about arm's length, comfortably at waist height, with the tip down close to the ground. From this position, if the line is straight out in front, the entire line,

including the fly, will begin to move instantly when the rod tip is lifted, giving power and speed to the backcast.

Demonstration One: The Casting Stroke

Before the actual demo cast, explain the parts of the casting stroke. This should be demonstrated without the rod, using your hand, the rod butt only, or a dowel.

During the stroke demo, point out that the *backcast* and the *forward cast* are the same movement and are interchangeable. There is really only one movement to learn: the acceleration to an abrupt stop. Note that in some circumstances, the wind or an obstacle may prevent the regular casting style. The backcast can then be used as the forward cast.

Keep the casting arm relaxed at your side, an inch or two from the body, with the forearm held forward at about a 45-degree angle (10 o'clock). The rod hand should display the proper grip and be held at about shoulder height. The thumb is on top and the wrist held firm.

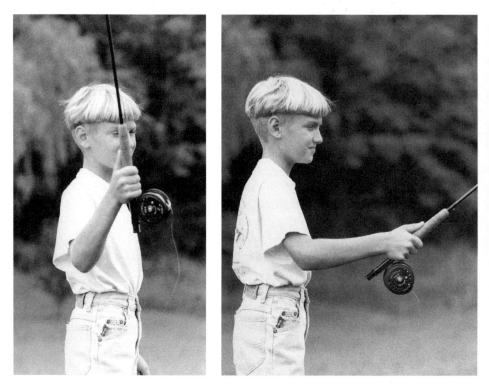

Patrick Sodums demonstrates the proper two-part casting stroke.

Stress that a short, powerful casting stroke, between 1 o'clock and 11 o'clock, with an abrupt stop on the backcast and forward cast will cause a tight loop. Some drifting after the stop, back to 1:30 or so, is natural and acceptable. It will even help the backcast uncurl better.

Urge the students to watch their backcasts.

Start at this position and go through the two parts of the casting stroke. Repeat several times, having the kids follow along.

1. *Backcast.* This can be described as "the windup" for "pitching" the forward cast. Keeping the hand in the same plane, at about shoulder height, with the wrist rigid, accelerate the rod *quickly* to an abrupt stop between 12 and 1 o'clock. Pause for a second (count "one Mississippi"). This allows the line to straighten out behind the caster and is a good habit to get into from the start.

2. *Forward cast.* Once again keeping the rod hand rigid, in line with the forearm, and in the same plane (about shoulder height), accelerate *quickly* to an abrupt stop at the starting point (45 degrees or 10 o'clock).

This very important quick acceleration–abrupt stop sequence can be described in many colorful ways, such as flicking paint from a full paintbrush, hammering a nail, throwing a ball, or flicking an apple, potato, or ball from the end of a stick. We often describe it as hitchhiking on the backcast and flicking an apple off on the forward cast. If the stroke isn't strong enough, we jokingly tell the student, "Nobody will ever give you a ride with that form; put a little more enthusiasm into it!"

The use of props can be very effective. It will give your demo stronger visual impact and is fun to pass around to the kids. Possible props are a toilet brush and some water (the water will flick from the brush at the abrupt stop); a foot-long dowel or old rod butt section (minus the guides), with a ring attached to a string around it (the ring will shoot off on the back and forward casts); or an old ball, with a string attached, impaled on a dowel.

After demonstrating the correct stroke, show the class what an *incorrect* stroke looks like:

- *Bending the wrist.* While demonstrating the stroke, bend your wrist back and forth, leaving your forearm in the same position. Explain to the class that the rod can be seen as an extension of the arm, and the rod tip will follow and exaggerate each movement. Casting with the wrist only will tire the caster out quickly and result in a poorly executed cast. There is much more power and strength in the arm. Bending the wrist can lead to the "buggy whip" type of casting problem.

- *Arm held too high.* This tires the caster out quickly and results in a poor cast.

Nancy Zakon shows the class how not to hold your wrist during a cast.

- *Arm going up and down.* When the hand is not kept in an even plane, the rod tip does not move evenly, resulting in a sloppy and ineffective cast.

Demonstration Two: The Overhead Cast

The beginning fly fisher should master two basic casts, the overhead cast and the roll cast. Both have almost identical strokes, but the timing and line path are different.

The overhead cast is the foundation for fly fishing. It is used when there is plenty of room for the backcast to travel behind and above the caster. Optimum distance can be achieved with this cast.

I begin teaching the overhead cast and move into the roll cast and the roll cast pickup later in the initial lesson or when we get to the water.

Don't show off by shooting a bunch of line or doing trick casts. The kids will tend to mimic this later. Save that for a future lesson when everyone is a little more advanced. Do a short cast (30–40 feet or less), keeping it slow and making it look easy. Refer to the terms that were covered in the stroke demo.

Fly casting is a skill composed of timing and feel for the equipment. Each individual rod and line will have its own unique balance and optimum action. Each caster will have his or her own unique style. Modern fly casting instructors have gotten away from the old standard hands of the clock

method of instruction in favor of a more technical and individual description of the process.

I've found that the clock face is still a handy and easy to understand reference when working with youngsters. As the student advances, individual rod performance and proper power strokes will become more meaningful and help the budding angler become a more proficient caster.

Begin your demo cast by assuming the proper stance, going over the three important starting points: grip, foot position, and pointing the rod tip down. Stress again that these three important steps should be taken before every cast.

The basic overhead cast has four parts. These should be explained and demonstrated thoroughly and then referred to when actual instruction takes place.

Step 1. Pickup. Work the line out so that it is straight in front of you on the grass. The pickup gets the entire line moving and sets up the rest of the cast. The rod tip is held low, nearly touching the surface. The rod is then pulled with a smooth, quick movement to backcast position (90 degrees), with an abrupt stop. Hold the rod to the side at a slight angle and urge the students to do the same. It will help them maintain better line control than they would get from a perpendicular position.

A good, crisp pickup helps load the rod and gives power to the backcast. If the pickup is weak, the line will not straighten out correctly on the backcast and will collapse behind the caster. When working with youngsters, it is important to be on the lookout for this problem.

I tell young casters to pretend they're throwing the line up into a tree behind them or throwing an apple off the end of the rod up over a building. This works well in helping them attain the power needed to get the line moving. It also helps them catch on to the abrupt stop that makes the cast work.

When casting and while fishing, the line hand holds the line near the waist. The rod hand and line hand are then only inches apart. When the rod is snapped up during the backcast, the line hand remains in about the same position, holding the line securely. The rod snapping up quickly gets the end of the line moving, and as the rod goes back to backcast position, the two hands get farther apart. This dramatically increases the line speed and, therefore, the power of the cast. When line is released on the forward cast at the right moment, casting distance is achieved.

Step 2. Backcast. The rod is accelerated after the pickup to a point where the forearm and hand stop abruptly at about 90 degrees or so (between 12 and 1 o'clock). Turn with the backcast and watch the line straighten out. As it does so, it will continue to load the rod, putting a deep bend in it.

Urge the students to watch their backcasts. Make the point that 80

Patrick Sodums shows us the overhead cast sequence—pickup.

Backcast

Beginning forward cast

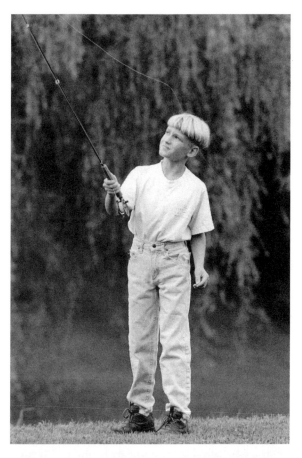

Continuing forward cast—front view

Ending forward cast

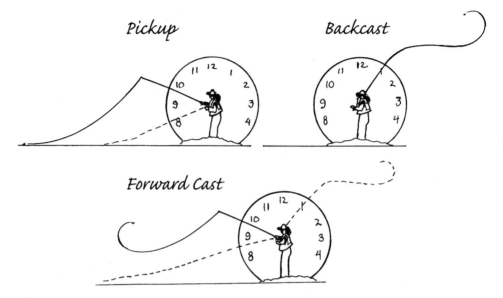

The parts of the overhead cast are easily shown with the aid of a clock face.

percent of a good cast is a proper backcast. Demonstrate the correct way to watch the cast by turning comfortably at the waist, following the rod tip.

Just a split second before the line uncurls completely and starts to drop (say, "Stop—one Mississippi"), begin the acceleration for the forward cast. The energy stored in that deeply bent, loaded rod will propel the line forward, forming the *casting loop*.

The casting loop is the shape described by the line as it moves through the cast. A tight loop is desirable and will transfer energy efficiently into the cast. This will be an even, compact U shape and will lay the line out smoothly till it straightens at the conclusion of the forward cast. A wide, uneven-shaped loop tends to disperse the energy of the cast and will cause many problems.

The loop is formed by the movement of the rod tip. If the tip moves evenly and in a level plane, the loop will be even and tight. If the tip moves out of plane, in an up-and-down movement, the loop will open up and become sloppy. The rod tip is controlled by the movement of the casting hand. Each small movement of the wrist is exaggerated greatly by the time it reaches the tip. Demonstrate this: Hold the rod in a vertical position (12 o'clock). Move your hand back an inch or so, using the wrist only. The tip will move several inches.

Step 3. Forward Cast. As the rod hand accelerates through the stroke in a level plane, with the wrist rigid, the rod bends even deeper, then starts to spring forward, bringing the line with it. At the peak of the acceleration, the

rod hand is abruptly stopped, with the rod aimed several feet above the target and the caster describing about a 45-degree angle (10 o'clock) with the forearm. The rod tip should end up just above eye level. The line should uncurl smoothly in a tight loop.

Step 4. Finish, or Presentation. Just before the line uncurls completely, start to drop the rod hand slowly and smoothly, stopping the rod tip somewhere between the shoulder and waist (close to 9 o'clock). This will cause the line to land on the water as evenly and quietly as possible and will get the rod into a fishing position where the line will be under control and the retrieve can begin.

At the conclusion of the demo cast, let the students ask questions and make comments. Everyone will be excited and eager to get casting.

Demonstration Three: The Roll Cast
The roll cast, as the name implies, is achieved by rolling the line out onto the water. It is used for two specific purposes, to make a forward cast when there are obstructions behind the caster and as a convenience pickup for the overhead cast. Many instructors teach the roll cast first, explaining that it is easy to learn and essential as a skill for handling line control and presentation.

Tension on the line during the pickup is essential to the successful execution of the roll cast. A lawn is not the optimum surface to use for teaching the roll cast. Grass does not exert enough friction on the line to load the rod properly and may grab at the knots and yarn fly causing a real problem in timing for the caster. The roll cast works best on water.

The roll cast is best executed and taught on still water. It is composed of the same four parts as the overhead cast. The major differences are the speed

Roll Cast

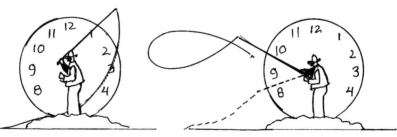

1. Slide the line behind you on the backcast/pickup.
2. Pause, lift your arm, and perform a standard forward cast.

of the pickup and the position of the rod, which is raised and moved forward just before the forward cast.

Begin by assuming the proper stance and working at least 30 feet of line out directly in front. The entire cast is made with the rod at a comfortable angle to the side. Pick the rod up in a slow motion version of the overhead cast pickup. Stop the rod at about 1 or 2 o'clock. The line should now be sliding across the water and be behind and to the side of the rod. Pause for a split second.

Move the casting arm upward then forward, lifting even more line from the water and going immediately into the standard forward cast, stopping at 10 o'clock. Slowly follow the line as it uncurls onto the water.

To use the roll cast as a pickup, simply snap the rod back into a backcast after the line has begun to uncurl and before it hits the water. Correctly performed, this will give the caster good line speed for the pickup on an overhead cast and create a powerful backcast.

The Casting Lesson

Decide in advance how the actual casting lesson will be conducted, taking into consideration the number of students and the size of the practice area.

It's a good idea to break up a half day's casting instruction into sections that focus on related skills or subjects. Various types of tackle, fishing situations, tackle care, conservation, locating fish, or insect hatches are all topics of interest to the young anglers. This will give everyone an opportunity to rest, have a drink, and interact with others.

Plan a schedule in advance and keep track of the time allotted for each part of the day's activities.

A typical half-day class may look like this:
- Introduction and lecture, 20–30 minutes
- Stroke and casting demonstrations, 15 minutes
- Casting lesson, 30–60 minutes
- Discussion time, 20–30 minutes
- Another casting or roll cast demonstration and lesson, 60 minutes
- Line control and retrieve practice, 15–20 minutes

Many instructors teach students in pairs. This is an especially good idea when there are too few outfits or teaching assistants. The student who is not casting can serve as a mentor for the caster and can give his or her casting arm a rest as well. Have the student who is not casting stand on the line hand side of the caster to assist.

If one of the parents has a camcorder ask him or her to record each student. It is a marvelous way for the students to see their casting form.

Use pieces of rope as starting lines, placing them at least 10 feet apart,

either in a circle around the instructor or in a line in front. Allow enough room for both the forward cast and backcasts; for first-timers, 40 feet in either direction should be safe. During subsequent lessons, as skill levels increase, so should the safety distances.

Once students are in place at the starting lines, check that both casters and assistants have on safety glasses and hats. Then hand out the outfits and targets. Have the students string the rods and pull the leader and a few feet of line through the tip-top.

Begin by instructing the students to strip 30 feet of line from the reel onto the ground (the mark made on the line earlier indicates 30 feet).

Demonstrate how to wave the rod back and forth at waist level to pull the remaining line up through the guides, then have them try it.

Line control is paramount to good casting and fishing. It should be taken into account and provided for from the start. Depending on the age and skill level of the group, instructors must decide how the line will initially be controlled for casting instruction. It's sure to become an issue, so you should consider it early on.

If your students are very young (under twelve), it's prudent to secure the line on their practice outfits so that it won't tug on the reel during the pickup and cast. If additional line is jerked off the spool when power is exerted, a

The line is doubled when strung up through the guides.

Patrick Sodums
demonstrates how to
wiggle the line out
of the rod tip.

tangle will result, and the cast will be ruined. An easy way to accomplish this is to loop the line once or twice around the foot of the reel. Have the youngsters grip the rod handle and line together between their fingers and the rod handle.

Older students can hold the line against the rod handle with the index finger of the rod hand or in the line hand near their belt buckles from the start. Explain that the main purpose of the line hand is to keep constant tension on the line so that it doesn't go slack and ruin the cast. Caution them not to let the line go until the session when you will teach them how to release it on the forward cast. Practicing the stroke and developing control are the goals for this initial session. Let the students cast their lines out toward the target as best they can.

Then have the youngsters place the rod on the ground, with the rod butt on the starting line, tip pointing straight out. This is one of the few times

when laying the rod down is allowed. Then have the students or assistants walk toward the instructor (being very careful not to step on the rod!), pulling the line out straight until it tugs on the reel. The target should be laid on the ground about where the leader connects to the line. When they return to the starting line, instruct the students to pick up the rods carefully, keeping the rod tips low so as not to move the lines.

Now it's time to have the students go through the casting sequence with you, *doing one cast at a time,* following the steps outlined above and aiming at the targets. Assistant instructors should help the individual students. Have the students check the three starting points and parts of each cast. Stress that *timing and accuracy are more important than strength and distance.* Feeding line into the cast and achieving more distance will come as skills mature, and timing will improve with practice.

Many instructors have the kids wave their rods back and forth in the casting movement several times before laying the line down. This is not a good practice, as it tires the young students quickly and encourages them to use more backcasts than are necessary. It's good for them to get the feel of the whole stroke and become familiar with this movement; however the fewer backcasts per cast, the better.

An ideal spot for a roll-casting class—no weeds along the shore and plenty of room behind the casters.

Casting Checklist

- *Check foot position.* comfortable, legs spread about shoulder width, line hand foot slightly forward
- *Grip.* comfortable, thumb on top, not too tight
- *Rod tip down.* arm in comfortable position
- *Pick up.* quick, crisp hitch hiking motion, wrist rigid, hand in a level plane, "throw the line up over the trees!", caster turns to follow the stroke
- *Accelerate to an abrupt STOP.* stop the rod at approximately a 90 degree position
- *Watch backcast.* a split second before the line uncurls start to bring the rod forward
- *Accelerate to an abrupt STOP.* stop the rod at the 45 degree angle starting point, wrist rigid, hand in a level plane, "flick that apple off the rod tip!"
- *Lower the casting arm and rod.* the line lays out straight on the lawn over the target!
- *"GOOD JOB!"*

Line Control. After the initial casting skills have been practiced and the student is casting 30 feet of line smoothly and accurately, it is time to begin releasing or shooting more line on the cast, retrieving the line and manipulating the fly, playing a fish, and reeling in slack on the reel.

After the basic casting strokes are learned the student will want to add a little more distance to the cast. Assume the casting stance and strip approximately 5 feet of line onto the ground. Release the line from under the index finger of the rod hand and grasp it between the thumb and index finger of the line hand. Hold it just under the rod at about waist height.

Go through the pickup and backcast without moving the line hand too far. Maintain tension at all times. Release the line on the forward cast just as the loop starts to straighten. Releasing too soon is a common mistake. Timing is critical: Be sure the line is released at the end of the stroke. Proceed slowly, stressing accuracy over distance.

In a fishing situation the angler should gain complete control of the fly line and fly as soon as the cast is completed. The easiest way to accomplish this is to learn the two-point method of line control.

Grasp the fly line in the line hand and loop it over the index finger of the rod hand. Maintain the grip on the line with both hands. The line can then be stripped over the index finger by pulling from behind with the line hand. The length and speed of line retrieve is controlled by the line hand. Grasp the line from behind the index finger and strip it at the desired speed and the desired length. Practice this after each cast until it becomes automatic.

Beginning hand position when student is releasing line.

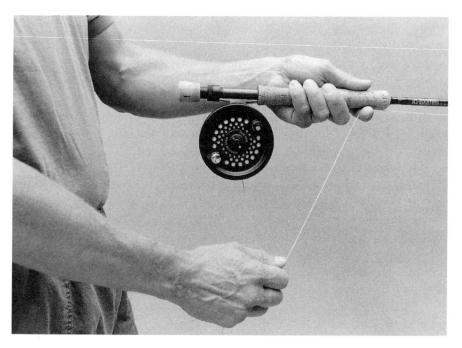

Two-point control.

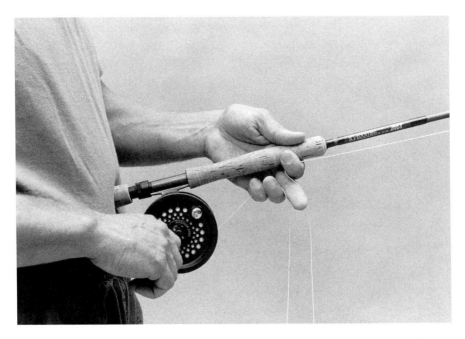

Retrieving line onto the spool in an even manner—note tension between small finger and reel.

The index finger can apply pressure immediately if the fly is taken by a fish. The line hand can then strip in the line while playing the fish. When a large fish is hooked, get it on the reel as soon as possible. This is accomplished by putting sufficient pressure with the index finger on the line as the fish pulls it out. In the meantime, the slack line behind the index finger should be reeled onto the spool quickly and evenly. Hand the loose line to the little finger of the rod hand and maintain tension while the slack is reeled in.

Modification of the Stroke. For some beginners, modifying the casting stroke by starting out with the casting arm moving to the side may be effective. The stroke is the same; the arm is just held out to the side at a comfortable angle. This will be especially helpful for smaller casters who lack the strength to keep the rod at shoulder height. This can also be an effective way to help youngsters form a better loop if they are having problems with the standard cast. Safety space between casters must be adjusted if one of the students is side-casting.

Damage Control. The secret to running a successful fly-casting program with a group of youngsters is having effective damage control and being aware of what's going on around you.

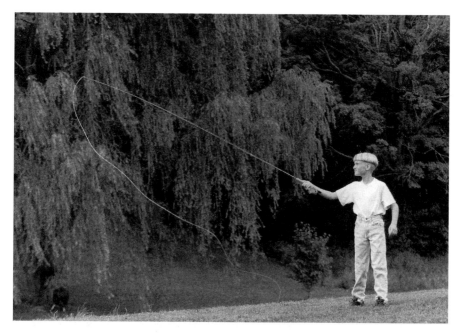

A modified side stroke may be just the thing for a youngster who is having a hard time with the overhead cast.

Here's a quick list to keep a lookout for:
- Stop "buggy whip" type casting ASAP. It can be dangerous, can ruin tackle, and basically, just isn't fly casting! Emphasize that they are to do one cast at a time.
- Some of the smaller kids may need a lighter rod. Have a few 8-foot, 4- or 5-weights around with slimmer grips.
- Be sure all students keep their sunglasses or safety glasses and hats in place.
- Don't use real flies.
- Keep the students focused on the three starting points of the cast. Doing this will slow them down, make them think a little, and greatly improve their casting.
- Be sure to enforce the "rod tips down" rule. Keeping rod tips high and waving them about will not make for good casting.
- Don't let the kids wander around; it they are tired, they can lie down where they are casting until everyone is through.
- Look for students who are obviously tired but just keep on going. Stop them, talk to them, have them rest. They are doing no one any good by continuing.

- Don't let the youngsters lay rods and reels down flat on the ground. The rods will be stepped on and broken.
- Keep classes to a reasonable length. Young arms tend to weaken and concentration becomes difficult after an hour or so of casting.

Common Problems. Look out for the following problems and help correct them with thoughtful suggestions and lots of praise in the right places:

- *Wrist casting.* This is by far the most common problem. Stress that the student will tire quickly using this weak part of his or her body. Go back to the image of hammering a nail or flicking paint from a brush. Go through the casting stroke minus the rod. Some instructors tuck the rod butt into the student's long-sleeve shirt in order to prevent "spaghetti wrist." Be persistent.
- *Casting too much line.* This is a very common problem. Be sure to limit your students to a manageable amount (30 to 40 feet maximum for the first class). Reinforce this by telling them that most fish are caught

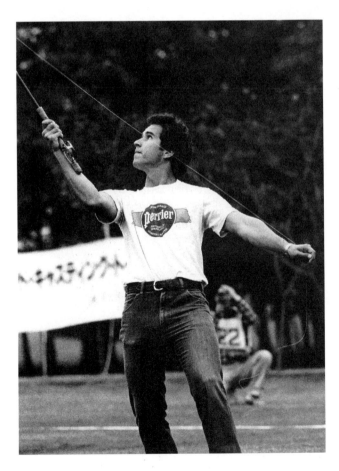

Early photo of Steve Rajeff during a tournament. Notice that even tournament casters watch their backcasts.

Our house was right next to the Golden Gate Park in San Francisco. Only five minutes away by bicycle was the Golden Gate Angling and Casting Club, where I watched the grownups practice fly casting in the pools.

I'll always remember my first time out fly-casting. I was struggling to 25 feet, when one of the club members came running over and said, "Hey kid, don't let your wrist go back so far; you're hitting the tip on the ground. Try keeping the tip high like this." He reached around me, grabbed my hand, and after a couple of back and forths, the line and fly extended to a target about 50 feet away. I was amazed and eager to do it myself.

I kept going back to the club to practice fly casting after school. After almost a month, my parents met one of the club members and asked if it would be possible to get me some lessons. It turned out to be a young tournament caster named Mel Krieger, who was willing to show me how to cast better.

I started going to the casting club every day after school to practice with Mel. He told me to keep trying to hit those targets, because when you go fishing, you'll be able to cast right to the fish. He also told me to keep practicing because in two weeks he wanted me to enter a tournament.

I cast poorly in the tournament and wound up in last place against all the grownups and one kid my age. Mel told me not to worry about my score in the first tournament. Now I knew what to expect.

The next tournament was in two weeks. I kept practicing every day with Mel. My event was dry fly, in which you can make as many false casts as you like, then set it down on target. There are ten casts for score to five targets spread between 20 and 50 feet. I don't remember how many cast before me, but I scored a 97, three points short of a perfect 100. Mel cast a 95.

At the end of the event, I had the highest score and won. The other casters started asking "Who is that kid?" One offered to let me use his spinning rod in the next event.

It was a wonderful time for me and really paid off. I went on to win the National All Round Casting Championship twenty-three times and the World All Round Championship (held every other year) thirteen times.

—Steve Rajeff, fishing rod designer for G. Loomis

At thirty-three, I discovered the fly rod. Within minutes of trying one belonging to a friend, I knew it was for me. I bought a truly terrible outfit and used it only a few times for bass and bluegills, with sporadic results.

A year or so later, I moved with my wife and two small children to San Francisco, where I discovered the Golden Gate Angling and Casting Club in Golden Gate Park. There was a group of superlative fly casters and fly fishers that were active and helpful. It was an open door, and I hauled myself through and into the world of fly fishing.

Jim Green, probably the finest rod designer of our time, and one of the most graceful and effective caster, was my most influential mentor. I became a tournament caster, an analyst and teacher, a trout and salmon fisher. I've been gathering momentum ever since, into the fantastic world that even now continues to grow.

—Mel Krieger, master casting instructor

within 40 feet, then show them that distance. Stress that control is more important than distance.

- *Line slamming into water on the forward cast.* This is caused by using too wide of a casting arc and not stopping the cast high enough (at 10 o'clock) and following through. Simply stop the forward cast sooner and aim higher.
- *Line collapsing on backcast.* If the line hits the ground on the backcast, the rest of the cast will not work. There are probably two factors here: not enough power on the pickup (tell the student to throw the line smartly "up over the trees") and the wrist is being bent (run through the casting stroke again, minus the rod).
- *Not enough power on pickup.* Sometimes getting the student to really throw that line up in the air on the backcast is all that's needed to make the whole cast work.
- *Whip-cracking sound on forward cast.* This is caused by starting the forward cast before the backcast has sufficiently straightened. Urge the caster to follow the cast backward and say, "One Mississippi" on the abrupt stop, before bringing the cast forward.
- *Hotshots.* If you have students who catch on fast and advance quickly, have them help you out and use them as examples for the others. Otherwise, boredom sets in, and they will be trouble instead of an asset.

- *"Hopeless" cases.* Some folks just have a really hard time. Find an aspect of the casting skill they can do, praise them, and work slowly from there. Look for any obvious problems, such as a too-large rod, use of the wrong arm, or sickness. Come up with some sort of contingency plan and help to lead them to *some* success.
- *Wiseguys.* This is a tough call. If they are disruptive, try to get them out of there quietly. Your obligation is to those who want to learn.
- *Avoid humiliating anyone.* Humor is an essential point of any activity with young people. Fly-casting class is a rich source for lots of good laughs, but some youngsters are very sensitive, so use good judgment.

PRACTICE

If possible, each youngster should have a balanced rod and reel that can be used for practice at home. It may be troublesome to lend out rods and reels, but sometimes it's necessary to do this until the young angler can get his or her own outfit. If young casters are to progress quickly, it is essential that they practice their skills between classes. Give them some memorable phrases (hitchhike and flick the apple, throw the line up over the trees) to take home, and suggest that they practice at least fifteen minutes a day.

Several years ago, the legendary innovative fly fisher and conservationist Lee Wulff designed a simple device for practicing fly casting indoors. His invention, called the Fly O, consists of a short rod and handle with several feet of heavy yarn attached. This diminutive outfit can mimic the casting stroke of the real thing perfectly. At about $40, it's a great investment and a sure way to improve anyone's casting abilities. Contact Royal Wulff Products, HCR 1 Box 70, Lew Beach, New York 12758, telephone (800) 328-3638, for a dealer in your area.

If you have an old fly rod that can be sacrificed, you can make a similar device by sawing off the butt at the handle, fitting in the base of the tip, securing it with epoxy, and attaching 10 feet or so of heavy yarn to the tip-top.

6

Skills, Rules, and Techniques

The lifelong adventure of fly fishing begins with the first cast and then moves along as you change, grow, and become more individualized. Your overall personality as an angler is determined by the skills you choose to develop, the personal rules you follow, and the techniques you employ. The first few years of this adventure will lay the all-important groundwork for the rest of your angling life. Within the two major skill areas of fly tying and fly casting, there are a host of minor skills, rules, and techniques that the fly fisher needs to learn over time.

Once the young fly fisher has learned the basic skills, it's time to teach him or her some of the other skills, rules, and techniques vital to the proper overall development of a young fly fisher.

KNOTS

Knots are the weakest link in the entire fly-fishing system. No matter how good a caster you have become, how well you know the area you're fishing, how many books you've read, how nicely your flies are tied, or how many fish you're capable of hooking, you will not be a completely successful and truly skilled angler if your knots are weak and poorly tied.

A game fish will respond to being hooked by jumping and trying to shake the fly loose, wrapping your line on an obstruction and attempting to pull the hook free, or fighting hard to earn its freedom. In this sort of encounter, you and the fish both win. You are exhilarated by this brief moment of excitement, and your opponent swims off none the worse for wear and wiser for the experience. If your knot pulls loose, however, you lose both the fish and your fly, and you end up looking at the water with an empty feeling in your stomach.

Proper knot tying is the most essential skill in all of fishing. Volumes could be written about the virtues of a well-tied knot. We'll cover the basics in the next few pages.

The small brown trout shot through the surface like a missile from a submarine, arched across the sky in a welter of jewel-bright spray, and came to rest among the branches of a hawthorn tree with a very solemn, surprised, yet forlorn expression on its dappled face. Little hands scrambled to liberate the prize. My first trout! I had struck a mite too hard.

Looking back on the near countless seasons that have slid inexorably, and sadly, irreversibly, under Old Father Time's bridge, I could still take you to that river, that place, and guide you through that first fly-fishing encounter. I could show you the lie, knot on the fly—a partridge and yellow—and have you using the same outfit, my father's lissome Hardy Gold Medal 8-foot, 6-inch split cane rod, Perfect reel, and Kingfisher silk line.

—Charles Jardine, author and fly-fishing historian

For the initial field trips with very young children or physically impaired anglers, it may be necessary for the instructor and assistants to tie the knots, keeping everyone rigged and productively fishing. But it's important to get young fly fishers tying their own knots—and tying them properly—as soon as possible. This means teaching the proper method of tying a knot and acquainting youngsters with the properties of a good knot.

Teaching Knot Tying

It's good to begin the initial knot-tying classes with a list of dos and don'ts. The list may look something like this:

Do
- Use the recommended number of wraps and turns.
- Lubricate thoroughly.
- Snug up tightly.
- Snip the tag end closely.
- Use a line clipper.
- Retie if there is any doubt about whether the knot is tied properly.

Don't
- Use cements or adhesives to try to make the knot stronger.
- Use more or fewer wraps than suggested.
- Snug up knots without lubrication.
- Leave knots loose.

The summer I was eleven years old, it happened that a private smallmouth bass fly-fishing club that had been active on the St. Croix River since the 1920s was short a guide one weekend. The camp owner approached my dad to ask if he'd help out. He declined but suggested that they give "the kid" a try. The camp owner was reluctant but in a jam, so I got my tryout.

As luck would have it, my client and I creamed the smallmouth, and in fact, we outfished all the older guides and their clients. While fishing with my grandpa and using night crawlers, I'd learned where the schools of bass lived, and while fishing with my dad and using big topwater muskie lures, I'd learned where there were some really big ones.

My tryout wound up as an everyday job that paid $14 a day that first year. I'd guide all day and be off the water and at the landing at 4:30, where I'd meet my dad and we'd fish muskies till dark. For over ten summers I spent an average of fifteen hundred hours on the water. It was during this period that I invented the Dahlberg Diver and Flashabou. I ended up guiding for a total of twenty-three years.

I got to fish with some great anglers. Probably the best two were Philip Pillsbury, of the Pillsbury baking company, and Chuck Walton, head chemist for the 3M Company. Pillsbury could, from a seated position and without apparent effort, cast a big bass bug under a tree and have it land an inch from the roots beneath an undercut bank—this using an old silk line and a bamboo rod (he used all Pinkie Gillum 9 for 9s). Knowing what I know now, I have no doubt that at that time he was one of the top three casters in the world. He was also one of the nicest people. In fact, it was he who put me on the path to figuring out how to catch northerns and muskies on flies. Unlike the other fly fishermen, who only wanted smallmouth and would curse the pike, Pillsbury would pay good tips for pike—something like $10 for a 10-pounder, then $1 a pound after that. Great incentive for a little boy who was always needing money for more feathers, hooks, and stuff from the Herter's catalog.

—Larry Dahlberg, professional sport fisherman

Your true-born angler does not go blindly to work until he has satisfied his conscience. There is pride, in knots, of which the laity knows nothing, and if, through neglect to tie them rightly, failure and loss should result, pride must not be restored nor conscience salved by the plea of eagerness.

—Roland Pertwee, "The River God"

- Leave untrimmed ends.
- Burn tag ends to finish.
- Improperly tie knots.
- Use teeth to cut the line.

The main points to get across are that fishing knots are designed as they are because they work; the student should not try to modify them. And knots that are not securely tightened up will slip when pulled on by a fish or a snag and will break or come loose.

Preparation. Choose two knots for the initial instruction. One should be a knot used to tie the tippet to the fly. We usually use an *improved clinch knot*. The other should be a knot used for a line-to-line splice, such as a *blood knot* or a *double surgeon's knot*.

For the lesson, use a few sections of rope or some lengths of old fly line. These larger lines will enable the youngsters to get a better picture of how the knot is constructed. Use ropes or fly lines of two different colors to demonstrate the line-to-line splice. Plastic-coated clothes lines work well.

For beginning classes, use larger hooks (size 1 or larger), and clip off or file down the hook points to make them safe. If you can acquire a *very* large hook (I use a 19/0 Mustad shark hook), it can be a great visual aid and really gets everyone's attention. A large screw eye fastened to a piece of wood can also serve as a jumbo-size hook eye.

Use 10- or 15-pound test monofilament. Lighter line may be difficult to work with, and line that is much heavier is too stiff to tighten securely. Provide nail clippers to trim the final knots.

Each fly-fishing knot has been designed to fulfill at least one specific purpose. The young angler should build a practical knowledge of the basic knots used in each of the following situations, then build on this, adding more knots that will fill specific needs as his or her skills advance:

1. To secure backing to reel, use an arbor knot.
2. To fasten backing to fly line, tie an Albright knot or nail knot.
3. To attach fly line to leader, use a nail knot or loop.
4. To make a loop in leader, tie a surgeon's loop.
5. For leader knots, use a blood knot or surgeon's knot.
6. To secure tippet to fly, tie a clinch knot.

Knot instruction books are readily available free of charge from most line manufacturers. Two very useful works on the subject are *Practical Fishing Knots* by Lefty Kreh and Mark Sosin (Lyons and Burford 1972), and *Baits, Rigs and Tackle* by Vic Dunawa, (Wickstrom Publishers, Inc. 1984).

The Demonstration. It is wise to brush up on the exact method of tying each knot before the lesson. Tie several practice knots, no matter how confident you are that you know it.

Start the demonstration by identifying the two line parts. The very end of the line is the *tag end*. The long portion of line that goes back to the reel is the *standing end*. Demonstrate a simple *overhand knot* to help familiarize everyone with these terms. Take the tag end and bring it around, under, and back around through the loop formed by the standing end. Pull the two ends to tighten the knot.

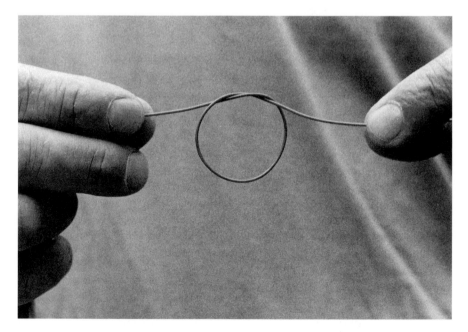

Overhand knot, using a piece of fly line for the demonstration.

Explain that for the most part, however, overhand knots aren't used in fishing because they weaken the line. When a knot like this appears in your leader, it's called a *wind knot*. It will make your leader half as strong. For example, 8-pound test tippet will fail when 4 pounds or less pull is applied. The mono will cut into itself and break.

Now it's time to demonstrate the first of the two knots you will be teaching. The *improved clinch knot* is a popular, easy-to-tie knot used for securing the tippet to the fly. We'll use this knot for our first sample lesson.

Initially demonstrate for the students using rope. Do not have them tie along. Be sure each youngster is paying attention. Pass around the finished knot, ask for questions, and then have them tie one along with you. Have them tie two or three with rope or fly line, and as they become more proficient, let them use mono. Explain the properties of a well-tied knot while demonstrating the proper method of tying it. The following is a list of the important points to cover, as well as step-by-step instructions for tying the knot:

1. *Use of the knot.* The improved clinch knot is used to tie the monofilament tippet to the hook eye. When using very light tippet, you may choose to double the mono before tying for added strength.

2. *Relative percent knot strength.* The improved clinch knot maintains about 100 percent knot strength. This means that if properly tied, the knot is almost as strong as the mono itself.

3. *Exact number of turns.* Each knot has been designed to work best with a specific number of turns. Too few will result in a weak knot; too many will prevent the knot from being properly tightened up, or seated. Use *five turns* for maximum strength in an improved clinch knot.

 Demo: Insert the line through the eye of the hook. Put the thumb and index finger of your left hand (left-handers should reverse the instructions) over the eye of the hook, pressing the mono between them and making about a ¼-inch space at the hook eye. Keep tension on both the tag and standing ends. An alternate method is to place the middle or index finger on the hook eye and make a loop around it. This will also keep the loop open. With your right hand, wind the tag end around the standing end five times, using the middle and ring fingers of the left hand to help out. Maintain constant tension on the standing end so that the wraps are snug and even.

 When this has been accomplished, while keeping tension on all ends, run the end back through the ¼-inch space you created earlier. This will form a circular loop. Run the tag end back through the loop (this is the "improved" part of the knot).

Clinch knot demonstration. The line is run through the eye forming a loop.

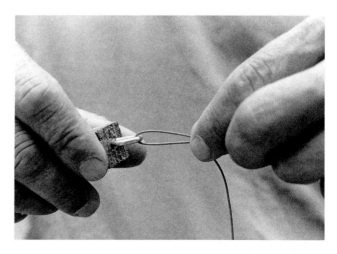

Five turns around the standing end.

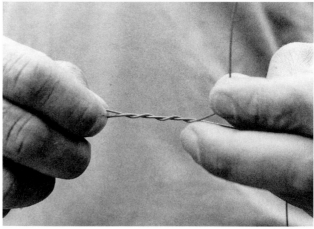

Tag is run back through the first loop.

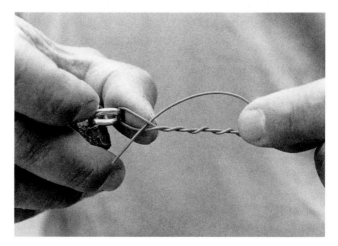

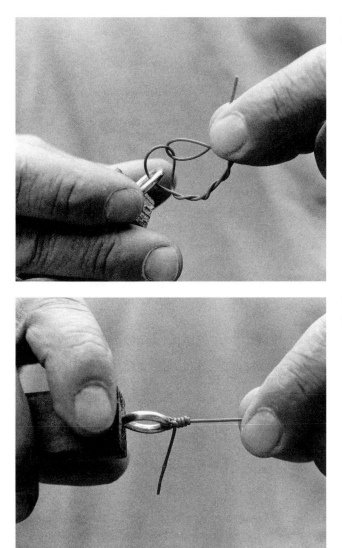

Then back again through the second.

The final clinch knot.

4. *Lubricate completely before tightening up.* In order for a knot to retain maximum strength, it must be drawn in tightly and seated so that it will not slip when pressure is applied by a large fish, snag, or rock. In order for mono to be correctly and firmly tightened, it must be lubricated. Under most conditions, the handiest form of lubrication is your saliva. When demonstrating this to young kids, use "slobber" or some such graphic term to make the point. Kids love that and they'll remember!

Demo: Grab the tag end in your teeth and snug the whole thing up uniformly, lubricating with saliva as you go. (Don't do this when demonstrating with rope.) Explain that the mono has to be tight and properly seated for the knot to maintain its full strength. Otherwise it will pull out or break when tension is applied. Stress that they should *never* fish with an improperly tied knot, but should take the time to retie it.

5. *Finish up.* Explain that a good knot will not slip after it has been tied, and it can be trimmed closely. If a short piece of the tag is left, it will foul the rest of the leader on the cast or will snag on weeds, ruining the presentation and retrieve. The tag end should be cut cleanly and as close to the knot as possible without nicking the remaining mono. A nail clipper or line clipper is best, but scissors can be substituted if necessary. Never bite off the tag end with the teeth or use a match to burn if off, as the heat will severely weaken the line. Also, tell your students to be sure to put discarded clipped mono in the trash.

6. *Practice.* Encourage your students to practice knot tying at home. All fishing skills improve through constant practice.

For our second sample lesson, we'll tie a blood knot. The blood knot is used to connect two sections of line. Fly fishers use it most often when tying mono leaders. Demonstrate this knot using two different colored pieces of fly line or rope. This will be a more difficult knot for young anglers to learn.

Explain the properties of this knot while tying it, including the following:

1. *Use of knot.* The blood knot is used to tie similar diameters of line together. Do not use the blood knot if the diameter of one line is double, or more, than the other (for example: 20 pound test to 10 pound). Substitute the surgeon's knot.

2. *Relative knot strength.* It has a relative knot strength of 90–95 percent.

3. *Number of turns.* Use five turns on each side.

 Demo. Using two different colored fly lines, hold one in each hand with a tag end of about ten inches. Cross them, forming a flat X.

 Squeeze them tightly at the X with the thumb and index finger of the right hand. Put tension on the standing end using the last three fingers of the left hand.

 Using the thumb and index finger of the left hand, wind the tag around the standing end, handing it to the thumb and index finger of the right hand. Repeat for five turns, keeping constant tension on the standing end.

 Put the tag end up through the space just before the first turn, at the X. Grasp this space and the tag end firmly with the left hand.

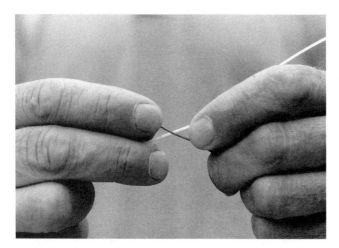

*Blood knot demon-
stration. Use two
different colors and
form an X.*

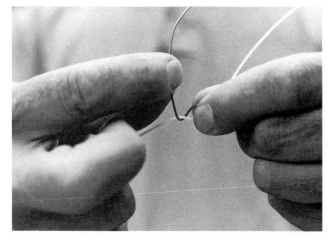

*Hold one tight and
wrap the other
around it, keeping
space at X open to
insert the tag.*

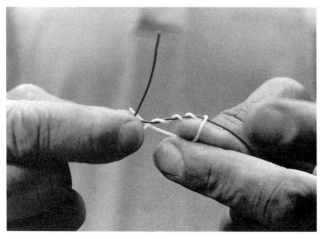

*Repeat on the other
side.*

Note tags go in opposite directions.

Repeat the process with the right hand, placing the tag end through the space in the opposite direction.

4. *Lubricate before tightening.* Snug up, but don't tighten, all four ends. Tighten and finish the knot with a quick, forceful pull on all four ends, seating the knot firmly.

5. *Finish up.* Trim the tag ends to about ⅛ inch.

In the Field

While fishing, check all knots after several casts—more often if frequent snagging occurs. Check after each fish is released and even after you've missed a strike. Inspect knots and leader closely, running it through your fingers, feeling it for abrasions. Replace any damaged section and retie any questionable knots. Retie any area where a wind knot is found. Retie the tippet section after a long, difficult battle with a large fish.

Keep reminding your students that it takes only a moment to check and change knots and that the next fish could be the fish of a lifetime. I could tell many tales of woe about encounters involving such big fish which ended with a moan and a groan and a "pig tail" at the end of the leader where the fly used to be as a result of poorly tied knots.

SHARPENING HOOKS

There is no question that sharp hooks catch more fish. It is up to you to decide when your young charge will be ready to handle the responsibility of

sharpening and using these potentially very dangerous items. From the first day you start working with your apprentice, instill in him or her a healthy respect for hook points.

I learned the virtues of good, sharp hooks fifteen years ago from my now deceased mentor, Eric Seidler. He seldom missed a strike from any of the huge landlocked salmon or brown trout that frequented our Finger Lakes tributaries in the spring and fall. "Keep the hooks sharp and they'll set it on the strike," he would preach.

Instructions on preparing a hook at the fly-tying table and checking its sharpness are in Chapter 2. Follow these instructions at home before a trip. In the field, you must use the tools you have on hand. Always carry along a small sharpening stone, file (small nail files found in cosmetic stores work well), or some other type of hook hone.

Teach young anglers to check and touch up the points on their flies often. Remind them constantly out in the field. Have them check their points each time they check their knots. Make a game of it. You'll start to notice that every time you walk toward them, before you say a word, they'll pull up their line and check out their knots and hook points. Soon it will become second nature to them, and they'll be on their way to master angler status.

READING THE WATER

In order to have the opportunity to offer a fly to a fish, the fly fisher must first know where the fish will be located in the body of water and how to offer the fly in a manner that the fish will accept it. Understanding the *where* part is called *reading the water.*

This is a basic skill that all fly fishers must acquire. Like most skills, it will improve with time if diligently practiced. The angler must learn to read the water early on and hone this skill through experience in the field. Once the basic angling skills have been covered, a complete youth fly-fishing program should spend a good deal of time focusing on the water and helping the youngsters discover the places that hold their quarry.

Where Do Fish Live?

One of the great rewards in all angling comes after you arrive on a new piece of water that you've never seen before and, following a brief inspection of the area, immediately begin catching fish. This is usually not just a chance occurrence, but happens because study, experience, and common sense have all combined to help the angler put the pieces of the puzzle together successfully.

It is important for the young fly fisher to realize that fish have the same basic needs in life as we do. Starting from this assumption, have the students come up with a list of all the things that make *their* life and well-being pos-

I started fishing at six years old off a dock in Florida for sheepshead and with a worm and a stick for trout in New Jersey. At seven, while fishing with a real fly rod and a worm on my uncle's farm in Walkill, New York, I caught yet another chub, but this one had spots. I told my mother, who was keeping watch over me, that Dad and Uncle Pete would surely be impressed by this strange chub. I think it was when they trampled me on the way to catch some trout (speckled chub) that it dawned on me that this was important.
— Pete Van Gytenbeek, editor and publisher
Fly Fishing in Saltwaters magazine

sible. After some prodding, a pretty complete list of the necessities of life will emerge. Once they've made up their list, go over the following factors, along with a brief explanation of each.

Oxygen. Animals cannot exist long without a supply of oxygen. Most organisms naturally gravitate to and occupy an area where they can be assured of an abundant supply. Wave action, riffles, wind, and green plants all help dissolve oxygen into the water. Stagnant, very warm, weed-choked water tends to have less oxygen and, as a result, fewer life forms than cool, clean, moving water. As long as all other factors necessary to life are present, fish will thrive in oxygen-rich waters.

Initially, anglers can use a dissolved oxygen test kit to determine if the area being fished contains a good supply. After a period of time in the field, the fly fisher will develop the ability to know this through observation. An abundance of riffles in a stream, bright green healthy plants in a pond, or a rich variety of readily seen life forms all indicate a healthy body of water.

Food. A healthy population of fish will exist only where there is a good food supply. Most fish are opportunistic feeders and have many food sources. Some species have definite dietary preferences and are built to capture and eat a particular type of forage in a specific manner that is easiest for them. The main food items of interest to the fly fisher are baitfish of all sizes and shapes; crustaceans, such as crayfish and shrimp; aquatic creatures such as leeches and frogs; terrestrial creatures that live on land but fall in somehow, such as worms, caterpillars, and mice; bugs, both aquatic (mayflies, stoneflies) and terrestrial (grasshoppers, crickets; and other usually seasonal items, such as fish eggs and mulberries.

Shelter. Fish are eaten by a variety of predators, including larger fish, birds, reptiles, and mammals. Fish that live in the open ocean rely on speed, maneuverability, and sheer numbers to avoid being captured and eaten. In the more confined quarters of lakes, streams, rivers, or inshore habitat, fish will usually be found confidently but cautiously feeding somewhere near an area that will provide them sanctuary if threatened.

On streams and lakes, this protection will come in the form of undercut banks, deadfalls (trees that have fallen into the water), weed beds, sharp drop-offs, or rock ledges. Such areas, however, also serve as ambush points for predatory fish. In the inshore waters of the seas, the same rules apply. Access to deeper water also plays a major part in the choice of a feeding area for many predators. With the change of tides, the formerly low waters may harbor an abundance of food that is now accessible; however, shallow water will make the hunter feel vulnerable, so it usually hunts near an escape route to deeper, safer waters.

Comfort. Fish will choose an area in which to feed that is within a preferred temperature range. Freshwater fish are usually classified into either coldwater or warmwater categories. This determination is made based on their water temperature preferences. Saltwater species also have preferred temperature ranges.

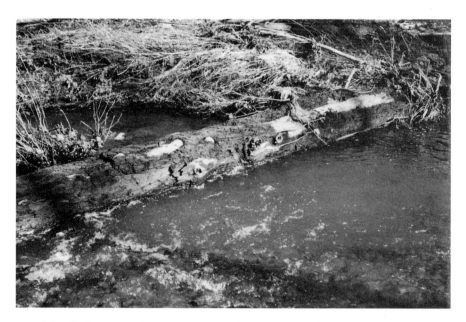

A deadfall across a deep current provides a perfect, safe feeding area for fish.

Freshwater Fish	
Coldwater Species	**Temperature Range**
Lake trout	40°–55°
Brook trout	45°–61°
Rainbow trout	50°–70°
Brown trout	56°–65°
Atlantic salmon	50°–62°
Landlocked Atlantic salmon	45°–58°
Chinook salmon	50°–63°
Other Pacific salmon	45°–58°
Warmwater Species	**Temperature Range**
Northern pike and walleye	55°–58°
Sunfish	60°–80°
Muskellunge	63°–78°
Smallmouth bass	65°–73°
Largemouth bass and pickerel	68°–81°

Saltwater Fish	
Species	**Temperature Range**
Atlantic mackerel	45°–68°
Winter flounder	53°–60°
Weakfish	55°–70°
Striped bass	56°–77°
Pacific bonito	58°–76°
Bluefish	64°–75°
Summer flounder	65°–72°
Spotted sea trout (weakfish)	65°–75°
Atlantic bonito and false albacore	65°–76°
Spanish mackerel	67°–85°
Most offshore species	70°–85°
Tarpon and snook	74°–88°
Bonefish	75°–88°

Shallow water can change temperature quickly. Sun, wind, cooler evenings, and tide changes all can have a dramatic effect on water temperature in a short time. Deeper water will tend to be cooler and maintain a steady temperature longer. Temperature will also be affected by the existence of springs, inlets, power plant discharges, dam releases, and currents. A single body of water is likely to have a variety of temperature readings. Look for each species to be most active in its preferred comfort range.

Economy of Effort. Feeding fish will position themselves where they can obtain the most food with the least effort. Movement burns up calories, and in the fish's world, the food supply may be meager and the competition tough.

In a moving column of water, whether it be a freshwater stream or saltwater tidal rip, the fastest-flowing water is in the surface layer, with the current slowing as depth increases. Water forced through a narrower area will pick up speed; that same water when pushed into a wider area will slow down.

Rocks, logs, sandbars, pilings, and other types of structure will offer natural breaks from the current, with slower-moving water directly in front of and for a distance behind them. Holes and other depressions along the bottom also create breaks in the current.

Current seams offer ideal places for fish to rest and have access to a variety of food. A seam occurs where two different current speeds meet and run alongside each other for a while before merging into one. Fish will lie in the slower water, taking advantage of the fact that food dislodged or pushed along by the faster water will be swept by them.

It would take more effort, and hence burn more precious calories, to fight the current and chase after a meal. Unless competition is fierce, a fish—especially a large fish—will seek out the easiest, most economical way to eat. In moving water, a feeding fish will usually lie facing upstream where there is shelter from the moving water and the current will bring dinner within easy reach.

Putting It All Together

Assuming that certain special conditions, such as spawning activities, are not in effect, the process of finding fish is basically a matter of becoming familiar with the factors that influence feeding behaviors.

To successfully read the water, a fly fisher must look at all of these factors together with knowledge of the species being sought and information specific to the locale. Polaroid glasses will help eliminate glare on the water, allowing for direct exploration of the shallower areas. A quick check with a thermometer will reveal water temperature.

FLY CHOICE

Once the angler has determined what kind of fish to expect and where they'll be dining, he or she needs to decide what to feed them. Fly selection can be a very complicated decision that may be, at times, critical to success. Early in the fly-fishing education process, however, fly choice should be kept simple. Young fly fishers should be encouraged to ask local anglers about the fly preferences of their resident fish population.

Have the young anglers tie a selection of flies beforehand and take them along, displaying them for the local "experts" and asking them to pick a likely candidate. You also can purchase a few of the "hot" patterns from the local fly shop to give the tiers an example to copy.

My yellow Woolly Bugger touches down upstream from me on the waters of Fall Creek. It is an October afternoon and I've just gotten out of school, so I'm itchin' to fish! As the fly swings below me, a large fish rises from the bottom of the river to strike my fly but misses. I make the second cast, my heart pounding with excitement. The same fish rises off the bottom, and this time the hook sticks. As my rod flexes, I get that wonderful feeling of dead weight that one gets before the fish is aware it is hooked. Then the fish realizes it is hooked, and 2 feet of head-shaking silver comes shooting out of the water.

The fish is a landlocked Atlantic salmon. The incredible experience that I have each time I catch one of these magnificent creatures is etched in my memory forever.

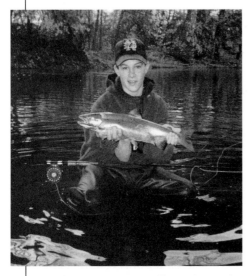

Mike Terepka put it all together and the result is this beautiful landlocked salmon.

—Mike Terepka,
age fourteen,
Ithaca, New York

As a general rule, I have beginners use wet flies and pursue smaller, easy-to-catch fish. Under most circumstances, this means using Woolly Worms or Buggers in just a few sizes (10 to 6) and colors (black, olive, and gray), while pursuing panfish (usually bluegills) or hatchery trout.

Choosing the right fly for a particular situation must include developing a thorough knowledge of *what* the fish are likely to eat and *where* in the water column they are likely to eat it. Young anglers should be constantly encouraged to learn about the world of the fish they seek and put together the pieces of this glorious puzzle. The final, inspired decision is a product of study, field experience, and instinct.

THE PRESENTATION

The entire process of attaining the proper position and offering the fly to the fish is included in the presentation. The nature of the sport of fly fishing and the limitations of the tackle force the angler to think well ahead before presenting the chosen offering to the fish. Many factors must be combined in making a final decision. Success will come only if the angler has detailed knowledge of the fish's habits, can put together the pieces of the puzzle, and has the skills needed to deliver the fly properly. The sport can never be completely mastered. Every situation has a unique set of variables that the angler must ponder and act on. Herein lies the endless challenge of fly fishing.

Once an educated guess has been made as to where a fish may be feeding, and a fly has been chosen in hopes of enticing it to strike, the next step is to figure out how to offer the fly without making the fish suspicious of this potential meal. To accomplish this, the successful fly fisher must combine a careful approach with a properly executed cast and drift to bring the fly into the feeding zone of the target.

The Approach

The fly fisher needs to determine where to stand to keep out of the fish's view and be in position to get the fly to the fish in the easiest possible way, and how to approach this ideal standing spot without alerting the fish to his or her presence. Before entering the water and making the cast, beginning fly fishers should mentally outline the entire process from beginning to end and follow five basic rules in determining the final standing position:

1. *Safety first.* Don't choose an area that will in any way be dangerous. If you must wade in the water, be sure you choose the path that will be the easiest in and, even more important, easiest out.
2. *Plan the fish landing ahead.* Consider where you will play and land a large fish. Find the easiest and safest spot for both of you.

3. *Use the shortest cast possible.* Control is more important than distance and is critical to the proper manipulation of the fly. Be aware that the fish will be facing upstream; this is a major factor in choosing an acceptable distance to cast from.

4. *Cast across-stream and drift down.* This will help the angler learn line control, allow for much easier retrieval of hooks fouled on the bottom, and in many cases, account for more fish than the more difficult upstream drift method.

5. *The first cast is the most important.* This is the fly-fishing version of the axiom "You don't get a second chance to make a good first impression." A poorly executed first attempt could possibly alert the quarry and put it in a cautious mood and off its feed.

Young anglers must be made aware that the creatures in and around the water in which they'll be fishing are constantly on the lookout for danger. Fish live underwater but are still very tuned in to the outside world, from which many threats to their existence come. Heavy walking, careless wading, or crunching gravel will send vibrations into the ground and through the water that will be "heard" by a fish via its *lateral line,* a sensory organ along the fish's side that acts as its ears. Fish also can see the angler's shadow or that of a bird frightened by the advancing fly fisher and will scurry for cover.

The fly fisher must use stealth at all times while approaching and entering a body of water. Clothing should be drab, not brightly colored. Movements should be slow, deliberate, and quiet. If an area can be fished without entering the water, so much the better. When wading is necessary, it should be done slowly and quietly, concentrating first on safety and second on causing as little disturbance as possible to the stream bottom or surface. Before making the first cast, pause for a moment and "rest" the spot. If the fish have been put on alert, this will give them time to regain some confidence and resume feeding.

The Wet-Fly Swing

It's important to present the fly in a manner that will be appealing to the fish. One time-tested method of doing this while fishing moving water, whether in a clear mountain stream or a fast moving saltwater tidal rip, is the wet-fly swing.

The "hot spot" of this presentation is toward the end of the drift. The fly has sunk below the surface and dead-drifted for a distance. Then, after the line begins to tighten, the fly starts to rise up through the water column on its swing. When the line is straightening as the fly rises, the fly picks up speed.

When I was a youth and growing up near a small river in the Berkshire Mountains of Massachusetts, my father wrote an outdoor column for the *New York Times* called "Wood, Field and Stream." His friend, book writer Richard Wolters, accompanied my dad and me on my first fly-fishing foray in May 1957.

It was a bright day, with the willows in pale green leaf along the river and the hope of spring and summer in the air. When we approached the river, Dick gave me a quick lesson in fly casting, handed me a bamboo rod with a bright Mickey Finn streamer attached, and said, "Just cast the fly out there in the current and let it swing down below you. If a fish is going to strike, it will hit at the end of the swing down below you. If you don't get a hit, take two steps downstream and try again. Good luck."

Then he headed downstream to find his own fishing.

I was alone, not entirely sure what this fly fishing could deliver, but certain that it was a new, if unproven, way to attract trout.

I made the first cast into a fast rip and let the fly swing deep into the current. At the end of the swing, a strike jolted me, and I struck instinctively. A fat rainbow leaped into the sunlight below, and I was hooked for life.

I took four nice 'bows from that run in the next half hour and laid them neatly on new fiddlehead ferns beside the clean spring river. When the men returned with empty creels, they looked at the trout. I was going to explain how I caught those fish, but my old man mumbled something about kids being seen and not heard.

Today I would not kill a trout, but then it was okay for kids to bring home trophies from the stream.

—John Randolph, editor of *Fly Fisherman* magazine

Wet-Fly Swing

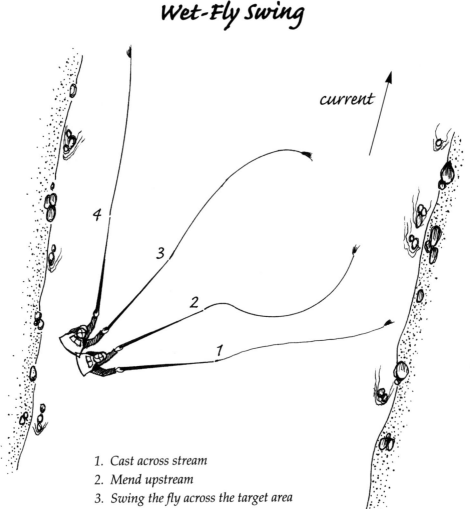

1. Cast across stream
2. Mend upstream
3. Swing the fly across the target area
4. Hold in the current and retrieve

The change in movement from dead drift to a speed-up and rise can trigger an aggressive response in the fish. Whether the fish thinks the prey it has been observing drifting along is suddenly trying to escape or whether it's just the change in depth that is appealing is anyone's guess. The fact remains that this method works.

It's a good idea to have the youngster practice this skill often in an area that's familiar. A nice, easy run with clear water and lots of *pockets* (slower water) behind boulders is good. Use a very visible wet fly so that its movements can be watched closely even after it sinks below the surface.

The young angler should start by picking a pocket for a target in an easily wadable portion of the stream, then wade in carefully, considering all the aspects of a good approach. Upon reaching the desired position, the youngster should feed out the proper amount of line with as little movement and disturbance as possible. The aim here is to avoid disturbing the target fish or any other creature in the stream or surrounding area.

The fly is cast directly across or a little downstream, with as few false casts as possible. The line is then *mended* to help eliminate drag on the fly during the drift.

Mending the Line

Water moves faster on the surface and slower as it gets deeper. When the current pulls on the line and creates unwelcome drag on the submerged fly, causing it to move in an unwanted or unnatural fashion, the line needs to be mended.

To mend a line, hold the rod out, pointed at the floating line, and simply give the belly (or curve) in the line a flip. Mending is usually done upstream, but in some cases, where slower water is between the rod tip and the fly, a downstream mend must be made. In an ideal mend, the belly of the line is flipped into proper drifting position, while the front section or tip, leader, and fly remain drifting along naturally. Tell the young angler to imagine he or she is jumping rope and the rod's grip is the rope's handle. A simple flip will roll the fly line nicely.

Practice

In any presentation, it is essential that the fly fisher keep a mental picture of the fly's progress and position as it moves along under the surface. In a sense, the angler mentally learns to "see" what the fly is doing under the surface. This can be accomplished only through practice. Time spent on a local stream practicing presentation skills will pay huge dividends when new waters are fished.

After choosing a stretch of water, begin at the top or head of the pool or riffle. Start with short casts targeting specific areas and increase the length gradually. Cover only the water that you can present to accurately. A long sloppy cast may spook a fish, disturbing others in the area.

The fly starts sinking immediately, the line is mended, and the progress on the drift is followed by the rod tip, as the angler's body pivots slowly, keeping complete control. The line will tighten up and straighten below the position where the rod tip stops.

In an ideal swing, the fly starts its speed-up and ascent just before hitting the "hot spot," and then swings along the front of the target right into the

And then with the suddenness of a rocket, it happened. The water was cut into a swath. I remember a silver loop bearing downward—a bright, shining, vanishing thing like the bobbin of my mother's sewing machine—and a tug. I shall never forget the viciousness of that tug. I had my fingers tight upon the line, so I got the full force of it. To counteract a tendency to go head first into the spinning water below, I threw myself backward and sat down on the hard rock with a jar that shut my teeth on my tongue like the jaws of a trap.

—Roland Pertwee, "The River God"

fish's field of vision. After the line straightens out, the fly should be retrieved with little twitches and pulls to entice fish along the way.

When you have covered the area thoroughly, move downstream a few steps and repeat this series of casts.

Practicing of this method will help develop control and increase the overall skills needed for a successful presentation. The take of a fish can be the only sure indication that the wet-fly swing has been mastered.

7

The Saltwater Fly-Rodding Experience

There is something special about casting a fly into the ocean—something that automatically raises this simple act above other forms of fishing. It's an intimate interaction with the marine environment that cannot be experienced any other way.

The take of a great saltwater game fish, regardless of its size, is an explosive moment that connects you directly with the power and life force of these remarkable animals. Each inhabitant of the marine world survives because it is stronger, faster, or tougher than the next. With few exceptions, such creatures can easily wind up as a meal for their neighbors if they are not alert or cannot maneuver out of range in an instant.

Heavy boat rods with winchlike reels and spaghetti-size monofilament or the tremendous mechanical advantage of a 10-foot surf rod with an oversize spinning reel can usually make short work of even a trophy-size fish. Challenge that same animal with a fly rod, and its full power and potential are realized. The battle is now on more even terms.

These are not placid hatchery fish that have been raised in a concrete tank where the only competition for food was from fellow fish of the same size. The pull of a good brown trout or the acrobatic leaps of a 2-pound smallmouth are exciting and draw us back again and again. Pike, panfish, and largemouth bass also make worthy adversaries. But all of these pale in comparison to the power and strength of a striped bass that fights the riptides day after day or a false albacore that must hit speeds of 40 miles an hour to escape a hungry blue marlin fifty times its size.

The ocean is a rough neighborhood to live in, and the game fish there are all well equipped to handle the strong currents, competition for food, and ever-present threats from a multitude of larger creatures. They must be lean, mean, and full of energy or they will not survive.

Each time we hook into one of these gamesters with a fly rod, we hook directly into the life force. The smells, sounds, and sheer magic of the sea

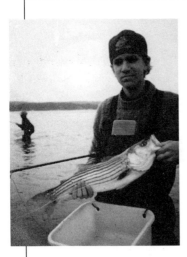

Stef Jirka with a striper.

The van ride—as with most others made from our central New York departure site—was long and uncomfortable. The exhaust pipe had a hole in it, and the fumes seeped in, making us all feel nauseated. But we made it across the state border and to our destination sometime around midnight.

The year was 1992 and I was fifteen. I was in the company of the same ol' guys: Eamonn, Diallo, Ryland, Paul, and Phil. These were the guys with whom I had learned about fly fishing, ecology, teaching conservation, and so much more, and with whom I had shared many intimate times on the murmuring trout streams, on the still ocean shore, and behind the ever-familiar Fly Fisher Apprentice Program booth at countless fly-fishing shows.

This trip sent us to a place we had never been before: Quanny Pond on the Rhode Island coast. As it was very late when we arrived, we decided to drive to the shore and snooze in the van for a few hours until sunrise. It was a cramped sleeping area, to say the least. I slept on a seat and so did Diallo. Ryland and Eamonn got stuck with the worst spots, as usual, as they were the youngest and smallest.

An uneasy sleep washed over me, but I was awakened what seemed like moments later to the curious sound of water splashing and Phil's excited yet hushed voice urging us to grab our gear and start fishing.

I stumbled out of the van, and in the dim moonlight, I could see fish slapping the surface of the water not 50 feet away. Slipping into my waders, I snatched my rod and clumsily made my way to the beach. Phil had a fish on line and was urging us to wet our lines. I threw in my fly and began the hand-over-hand retrieve I had learned on previous saltwater trips. Fish were erupting everywhere. Another cast, and I began retrieving. Then it hit.

WHAM!

The characteristic clobber of the rod that I had grown to love and the unmatched rush of adrenaline that accompanies the fight—this is what I had longed for. And now I had it!

—Stefan Jirka, age nineteen,
Ithaca, New York

combine to make each moment memorable. The vastness and power of the ocean, the high winds, and the strength of the fish make saltwater fly fishing the ultimate test of a fly fisher's skills and mettle. Success will make it the ultimate in fly fishing excitement.

GETTING STARTED

First off, the sea is no place to fool around. Youngsters must obey strict rules and cannot just do as they please. Currents and undertows will sweep a youngster away in seconds. A lightweight child in a pair of waders can be pushed around by the breaking waves of a windswept sea. Choose a day when the elements are kind, and find an area that affords the easiest access and least difficulty in fishing. Never let youngsters wade more than knee-deep in heavy surf, or wade out to climb onto a rock as the tide is coming in. One slip, one mistake, and they will be gone.

Any youngster who can comfortably cast 50 feet of line, has some angling experience on the water, is able to tie good knots, and is trustworthy can have a quality saltwater fly-fishing experience. The best way to plan for the initial saltwater adventure is to first become familiar with the tackle, techniques, and situations that may be encountered in the area you will be fishing. In general, the challenge of saltwater fly fishing begins where fresh water leaves off.

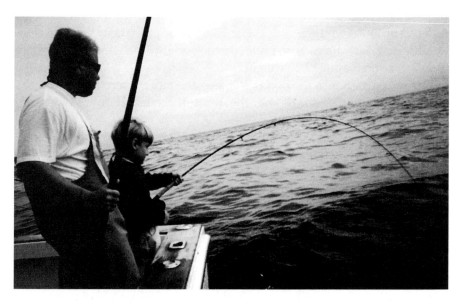

Patrick Sodums shows us that you don't have to be a big guy to handle a powerful saltwater fish on heavy fly tackle, while mate Anthony Grassi waits with the gaff.

Before rushing to outfit a youngster (or yourself) with all the gear needed for an excursion to the salt, you need to determine what conditions you will be fishing under most of the time (heavy surf, no surf, shallow flats, deep rips) and what kind of fish you are most likely to encounter (species, size, habitat, and characteristics).

Familiarize yourself with local conditions by reading as many publications and articles on the area as possible. Learn about the species of predators and prey, birds, shellfish, and crustaceans. You will then be able to make an educated decision about what size and type of flies to cast, what size and weight outfit to use, and what other equipment you should purchase, build, or otherwise obtain.

Contact a tackle shop in the area you'll be fishing and ask lots of questions. Have them send you a current tide chart. Stop in and identify yourself upon arrival, and purchase a few flies or some tippets as a thank-you.

TACKLE AND EQUIPMENT

Saltwater fly fishing has recently grown in popularity, inspiring manufacturers to create a wide range of tackle that will meet the demanding conditions and perform well under a variety of situations while still fitting into most budgets. Once again, the best people to talk to are the folks at your local tackle shop. If they don't have any direct experience with salt water, they'll be able to tell you where you can go for advice.

Fly outfits designed for saltwater use have the same components as their freshwater counterparts but are beefed up to withstand the more severe conditions encountered in the salt. Most lakes, rivers, or streams can be comfortably handled with rods and lines up to 7-weight. The salty fly rods range from 7 to as high as 13- or 15-weight.

As a rule of thumb, the bigger the flies, the more severe the conditions, and the larger the fish, the heavier the fly outfit needed. Here are some general guidelines:

- 7-, 8-, or 9-weight: medium-size and smaller school fish, calmer conditions, light surf, smaller (up to 1/0) flies, shallow areas.
- 9-, 10- or 11-weight: larger fish (depending on conditions), windy conditions, heavy current, mostly surf, flies up to 3/0, deep waters.
- 12-weight and up: big inshore and offshore fish, minimal amount of casting, flies up to 5/0.

Rods

Rods specifically designed for saltwater use usually have a little faster action and are stiffer in the butt to aid in the tug-of-war that's sure to follow a hookup with a powerful fish. Guides are larger and sturdier than those on

lighter rods. This heft will help in the fight as well as in casting the thicker-diameter lines. A fighting butt is attached to the butt end of the rod behind the reel seat. This can be held tight against the angler's stomach to help in gaining a mechanical advantage during the battle. It should be no longer than a few inches, or it will interfere with casting. An uplocking reel seat made of solid, corrosion-resistant materials and built to last is a must. Thin, easily bent materials will quickly fail and render the rod useless. Quality fly rods suited to salt water cost between $90 and $700.

Reels

In freshwater fly fishing, the reel is not much more than a device to hold line. Many a sweetwater fly fisher will go for years, catch hundreds of fish, and never even see his backing. Salty fly rodders learn early on however, that the reel is all-important in a fight with a big fish.

When choosing a reel for saltwater use, be sure that it is corrosion resistant. A reel made from inappropriate materials may not last a day's fishing. There is a large variety of quality reels available in a wide price range—from approximately $45 for the Pflueger Medalist model 1598 rim control to over $2,500 for a Seamaster. If there is only one component of the saltwater outfit you can afford to spend extra money on, it should be the reel.

Look for a reel with a line capacity that will match the fighting style of the species of fish most likely to be encountered. Long-running offshore species like tuna and big inshore quarry like tarpon demand a minimum of 250 yards of 30-pound-test backing. With the exception of large bonefish and false albacore, most inshore species will rarely run over 100 yards. Here, a reel with a 150-yard, 30-pound-test capacity should work nicely.

Be sure the reel has a good drag system, a wide range of adjustments, and a knob that is easy to handle. A good, smooth palming rim is a welcome addition. An easy-to-grip handle will also be an advantage.

Before purchasing a reel, remove the spool and replace it several times to check for ease of operation. Note how accessible all the parts are and how easy it will be to clean. Try to find the best reel with the fewest number of parts that can be worn or lost or fail somehow in the middle of an epic battle. The availability of inexpensive, easy-to-acquire extra spools is also a plus.

Lines

For salt water, you should always use weight-forward fly lines. They will give you an advantage in casting big flies in windy conditions and will help you achieve maximum distance. Many special tapers have been developed for specific saltwater fish, such as bonefish tapers or tarpon tapers. These are still basic weight-forward designs, however.

A floating line is in general the most useful. An intermediate sinking line is a very useful alternative, especially when some wave action is expected. The floating line has a tendency to ride the waves, creating curves and leaving the angler with several feet of slack between the rod tip and the fly. The intermediate line will cut through the waves, eliminating the slack and imparting more control to the retrieve. This will mean a tighter line and a direct connection to the fly that will transmit a strike more effectively, resulting in more hookups. The intermediate line is also good when floating weeds are a problem, as it can be retrieved slowly just below the surface.

Full sinking lines are difficult to handle and cast. If you need a fast-sinking presentation, use one of the new quick-descent sinking-tip line designs or a shooting taper. When you are starting out, however, stick to less-demanding situations where a floating or intermediate line will fill the bill.

As you become more proficient in the salt, you will seek different species in a variety of conditions and will need to have more than one line along. The easiest way to do this is to include an extra spool filled with a running line and then purchase or build a shooting taper system to accompany the full floating or intermediate line.

Backing

In saltwater fishing, the backing on a fly reel plays a much more important role than just a spool filler. A powerful game fish will have the whole fly line out of the guides, with the backing singing along behind. The combination of shells, sand, and rocks found along most coasts will grind at this thin braid and can cause it to part if it's not of good quality and up to the task. It's worth spending a few extra dollars on quality backing.

Purchase 30-pound braided Dacron or Micron backing, in a bright color for ease of visibility when fighting a fast-moving fish. It should be installed on the spool tightly and carefully to avoid tangles. As the spool is filled, break up the even, constant filling with an occasional crisscross back and forth across the spool. These diagonal runs will provide a barrier when the fly line has been ripped from the spool and tremendous pressure is forcing the backing to slice between the even rows on the spool. Otherwise, the backing may embed itself deeply, causing it to jam up and stop the spool, snapping the tippet.

Leaders and Tippets

Saltwater leaders should be constructed as simply as possible, the fewer knots the better. The purpose of a leader is to aid in presenting the fly efficiently while keeping the fly line directly away from the fish; it should not

Saltwater Leaders

Standard Leader

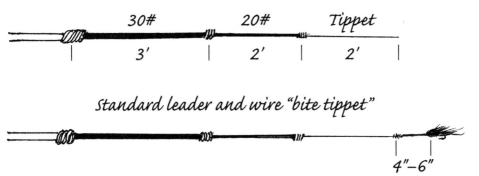

Saltwater leaders should be kept simple.

adversely affect the action of the fly or scare any fish that may be considering the offering.

A basic saltwater leader will have a butt section of 3 to 4 feet of 25- to 30-pound-test mono, with a midsection of 2 to 3 feet of 17- to 20-pound test. The tippet will be about 2 feet long of 10- to 15-pound-test. These measurements can be adjusted to suit personal preference and fishing conditions. You may need a longer leader with a finer tippet to fool spooky fish in shallow, calm water or a shorter leader with a heavier tippet for heavier water and bigger flies.

Under most circumstances, there is no reason to use a tippet less than 10-pound-test or more than 15. Heavier tippet will detract from the action of your fly, and finer tippet may not withstand the abuse it is likely to be subjected to. Never use tippet heavier than the backing on the reel. It may be necessary to break off a fish for some reason, and if it's into the backing, this could result in a lost fly line.

If you are using a sinking or sinking-tip line, attach your tippet directly to the fly line loop, and keep the length to 3 feet or less. The fly will sink along with the line instead of following along several feet above it.

Bite Tippets. Many saltwater fish have teeth designed to grab and cut through the tough skin of the prey they are feeding on. Your leader will quickly become mangled and will part during a long battle, or maybe even on the take. A bite tippet, a short piece of heavy mono or wire attached to the fly, will help solve this problem.

Wire bite tippet should be a short as is practically possible (4 inches or less is usually sufficient). Fine, single-strand, coffee-colored stainless trolling wire is good because the thin diameter makes it difficult to see, but this wire will kink easily and will probably last for only a fish or two before needing replacement. Heavier wire (100-pound-test or more) is a little harder to work with but will not kink easily. Use heavier wire when the fish are not leader-shy. Orvis makes a pre-looped wire leader that is easy to use.

Vinyl-coated braided wire made especially for bite tippets is available from a number of manufacturers and should be stocked by any full-service saltwater fly shop. This material is easy to work with but costs three or four times as much as single-strand wire.

Mono bite tippet is less visible, preferred over wire, and can be chosen to fit the species. Tough mouths and bigger fish, such as tarpon or cobia, demand a tippet of 80- or 100-pound-test. Smaller fish with less biting power, such as snook, snapper, or sea trout, can be handled safely with 30- to 50-pound-test bit tippet.

Tackle Care

Many folks tend to lay down the rod and reel while changing a fly, unhooking a fish, or taking a rest. This is not a wise practice on the beach or any other sandy, salty area, however. Never lay the outfit down on the beach, and do not allow the reel seat, reel, or line to come in contact with the sand. Any sand or other debris that gets into the working parts will lead to severe wear and cause the reel to make a grinding sound as the spool is turned. Always pay attention to where you place the rod and reel. The stripping basket makes a fine resting spot for the outfit. Keep the rod tip up. Stress the importance of this to your youngsters and don't let them forget it.

If by chance a reel becomes covered with sand, rinse it off immediately, using a light stream of fresh water if available or a gentle dunking in the sea as a last resort, and give the entire reel, line, and reel seat a thorough cleaning as soon as possible.

At the end of each trip to the salt, rods, reels, and lines should be washed down thoroughly with a mild soap and warm water. Rinse off all tackle with a light spray of fresh water, and wipe everything dry. Be sure sand is cleaned from the insides of reels and from around the reel seat. A light coating of WD40 on all metal parts is recommended. Some anglers use a light coating of a high-grade auto wax on all exposed parts of the reel. A light, even wax coat can really help prevent sand and salt particles from penetrating the reel's finish.

Rinse off flies, boots, and anything else used near the salt water. Don't allow tackle to lie around uncared for between trips. Form a habit of cleaning

everything immediately following a saltwater adventure. Tackle is too expensive to abuse, and corrosion on all parts will begin immediately.

Stripping Basket

The stripping, or shooting, basket is about as important to the shorebound angler as the rod and reel. This handy device has been used in various forms by anglers for hundreds of years, both on shore and in boats. It is simply a container worn by the fly fisher to hold line stripped from the reel. Line laid out neatly in the bottom of the basket will not tangle around feet due to wave action, become fouled in weeds or other debris, or stream out behind while an angler is chasing fish along the beach. The line can be cast with little resistance and will also feed out evenly while being pulled by a freshly hooked fish.

A standard serviceable basket can be easily constructed and should cost not more than $7 to complete. You'll need a deep plastic dishpan (the 7-inch-deep model by Rubbermaid is a dandy) and a shock cord or belt that will fit snugly around your waist when wearing a pair of waders and a jacket or other clothing.

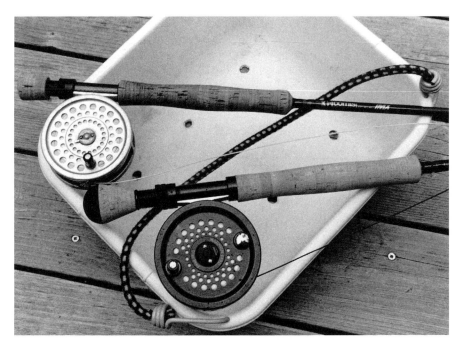

The two most popular types of fighting butts on top of a simple plastic dishpan shooting basket.

Drill several ¾-inch holes in the bottom of the dishpan for drainage. If a shock cord is used, drill a ¼-inch hole in the two top corners of one long side of the pan. Insert the cord hooks into the holes. If a belt is used, use a utility knife to cut two slits to fit the belt width in one long side of the pan. Run the belt through the slits and it's ready to go!

Fill the basket for a cast before entering the water. Pull off the length of line that you will use. Cast only the amount of line that you can throw comfortably, extra line will only cause tangles and trouble. Stretch each short section as it's pulled from the reel in order to straighten the line and take the "memory" out of the coils.

Once the line is out, arrange it neatly in large coils on the bottom of the basket, *putting the line closest to the reel in first.* This will be the last line out when cast. Reversing this procedure or having loops fold over each other will cause a tangle.

While you're moving about or retrieving the fly, a large loop of line may slide out of the basket. Stop and dump *all* the line out of the basket, and carefully coil it back in neatly. If you simply toss the loop back in and it crosses over another loop, the take and initial run of a big fish will pull the tangle through the guides on the way out, popping the tippet or breaking the guides. Make your youngsters well aware of this fact, and have them take the time to rearrange the line whenever necessary.

Other Equipment

Personal preference will play a large part in outfitting yourself for saltwater fishing. I prefer a small daypack or a jacket with big pockets to a fishing vest. I use plastic snap-top storage boxes instead of standard fly boxes.

A small knapsack is indispensable for trips to the beach or on days when you have to travel a distance from your vehicle. Be sure to carry an extra reel or two, first-aid kit, extra sunglasses, flies, pliers, extra lines, tape measure, and plenty of good tippet. Include a flashlight and a compass, along with some snacks, a camera, and a pair of binoculars.

No special gear is required for the saltwater fly fisher. The main point to keep in mind is that salt will rust and corrode many types of materials. Choose equipment that can handle the salt spray, and clean and care for it regularly.

Clothing

The amount and type of clothing needed depend on the temperature and conditions. You need to protect against weather extremes. For a long day on a tropical saltwater flat, exposed skin should be protected with sunscreen.

*Eamonn McCarthy
dressed properly for
the October surf.*

Light, loose-fitting long-sleeved shirts and long pants will offer maximum protection.

Where the cold winds blow, dress in layers, with the top layer being a nylon shell. Flies will bounce off this material better than a shaggy wool sweater. Hats and sunglasses are mandatory in *all* conditions.

When fishing in salt water, the wind, big rods, heavy lines, and big, sharp hooks can produce a lethal combination. Youngsters must constantly be reminded of this fact and should be told to dress appropriately.

FLIES

One of the great joys of saltwater fly fishing is the opportunity to construct and use some pretty wild-looking flies. Anyone accustomed to tying and fishing small nymphs and dry flies that match the hatch should get a real kick

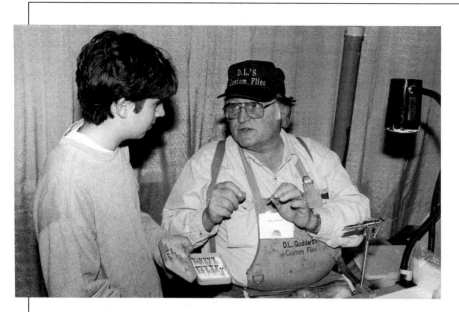

Saltwater fly tying expert D. L. Goddard gives a few tips to Ryan Rosalsky.

When I'm tying, I try to visualize being out on the beach, stripping the fly and all of a sudden getting a huge strike. At this moment, you know you've succeeded, even if you don't catch the fish. It's amazing to think that you tricked this remarkable predator into thinking pieces of fur and feather tied on a hook is a living fish.

—Ryan Rosalsky, age fourteen,
Dumont, New Jersey

out of being able to break loose on the vise and combine big hackles and bucktail to create streamers that can approach the size of a hatchery trout.

Hundreds of new patterns designed specifically for the salt have been created in the past few years. At first glance, it may be an exhilarating experience to see all of these exciting new patterns, but it can be difficult to choose which flies will work best. Once again, staying with the basics and keeping things simple will get the best results.

Baitfish in various sizes, shapes, and colors make up the major source of food for most saltwater predators. An effective fly is easy to tie and to cast and can be fished effectively in one of three ways: near the surface, near or on the bottom, and in weedy, snag-filled waters.

The Big Three Saltwater Patterns

Three time-tested patterns, when tied in a variety of sizes, shapes, and colors, will cover nearly all situations and most species. (See pages 79–83 for tying instructions.)

The *Lefty's Deceiver* was designed by angling legend Bernard "Lefty" Kreh as an all-purpose baitfish imitation that can be tied in lengths from an inch or two to over a foot. It is not so much a specific pattern as a method of tying.

The *Clouser Deep Minnow* was developed by Bob Clouser for catching smallmouth bass in the rock-littered waters of the Susquehanna River. Outfitted with lead eyes and tied so that the hook rides up, this fly can be bounced along the bottom without getting snagged. It has few equals as a fish catcher in salt or fresh water.

The *Bendback Streamer* was originally designed long ago by largemouth bass fly fishers who needed a single, nearly weedless fly to offer their quarry. In recent years, master saltwater angler Chico Fernandez revived this forgotten design and proved its worth for luring redfish, snook, and other denizens from their weed-infested haunts.

You can use these patterns as guides or design your own baitfish imitations. When putting together an assortment of saltwater flies, consider the following characteristics:

From left to right: bendback; Lefty's Deceiver; Clouser Deep Minnow; and an Ultra Hair Clouser rigged with a wire bite tippet.

- *Size.* This is arguably the most important criterion for fly selection. You need to determine the size of the baitfish your quarry is feeding on. This can be accomplished by asking the locals, becoming familiar with the species and their forage, or direct observation (along the beach, look for dead or wounded baitfish in the wash). Take along flies in a variety of sizes. Start at about a number 4 hook, and proceed in length and hook size to 4 or 5 inches and 1/0. Begin fishing with the one that best approximates bait size. If that doesn't work, try other sizes and shapes. Occasionally you'll find that fish like a little variety in their meals, too.
- *Shape.* Baitfish are usually slim (sand eels, rainfish), broad (bunker, herring), or somewhat cylindrical (mullet, sardines). Each of the three fly patterns can be modified by adding extra hair or hackles to approximate these shapes.
- *Color.* Saltwater baitfish have evolved to blend in with their surroundings. A white belly makes them hard to see against the sky from underneath, and a darker top helps them blend in with the deeper water and the bottom when predators are looking down from above. Flies should emulate these characteristics. Colors that will work under a variety of conditions include all white, white with a sparse darker top (any color), white and chartreuse, and all black.

Hooks

Tie all saltwater flies on rust-resistant stainless steel hooks. Crush the barbs and sharpen the points before putting them in the vise. Sharp hook points and flattened barbs allow the limber fly rod to set these larger hooks into the very tough jaws of saltwater fish. Use longer-shanked hooks when sharp-toothed adversaries may be encountered. Rely on regular-length hooks for most other applications.

CASTING AND RETRIEVING

Most youngsters who are fairly proficient casters and can handle 50 feet of line should have little trouble with 8- to 10-weight outfits. A good outfit for the young angler venturing out to the salt would be an 8½- or 9-foot moderate-action (not fast) graphite rod and a quality reel filled with 30-pound backing and a weight-forward floating line, a weight or two heavier than that suggested on the rod blank. Smaller anglers who can easily muscle a 5- or 6-weight may have a little trouble with the larger rig. They can modify their grip and hold the rod handle with two hands on the cast. It will also help to hold the rod out to the side at an angle while casting. The whole procedure may look awkward, but it works nicely and will enable the young

Every now and then someone asks what inspired me to design and tie imitations of saltwater baitfish. This has always come as a surprise to me, as I have always believed in matching available fodder for all game fish.

I was fly-rodding in fresh water and then conventional surfcasting when I went to the ocean. Occasionally, when I went to the beach, I would think, "Wow! Wouldn't that fish have been great on a fly rod?" I began to take my fly rod to the ocean but found that there were no good fly patterns to imitate the bait. So I began to develop patterns to fish with. First I designed herring and tinker mackerel patterns. These two went through stages of evolution, until they became fixed and have remained unchanged for thirty years.

Bill Catherwood at age 16 with three fox pelts destined for the fly-tying table.

Originally these streamers were 2½ inches in length. It occurred to me that this in no way approached the proportions of the naturals, so I started making them bigger. Along the way, I also developed a style of tying that give my patterns realistic outlines with a truly three-dimensional appearance.

For all of my saltwater fly-fishing life, I've done my best to design and tie lifelike imitations of the saltwater fodder. I haven't taken any shortcuts, as I sincerely believe that a well-designed, properly tied fly will take all of the average fish and be the most likely to fool the bigger, older, and more educated fish, which would turn up their noses at poorly designed and crafted patterns.

—Bill Catherwood, pioneer saltwater fly designer

angler to gain more line control. Youngsters who are good casters will adapt remarkably well to the heavier tackle and will make it work for them!

The young fly fisher must develop strong casting, retrieving, and presentation skills before fishing the salt. It's important to choose an outfit that can be cast comfortably and is not awkward to handle. Regular daily practice should be begun well before heading out. The ocean is not the place to familiarize oneself with the tackle and how to use it.

Once the young fly fisher becomes comfortable with the larger outfit and can cast 50 feet of line easily, it's time to work on accuracy. Lay out a target area where there will be plenty of casting room. Pace off 30, 40, 50, and 60 feet in different directions, placing targets at each distance.

The instructor should stand behind the caster and call off different distances, having the youngster shoot at the target with no more than two false casts for each attempt. Each cast should be completed and retrieved properly, using the stripping basket. Have the young angler do this until it becomes automatic.

Two types of retrieves are appropriate for saltwater fly rodding. In the standard strip, after the cast, the rod hand grips the handle and controls the line under the index finger. The rod tip is held low and pointed directly at the fly. The line hand strips in line. The speed and length of strips can be varied to suit conditions, species, and personal preference. In the second method, after the cast, the rod is placed immediately under the casting arm, and the line is hauled in hand over hand into the stripping basket. The advantage of this method is that the fly can be retrieved at any rate from slow and steady to lightning fast. The strike is transferred immediately to the hands of the angler. A strong, steady, quick pull on the line with little rod movement will set the hook. If the take is missed, the fly will stay in the area to be offered to any other fish that may be close by. This technique will also keep the fly in the water and not flying at 100 miles an hour toward the angler. The stripping basket should always be worn while practicing the two types of retrieves.

Retrieve rate and style should be varied. If a slow, jerky action does not produce, shift to a steady, fast method. Fish the fly as you would in a river, using the wet fly drift in combination with a variety of retrieves. Sometimes, in a quickly moving rip, a dead drift with a retrieve that only keeps the slack out will work best.

If you are sight-casting to fish, place your fly so that it runs a few feet across from and in front of the fish. Even a large predator will realize something is wrong if the baitfish swims toward it.

After some competency has been achieved in casting and retrieving, it's time to venture to a lake on a blustery day and have the youngster practice punching casts into the teeth of the wind. Tie on the largest fly that will be

Standard strip (a).

Standard strip (b).

Rod-under-arm retrieve.

used, and clip off the point at the bend. All safety gear, including hat, glasses, and windbreaker, must be worn.

Quarter-cast across the wind, laying the line between the waves. The young salts will experience what they may be up against when they hit the beach, and they'll get the feel of using the outfit in the wind. They'll also learn to duck!

FIGHTING BIG FISH

A fun way to work on big-fish-fighting skills is to choose a lake that's filled with a resident population of large carp. Impale a kernel of corn on a hook, and cast the offering out. Strip 20 feet of line into the stripping basket. Toss a handful of kernels out to the carp for a snack, then sit and wait. The ensuing battle is a great introduction to fighting big, powerful fish on a fly rod and is

During the late '60s, I fished with Ray and Herb Chase. Herb was one of the first in the area to fish a fly in the salt. He and Ray were among the founding members of the Rhody Flyrodders, in the company of Harold Gibbs, Rube Cross, Al Brewster, Howard Lewis, Armand Courchaine, and Ron Montecalvo.

While watching Herb cast, I learned what is now called the *water haul*. I never saw him false-cast. Instead, Herb would retrieve the fly line until he had the splice of the shooting head in his stripping hand, lift the rod tip enough to inspect the fly, roll-cast the head onto the water, make one backcast, and shoot the line to an intended destination. Herb used this method of casting from the rocks above the ocean front as well as when wading the upper bay. He made casting look easy, and his method truly is. The strong onshore wind never fazed Herb . . . he simply compensated and continued fishing.

He showed me where to cast a fly along the rocks of Prices Neck, Newport. Etched in his memory were the many experiences encountered fishing these cliffs.

"I can recall taking a 30-pound striper off the left side of the rip back in '52. In fact I've hooked a lot of bass on this part of the tide," he would say. Or, "There's always a resident schoolie below the cut in the reef. Lay a popper there on your first cast and he'll slap at it!"

And a striper usually did—and still does today.

—Bill Peabody, saltwater fly tier

lots of fun. It's also important that the young angler become accustomed to the drag setting on the reel and form a habit of checking it periodically. The carp will also be an effective teacher in showing the young angler how to palm the spool.

If this is not a practical idea, then the "bonito game" is a good alternative. Our kids invented this very effective game during our casting practice session just before a trip to Martha's Vineyard in pursuit of bonito.

One youngster took on the identity of the fish and the other the caster. Only a well-placed cast of at least 60 feet would interest the "fish," who would grab the fly at his discretion. After the "take," the caster would practice feeding line out of the basket evenly on the initial run, keeping it under tension and avoiding tangles while getting the fish onto the reel without a tangle. From here the bonito was played carefully and landed. They had invented a game that enabled them to practice some very necessary skills and have a ball while doing it!

LANDING A FISH

A fish hooked from the beach should be brought in quickly if it is to be released, or played to exhaustion if it is to become dinner. If there is a drag on the reel, it should be adjusted before fishing. Set it so the line will pull off with some resistance, putting a hefty bend in the rod but not causing a backlash. The drag will put some pressure on the fish; then care must be taken to palm the reel spool gingerly, with the fingers flared back out of the way.

After the hook has been set, get the fish onto the reel as soon as possible by directing the line neatly out of the stripping basket and through the rod guides. Watch for line tangles and wraps around fingers, rod guides, or parts of the basket.

A large powerful saltwater game fish will peel the entire fly line off in short order, spinning the handle of a single action reel with knuckle busting speed. The backing that is streaming along behind will slice into a finger in seconds.

Avoid touching the fast moving backing. Hold the rod butt just above the handle to gain some mechanical advantage over the fish. Don't overdo this maneuver; yours would not be the first blank to shatter by using undue force.

Don't tighten the drag too much, as a fast unexpected run will snap the leader. To put extra pressure on a tired fish, simply hold the line (not backing) between the blank and the rod hand. Slowly and carefully pump the rod up or to the side, moving the fish closer and reeling in slack line as the rod is moved quickly back, regaining a tight line. Be ready to free the line from this grip in an instant if the fish speeds off.

When the battle is nearing its climax and there are still 10 or more feet of

Keep fingers away from the rotating handle while putting pressure on the spool with the palm of your hand.

line out, the angler should slowly back up the beach, to tow the fish out of the wash. The fish, especially a big fish, will be pulled out by the undertow, making it feel even heavier. Move back toward the water with the outgoing waves, and back up as the incoming waves wash the shore. Slide the fish through the wash and up onto the beach with the help of the waves.

If the fish is to be released, avoid dragging it too far up the beach, which will cover its wet body and fill its gills with loose sand. Remove the fly immediately, and get the fish back into the water. If the fish is destined for the dinner table, get it far up on the beach and dispatch it quickly with a whack on the head. Remove the fly, and get the fish on ice right away.

When wading on a flat, smaller fish can be picked up slowly and laid in the bottom of the stripping basket. This will give you a little more control over the situation while removing the hook.

FACTORS THAT AFFECT FISHING
As in all types of fly fishing, the entire environment plays a part in putting together the total picture. The stages of tide, weather conditions, time of day, and time of year, as well as the species, all need to be considered in making decisions regarding flies, tackle, destination, and presentation.

Tides
Tides are a vital component of the marine environment. They are considered the rivers or streams of the saltwater angler and are fished in a similar manner. A quick overview will help explain their significance and aid you in asking the right questions and making some informed decisions when choosing a time and destination.

The major factor in the tidal movement of the ocean's waters is the gravitational pull of the moon. Over the twenty-eight-day lunar month, the moon will be closest to the earth twice, once at the full moon and once at the new moon. At these times the gravitational pull is strongest, and as a result, tides will reach the highest and the lowest points. These are called *spring tides.*

As the moon moves away, the tidal movement will become less and less pronounced, resulting in the smallest difference between high and low tides. These are called *neap tides.* The least movement will occur on the first and third quarter.

Simply stated, the most water movement and most dramatic changes can be expected in the three days prior to and after the full or new moon. This movement affects the volume, clarity, temperature, current speed, and depth in a given area. More important to the angler, the water movement will carry a variety of food, disorient baitfish, and create conditions favorable to predators.

No one tidal stage is better or more productive than another, however. Species in each area react to water movement in ways that will be most advantageous to them. It's your job as an angler to figure out this system and react accordingly. Be aware of this, and use high- and low-tide times as references. Local experts will usually refer to the incoming, or flooding, tide and the outgoing, or falling, tide when pinpointing the best times to fish a certain area.

There are usually two high and two low tides a day. Tide stages will repeat an hour later each day. If you experience good fishing conditions today at 1:00 P.M., chances are that the same conditions will be had tomorrow at 2:00. A good log or notebook will be an invaluable tool in helping you figure out the fish's reactions to the tidal patterns in your area.

Wind
In many locales, wind is everything. It is a determinant in water temperature and the height of the tidal flow. Strong wind can pin a school of hapless bait against a shoreline or fill the waves with a tangle of debris. Wind is so important that there is even an old expression: "Wind from the East, fish bite least. Wind from the West, fish bite best!"

I was introduced to fishing by my father when I was about ten years old, and at the time, it was just an exciting grownup thing to do with my dad. But looking back, I realize that fishing gave me the early contact with the natural environment that led to my interest in environmental conservation (I now have a degree in conservation management).

As a "conventional" fisherman, I had time, while sitting on the bank, to look around me, watch the birds, the changing weather, the flowers, and sometimes the fish. These pleasures and the guarantee of catching fish with the simplest of baits and methods maintained my interest in fishing for many years, but recently it had started to wane. That is, until my reintroduction to the sport in the form of fly fishing. This happened during my stay in America, where, away from the stuffy traditional image that seems to stifle the sport in England, it was much more appealing.

My new hobby gave me the excuse to explore and learn about my new and surprisingly different environment. To my amazement, all the publicly accessible waters had public fishing rights, in stark contrast to England, where you must either join a private club (very expensive), buy a day permit (expensive), or poach (illegal). Here I fished trout and salmon streams that would cost hundreds of pounds to fish in England. But my most enlightening experience came from a trip to Long Island to fly-fish in the ocean.

Accompanied by a very knowledgeable biologist and a group of dedicated young fly fishers, I studied the effects of tides, beach conditions, the life cycle and habits of the fish, and how these factors interact to create fishing opportunities. But lying beneath these lessons was a more important learning experience. Armed with this new knowledge, I began to become more aware of my surroundings and had a sense of being part of a complex and dynamic system. This gave me a feeling of empowerment and deep respect that I had not felt before, and after years of spending money on colorful lures and gadgets, I realized that the most important piece of tackle is your mind.

The understanding and awareness of the environment that I gained over the weekend helped me to develop a stronger spiritual and intellectual link with the environment, and this has enhanced my enjoyment of fishing. Mark Twain said, "Men go fishing their whole lives without realizing it's not fish they are after." I think that now I understand him a little better.

—Jonathan Woodcock, Essex, United Kingdom

Jonathan Woodcock and his first fly-caught fish.

Time of Day

In many places, dawn and dusk are the hot times to fish. Predators are more at home and feel less vulnerable in low-light conditions when hunting in shallow areas. Many species become active only when the waters are warmed by the sun or cooled after the sun goes down. Fish that feed by sight, such as tuna or mackerel, will be more active during the day. Fish that find bait in a variety of ways through many senses, such as stripers or red drum, may be more active in the cool, low-light evening hours.

Many folks believe that the darkness of the night or the fullness of the moon plays a large role in determining fishing success after dark. A dark moon, some say, will make the fish less wary and give the fly a better profile against the sky. For some species, a bright night will mean that they can readily see baitfish.

Time of Year

Water temperatures and, as a result, the food supply and comfort levels for bait and predators change with the seasons. Many species migrate with the changes, eating voraciously to prepare for the long winter months and once again going on a feeding binge when the waters warm in the spring.

OFFSHORE, INSHORE, AND SHOREBOUND ANGLING

Fly fishing in salt water is generally broken down into three basic areas that are based on three different habitats, involve a variety of species, and demand different approaches.

Offshore

Several miles from the beach, a rich variety of sea creatures inhabit the wide open waters, which may be thousands of feet deep. Huge masses of water move along in currents that are not unlike vast rivers. The Gulf Stream (Atlantic Ocean, east coast of the United States), the Humbold current (Pacific Ocean off Chile and Peru), and the Caribbean current (northwest coast of South America into the Gulf of Mexico) are examples of famous big-game-fishing destinations. These currents sweep countless numbers of small plants and animals along with them. Game fish that live here are usually *pelagic,* which means that they live close to the surface and tend to move seasonally with the changes in water temperature and the food supply. These waters are also affected by tides, but not as noticeably as the waters along the shore. Large sea mountains, mounds, hills, and valleys far under the surface affect the movement of the currents and form a sort of structure that attracts fish.

Lines of floating debris form along another type of structure called *temperature breaks.* These areas appear where two water masses or currents with different temperatures meet, forming a sort of barrier. The floating junk piles are home to small plants and baitfish and serve as dining areas for larger predators.

Even miles offshore, the behavior of a giant marlin is influenced by the same survival needs as that of a brook trout in a tiny mountain stream. Things are on a different scale and include different players, but the rules are the same.

Offshore fly fishing is a matter of finding a school of fish, locating a floating debris line, or somehow attracting hungry fish to come within casting range of the boat. In recent years, nearly every species of game fish, including tuna, billfish, and sharks, have been successfully subdued with fly tackle. Rods and reels up to 15-weight are used to battle the largest of these creatures.

Offshore charter boats that troll for big-game species are often equipped with fly rods that are brought into use when smaller fish like dolphin (mahi mahi) or blue runners are encountered in a debris line. Here an 8- or 9-weight outfit can provide very exciting sport for the young angler. Youngsters going on an offshore adventure should be encouraged to take along a suitable fly rod rigged in a standard saltwater manner, with a selection of larger flies, as well as a stripping basket. Have them call ahead to the captain to ask what to expect and for tackle suggestions and information. Casting should be at fairly short distances of less than 50 feet; floating, intermediate, or sinking-tip lines

should be sufficient. Large offshore fish require special tackle and techniques that are outside the beginner's skill level.

Inshore

Closer to the shore and out of the direct influence of these vast currents are the inshore waters. The fish in these areas are influenced by the same needs as fish in other places, but they may be found centering their activities directly over and around submerged structure such as reefs, wrecks, and rock piles. Floating debris lines will also appear along temperature breaks inshore and form another significant type of structure. Good fishing is also found around man-made structures such as oil or radio towers, buoys, channel markers, or lighthouses. Small fish are attracted to all of these areas, as they find food and shelter there. Big fish hang out there because that's where the small fish are. Many other types of inshore habitat, including river mouths, harbors, bays, and sounds, contain good populations of fish and can be reached by boat.

Fish will congregate around, above, and below the structure in these habitats. If the fish are in deep water, sinking shooting heads or full sinking lines may need to be employed. Try to use these rigs with a minimum of casting. Drifting over a target area and letting out line as the boat moves is a productive and easy method of reaching fish in deeper waters. Drifting a fly with the current from the stern of an anchored boat will also work if a sinking line is employed.

Many times on a drift over a likely spot, the current may be too swift to allow a sinking line to reach the level of the fish. With schooling predators, it may be necessary to first hook a fish on a fast-sinking diamond jig or bait attached to a conventional outfit and lowered quickly at the beginning of a drift. When a fish is hooked, bring it up to the surface slowly, passing by the flies that have been lowered to their maximum depth. Often other members of the school will follow along, shadowing the hooked fish and looking for an opportunity to either steal the bait or grab pieces of the meal that have been torn away. Those fish will readily accept flies hovering in this area.

Chopped-up bait, fish, clams, and other assorted goodies can be tossed overboard from an anchored boat to form a *chum slick*. Interested fish will follow their noses up the slick, dining as they go. Offer a fly the size and color of the chum pieces on a dead drift in this buffet line, and one of the diners may mistake it for the real thing!

Shorebound

Angling from the shore is by far the most popular, inexpensive, and accessible way for the young fly fisher to experience the salt. A great number of species are available to the shorebound angler on all the coasts. Each species has its

favorite prey and habitat. It is wise to become familiar with the habits and preferences of the species you're most likely to encounter.

Look for fish in the same sorts of places you'd find them in rivers and lakes. Saltwater fish have the same basic needs as their freshwater cousins (see chapter 6). The main difference is that saltwater fish don't have permanent homes and are always moving with the changing conditions. Some inshore predators position themselves out of the main current flow in an indentation or behind a rock, pier, or other piece of structure. Many large predators are built to be able to glide easily through heavy flows of water and will concentrate their attention on areas where the much smaller and weaker baitfish will be tossed and thrown about by the turbulent waters.

The Beach. The wash (where the waves meet the beach) and heavy rips (fast tidal flows) off points are areas of heavy, turbulent waters where strong predators will take advantage of the hard-to-navigate waters.

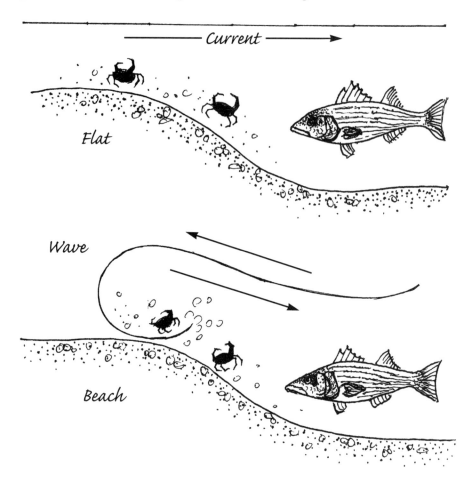

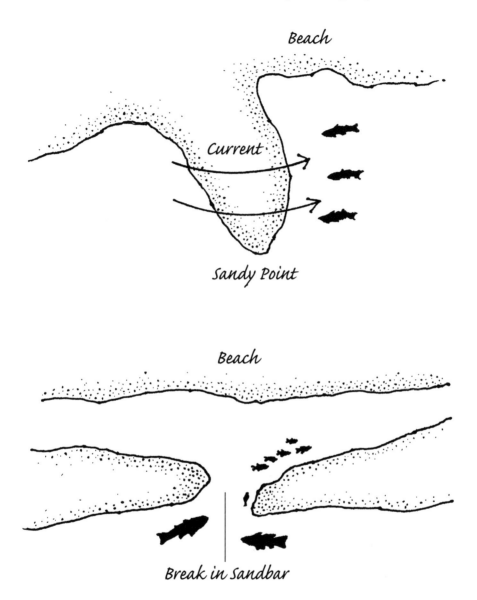

Beach

Current

Sandy Point

Beach

Break in Sandbar

At low tide, walk the area you will be fishing and note any deep holes, indentations, rocks, pilings, or other cover that fish may travel in or hide behind when the area is flooded by the high tide. Go above the high-tide line and put a piece of driftwood in the ground or note a landmark in line with the structure or hole. Pace off the distance from the high-tide mark to the water and guess the casting distance to the "honey hole" so that when you return and the area is flooded, you'll know with some confidence where to cast.

Fish on the sides of sandy points and off deep, sloping beaches. If there's a sandbar just off the beach, look for a hole that will give fish access to the deeper water. These are all places where fish lie in ambush waiting for bait to be swept by.

The Flats. While wading on (or drifting over) a saltwater flat, look for open spaces in a weedy bottom. These openings are deeper than the surrounding areas and form ideal ambush spots for predators, which will station themselves around the edges facing into the current. Make a series of casts around the edges, and drift or retrieve the fly with the moving water.

Fish will also work around areas where depth changes occur. Look for areas where two colors meet or blend. This will often tip you off to a likely feeding spot.

Look for areas on the flats where the sand is being kicked up by feeding or moving stingrays. Often opportunistic feeders, such as jacks, snooks, redfish, or other predators will be looking for an easy meal in this plume. Cast a fly into the discolored water.

Saltwater Ponds. Saltwater ponds can be marvelous fisheries and are highly recommended for breaking in the beginning angler. These ponds are connected to the ocean by a channel called a *breachway* and are directly

Saltwater Flat

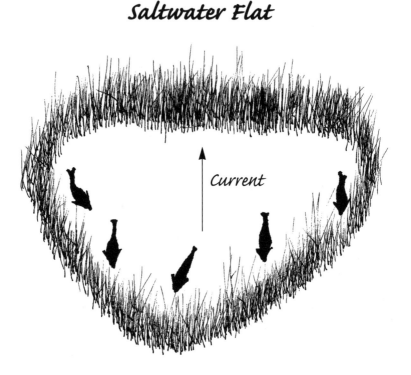

Current

M y first exposure to fly fishing was in salt water. It was in early May 1963, on a white sand flat on the northeast side of Cat Cay, in the Bahamas. I was wading on the flat, catching small bonefish (1 to 2 pounds) with a spinning rod and using conch for bait. We were going to use the bonefish for rigged marlin baits.

As I was fishing, I crossed paths with a white-haired gentleman, a guest at the club, who was casting to bonefish with a bamboo fly rod. Well, needless to say, he got my undivided attention. He was kind enough to show me what he was doing, and he soon hooked a nice bonefish as I watched. What impressed me most was how graceful he was as he stalked the fish, then made his presentation, and soon landed the fish. Before long we moved apart and went our own ways. I never saw the gentleman again, but I never forgot what he showed me that day.

—D. L. Goddard, saltwater fly designer
and fly-fishing instructor

affected by the tides. Quantities of food are carried in and out of the ponds with the tidal currents, and hungry predators are sure to follow.

Each pond has its own peculiarities, hot spots, and dangers. Quiz the locals and get acquainted with these features before venturing out. Become familiar with the tide differences that occur between the ponds and the ocean. Often the ocean tide's falling signals the hunters that food from the pond is being flushed out to sea. Plan to be there waiting along with them.

Jetties. Lining the sides of the breachways at harbor mouths and other places along the shore are rocky piers called *jetties*. These are fish magnets, offering shelter and food for baitfish and great dining for predators. Cast flies in tight, and fish slowly around the edges of the rocks. Always try a few casts in the bowl created where the jetty meets the beach. Metal cleats should always be worn on a jetty, as the rocks are very slippery. If the waves look at all treacherous, stay off. Never let a child wander onto a jetty alone. Even a minor wave can easily wash a youngster off the rocks.

Working the Crowd. If a school of feeding fish is being heavily attacked by a group of other anglers, move to the edge of the crowd. Cast your fly in the direction of the school, but avoid getting too close to spin or bait fishermen. Fly rods do not belong in the middle of these other angling situations. Backcasts can be dangerous to everyone. You'll have a good chance to hook

Sometimes good fortune plays an important part when taking a big fish on a fly rod. Large stripers, 30 pounds and over, are lifetime fish. Here's a story where lady luck played a big part.

We were fishing a big jetty on Cape Cod. It was a cold, windy October morning, with good conditions but no action. We had started well before first light. As the sun rose, I walked back toward shore, stopping where the rocks met the beach, as it was incoming tide and the jetty's corner can produce fish. As if on cue, fish began feeding right in the pocket. They looked small, but I still wanted a bend in the rod.

My first two casts produced a light strike but no take. Letting the line sink, I worked the 4-inch Snake Fly deep, even though there was heavy surface-feeding action. On the third cast, the line tightened, and a garbage-can-size boil appeared off my rod tip. The fish rose, creating several large explosions on the water's surface as line melted from my reel.

I started moving quickly down the beach, following the fish. The big striper had power. The run was strong and steady, but instead of heading out, the fish ran along the beach. Most big fish beat themselves on the first run. When this fish stopped, it had run well over a football field, yet it was still close to the beach. Before the fish could recover, I applied hard pressure, moving the fish inside the wave action. This, along with sideways pressure of the rod, will easily beach a fish. Even large fish—and this one was over 40 pounds—are helpless once you have them inside that first wave.

Most anglers believe you need to fish big ocean waters at night to catch big stripers on a fly. And yes, your odds *are* better fishing big water on a dark moon. However, large fish do not always follow the rules. One excellent angler and long-time friend has a good philosophy: He expects to catch a fish on every cast. If you fish with confidence, you'll be a better angler—and one day a big striper might surprise you in the least expected place.

—Lou Tabory, "the Dean of Northeast Saltwater Fly Fishers"

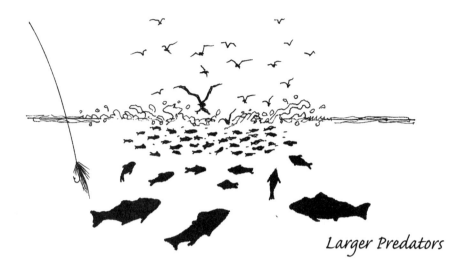

Larger Predators

up with a fish on the edges, and it will be a much more pleasant experience for everyone.

Many times a slowly retrieved fly will work best with schools of feeding fish. Most fish are opportunistic feeders, and a slow-moving or motionless fly will signal an easy meal to a smart, lazy predator.

Birds or Baitfish as Indicators. A flock of birds diving and feeding over a spot is a sure sign that something is up. Even birds just holding in midair over a spot may indicate fish activity below. A rule of thumb is that the higher the birds are, the deeper the fish. It's always worth a few casts.

Baitfish jumping into the air, swirls, and splashes are also clues that may lead to a school of feeding fish. Toss the fly to either side of the activity and hold on. A strike will almost surely follow. Occasionally allow the fly to sink well below the surface before retrieving. Often larger fish or different species will lurk below a school of more energetic juvenile fish. These opportunistic feeders wait for injured or dead baitfish to sink to their level.

COMMON SALTWATER SPECIES

Here is a list of some popular saltwater species that have a large range, take a fly well, and will be the most easily available to the shorebound young angler. Many other game fish, including barracuda, tarpon, black drum, bonefish, sharks, jacks, and snook may be encountered, but the following are the most likely targets.

Bluefish. The bluefish can be found in all the oceans of the world. The largest numbers are located along the east coast of the United States, from Maine south to Florida. They are voracious feeders with razor-sharp teeth. Extreme care must be exercised when handling bluefish of any size. Grab the fish from the top, directly behind the head, and remove the fly with pliers. They are marvelous sport fish, take a fly with reckless abandon, and will readily jump when taken on fly tackle. A wire bite tippet, or short trace of wire, should always be used on the fly. Bluefish are close-in bulldog fighters that will seldom run out 100 yards of line.

Flatfish. There are over two hundred varieties of flatfish in the Atlantic and Pacific Oceans. Only a few, such as the Fluke, Flounder, and Halibut, are

Ryland Engelhart holds a nice fluke caught on a Clouser Minnow while on board "Tippet" charters out of Martha's Vineyard, MA.

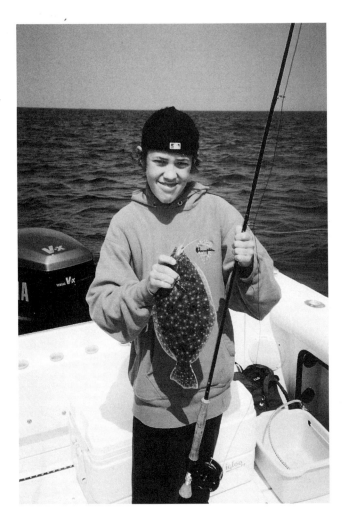

of interest to the fly fisher. Most shallow-water flatfish are fierce predators and will be found lying in ambush, belly down, camouflaged against the sand or mud bottom. Even though they are equipped with sharp teeth, wire bite tippets are not needed. Flies retrieved near the bottom are most effective. These fish are strong fighters but seldom make sustained runs of any length. Flatfish can be easily secured by grabbing them firmly behind the head.

Inshore Little Tuna, including false albacore and bonito and the Mackerels, including Spanish, Atlantic, and Sierra. At various times of the year, these fast-moving predators will be available to the shorebound angler. They are sight feeders and prefer smaller baitfish. Bonito and many of the mackerels have sharp teeth. However, light (15-pound-test or under) mono must still be used because their extremely keen vision will usually detect a wire trace. The tunas are powerful fighters, and even the smaller specimens will strip off 100 yards of line in a heartbeat. Be sure to have a reel with at least a 250-yard capacity. The mackerels encountered from the shore will usually weigh under 5 pounds and can be easily subdued. Small Atlantic mackerel are especially vulnerable and can be caught on very light tackle and small flies. Land both by grabbing the tail and supporting the body from underneath just behind the head. To release a tuna unharmed, land it as quickly as possible, and return it to the water headfirst in a smooth, fast motion. Small Clouser Minnows in various color combinations are recommended and will sink instantly when cast in the area of these fast-moving predators.

Panfish. Several smaller marine species, as well as immature versions of the larger game fish, make excellent targets for young anglers. These include snappers, grunts, pompano, and croakers. Lighter rods and smaller flies can be employed while fishing in shallow bays, canals, and docking areas or around bridges. This may be the best way to introduce the youngest fly rodders to the salt. Toss out small bits of shrimp or other bait to lure in these usually aggressive gamesters. As in freshwater angling, a bit of bait on the tip of the hook will add appeal to the feathered offering. Contact the local bait shop to find what pan-size species will be most available. Small Clouser Minnows in sizes 8 to 4 are perfect for these small fish.

Striped Bass. The striper is native to the Atlantic coast and is found from New England to South Carolina. It has also been transplanted to the west coast, thriving in waters from Oregon to northern California. It is held in high regard by the fly rodder for its willingness to take many different flies under a variety of conditions. Fly fishing for stripers can also be very productive at night, especially in the warmer months. Striped bass do not have sharp teeth, so a wire leader is unnecessary. These fish can be landed by grasping the lower lip to remove the hook. When handling Mr. Linesides, take care to avoid the sharp edges of the gill covers and the points on top of

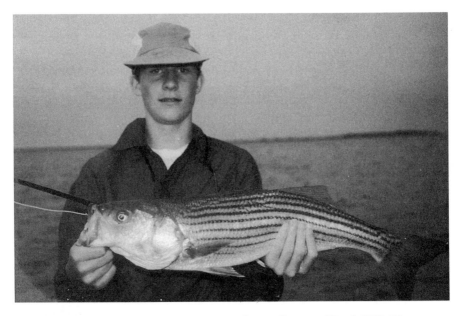

Tyler Rice with a nice June striper from a flat near Watch Hill, RI.

the dorsal fin. Large striped bass are wide-bodied, powerful fish capable of extended runs of over 100 yards, especially in heavy current.

Red Drum. This large member of the croaker family, also known as channel bass, redfish, or spot tail, has experienced a tremendous growth in population and popularity over the past ten years. Available from the Chesapeake south to the Gulf coast, they offer the saltwater fly rodder the opportunity to cast a fly to a large, relatively easy-to-fool game fish while wading in shallow water. Call tackle shops and do some homework ahead of time to locate wadable flats and beaches when visiting redfish country. Big bull reds pull hard and make powerful sustained runs. Be sure to have at least 150 yards of backing when reds of 20 pounds or more can be expected. They have no teeth but are equipped with powerful crushers in the back of the throat. Keep fingers out of this area! Bendbacks are excellent when reds are on the weedy flats, and chartreuse and white Clouser Minnows are hard to beat in deeper waters.

Weakfish and Spotted Sea Trout. These two members of the croaker family offer great fly-fishing opportunities to young anglers from Massachusetts to the Gulf coast. They are usually found near weedy areas, where they feed on shrimp and small baitfish. The weakfish, also called tiderunner or graytrout, is softer fleshed, silver colored, and found from Florida to just above Cape Cod. The spotted sea trout, also known as speckled trout, is beautifully spotted and is considered an exceptional food fish. It is occasionally

found as far north as New York but is most common from the Chesapeake south around the Gulf coast to Texas. Both have sharp teeth at the very tip of the mouth; however, the teeth are long and the mono leader will slip between them, making a wire trace unnecessary. To hold these slippery fish, apply a firm grip behind the head, being careful to avoid the sharp dorsal fin. These fish are not particularly strong fighters and will not require any special tackle. The sea trout's habit of hunting for baitfish and shrimp in the holes and deep spots makes it a prime candidate for a well-placed bendback.

WADING

Most shore-based fly fishing will involve wading. Chapter 8 looks at wading in depth, but there are certain special considerations for wading in the ocean:

- If waders are used, be sure they are boot-foot. Stocking-foot waders will fill with sand and shells quickly.
- Chest waders geared with a wading belt are preferred for most situations. Waves will usually crash over hip boots and may cause a dangerous situation if the boots suddenly fill up.
- When wet-wading, wear shoes with good support and tight-fitting tops to keep debris out. High-top sneakers, old tropical army boots, and specially designed wading shoes are all acceptable. Long pants are also suggested for added protection from sun and injury.
- Shuffle your feet along the bottom to avoid stepping directly on any stingrays that may be hidden in the sand.
- Wear metal cleats or "Korkers" whenever fishing on jetties, large rocks, or anywhere that it may be slippery.
- Wade in shallow water only. Move slowly and carefully, especially in unknown waters.
- Avoid muck and mud bottoms unless they are firm and wadable. A bottom that starts out soft may get softer as you go deeper. Back out slowly from these places.
- Be aware of when the tide will change, and know the effect the tide change will have on your exit from the water.
- Exit immediately at any sign of a shark or other possible danger.
- Never drag a stringer of fish along through the water if there is even the remote possibility of sharks being in the area.
- When wading saltwater flats at night or in the fog, carry a compass and flashlight, always fish with a companion, and *be sure* you always know which direction leads to shore.
- Stay back from the deep edges of surf or currents. Sand or shells can be washed out easily from underfoot, and an undertow can pull over even a strong swimmer.
- Don't take any chances; the sea is unforgiving!

GUIDES

The first experience many anglers have in saltwater fly fishing is orchestrated by a professional guide. If this is affordable, it's the best way to go. A good guide will expose his or her clients to an amazing number of wonderful and exciting experiences. A good day with a guide is worth every penny of the daily fee and can create unforgettable memories. A bad day with an uncaring guide, however, can be an expensive nightmare. Choose a guide by getting recommendations from people whose judgment you trust. Be sure the guide is willing to work with youngsters and beginners. Make reservations well in advance; competent, popular, and experienced guides are usually booked months ahead, especially during the most productive times of the year.

The more you prepare and practice for the trip, the more successful it will be. Concentrate on working with casting and retrieval skills. Be sure the line can be picked up and cast accurately in any direction, with few backcasts.

Work on picking up 30 to 40 feet of line off the water in one direction and, with one false cast, delivering it 50 or 60 feet in another direction. Tune in to what 40, 50, and 60 feet really look like.

Guides will usually indicate the spot where they want you to cast by using the face of the clock as a reference. Noon is directly to the front (bow) of the boat, 1 o'clock to the right, and 11 to the left. A typical command would be "Redfish coming at you at 60 feet, 10 o'clock cast, *now!*" Your guide will expect you to cast the fly where he tells you, when he tells you, even if you don't see the fish.

Practice casting and presentation skills with this in mind. The instructor can take the place of the guide and shout out commands to the caster. This sort of practice can pay big dividends when drifting a saltwater flat.

Guides do this sort of work because they love it. Conscientious practice will make the fly fisher more proficient, which will make both the guide and the client happier on the water. Do some study ahead of time and show him you've cared enough to practice and are ready when the time comes. "Great cast! You got 'em!" Magic.

CONSERVATION

The oceans of the world are under attack from a diversity of interests looking to plunder and deplete our marine resources for monetary gain. Coastal environments are destroyed to make way for development. Commercial fishermen are working their way through the magnificent variety of species the sea has to offer, rendering each economically unviable, then moving along to capture and market long-lived, very vulnerable deepwater species like the orange roughy and apex predators like sharks and billfish. Concerned sport-

fishers and dedicated conservationists have joined together to meet the challenge of protecting the inhabitants of the oceans from complete devastation. The following groups look after our interests, and they deserve our support:

AMERICAN LITTORAL SOCIETY
Sandy Hook Highlands, NJ 07732

COASTAL CONSERVATION ASSOCIATION
4801 Woodway, Suite 220 West
Houston, TX 77056

INTERNATIONAL GAME FISH ASSOCIATION
1301 E. Atlantic Blvd.
Pompano Beach, FL 33060

NATIONAL COALITION FOR MARINE CONSERVATION
3 W. Market St.
Leesburg, VA 22075

STRIPERS UNLIMITED
P.O. Box 3045
South Attleboro, MA 02703

BILLFISH FOUNDATION
2419 E. Commercial Blvd., Suite 303
Ft. Lauderdale, FL 33308

8

Field Trips

Once the young angler has learned the basics, gotten the appropriate equipment, and spent some time practicing, it's time to head out into the field to put his or her recently acquired skills, brand new outfit, and freshly tied flies to the test. But first you need to do some planning and preparation.

PREPARATION
If this is a community program and involves other people's kids, personally contact all parents and discuss the trip with them. Your organization may wish to provide required permission slips for the parents to sign.

You need to have proper liability insurance, provided either by a support organization or through a homeowner's policy. Speak to a representative of the organizations or an insurance agent to make sure you have appropriate coverage.

Ask the parents of each youngster to note all medical conditions and ensure that proper medications are available. Ask for details, and also find out about any allergies to insects or plants and the proper procedure in the event a problem arises. Many organizations have medical and liability release forms for the instructor to use, but note that this does not completely relieve you from any responsibility.

If the youngsters will be taking leave from school, it may be necessary to send a letter with them to the proper authorities requesting time off. It is wise to build bridges with the faculty and administrators of the local schools. They will be of great help in making the trip and program a success. This may open the door for youngsters to gain valuable credits and acclaim for fly-fishing-related activities in the school system.

A list of what to take along and what to expect should be given to each child well in advance. It may include a variety of items, depending on the destination, expected length of stay, time of year, and age of the youngsters.

Here is a typical checklist and basic set of instructions the kids can use to get prepared. Give a second copy to the parents for reference.

Rod and reel (in good shape, ready to use)
Flies (in boxes, hooks sharpened)
Vest or small pack (filled with necessary items, double-checked!)
Extra clothes (wool sweater, socks, pants, etc. to fit conditions)
Waders (checked for leaks, plus suspenders, belt, straps for hip boots)
Personal items (sleeping bag, towel, toothbrush, soap, etc.)
Sunglasses (cleaned and with a strap to hold them on)
Sunscreen (proper strength for the conditions)
Insect repellent (the right kind for the insects expected to be encountered)
Rain jacket (and/or water-repellent windbreaker)
Stripping baskets (for saltwater fishing only)
Water bottle (size to be carried in pack)
Medications (along with directions on how and when to use and emergency numbers)
The instructions should include the following information:

We will leave on (date), at (time) from (place). We will return on (date), at about (time). Please call (instructor's home phone number, even if you know they already have it) if you need to make special arrangements.

You will need (amount of money) for food, etc. Bring along a lunch to eat on the way and a small cooler for snacks.

Here is the phone number where we can be contacted during the

From the very beginning, fishing was for me a way to be with my father and a way for me to be outdoors. It has always had more to do with the *being* than the doing. Early on, my brother and I were taught how to find worms, bait hooks, read water, stalk trout, sneak up on pools, and always be observant and patient. When we were very young, we worm-fished while Dad fly-fished.

Part of the great attraction was rolling the car out of the driveway so as not to wake my mother, popping the clutch on the old Renault as it rolled down Indian Lane, returning with trout for breakfast, and then getting dressed for school.

—Page Rogers, minister and saltwater fly designer

entire trip: (phone number, name of contact person, and position, such as ranger, owner, etc.)

A preliminary meeting a day or two in advance of the trip is highly recommended. During this session, tackle can be assembled and checked out, leaders tied, flies discussed, waders inspected for leaks, and a general overview given of what's expected. This can be as much fun as the actual trip if it's planned right. It will help the entire outing run more smoothly by addressing potential problems and making sure things are in working order well before heading out to the water. Include a couple of pizzas and a fishing video or two, along with tall tales, and you have the makings of an exciting, productive, and entertaining meeting.

Practice knots, sharpen hooks, and check tackle well before departing. Time on the water is too precious to be spent fooling with things that should have been prepared beforehand. Unexpected, time-consuming problems are bound to occur during the trip, so you should do as much as possible before leaving. This is a very important lesson that should become second nature to you and your students: *The ultimate success of a fishing trip is determined before you ever leave home.*

On any extended walk along the waterside with youngsters, the instructor should carry along a small backpack or daypack stocked with several essential items. A large utility pocket in the back of a fishing vest will also serve the purpose. I keep a small pack stocked for outings with kids. The contents are mostly inexpensive and cover a wide range of needs. Some of the more costly items might have to serve double duty elsewhere but always get returned to the pack. Here's a partial list that you can add to as conditions warrant:

- First-aid kit and related items (see Safety section later in this chapter).
- Tape measure (cloth type from fabric store works best).
- Small flashlight, with spare batteries and a lanyard to hang around the neck.
- Small pliers and/or vise grips.
- 10 feet or so of strong rope.
- Compass.
- Logbook and pencil.
- Camera, with extra roll of film and batteries in a Ziploc bag.
- A few pairs of Polaroid sunglasses with straps.
- A few dollars in change.
- Snacks.
- Water bottle.
- Small pair of binoculars in waterproof case.

- Spare reels and spools.
- Lines of different types.
- Spare spools of tippet material.
- 5-minute epoxy.
- Small Phillips-head and regular screwdrivers.
- Trash bags.

Whenever we're going to fish a beach and a long hike is likely, and we intend to stay at least through the entire tide, I also take along a small cooler loaded with some essentials: a loaf or two of bread, peanut butter, jelly, a knife, a spoon, maybe some fruit, drinks, and a few other treats. This is a pain to lug out onto the beach, so take turns carrying it. The food will come in very handy when the stay is longer than anticipated. If you don't already know this, teenagers can eat lots, are always hungry, and never carry enough food with them! It will also serve as a nice way to meet fellow anglers. We've shared many a peanut butter sandwich on the beach with new local acquaintances who became fast friends and have since introduced us to some of our favorite "secret" hot spots.

THE TRIP

A field trip with a group of young fly fishers can usually be labeled as *fishing* or *nonfishing*. More often than not, each excursion will be a combination of the two and, as such, will become a diverse and very exciting adventure! Whatever the purpose of the trip, any adventure with a bunch of young eager anglers will involve many educational opportunities. These may not be immediately obvious and will come in many forms. I strongly urge the youth leader to anticipate their appearance and make the most of any solid chance to help these youngsters grow in a variety of areas.

On early trips, to get the most out of this precious time afield, some consideration should be given to constructing a schedule in advance. After a few trips, this won't be as necessary; it will become automatic, and a marvelous, spontaneous sort of energy will propel the group along, making the most of an outing.

Nonfishing Trips

Nonfishing trips can be lots of fun and can be done in conjunction with any angling sojourn. Museums, fly shops, college campuses, equipment manufacturers, and hatcheries are all wonderful spots to include in a day trip. We always combine hikes along with any of our camping trips. Plan for these side adventures and pack accordingly.

Fly-fishing and fly-tying shows make for exciting and memorable experiences. From November through April, something of interest to fly fishers can

M y earliest days of fishing proved to be an introduction to the environment as a whole. My dad was familiar with this pond, as it was on the southern border of an estate where he had been a night watchman before joining the police department.

We would venture into the woods along the east bank of the pond, following animal paths through the brush and trees. My father pointed out the bones and hide of a mole that an owl had regurgitated in the woods. I was amazed to think that the owl would digest the important parts of its kill and rid itself of the rest. I learned to identify the scat of rabbits, foxes, coons, and squirrels. A pile of feathers along with the remnants of a wing or two indicated that a fox had recently dined on a ringneck. Little did I know that in later years I would be salvaging these feathers in order to tie Muddler Minnows.

—Bill Peabody, saltwater fly tier

Hannes Maddens gets a few casting tips, before the show is opened, from two of the best: Lefty Kreh (left) and Bob Clouser.

be found within a few hours' drive of almost any home. Look through maga-
zines or give the outdoor editor of the local newspaper a call. Well-known fly
fishers should be in attendance. The newest fishing gear will be on display.
It's a unique opportunity to cast some very expensive fly rods and meet some
interesting people, and it should prove to be an enjoyable and educational
experience for fly fishers of all ages. Kids can usually get in free or inexpen-
sively and may even have the opportunity to receive some free fly-tying les-
sons. The Fly Fisher Apprentice Program teaches several hundred youngsters
at shows along the East Coast each year. Stop by and visit us!

Stream-sampling and bug-collecting safaris are another form of nonfish-
ing trip. These are a must for the budding young angler and are covered in
detail in chapter 9.

Fishing Trips
When planning the initial fishing excursion with new young anglers, it is
important to keep three goals in mind: achieve some angling success, ensure
comfortable conditions, and strive to avoid mishaps. This roughly trans-
lates into lots of easy-to-catch fish, plenty of backcast room, and constant
supervision.

First off, it is important that the youngsters achieve some initial success.
This prevents boredom and frustration and keeps enthusiasm and excite-
ment levels high. Avoid trips to areas with difficult terrain, large crowds,
banks lined with overhanging bushes, or dangerous, difficult-to-wade waters.
Heavily fished waters with wary trout are not a good choice.

Opt for destinations that provide open shorelines, comfortable spots to
rest for lunch, easy access, and generally pleasant surroundings. Leave all
pets and baby brothers and sisters at home. Your complete attention must be
devoted to the apprentice fly fishers, and the young anglers need to give their
full attention to the task at hand.

Choose a familiar area for the initial trip. There's a distinct advantage in
knowing the lay of the land, the wading hazards, the places where fish are
most likely to be found, and the best way to achieve angling success. In an
unfamiliar area, seek the advice of local "experts." They are often especially
willing to help out young fly fishers.

A day or two before the outing, take a quick "reconnaissance mission" to
the area and look it over with the eyes of a mentor. Plot your strategy and
determine ahead of time where the easiest drifts, least hazards, and best
backcast opportunities lie. This brief inspection of the area may save some
headaches, as well as help instill the peace of mind needed to confidently
lead the expedition.

If one is nearby, a farm pond stocked with bluegills, pumpkinseeds, and

largemouth bass is an ideal situation for beginning anglers. Contact your local cooperative extension office for a list of area ponds. The folks there are usually very familiar with the local pond owners and can recommend the best possibilities for success. The cooperative extension office is also a rich source for a variety of publications on insects, watersheds, and local flora and fauna, as well as information on exciting educational possibilities for the young fly fisher.

Be sure to get permission from the owner (a big "Thank you!" from the kids is also in order). Ask him or her for the best spots to fish and instructions on what should be done with the fish after they are caught. It may come as a surprise to everyone that tossing the fish into the bushes for the "coons" might be the suggested procedure for some "stunted" ponds, which have many small fish due to overcrowding.

Casting small poppers or large dry and wet flies will be productive and lots of fun. Along with the fly outfits, it's wise to take along a spinning rod or two, some hooks, and maybe even a few garden hackle. Gathering bait from the fields and around the edge of the pond may add to the kids' adventure. Don't hesitate to tip the youngsters' wet flies with tasty red wigglers to enhance their appeal. In the case of farm ponds full of eager bluegills and bass, however, this is seldom necessary.

Stocked trout can also serve as easy targets for your budding fly fishers. Few game fish are more eager to attack even a poorly presented or tied fly than a freshly stocked brown, brook, or rainbow. Most states that harbor reasonable numbers of these popular game fish have stocking programs that include easily accessible ponds and streams. Contact the local State Department of Natural Resources (DNR) or Department of Environmental Conservation (DEC) to get a list of species and stocking locations in the local waters.

Also consider approaching these folks well ahead of the season opener and asking to be included on their list of stocking assistants. This will be an advantage in two important ways. First, stocking fish is a fun outing for the kids and can be full of all sorts of fish-handling and conservation lessons. Schedule a trip to the hatchery during the winter, well ahead of opening day. The kids will get a tour and see where all those fish come from, and may even be in for some hands-on fun. Excitement will build into the spring, and the stream-stocking experience will be eagerly anticipated.

The second advantage is knowing firsthand where all the fish have been dumped. This will lay the foundation for a return fishing trip to those areas in the coming weeks, with the knowledge that some easy-to-catch stocked fish, or stockies, will be in residence. Avoid promoting a "hatchery truck chasing" mentality by downplaying the temptation to go back too soon and catch those newly-stocked fish. And don't take fly rods along on these trips,

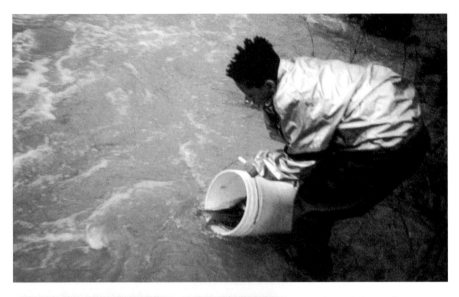

Stocking fish can be great fun and very informative.

Stef Jirka removes eggs from an adult King salmon at the Salmon River Hatchery Lake Ontario, Altmar, NY.

even if it's open season. Stocked fish should be given at least several days to spread out and take up residence; to fish for them as soon as they are dumped in the stream is considered highly unethical.

Depending on your personal beliefs and intended goals for the education of these young anglers, many lessons are here for the teaching. In a well-rounded, ethically based, and environmentally sound youth fly-fishing education program, you need to make sure your zeal for catching doesn't obscure your final goal of creating concerned, caring stewards of the resource.

In the beginning, catching a panfish or stocked trout on a fly is a marvelous way to get the young anglers excited about the sport. They've worked hard, faithfully tied flies, diligently practiced learning to handle the long rod, and spent many evenings reading about the life cycles of the insects and the fish that prey on them. The firm tug on the line at the end of even a poorly executed cast, with a not exactly anatomically correct nymph imitation, tied to the leader with a less-than-perfect clinch knot, is a great thrill and a suitable reward for the youngster's efforts.

Make this experience a bridge to the complete understanding of how the entire system works. All young anglers should learn why we need to stock trout and why all native species are such precious and wonderful treasures.

Use these early stocked trout and panfish angling successes to teach the lessons of predator and prey. Allow the kids to make the decisions of life or death for their captured prizes. Instill a thoughtful respect in the budding angler for all living things encountered in every aspect of the fly-fishing experience.

As a mentor, you are helping to build a foundation for the youngster's understanding of many things in life, not just teaching him or her to catch a fish. Take advantage of teachable moments, and revel, along with the young apprentices, in their new discoveries.

WADING

Every fly fisher sooner or later is likely to wind up in a situation where wading will be preferred, if not absolutely vital, for success. Since some of the most productive fly fishing may occur under potentially dangerous conditions, proper judgment, knowledge of your youngsters' abilities, familiarity with the area, and common sense become matters of life and death. *Never underestimate the power of water or overestimate the abilities and common sense of your kids.*

This section gives basic guidelines on the dos and don'ts of wading, proper equipment, and related activities. If necessary, tailor your approach to fit your own situation. Special saltwater situations are addressed in chapter 7.

The decision to wade or not should be made by the individual mentor.

Small, lightweight children should be kept far away from even mild current. Kids that cannot be trusted should be left at home.

Waders

If wading will be part of the program, proper wading attire must be decided on. There are three basic methods of dressing for a variety of wading conditions:

1. *Wet wading.* This is wading done without the benefit of any water-proofing equipment. Water and air temperatures must be comfortable for the person who will be wading. In the southern climes, this may be almost any time of the year; in the north, wet wading may be relegated to the summer months. I recommend long pants for protection from the sun and possible injury while wading or walking along the shoreline. Footwear should be over the ankle for support and have soles that will not slip, such as felt or cleats. Specially made wading boots are the best choice, and gravel guards are a worthwhile addition.

2. *Hip boots.* Hip boots are used when only shallow wading is expected. Soles that grip well are mandatory. A strap at the top of the boot is attached to the angler's belt to hold the boots in place. A pair of suspenders worn while wading will help keep boots (and pants) from slipping down. A buckled strap will be built into the top of the boot. This should be tightened when the boot is being worn. It will make the boots more comfortable to wear, and if a fall does occur, water will not fill up the boots and make it difficult for the wader to regain his footing.

3. *Chest waders.* Standard chest waders usually reach up to just below the angler's collarbone and are used for deep wading situations. A pair of special suspenders is usually included with better-quality waders but must be purchased separately with most others. A wading belt must be worn around the outside of the chest waders to help support the weight of the boots and prevent water from filling them if the angler falls in. Chest waders come in two designs:

 - *Boot-foot.* Boot-foot waders have the boot built into the wader and are usually warmer than stocking-foot waders. They are recommended for wading very cold water and are ideal for saltwater applications. Boot-foot waders are probably the more common type on the stream.
 - *Stocking-foot.* Stocking-foot waders are worn with wading boots or shoes. The wading boot and stocking-foot combination will probably cost more than an equivalent pair of boot-foots; however, they are more flexible, easier to wade in, less awkward, and give the ankles more support.

Some folks recommend that youngsters wear hip boots, feeling that they may be encouraged to wade in waters that are too deep and potentially unsafe if they are wearing chest waders. Advocates of chest waders believe that hip boots will fill up too quickly in a fall and will impede a youngster's efforts to get back on his or her feet. They feel that a snug-fitting pair of neoprenes or other chest waders secured with a wading belt afford a much greater degree of protection and will keep the child afloat much longer than even the snuggest hippers.

To decide what's best for your youngsters, weigh the pros and cons of each type of wader. Make a list of the fishing spots that you will be frequenting and the conditions you'll find there. This, coupled with firsthand knowledge of the youngsters who will be involved, will help you make a prudent decision.

Wader Materials. Waders can be found constructed with a variety of materials, in a multitude of designs, and in several price ranges. The three most common materials are vinyl, rubber, and neoprene. "Breathable" waders, constructed from new high-tech fabrics, are also available, and several other models use combinations of various materials.

Vinyl waders are usually the most inexpensive and readily available. This type is especially practical in special lightweight, warm-weather, or fly-weight designs. However, vinyl waders tend to tear easily and will not hold up under heavy usage.

Rubber in many forms and combinations—nylon-coated, insulated, layers, or plain—has been the standard wader material for years. Waders of different qualities are available in a variety of prices. Boot-foot rubber waders are excellent for most saltwater applications. Rubber chest waders tend to be heavy, hard to move around in, and uncomfortable in hot weather. However, if properly taken care of, a pair of rubber waders will give the angler many years of leak-free service.

In recent years, neoprene has become the wading material of choice for many anglers, and in cold weather, it cannot be beaten. This material also fits the body more snugly, is very comfortable, easier to walk in, and less likely to fill with water if a fall occurs. Neoprene waders are available with double knees for longer wear, in various weights (heavier being thicker and warmer), with hand warmers on the front panel (a must for cold weather), and in many price ranges. Boot-foot neoprene waders are fine for saltwater use and excellent for very cold wading, where the water barely rises over 30 degrees F.

Purchasing Waders and Accessories. Kid-size stocking-foot neoprene chest waders are available from many companies and are the best choice if you have decided to go with chest waders. If most wading will be done

during the warmer months, lightweight stocking-foot vinyl is a good second choice. The same wading shoes can be used for both.

When buying waders for a youngster, be sure they fit properly. Baggy waders will weigh a youngster down and inhibit movement. Have him or her try on the waders and walk around a bit. Be sure the child can easily lift his or her foot up to at least knee height. There's a tendency to buy items for kids in a size that they can grow into; avoid doing that when it comes to waders. Finding the best type and correct size waders for youngsters may take some doing. It's well worth the effort, however, because improperly fitting waders are very awkward to move about in and can endanger the young angler.

Wading boots or shoes will give the young angler more support than boot-foot waders. Be sure any wading boot has good nonskid bottoms covered with felt or, better yet, a combination of felt and metal cleats. These boots can also be used for wet wading or with vinyl or neoprene stocking-foot waders. Wading sandals outfitted with cleats, which fit over wading boots or shoes, allow for sure-footed wading, but they may be clumsy for very young anglers to handle and may cause more problems than they're worth.

A snug-fitting *wading belt* is mandatory with any type of chest waders. It helps keep water from filling the boots if the angler falls and, in addition to the suspenders, offers extra support for the weight of the waders. It also may serve as a great "handle" for an adult to help a fallen young angler to his or her feet.

Wading Staffs, Life Vests, and Personal Flotation Devices

Having the children use wading staffs and life vests when wading will increase the measure of safety. Wading staffs can be made from an inexpensive mop handle, a paint roller extension, a ski pole with the basket removed, or a sturdy stick. Fold-up staffs are available at the local fly shop for about $40. Snug-fitting life jackets that double as fishing vests are available at most department stores and marinas or through a good fishing catalog.

When fishing big waters or from boats, youngsters and physically disabled individuals should wear life vests or other personal flotation devices (PFDs) at all times. For teens and adults, the decision should be based on whether they are strong swimmers and the conditions. Use common sense.

There are various types of PFDs and which to use is up to the individual. The person who will be using the PFD should try it on before buying and, if possible, should try it out in the water. Even though a PFD fits well in the store, it may not work satisfactorily when worn in the water. If it does not fit snugly, it will not be comfortable and will not provide proper flotation. If it is not comfortable and does not allow for easy casting and fishing, the angler will not want to wear it.

Wading Safety

If you've decided to include wading as part of your youth fly-fishing program, it's imperative that you teach the youngsters proper wading procedures and emergency actions. They also should become familiar with their wading equipment before going out in the field.

Proper Wading Procedures. The following are important principles for wading safely. Teach these to your young anglers before they venture out into the water.

- *Think before you enter the water.* Is wading really necessary? It's always better not to wade if possible. It's safer, and you won't scare fish as easily. It's much easier to avoid a dangerous situation than to get out of one. Plan your route ahead of time. The head and tail out of a pool are always faster and more treacherous than calmer water.
- *Find out about possibly dangerous situations.* Always do some investigation in unfamiliar waters. Check for treacherous footing, dropoffs, underwater hazards, floating debris, or ice floes. Make sure beforehand that there are no planned dam releases, and avoid areas with powerboat traffic.
- *Use proper wading gear.* The lightest, most comfortable waders are best for the job. Dress properly for cold weather, but avoid a long walk in heavy winter gear; instead, remove a few layers and carry as much as is comfortable to the destination to avoid overheating. Felt soles can build up uncomfortable layers of ice in long walks through the snow; this ice will come off upon contact with the water. Be sure the soles give proper grip for the situation. Felt soles are a minimal precaution; metal cleats may be needed if the bottom is very slippery or icy.
- *Use a wading staff.* A wading staff is useful to feel ahead for deep water and to add stability. To properly use the staff, always hold it in the upstream hand, and move the corresponding foot first along with it. Use short steps and a shuffling sort of motion.
- *The fly rod can also be used as a wading tool.* Few anglers understand the value of the fly rod in wading. It can be held out to the side and used to help in keeping balance. It can be plunged or slapped into the water to break a fall or to serve as a solid anchor, using the resistance of the current pushing against it. Don't be concerned about the rod; a good graphite rod can take a bit of abuse, and in an emergency situation, who cares?
- *Shuffle the feet rather than take big steps.* Take small steps, feeling along for solid footing and watching for deeper water. Be sure one foot is firmly in place before moving the other. Never jump over a rock or log; go around it. Tops of large rocks may be slippery and in heavy

A submerged fly rod serves as an anchor to help keep balance.

current will not give a solid resting spot. Step on small patches of gravel between rockpiles when possible, but watch out for large areas of deep, loose gravel and sand that may wash out from underfoot. Avoid wading in mucky or muddy areas; such places offer treacherous footing and when disturbed will fill the stream with suspended silt.

- *Always walk sideways into any current.* Present the narrowest profile possible to the current. Never go directly upstream or downstream; always angle into the current.
- *Avoid deep water and fast-moving shallow water.* Deeper water will tend to float lightweight youngsters and cause them to lose their footing. But also beware of fast-moving shallow water, which may sweep the feet out from under a youngster.
- *Take care even in shallow water.* Drowning is not the only danger in wading. When wading along a very shallow shoreline, the youngsters often tend to drop their guard and wade carelessly. A slip or trip can send them tumbling onto a rock or log, causing serious injury.
- *Buddy wading.* Occasionally it may be necessary for the group to team up and wade an area together. The largest, most stable person should be positioned upstream to act as a current break for the others. It's

*Jesse Sandvik
demonstrates how to
walk across current.*

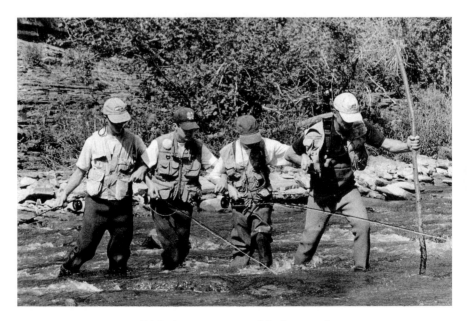

Eight legs are more stable than two!

wise for the lead person to use a wading staff. The other anglers should hold hands or lock arms and cross in small, deliberate steps. The combined weight, along with all those legs, will make for a stable unit and should facilitate a safe crossing.

Emergency Situations. If a problem arises, don't panic. Stop, keep calm, and look over the situation. If you feel out of control while wading, try to regain solid footing and back up slowly along the path by which you came. If this is not possible and you have to turn in midstream, do it slowly. This is one of the most dangerous wading situations and must be done properly. Always turn *into* the current, facing it as briefly as possible. Plant the *downstream* foot firmly, and gradually move the *upstream* foot first. Set that foot firmly, and then bring the other one around. *Never turn with your back to the current.* The current will push you forward, and it will be difficult to regain your balance.

If you become caught in the current, the only thing you can do is go with it, gradually making your way to the shallows. Having a tight wading belt properly in place will give you some buoyancy, and hopping on tiptoe will help you along. If the current knocks you down, turn face-up with feet facing downstream, and work your way toward shore. Avoid being swept into the upstream side of a brush pile, deadfall, or undercut bank; you may be pushed under and trapped. The downstream side of such an obstacle may have calmer, easier-to-exit water.

Practice

Wading practice during warm days on safe waters is recommended. This, combined with a bug stream safari (see chapter 9), can make for a fun non-fishing day. Have the youngsters take along a dry set of clothes and some towels. Pick a shallow, easy section of stream without a lot of sharp rocks or branches.

Begin by going over stream safety and proper wading procedure. Show them the proper form in an emergency (see Emergency Situation, above). Have them get used to moving about in their waders. Ask them to sit down in the water and fill up their boots, then try to get up. Direct them in wading across sections individually and as a group, with fly rods in hand. The more skills they learn prior to the actual fishing experience, the more smoothly all will go.

Always keep all of the youngsters in sight and within a few seconds of you. Have them stay in pairs and wade across even easy stretches together or with you. Locking yourselves together and crossing in a bunch will give you much more stability.

In wading, it's critical that the youngsters observe the safety precautions you teach them. If one of your youngsters cannot be trusted and insists on

fooling around, leave him or her at home. The waterside is not the place to teach discipline. Be absolutely sure everyone can be trusted and will respond to your command *immediately.* You are the absolute authority; there is no place here for anything less. This may seem a little harsh, but the consequences of a poorly made decision by a youngster or teen who is second-guessing your judgment can be devastating.

FLY-FISHING FROM BOATS

There is a lot of great fishing water that can't be reached by wading, and many exciting experiences await your youngsters when they shove off for a day on a lake, river, or ocean. This section provides only brief coverage of this enormous area of fishing. If you need more detailed information, contact your local Coast Guard Auxiliary or a marina for advice. Chapter 7 covers saltwater fishing in more depth.

Check with the support organization and the program's insurer before the trip. Some program plans cover this sort of thing; others require a small rider, which is usually inexpensive. A licensed charter captain will also have a comprehensive policy, or he couldn't be in business. It never hurts to ask.

I have yet to see a quality fishing spot with a resident population of qualified charter boats that doesn't have at least a few captains who love kids. They'll often take a group out at little or no charge. This will be the perfect introduction to fishing from a boat for the youngsters and will allow you the luxury of letting someone else give the kids an education in proper boating etiquette and operation.

Call the captain ahead of time. Find out if there's anything special you should know for the trip. Ask about the recommended number of passengers and how many kids will be able to fish at a time. Find out exactly what is expected of you in terms of lunch, cooler space, tackle, clothing, recommended tip for the mate, final total cost, and other details.

Some charter boats are designed for fly fishing; most are not. Ask the captain about the procedures and for his recommendations. If he fly-fishes regularly, there should be little problem. If he doesn't, be sure he knows that your group would like to, if it's okay with him. In any case, bring your own rods, reels, and flies. The captain will also have suggestions for these.

Before showing up at the dock, be sure the kids know that the captain is the boss, and whatever he says, goes. Period. On the boat, ask the captain to go over the rules with the kids. Have them become familiar with the location of the PFDs and how and when to wear them. The type of fishing and size of boat will dictate many of the rules and procedures.

Take along a few extra clothes and plenty of liquids. Also take along seasickness medication and remedies, and warn the kids ahead of time not to eat too much or anything too weird or too greasy for breakfast that morning.

Greasy sausage, butter, and eggs washed down with plenty of orange juice will spell disaster out on the rolling seas. Make is clear to the kids that once you're out there, you stay. They won't be taken back to shore if they're seasick.

Plan on giving the captain a gift from the kids. We usually take along a few Fly Fisher Apprentice T-shirts and a bunch of flies tied by the young anglers as a thank-you. Take lots of photos, and send the captain a set.

If you're not fishing with a trained charter captain, be sure that anyone operating the boats the youngsters will occupy can be trusted beyond a shadow of a doubt. Proper-fitting PFDs must be worn without question, and all rules adhered to.

Fly-fishing in a boat or canoe can be a little tricky. It helps greatly to have someone along who is familiar with the type of craft and the waters you'll be exploring.

SAFETY

Even for the most experienced fly fisher or outdoorsman, the natural world can hold some dangerous surprises. The angler must take care to avoid situations where problems may arise and be prepared to act quickly if there is trouble. In a group situation, the leader is responsible for the safety and well-being of the youngsters in his care. No fishing experience is worth putting any child or adult at serious risk. Basic precautions should always be taken.

One afternoon, while fishing the east side of Price's Neck, Ray Smith encountered a lobsterman whose skiff had just capsized and sunk. The man was yelling for help, as he was surely about to drown in the pounding whitewater of the ocean front. A nearby spin fisherman ran to the closest house to call for help, but the lobsterman was high and dry by the time a rescue team arrived.

In desperation, Ray had cast a WF10F line to the frightened man. His first cast was slightly short, but the next was on the mark, and he landed what he considers his catch of a lifetime! The 10-weight rod was stressed but, along with the line and leader, held up to enable the lobsterman to be pulled gently to a safe landing spot among the rocks.

The lucky waterman never again lobstered in the ocean, but instead pursued another occupation. Ray still fishes the Neck.

—Bill Peabody

Planning and preparation are the keys to making exciting fishing venues safe and accessible to the young anglers. Make careful note of the expected fishing conditions, and make sure the youngsters take the proper gear and attire. Teach them about safety precautions before and during the adventure. You are not only protecting your charges on the trip, but also helping them form lifelong safety habits.

First Aid

Prevention is always the best cure. Even minor physical mishaps can take the fun out of a well-planned trip. If you are a novice and feel unprepared to deal with the surprises Mother Nature may have in store, seek the help of a seasoned outdoor person.

Anyone seriously interested in running a youth fly-fishing program and accompanying young people on trips in the field should make formal first-aid training a priority. A Red Cross first-aid course is a good way to learn the basic skills needed to cope with a variety of circumstances. The Red Cross runs regular certification training courses that take only a day or so to complete. Refresher courses are recommended every three years. Also read over the *American Red Cross First Aid and Safety Handbook* occasionally and brush up on the care required for common problems you're likely to run into, such as cuts and abrasions, twisted ankles, and puncture wounds.

Be aware that the law states that a conscious victim must give consent to be helped. In the case of a minor, a reasonable attempt must be made to gain consent from a parent or guardian. Consent is implied for anyone who is severely injured, too sick to reply, or unconscious. "Good Samaritan" laws, which differ in each state, give some legal protection to rescuers who act in good faith.

Learn the location of the nearest emergency medical facility before any trip. Don't hesitate to cut a trip short if there is any question about the correct procedure for emergency treatment or any doubt as to the severity of an injury.

On any trip in the field, an emergency kit is a must. Keep it in the car at all times. Include the following items in an athletic bag:

- *Wool blankets,* needed if someone goes for an unexpected swim on a cold day.
- *Space blankets.* These are inexpensive, warm, compact, and very lightweight.
- *Heavy, clean towels.*
- *Clean, white cloths* for wiping dirt, mud, or blood from skin. Baby wipes are disposable and sanitary and are excellent to use.
- *A good first-aid kit* (available at any drugstore or from the Red Cross).

A compact first-aid kit will fit easily in a vest pocket.

- *Latex gloves* for treating any injury involving bodily fluids.
- *American Red Cross First Aid and Safety Handbook.*
- *Roll of duct tape.*
- *Length of rope.*
- *Tool kit,* including pliers, screwdrivers, sharp knife, scissors,and so on.
- *Powerful flashlight* with spare batteries.
- *Plastic garbage bags.* These can also be used as emergency rain coats or laundry bags.

Add any other articles you think are necessary. Keep these items for exclusive use on trips, and be sure the bag is stashed in the car at the beginning of each outing. Check the contents regularly for items that have a recommended shelf life and should be replaced and for supplies that need to be replenished.

For trips out on the water, carry a smaller emergency kit in a backpack along with lunch and fishing gear. Include the following items:

- A small *first-aid kit.*
- *Ace bandage.*
- *Clean bandanna* or two for sun protection or use as an emergency tourniquet.
- *Insect repellent.*
- *Sunscreen* (take enough for everyone).
- *Sunburn lotion.*
- *Rope or cord,* at least 10 feet.
- *Compass.*
- *Matches* in waterproof case.
- *Lock-blade pocketknife.*

Hook Injuries

Cuts from hooks are common when fishing. They will usually be minor puncture wounds or scrapes that need only a little cleaning and care.

A hook firmly embedded in the flesh is another matter. If the hook is barbless, it should be easy to back it out of the flesh; then clean and medicate the wound. If the hook has a barb and refuses to come out with a little coaxing, it's best to leave it and get the injured person to a physician immediately. The doctor will likely clip the shank and push it through, tearing less flesh than if trying to pull the barb out the way it went in.

To avoid hook punctures, don't leave loose hooks or flies lying about. Teach the youngsters how to remove flies from snags safely, and emphasize that they must look away when freeing a hook from a snag. A bowed rod will shoot a piece of split shot or hook back into an angler's face with tremendous force. When removing a fly, hold the fish firmly and don't have any tension on the line. Be sure the youngsters wear sunglasses or safety goggles and protective headgear at all times.

Insect Bites or Stings

Insect pests and the outdoors go hand in hand. Ticks, sand fleas, wasps, black flies, no-see-ums, horseflies, or mosquitoes can ruin even the most carefully planned trip. Take a few minutes to research what sort of insect pests you can expect at your destination. It may be the most important time you spend in the entire planning process. If the destination is unfamiliar, check with someone in the area who has intimate knowledge of what sort of crawling, flying, and biting nuisances can be expected. He or she will have valuable advice on what sort of precautions you should take and may throw in a fishing tip or two as well!

Pack plenty of the proper insect repellent. When applying it, avoid getting it on any fishing equipment. Apply liquid and creams with the backs of

A hook in the eye can be a very painful and frightening experience. Get to a doctor quickly.

Safety glasses are the key to eye safety.

the hands. Keep hands clean and spray well away from fly lines. Insect spray may dissolve the finish on reels and rods, as well as destroy the vinyl coating on fly lines. Long-sleeved shirts and pants with tight-fitting cuffs are usually recommended where insects are a problem. Insect screening may be helpful in extreme situations.

If ticks are present, avoid brushing into bushes or limbs or walking through tall grass or weeds. Lyme disease is a serious matter. Detailed information is readily available in all areas where Lyme-carrying ticks are common, from sources such as tackle shops, campgrounds, or tourist centers. Become familiar with these pests, dress appropriately, and don't spare the repellent. Make a regular tick check of all parts of the body a mandatory activity a few times a day and at the end of each outing. Have everyone pay special attention to any areas on their body where hair is present and to the seams of their clothing. Check any pets that were taken along. Shake out all clothes before taking them inside a tent, house, or car.

Find out before the trip if anyone is the group is allergic to any type of

insect sting. Ask the parents about the recommended procedures in the event these children are stung, and be sure to have proper medication along at all times. If poisonous snakes may be a problem, bring along a snakebite kit, wear the proper clothing, or better yet, go someplace else!

The Elements

It's a safe bet that left on their own, most kids will venture out on a trip ill prepared to cope with the elements. Most youngsters do not have the detailed knowledge or common sense to dress appropriately for the occasion and will need some advice from parents and mentors. Proper planning before a trip will help them dress correctly and stay as dry and comfortable as possible. Children should be advised not to take their good clothes along on fishing trips. It's a good idea to stock up on some inexpensive but serviceable "fishin' stuff."

No matter what the destination, if it's a fishing trip, water will surely be involved, which means wet clothes and wet kids. It is mandatory that each youngster have his or her own bag packed with a complete change of clean clothes and a towel or two. Loose clothes will only lead to a real mess. Items will be lost, forgotten, and left in the vehicle. I have a box of odds and ends sitting in my workshop to prove it!

The Sun. The fly fisher should take a broad-billed cap and sunglasses on all trips. They will serve as both protection from the elements and a shield from any errant casts. The cap should be dark under the brim (color it with a permanent market if necessary) and made of a comfortable, breathable material. A classic "up-downer" type of fishing hat with a flap in the back that can be folded down over the neck is best. The brim will help shield the face from the sun, and the dark undersurface will reduce glare from the sun on the water. This will ease eyestrain and help the fly fisher get a better view of what's going on beneath the surface. A blue cowboy-type bandanna worn around the neck will provide additional protection and may come in handy in a number of situations.

Sunglasses should be polarized and have an adjustable strap to hold them on even if the face becomes wet from perspiration. Trip leaders should carry along a few extra pairs of inexpensive polarized sunglasses. More often than not they will be needed.

Don't spare the sunscreen. Use at least SPF 15, and be sure it is waterproof. Have each youngster bring his or her own supply. Use the backs of your hands to apply the sunscreen, and clean the hands thoroughly after use to avoid getting it on equipment. When applying sunscreen, have the young anglers pay special attention to the backs of ears and necks and the ends of noses. A tube of lip protection is also a good idea.

Long-sleeved shirts and long pants are usually recommended for sun protection. Be sure they are lightweight enough to avoid overheating. Use subtle colors that will blend into the background and not stand out so that the fish will not detect you. Some anglers go as far as wearing camouflage. In hot weather, light colors will absorb less heat and serve as good, inconspicuous protection.

Take along some fresh water (the new "snap-cap" plastic bottles are ideal) to prevent dehydration, and carry a few snacks that won't melt in the heat.

Cold and Wet Weather. Some of the best fishing in both fresh and salt water occurs in the fall and early spring. Although this means colder temperatures, wind, and rain, most dedicated young anglers will happily brave some pretty drastic conditions for a go at a big steelhead or striped bass.

For cold-weather fishing, have the youngsters dress in layers, first a turtleneck, then a shirt and a wool sweater, topped by a nylon windbreaker for protection from wind *and* sharp hooks. A cheap, easily carried rain jacket should be stashed in the youngster's pack or vest.

It's hard to beat wool for warmth, even when it's wet. Army-Navy stores always have a great supply of low-priced, early-issue, tight-knit sweaters (which hooks are less likely to penetrate), watch caps, and socks. Make shopping for fishing clothes into an outing and descend upon the local Army-Navy store en masse. It will be fun, and the kids will all get what they need.

Good rain gear and windbreakers are critical. Outdoor and Army-Navy stores offer a variety of choices in a wide price range. Everything from inexpensive vinyl ponchos to top-of-the-line full rain suits may be used. Something in between is best, with major consideration being given to the budget and general needs. Rain jackets are available in rubber, vinyl, and a range of new breathable waterproof fabrics. For saltwater angling conditions, rubber or heavy vinyl pullovers without metal components are the best bet to hold up to the salt spray.

Specially designed fly-fishing or wading jackets are great. They are made for wading and usually have big pockets to carry fly boxes and other gear. The fishing style and the age of the participants will dictate the lengths that should be used. Waist length or shorter jackets may be best for older kids who can wade safely up to the waist in chest waders. Youngsters in hip boots might need the added protection of longer coats. The call is yours. Most full-line fly shops carry a selection of wading jackets. Parents should get the best quality that will fit the budget.

Severe Weather. Take along a weather radio if severe wind or weather may be a factor. Be especially aware of possible thunderstorms. At any sign of danger, get off the water fast! Give the kids a pretrip lecture of what they

need to do if lightning is a threat: They should lay down graphite rods immediately, as they will attract lighting, and get indoors if possible. If not, they should stay away from high points, such as hilltops, tall trees, flagpoles, and tall fences, as well as from metal buildings and open fields.

Hypothermia

Hypothermia occurs when the body loses heat faster than it can produce it. While fishing, this may be caused by a dunking on a cold day.

Get the victim back to the vehicle or indoors. Get wet clothes off him or her immediately and put on dry warm clothes, blankets, or a sleeping bag. Urge the youngster to drink some warm (not hot) drinks. If the body temperature has been severely lowered, someone should get into a sleeping bag with him or her to increase warmth, or take the youngster to a doctor or hospital.

Teach the youngsters beforehand that if they fall into cold, rough water, it's wise not to thrash about. They will lose heat and energy quickly, and the chances of hypothermia will increase. Teach them the heat escape lessening position (HELP): While wearing a personal flotation device, hold the knees up to the chin and wrap the arms around the legs while maintaining a comfortable floating position. This will allow the body to best conserve heat.

HELP Position

I charge you, that you break no man's hedges in going about your sports, nor open any man's gates without shutting them again. Also, you must not use this aforesaid artful sport for covetousness, merely for the increasing or saving of your money, but mainly for your enjoyment and to procure the health of your body and more especially, of your soul. And in so doing, you will eschew and avoid many vices, such as idleness, which is the principal cause inciting a man to many other vices, as is right well known. Also, you must not be too greedy in catching your said game as in taking too much at one time, a thing which can easily happen if you do in every point as this present treatise shows you. That could easily be the occasion of destroying your own sport and other men's also. And all those that do according to this rule will have the blessing of God and St. Peter.

—Dame Juliana Berners, *The Treatise of Fishing with an Angle*, 1496

RESPECT

Respect is a key word in the vocabulary of all educators. In order to become true stewards of the resource, it is vital that the budding fly fisher understand how the concept of respect is applied in a variety of situations. Youngsters are very impressionable and look to older kids and adults as role models. While in the field, pay special attention to the following areas and be sure you make a long-lasting good impression.

Landowners

Always ask permission to fish anywhere that is not clearly public access. Take note of the name and address of the landowner, and have the kids send a thank-you note after the trip, along with a few photos of the day's outing. The youngsters should always treat the land like their own and be sure to close any gates, take care not to destroy crops or plants, pick up litter, and generally show respect for someone else's property.

Other Anglers

If the field trip involves several young anglers, choose an area that will allow everyone plenty of space. Have an alternative spot in mind in case the first choice is crowded. It's good to expose these new fly fishers to other anglers; however, it must be done in a fashion that is friendly and will not alienate

them. It is imperative that behavior be courteous and not loud and offensive. Look over the situation carefully and make a prudent decision. If you decide to have the group stay, always ask the other anglers' permission to fish there. Most important, the youngsters must learn to respect other anglers, whether they are fly fishers or not, and to treat other people the same way they'd like to be treated.

Nonanglers

Not everyone who enjoys the water is an angler. The best fly-fishing spot is often the best swimming or canoeing spot as well. During the course of a day's fishing, a nonangler may appear and begin activities that will adversely affect the fishing conditions. In this situation, the adult leader must keep cool and act in a manner that shows respect for everyone involved. The answer may be to politely confront the person and explain the effect his or her actions are having on the fish. The person may not realize he or she is disturbing the fish or may know and not care! In this case, it's better to quietly move on.

The Resource

We all share the responsibility for protecting our natural resources. In the field, this means picking up litter and treating the forests, waters, and land with respect. It's also our duty as stewards of the resource to help others understand what this means. The best way to teach others is by example. Pride in our wild heritage should be instilled early on. Children will "follow the leader" and welcome this environmental responsibility very early in their angling lives. Our duty to the resource also extends to teaching others who may not be as aware of proper environmental etiquette and behavior. The sight of a bunch of young fly fishers removing litter from a streamside, carefully releasing a prize fish, or acting in a truly responsible and respectful fashion while enjoying their sport can be a powerful unspoken lesson to others.

On every field trip, encourage the kids to leave the place cleaner that they found it. Outfit each youngster with a trash bag, and instruct them to pick up any monofilament, cans, and junk from the shoreline and parking area. In the case of larger or more "nasty" stuff, pile it up and gather it at the end of the day. Besides being a good lesson in stewardship, this will make the area a nicer, more beautiful place to enjoy.

If blatant, harmful behavior by others is observed in the field, it is also your duty to report it to the proper authorities. Most states have hot lines that can be contacted. Write down as much as possible about the infraction and the person who committed the violation, and get this information to a conservation officer as soon as possible.

The Fish

Two recent events made me pause and reflect. Both were aimed at encouraging young anglers, and both were done with only the best of intentions. Both, however, involved catching freshly stocked hatchery fish that were cast to immediately as they were released from captivity. The youngsters and the adults supervising the activity seemed to be really enjoying themselves. The events had all the appropriate trappings of a fishing experience: rods, reels, lines, hooks, and screams of delight. It struck me as I watched, however, that there was one missing ingredient: respect.

Angling for stocked fish is standard practice across most of the United States. Modern pressures from habitat degradation and overfishing may prohibit native populations of fish from thriving and reproducing in many streams and lakes. In many cases, it is the only fishing available and can be a valuable experience for any fly fisher. Many of my own favorite destinations in the Great Lakes and in my home waters of New York's Finger Lakes are basically contrived fisheries relying on a population of stocked fish.

In the above events, however, the fish were stocked only for the occasion. I do not question the motives or intentions of the dedicated folks who worked hard to give these youngsters a fishing experience. But I do question the fact that these fish were released in improper habitat for the species—waters that

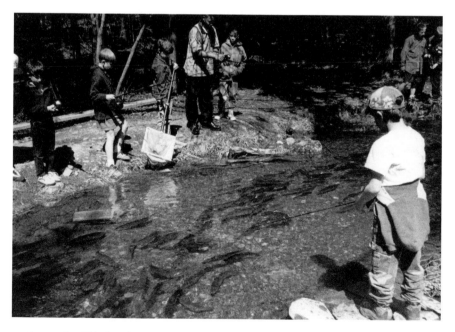

A trough of big hatchery trout. Respect should guide all our actions as anglers.

> The trout weighted 3¾ pounds. It was killed with pride and eaten with a relish that only the new hunter cub knows. I was not, nor will I ever be, repentant for that kill. It was consummation of the marriage vow between the angler and the quarry, wrapped in the very deepest respect imaginable.
> —Charles Jardine, author and fly-fishing historian

could not support them over any period of time—were caught as soon as they were dumped into their new "home," and were fished for mostly with commercially produced bait that had no resemblance to anything in their natural diet. An inordinate amount of value was placed on capturing the prize; little time was spent on the all-important process. I couldn't help feeling that it was a cheap game that involved living creatures as prizes.

The guiding principle in sportfishing should be respect for living things. Fishing enables us to satisfy many basic instincts that humans still have, even though we no longer depend on them for survival. We no longer need to kill to survive, as did our ancient ancestors, but the thrill of the hunt still entices us. Unlike hunters however, we can return our captured prize unharmed. And unlike bird-watching, where we enjoy merely observing, the direct interaction and contact with the fish satisfies a deeper instinct.

How can we participate in this natural experience and still show appropriate respect for these marvelous creatures? How can we rationalize tricking them, impaling them on a sharp hook, and finally capturing them, obviously against their wishes?

If we are truly sportfishers, we can show our respect for these animals in several ways and still satisfy our predatory instincts:

- *Use barbless hooks.* Although this may be a point of contention for some, who claim that barbless hooks cause increased damage, the quick release of a fish is expedited by the absence of a barb.
- *Avoid having the fish swallow the hook.* This is usually not a problem in fly fishing. The sharp hook will most times find its way into the jaw or tissue of the fish's mouth. A fish uses its mouth for many things, including rummaging around in stones, munching on hard-bodies crustaceans, and chomping down on rough-scaled, spiny baitfish. It must not cause the fish a great deal of pain to be hooked; many freshly released fish are observed returning immediately to feed and are

sometimes caught again within a short time. A hook sunk deep inside the body cavity is another matter. If a gut-hooked fish is to be released, the tippet should be cut at the mouth. Chances for survival are much greater if no attempt is made to remove the fly. The fish should be revived as much as possible and released gently. With luck, the internal wounds will heal and the hook will be expelled, dissolved, or grown over.

- *Promptly land all fish that are to be released.* Any fish destined for release should be landed as soon as possible. Exhausted fish have a lower chance for survival than merely tired fish. Use tackle suited to the fish. Very light rods and lines may be "sporty" but may extend a battle too long, leading to permanent damage of the fish.

- *If a fish is to be killed, dispatch it immediately.* Killing a fish as soon as possible will keep its flesh in better shape and is the humane thing to do. A small wooden club or "priest" should be carried along if killing the catch is anticipated. A rock or other hard implement will also work. A sharp, hard blow or two between the eyes is usually enough to finish most game fish.

 Dress the fish as soon as possible and ice it. Do not allow the fish to lie in water when being transported, it will spoil the flavor. Polluted water may make certain species unsafe to eat. Check with the local health department or consult the state fishing regulation booklet for information. Pollutants are often concentrated in the fatty tissue of the fish. On fatty fish (bluefish, some salmon), skin and remove the red meat along the lateral line and trim off the belly fat.

- *Handle the fish properly.* Fish are built to live in water, not air. Don't pick up soft-bodied fish (especially large ones) by pushing a hand up under the stomach; this may crush their organs and cause permanent harm. Become familiar with the species that will most likely be encountered. Each has a particular place that is safe for the angler to grip without injuring the fish. Most bass can be gripped by the lower jaw. A trout can be safely lifted, carefully, with support behind the head and at the tail. Pike and muskies need to be gripped securely on top, behind the head. Avoid jamming fingers into gill plates and touching the tender red gills. This will cause great damage to these very sensitive breathing organs. Don't use a dry rag or glove to grip a fish unless you plan to kill it; the fish's protective slime will be removed by the fabric and the skin will become vulnerable to infection and parasites. Gloves are often used, however, to protect the angler from the more dangerous adversaries, such as sharks or barracuda.

The smallmouth bass is an easy fish to handle safely.

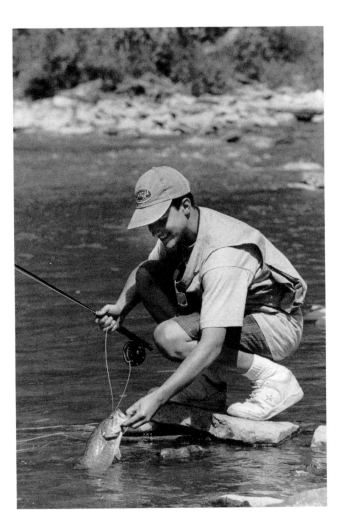

My conservation mentor was Lee Wulff. He taught me to give something back to the sport. He explained that surface fly fishing would always assure a sanctuary for game fish; the angler would not be dredging the bottom as could be done with a spinning lure. He taught me how to play a fish swiftly and release it without touching it. He taught me to think in terms of managing the resource from the point of view of the fish.

—Joan Wulff, fly-casting instructor

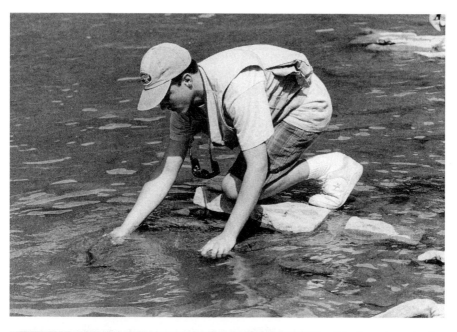

The bass is revived and released quickly.

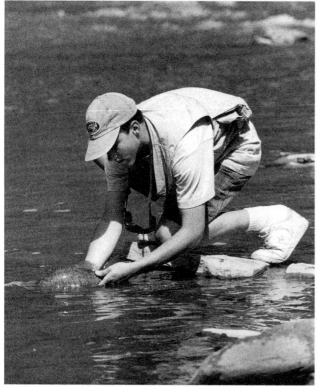

- *Revive the fish and release it into calm water.* When a fish is landed and is to be released, steps should be taken immediately to remove the hook and get it revived and back into its home. If the fish can remain in the water throughout, so much the better. A smaller fish can be easily released by simply grasping the hook firmly by the eye and bending it upward. If the hook is barbless and this is done properly, the fish will be able to slip off untouched. If the fish is exhausted, it should be slowly moved headfirst in a figure-eight pattern, running fresh water through its gills and reviving it. The fish can then be released into calm water and allowed to return to its home when ready.
- *Hook the fish fairly.* A great part of the fulfillment of the sport of fly fishing is the *take.* This wonderful split second when the fish grabs your bogus offering is the victory. It's a fitting reward for playing the game by the rules and fooling the fish, which is in the process of looking for something to eat. To foul-hook a fish on purpose is a dishonest act that shows no respect for the fish, other anglers, or yourself.

Exploring the
Aquatic Environment

A great deal of the wonder involved in fishing comes from the fact that we are directly interacting with organisms that live in a completely different environment than we do. Nearly all the other creatures we are likely to encounter in our world—dogs, cats, birds, horses, cows—exist in the same atmosphere as we do. When we're fishing, however, we are probing into a different world, a place we could not exist without special equipment.

Exploration of this world by the fly fisher is not limited to the fly rod and line. Reading about and studying the diverse forms of life that inhabit local waters will help us understand the habits of the fish we seek, and we will become more proficient anglers. If our examination involves an organized hunt for the creatures that inhabit the watery world and a close look at the elements that make up their homes, we are doing *aquatic sampling.*

There are few things, other than a bluefish blitz, that will excite a young angler more than a good bug hunt. And there's nobody I know who is a more enthusiastic bug hunter and expedition leader than my friend Paul Roberts. Paul, who serves as the aquatic ecologist for the Fly Fisher Apprentice Program and environmental advisor for the Community Fly Fisher, has long experience with environmental issues through work with the New York State Department of Environmental Conservation, Cornell University's Department of Natural Resources, the U.S. Fish and Wildlife Service, and many youth fly fishing education programs.

Whether it's a pristine Catskill mountain stream, a craggy Rhode Island beach, or an Ithaca drainage ditch, Paul's enthusiasm for finding and identifying creatures and explaining why they are there is truly inspiring.

Paul handles all the aquatic resource education chores for FAP, and I've asked him to lay out the nuts and bolts of an aquatic adventure for this chapter, which he does in the following sections introducing the aquatic world and aquatic sampling, and teaching ecological concepts.

I spent my childhood on a small farm on the edge of the Ozarks in a southwest corner of the State of Missouri. Like most youngsters, I was infatuated by water, particularly moving water. In the cow pasture below the barn was a small creek that contained all sorts of interesting aquatic creatures, and particularly during the springtime, I'd spend hours and hours making little dams and pools to hold minnows, small sunfish, and crawfish. Even now, almost seventy years later, I can still see a barefoot, towheaded boy sloshing around that stream, watching the little fish swim around in the temporary, and carefully engineered, pools. That's where my lifelong infatuation with fish—and fishing—began. Of course, that young lad had no way of knowing that fate would be kind to him and would lead him into a close and rewarding lifetime relationship with sportfishing.

—Leon Chandler, legendary fly-line designer

Paul Roberts leads the discussion after some stream sampling on the Delaware River (west branch).

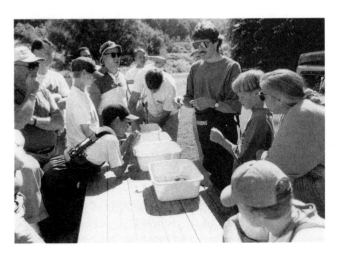

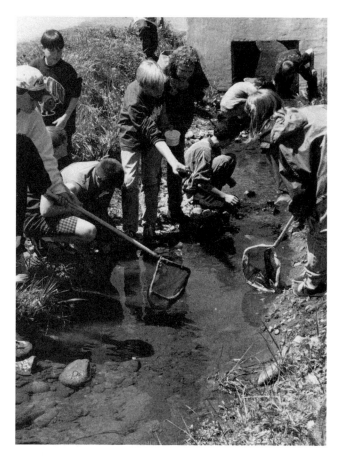

Even a roadside ditch can hold some marvelous surprises. Here Hannes Maddens leads a group of sixth graders in an exploration.

Detailed information about the multitude of organisms you may encounter is beyond the scope of this book. For more information, refer to the Appendix. Use the next several pages to inspire you and help lead you and your youngsters on an adventure of your own.

INTRODUCTION TO THE AQUATIC WORLD

Fly fishing is an excellent tool for learning about ecology, the interrelationships between living things and the physical world they live in. In an increasingly crowded world, this is an important subject for people to know something about. Fly fishing is one very good way to learn.

Fly fishing brings its participants to a level of intimacy with nature that few other sports can match. It is not surprising, then, that fly-fishing culture is laden with expertise in some of the most important issues of modern life:

> Think of our life in nature. Daily to be shown matter, to come into contact with it, rocks, trees, wind on our cheeks! The solid earth! the actual world! the common sense! Contact! Contact!
> —Henry David Thoreau, *Walden: Life in the Woods*

those of environmental quality, the management and distribution of natural resources, and spiritual well-being.

Nature study can be intimidating to many anglers and would-be naturalists because of the technical route through which it is so often approached. Science is, by definition, technical in practice. Just thumbing through a typical aquatic bug book is enough to frighten many people away. But the identification of aquatic life is a necessity for ecologists and anglers alike, because aquatic creatures, the invertebrates especially, are useful indicators of the health of watersheds. And the importance of these invertebrates to game fish as food makes recognition of the types, if not the species, of great utility to anglers.

What may seem intimidating at first is the enormous variety of bugs shown in the manuals. But it's not nearly as confusing as it looks. Some of these bugs are much more common than others, especially within specific habitat types.

The diversity of habitat types allows for a diversity of *niches*—the unique places and roles in the neighborhood that different organisms occupy—and a diversity of niches allows for a diversity of creatures. A healthy ecosystem is an intact ecosystem, with a diversity of niches available and functioning. We need to appreciate diversity among and within species. The chain of life includes not only us but all other living creatures. It is our future, as well as our history

One of the best ways to start learning about the aquatic world, especially for young children, is through simple, playful exploration. This is something educators employ in the concept of *discovery learning*. You do not have to be an expert to be amazed and delighted by other living things.

Little, rolling, fast-water brooks are often the most exciting to youngsters. If the little rill is not ephemeral (dry in summer months), it will likely contain a diversity of living things to discover, ooh and aah over, and carry home in one's heart. To a child, these experiences make a strong impact and are very important. Such lessons are called *affective learning* and should be strongly encouraged. These early experiences will have profound effects on an individual's motivation for learning throughout life.

A little over five years ago, at age sixty-one, I realized I was missing out on a very special activity that I'd experienced briefly thirty-seven years earlier. That special activity was fly fishing.

I decided that after my recovery from a few medical problems, I would pursue the development of the necessary skills and would acquire as much knowledge as possible about this unique and beautiful activity called fly fishing.

Since the spring of 1992, I have become as active as possible. Although my casting and tying skills still leave much to be desired, I have found in fly fishing a sense of satisfaction and enjoyment not found in any other recreational pursuit. As I examined this more deeply, I realized the reason for this is that fly fishing is more than recreation. Fly fishing adds to a person's life in ways that are indefinable, and for those who allow the activity of fly fishing to become an intricate part of their being, there is a sense of inner peace that makes all of life richer and more enjoyable.

I hasten to add that fly fishing is not limited to catching fish. In fact, that may well be the least important aspect of this unique activity. Whether it be casting in the salt from a jetty on the New Jersey coast or off the rockbound coast of Maine, or wetting the line in a mountain stream in the Catskills or the magnificent streams of central Pennsylvania, the fly fisher experiences a sense of tranquillity, peace, and a oneness with nature that is not achieved in any other outdoor activity.

The fly rod and reel provide an individual with the excuse to stand in the middle of a magnificent stream and absorb the magnificence of creation. The soft lullaby of a babbling brook, the gentle breeze rustling through the treetops, the song of a bird in flight allow the fly fisher to be totally immersed in the beauty of creation and to come as close as is humanly possible to touching the face of God.

—Dr. John Kirk, director,
New Jersey School of Conservation

SAMPLING AQUATIC HABITATS

Aquatic sampling can be as simple as lying on a grassy bank and observing a gin-clear stream pool or wading and turning over stones looking for surprises. It can also be a more formal and rigorous effort to obtain information

about a water body. In either case, there are some tools and techniques that can increase your effectiveness in acquiring useful information about your home waters or in simply catching neat creatures. Always follow strict safety precautions. Review the Safety Section of chapter 8 before going afield.

Sampling Equipment

- *Insulated waders, hippers, knee boots.* Old sneakers are okay for warm-water wading. Sandals and thin-soled surfing booties are not a good idea because they will not protect feet from thorns, sharp rocks, or glass.
- *Cotton-canvas garden gloves* for hand protection when working with stream substrate.
- *Dry gloves* for chilled hands. Wool or poly-fleece is best because these materials remain warm if damp and dry quickly.
- *Hat, warm socks, and thermal underwear* if much time will be spent in and around cold waters.
- *Polarized sunglasses.*
- *Fine mesh dip nets,* available at pet and aquarium stores. Reinforce the rim with duct tape or Goop adhesive, as most wear occurs here. White mesh is best, as the bugs contrast well against it.

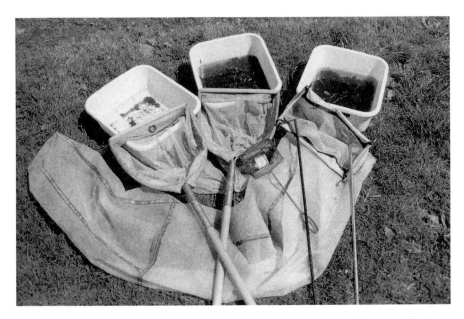

Tools of the aquatic sampler: plastic dishpans; D-nets; and a small dip net. The long tube shaped drift net is staked out overnight.

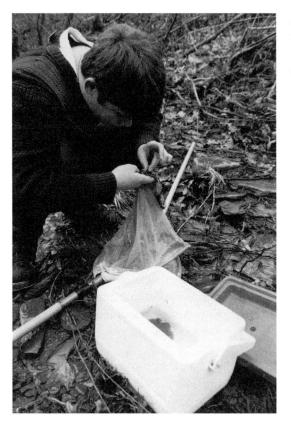

Eric Sincebaugh picks through the contents of a D-net and stores selected creatures in the cooler.

- *D-net.* Net with long handle and heavy net frame flattened at bottom for kick sampling. Professional versions are available, or one can be made.
- *Seines.* Mesh suspended between vertical poles, used to net a wider area. Insect seines require finer mesh than fish seines. I prefer a fine insect mesh even for small fish because it is less apt to "gill" captured fish. Wood poles are safer than metal should an electrical storm arise. See Appendix for instructions.
- *Minnow traps.* Wire or mesh funnel traps are good for passive sampling while you are busy netting or when preset before a planned excursion. Tie them in place, flag them to help you remember their location, and check them daily. Bait with bread for minnows, a meat scrap for crayfish.
- *Capture bucket.* A white, plastic pail is great. Bugs are very visible against white, and it doesn't absorb as much heat as a dark bucket. Wash and rinse it well with stream water before using it to hold

This plastic cube has a magnifying top end and is ideal for examining a single specimen.

aquatic life. Many aquatic animals are very sensitive to chemical content of the water. Use a lid or, better, a piece of mesh screen, or some specimens may hatch and fly away. A six-pack cooler is a compact alternative to the bucket. It's good for holding cold-water animals collected in warm weather.

- *Battery-operated bubbler,* available at bait shops and pet and aquarium stores. Many stream and turbulent-lakeshore creatures need a lot of oxygen. Use an inexpensive portable aerator clipped or taped to the side of the bucket or cooler.
- *White tray.* Shallow plastic or enameled metal trays are great for inspecting bugs or for separating the live things from the debris.
- *Hand lens or magnifying glass,* to see what bugs really look like. An 8X lens is helpful for hand ID of bugs.
- *Dissecting microscope.* Borrow one from a local school for use in close-up and ID work.

Permits and Regulations
Before doing any sampling, check with your state Conservation Department about regulations and required permits. Get to know your local biologist, who can be a great asset to your program. Ask these specific questions:
- Do adults need a fishing license?
- Is the size of nets regulated?
- Is it illegal to use seines in trout streams?
- Are aquatic insects protected? If you plan to take any home, get the proper permits. In my state, permits are inexpensive and easy to obtain for limited collecting and education purposes.

Capture Techniques

Most aquatic creatures are small and are associated intimately with micro-habitats in the nooks and crannies of bottom substrates. Much of our capture efforts will be focused on these structural elements of the aquatic ecosystem.

Dip Nets. Hand-held dip nets, such as aquarium nets, are inexpensive and lightweight, an important consideration for younger participants.

In stream sampling with a dip net, the current can be used to your advantage. Disturbing the substrate may cause insects clinging to the substrate to be swept into your waiting net. In one method, called *kicksampling,* the stream bottom in front of the net is disturbed with a foot. For most dip netting, though, I prefer to use my free hand to move substrate, because it causes less disturbance to the stream bottom and to the insects. Some creatures can cling tightly to the substrate, so it often pays to look over a promising piece before returning it to the stream bottom. Silt, sand, and gravel can be sifted by hand upstream of the net to dislodge inhabitants such as burrowing mayflies and mineral-case caddisflies.

Submerged vegetation or riparian vegetation that is hanging into the

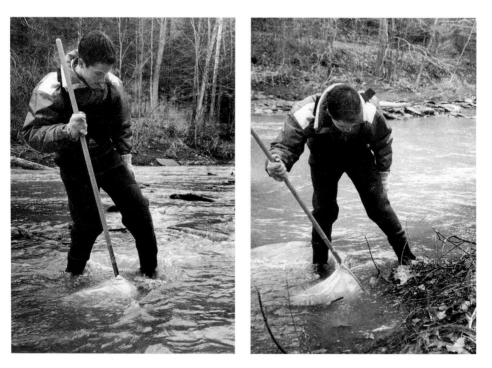

Jesse Sandvik demonstrates proper kicksampling with a long handled D-net *in a shallow riffle and in a brush pile.*

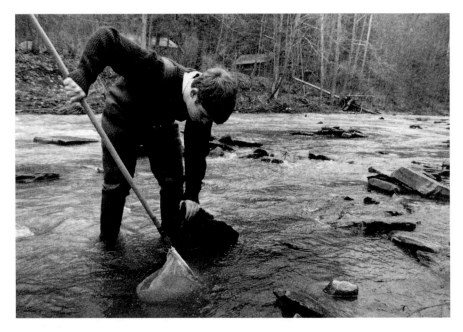

Eric Sincebaugh holds his net downstream from a rock to catch any creatures dislodged by the current.

water can be full of insects. Many of the swimmer-type mayflies, such as *Baetis, Centroptilum, Siphlonurus,* and *Ameletus,* can be found here, especially when close to hatching time. Dragonfly and damselfly larvae live here, too.

Dead leaf litter, packed into rock crevices, tree roots, or brush, houses and feeds a lot of creatures. Some stonefly and caddisfly species are only found here.

Fish can also be caught with dip nets. Some species are easier to catch than others. Bottom-dwelling species, such as sculpins, darters, and madtoms, are relatively easy to catch. But don't expect the current to sweep them into the net; they swim too well! Catch them by locating a good hide, usually a moderate to large piece of substrate, and as you lift it, scoop quickly and deeply beneath.

Open-water fish are more difficult to catch with the dip net. It's often helpful to herd them, getting them to bolt into a quietly waiting net, or to cloud the water to disorient them before scooping. Chubs and dace can often be scooped from beneath undercut banks or overhanging vegetation. True open-water inhabitants, such as most shiners, are best captured with minnow traps, umbrella nets, or seines.

Drift Nets. Many aquatic insects drift in the water column, to migrate, to hatch, or by accident. Such insects are available to stream fish as food. A drift net acts like a trout at a feeding station, sampling the insects that drift by over a time period. Drift nets are usually long-bagged nets with a frame that can be staked into the stream bottom. The greatest amount of natural (non-catastrophic) drift occurs at night. A lot of daytime drift, especially during summer, is composed of hapless terrestrial insects, such as ants and leafhoppers, and midge pupae that drift before hatching. Summer mornings and evenings can yield summer-emerging mayflies.

Drift sampling can also be done with a dip net held at the water surface, although for much shorter time periods. The drift can also be sampled by simple observation. By focusing your attention on the water surface or just below, you can see an amazing assortment of drifting things: leaves, algae, seeds, ants, bark, beetles, caddis and midge pupae, mayfly shucks. This can be quite practical for the angler, as well as downright entertaining.

Seines. A seine is a net stretched between two poles, with floats along the top of the net and lead weights along the bottom. Seining is easiest in still waters, but it also can be done effectively in streams. Pools may be the easiest places to seine, because alarmed fish will congregate in the depths of the basin, and you can then herd them with the seine to a shoreline. In current areas, you can sweep across the current and trap the fish against the shore, an undercut, or overhanging vegetation. Fish often dive for the bottom to hide, so be sure to keep the leadline of the seine on the bottom or you may pass right over them. *Note: Check state laws before planning seining activity. The size of the net and the type of water being seined are often regulated.*

Minnow Traps. Minnow traps are a passive capture technique, baited and placed to "fish" on their own. They add anticipation to an outing and can be fun for your youngsters. They work best in still waters. If you use them in faster currents, secure them with a stake or wire behind a current block such as a boulder or along quieter areas near the current. Such places will fish better, and trapped fish will not be subjected to excessive currents too long. Bait with bread or cheese. In currents, place bait in a mesh bag. Check traps at least daily.

Water Scopes. A water scope allows an observer to see shallow pond or stream bottoms with clarity, similar to a dive mask. A 5-gallon pail painted flat black inside, fitted with Plexiglas epoxied over the open end so it is watertight, and with a view hole cut into the pail bottom makes a serviceable scope. Wading quietly along or drifting with the scope through the hole of an inner tube raft are nifty ways of observing shallow pond or stream bottoms without reflections or distortion.

Handling Aquatic Life

A sampling net, after it has been dipped into a rich stream bottom is full of all sorts of things, all interesting, each with an incredible story of its own, and some of which are living creatures. Sorting out the contents of a net is the first challenge, and it's great fun! A shallow container with a white bottom is ideal for sorting the animate from the inanimate.

The intricacy of the forms to be found inspires wonder in children. They will not initially see most of what's alive in the sample, however. The life forms are so variable, they are muck covered and camouflaged, and some of the creatures freeze in position. It's necessary to look carefully. Caddisflies hide within cases made from sticks, pebbles, sand, or stitched-together pieces of leaves. Some creatures are minute, such as midge larvae or the very young nymphs (instars) of mayflies and stoneflies. Some are quite large, such as the hellgrammite, which may burst from some leaf gunk, rolling its head and snapping its jaws. One kid ran from such a sight and, after being coaxed back, swore that he had heard it roar! One net scoop could last your youngsters a good part of the day, it you really look.

Some aquatic creatures can bite or pinch. Giant water bugs and back swimmers can inflict a painful stab. Hold them in a net, jar, or flat on your palm. Water boatman, which do not bite, look similar but swim right side up, not on their backs. Crayfish and large hellgrammites can pinch, which may put a damper on a small child's curiosity. Hold them by the carapace or flat on your palm. If a crayfish manages to grab a finger, submerge the afflicted hand in the water and it will let go.

Many cobble-bottomed warmwater streams, rivers, and lakes contain small catfish called stonecats or madtoms. They have mildly poisonous dorsal and pectoral spines, but you can handle them easily without being stuck; just hold them lightly.

Many stream insects require cold, well-oxygenated water, and this needs to be kept in mind when retaining them for any time. I use a small, six-pack type cooler with a white bottom to make viewing insects easier. These are compact and will keep stream water from warming too rapidly. A battery-operated bubbler can be useful if you need to transport sensitive creatures during warm conditions.

Keeping Aquatic Life for Extended Periods

You may wish to keep wild aquatic life at home for further observation over a period of time. First check with your State Conservation department for any restrictions and required permits.

The biggest challenge for keeping stream life in a home aquarium is meeting the water temperature and oxygen needs of the species. This can be

an expensive proposition if a chiller is required. One good method for many early-hatching species of stream insects is to keep the tank outside in the shade until the days become too warm. Another method is to use a commercial stream tank that pumps water continuously through a series of pools. Here the water is not chilled but it works great for many warmer-water species.

Many insects can be hatched out in jars for observation or identification. Catch them close to hatching time and provide something, such as a stick, that they can use to reach the surface. Some species require this; for others it's just a convenience.

If you wish to keep a tank going for more than a few days, here are a few pointers:

- Don't crowd the tank, especially with fish. Start with a couple fish, adding one or two every week or so. A fish for every 5 gallons is plenty.
- Keep only species you can provide the proper habitat for. A noncirculating goldfish bowl is not adequate for riffle species such as sculpins, fantail darters, stone rollers, or fastwater insects. Get a guide on wild freshwater aquariums.
- Keep predator numbers to a minimum. A mix of functional groups is best. Add only one crayfish—they'll eat themselves out of house and home rapidly.
- A tank with fish or bugs kept for any prolonged period needs aquatic plants to control ammonia excreted and to add oxygen removed by the animals. This is the beginning of an integrated symbiotic ecosystem, making a great teaching and learning tool about the codependencies that make up life's diversity. Collect plants from nearby streams. Watercress is hardy, as are some streamside emergents. The plants need periodic replacement, as aquarium conditions are rarely ideal for long-term plant life, especially in newly set-up units.
- A grow light is important for plants and for the photosynthetic algae and diatoms that will soon cover the substrate. For algae and diatoms, add substrate pieces that have algal communities, collected from nearby streams.

It is not advisable to clean the aquarium very often, unless you have a noncirculating or inadequately filtered setup, which is not recommended for stream life. You want to allow a healthy aerobic community of diatoms, algae, and nitrifying bacteria to develop on the substrate. These are an invisible yet critical part of a healthy system. Still, a partial water change once a month or so can be good. Check a freshwater aquarium guide for chemical balance testing of your system.

TEACHING ECOLOGICAL CONCEPTS

Few people, including anglers, are aware of the goings-on in and around the water. A day astream should be a day of exploring, of shaking streamside shrubbery, turning cobbles, listening, and watching. The most satisfying fishing often comes through this seemingly indirect route.

When teaching such things, it's useful to have an idea of what's out there so that you'll be aware of teachable moments when they arise. Here are some suggestions:

- Choose a concept, lesson, or exploration you wish to teach. Define the key point or idea you want to get across so that you can say it succinctly.
- Research the concept so that you become somewhat familiar with it.
- Go to the site and run through the event ahead of time.
- Plan the itinerary and equipment needs.
- Plan so that the youngsters will discover what you already have a head start on learning about.

Here is an example of how a concept, in this case habitat structure and biodiversity, is addressed through a streamside project.

The *Life Inventory* is a project in which youngsters discover and record how many different types of creatures live within a healthy section of a stream and how the structural diversity of habitats and the body forms of the animals relate.

Start by choosing a healthy stretch of stream with a diversity of substrate characteristics for comparisons of habitat types and the creatures that live there. Visit the site ahead of time, finding spots that offer different current velocities and substrate types, and sample them.

On the big day, usually within a week of your visit, take your group of

I grew up in a fishing family with a lot of brothers and sisters. We lived on a farm that had lots of ponds, and we'd fish our summers away with bobbers and worms.

Having the kind of childhood that I did certainly made it easier for me as an adult to take up fly fishing. Growing up with pond water, mud, frogs, moss, snakes, and all that has taken a lot of the hesitation and unknown out of the sport and has allowed me to enjoy the good points.

—Cathy Beck, fly-fishing author

Don't neglect saltwater for your sampling adventures. Several types of crustaceans and baitfish, including a baby flounder, were easily captured by our young explorers.

budding ecologists in with dip nets and other catch gear. Catch as many different creatures as possible, sampling the selected habitats and keeping the results of each in separate trays. Then look through and discuss the findings. By this time, the kids are eager for information about the marvels before them, and you'll be able to answer most of their questions with what you learned while researching the project.

An excellent guide for leading a successful expedition into the aquatic world is *A Pond and Stream Safari: A Guide to the Ecology of Aquatic Invertebrates*, by Karen Edelstein, 4-H aquatic education specialist at Cornell University. The book contains an extensive reference guide to aquatic invertebrates, as well as activities, instruction in net building, worksheets, and more. This valuable youth fly-fishing education tool is available for $15 from Department of Natural Resources, 108 Fernow Hall, Cornell University, Ithaca, NY 14853.

MONITORING LOCAL WATERS

The aquatic world is a fascinating place, and as fly fishers, we are particularly drawn to it. Exploring the aquatic world is a necessary part of becoming

a complete angler and truly understanding what goes on in the underwater world. Any number of projects in which conditions are monitored can be done with a group of interested young fly fishers. Also look for opportunities to help local agencies by volunteering your time, and encourage your young-sters to do the same. You'll get to know local waters on the most intimate level. It will also help you catch more fish more often!

Logbook. A simple, personal way to record important fishing and related data is with a logbook. Note specific points about a day's angling, such as water temperature, bug hatches, wind direction, air temperature, and cloud cover. These factors all combine to affect fishing conditions and thus success. Each time you go afield, you can refer to the information you've gathered, which may provide you with the key to solving the fishing riddle of the day. (See Appendix).

Stream Walk. A stream walk, in which everyone takes notes concerning the organisms and other factors involved in the system, is an easy and casual way to monitor the health of a body of water. Over a period of time, as changes are recorded, an idea of the general health of the waterway can be ascertained.

Biological and Chemical Monitoring. In-depth biological and chemical monitoring may include measuring, sampling, and recording the organisms, dissolved oxygen level, hardness, pH, and chemical levels in the body of water. When done over a long period, the data gathered will provide valuable information to help researchers form a true profile of the water system.

REFERENCES
Here are several sources of further information on materials and programs.

National Programs

SAVE OUR STREAMS (SOS)
Isaak Walton League of America
1401 Wilson Blvd, Level B
Arlington, VA 22209
Stream monitoring and assessment using aquatic invertebrates.

NATIONAL PROJECT WET
Culbertson Hall
Montana State University
Bozeman, MT 59717
Water education for teachers.

I always loved all that was involved in fishing—the preparation of the tackle, laying out your clothes the night before, traveling to the spot, casting, anticipating, watching, waiting, constantly being alone and attentive and curious. Fishing gave me a way to be outdoors, And outdoors was where I wanted to be. I

was an intensely curious child and sort of a "science nut"—anything and everything in the natural world was worth exploring. Being on the stream opened countless new worlds to explore. I believe I spent as much time on my stomach peering over the stream bank's edge watching insect larvae hatch or discovering the tiny life form hidden inside the twigged home of a caddisfly as I did standing waiting and fishing.

I quickly learned to love that time spent watching and observing, as there was always some new mystery to discover and explore: a new bug, caterpillar, egg case, or larva. The natural world always rewarded my innate senses of alertness, attentiveness, and observation by giving up another secret, pulling me into a long journey of exploration and discovery. I thank God that I can still be so easily diverted from the quest of catching fish to begin these journeys of testing knowledge and exploring possibilities.

I went on to study botany, zoology, hydrology, chemistry, and climatology. I view all of that formal education as part of my preparation and formation as an angler and curious naturalist; one's education and formation are never finished.

—Page Rogers, minister and saltwater fly designer

AQUATIC PROJECT WILD
5430 Grosvenor Lane
Bethesda, MD 20814

Other Sources

MEDIA SERVICES CENTER
7 Research Park
Cornell University
Ithaca, NY 14850

Several manuals and publications, including *Water Worlds* (activities for children ages nine through twelve) and *Waterwise: Lessons in Water Resources* (activities for grades 5 and 6).

OREGON DEPARTMENT OF FISH AND WILDLIFE
Oregon Aquatic Education Program
P.O. Box 59
Portland, OR 97207

The Stream Scene, a publication about watersheds, wildlife, and people, for grades 6 through 12.

Community Programs

BUILDING A NEW TRADITION

Throughout its history, the skills and lore of fly fishing have been passed down from the seasoned fisherman to the wide-eyed youngster. Dad, Grandpa, Uncle Harry, or the old guy down the street would take a budding angler under his wing and tutor the youngster in this sport, so full of marvelous traditions.

The relationship did not end after a trip or two. The adult was there to inspire and advise, to help the youngster choose the right tackle, bend a feather properly, and cast a tight loop.

The type of family and neighborhood support structure that encouraged and nurtured this sort of interaction is no longer typical. Modern times have seen a radical change in the family unit and the neighborhood. Computers, television, and an endless variety of entertainment devices draw our attention away from close, meaningful interactions with other people. And the rapid change of our society from agricultural and rural to industrial and urban has pulled us away from intimate interaction with the natural world.

If we are to construct an effective educational initiative based on the mentor-apprentice approach, we must now work at consciously building a system that will redesign and help reinstate the traditional system. The new system must enable us to identify youngsters who yearn to learn about the outdoors. We must encourage these new explorers, even if their culture does not historically include fly fishing, and give them the support they need so that their enthusiasm will not diminish. Finally, we must educate them in the tradition, ethics, and skills that will not only make them consummate anglers, but also instill and develop within them the character and commitment that will keep them active stewards of our resources for life.

Youth fly-fishing education is an effective, productive, and fun way to build a sense of stewardship along with a true feeling of self-worth. Presented in a long-term, quality manner by a dedicated mentor, it will help a

Tradition! Growing up a British fly fisher during the early years, you were immediately aware of your past—Halford, Skues, Lord Grey, Prett, Kelson, of course—dear old Izaak. All seemed to march by your side up the river and cast with you. It's an odd feeling that never entirely departs.

—Charles Jardine, author and fly-fishing historian

child develop a sense of place and an understanding of his or her own local ecological system.

Many youth-oriented hunting and fishing events are one-day, derby-type events. They may serve as an introduction to the sport, but they do not provide any follow-up activities or lessons to support the young angler's newfound enthusiasm. If the young fly fisher cannot, with some degree of success, repeat this activity and learn and grow, he or she will likely lose interest.

Bruce Matthews, in his paper, "Reversing the Decline in Hunting and Fishing Participation: Successfully Recruiting the Next Generation," lists five elements that must be present if a support system is to be effective in helping a youngster adopt hunting and fishing as lifetime activities. A former director of SAREP (New York State 4-H Sportfishing and Aquatic Resource Education Program) Bruce Matthews presented this paper at the 1995 conference of the Outdoor Writer's Association of America.

1. A threshold experience that piques a youngster's interest and leaves him or her wanting more. This can come in the form of a fishing derby, a chance encounter along a stream or lake, or a fly-fishing show.
2. Proper equipment. The youngster may borrow it, buy it, or even build it, but it has to be readily available.
3. Places to fish, look for bugs, and, if desired, tie flies.
4. A competent mentor who can help guide the youngster over an extended period of time and help provide for equipment needs, answer questions, and provide a good role model.
5. People who are important to these youngsters—family and friends—must approve and encourage their active participation

COMMUNITY INVOLVEMENT

An individual who is mentoring one child can easily control and include the above five elements in a long-term apprentice-mentor relationship. It is another matter, however, for a community-based youth fly-fishing educa-

tion program to successfully supply these elements to a number of young-sters while recruiting, supporting, and keeping competent mentors for a reasonable length of time.

Most community efforts of this type will be volunteer based. Three ingredients are essential for any volunteer effort to be effective:

1. *A reason to begin.* A youth fly-fishing education program, when properly managed, can inspire and benefit a wide range of people. Young people will benefit by learning a wholesome lifetime activity. Parents will be excited to have their kids participating in a productive alternative to less desirable activities. The community will rally behind this sort of "feel-good" initiative. Mentors will get new angling buddies; relearn some of their old, forgotten skills; have a new excuse to go out on the stream; and most important, develop a real sense of pride and satisfaction from making a positive contribution to a young person's life and the future of the sport. And at the same time, our natural resources get a new champion.

2. *A key person.* A motivated, dedicated, and organized leader is essential. This person is the one with the vision and the drive to keep the others active and move the program forward. The bulk of the work will fall on his or her shoulders. It will be the key person's responsibility to make the proper decisions that will keep the program alive and healthy.

As a boy, I started fishing with my dad and brothers at the Jersey shore, mostly spin fishing and bait casting. It was not until 1960, when I moved to Ohio, that I was introduced to fly fishing by a kindly dentist from Van Wert, Dr. Phil Harris. Phil patiently taught me the art and magic of fly fishing and took me on many trips.

A few years ago, when he was gravely ill, I visited Phil. I told him I'd never be able to repay him for introducing me to the sport that I've come to love so much. His reply was to teach someone else. I've tried to follow these words ever since.

Fly fishing has opened a new vista for me. It has allowed me to meet so many interesting people and visit so many wonderful places. Most of all, it has taught me to truly appreciate and respect the grandeur of God's natural world and the creatures that inhabit it.

—Walt Maslowski, retired dentist and good friend
of the Fly Fisher Apprentice Program

3. *Support organizations.* Herein lies the key to making the whole program run smoothly and grow. Many of the organizational problems that arise when starting a new program can be eliminated if support from the appropriate group is enlisted. Combinations of like-minded but diverse groups can sometimes be a great help in building an effective initiative. The Fly Fisher Apprentice Program has been successful in working with and recommending organizations from three sources:

- Local communities. Youth-oriented groups, such as 4-H, Boy and Girl Scouts, and those at public and private schools, are ideal bases for beginning youth fly-fishing activities.
- Sportfishing and conservation groups. Most national organizations have active local chapters, whose members are very interested in working with young people. These folks can form grassroots youth programs and lend their expertise.
- Businesses. Local and national members of the business community can be invaluable in supplying products and even cash support to a youth program. The sportfishing industry has been especially generous in supplying start-up materials and equipment to legitimate youth projects.

STARTING OFF RIGHT

The creation of a successful, quality, long-term program will demand a great deal of work. The key person who is inspired to take on the job must realize that once the program is begun, many young people will be drawn to this exciting opportunity. The key person must be responsible, reliable, and dedicated. If the commitment is there and the key person is willing to make this project a priority in his or her life, success and great rewards are sure to follow!

When I first started fishing, there was little technical information or instruction available. Even the few books available at that time were not too explicit. I bought a very cheap fly-casting outfit. None of the components matched, because the guy at the tackle shop did not understand such matters. My $10 waders leaked from day one. Believe me, it was a struggle, and a long, often frustrating one.

I was lucky enough to meet a guy named Marv Goodfriend, who then lived near Albany. He was a superb fly fisher and very helpful. That was *the* breakthrough for me.

—Dick Talleur, author and fly tier

Some people just enjoy kids; maybe it's their destiny. Ken Truscott and Dave Webster were just the type of adults you'd imagine as perfect for running a Boy Scout program The Boy Scouts were a natural attraction for a boy of thirteen, and my parents were only too eager to have a responsible adult provide me some outdoor opportunities. Under their energetic guidance, we camped, canoed, hiked, and grew. They arranged fly-tying lessons for a group of us so that we could demonstrate at an upcoming Boy Scout Jamboree. Our instructor was an older man who was fond of fly-rodding for bass in the Delaware River and the Delaware Canal. He loved to tie deer-hair bass bugs, so one of the first fly-tying skills I learned was how to spin deer hair. We tied mostly Henshall-style bass bugs: white ones; gray ones; black ones; red and white ones; red, black, and gray ones; and every other pleasing variation we could imagine.

After the Jamboree, it was decided to draw straws to determine which lucky scout would keep the remaining fly-tying materials— and I won! I was now the happy owner of a sack full of floss and chenille, feathers and fur, tinsel and thread, little knowing how this good fortune would affect my entire life. Someone else won the tools, but I was able to fashion my first fly-tying vise in junior high school shop class. Using flat iron straps and assorted nuts and bolts, I constructed a C-clamp-style vise that held a hook (almost) securely. I borrowed scissors from my mother, and used a needle for a bodkin. With this assemblage, I began to tie flies at home.

—Dick Stewart, author and fly tier

Liability

Always take prudent action to avoid negligence, and plan for proper risk management. If the program is aligned with a stable support organization, speak with the administrator or coordinator to establish liability parameters and to learn about any coverage available, special considerations, and recom-

mended precautions. Personal or homeowner's insurance will usually cover many situations. Check with your insurance carrier.

If the program is being conducted without the benefit of a support organization, or the activities are in any way in questionable territory, consult an attorney. Lawyers, accountants, and other professionals will often be happy to give anyone who is legitimately attempting to start a youth initiative some pro bono time. Don't be afraid to ask.

Classes

If classes are part of the overall program, always keep in mind that they should be fun for everybody. For someone not used to standing in front of people and teaching, it may seem intimidating. The best advice is to teach what you know.

Set a goal for each class. Decide what topics you want to teach. Make a brief lesson plan that includes everything you wish to present. Take a dry run through it a few days beforehand. Make notes, and use a watch to time yourself.

During the class, get the kids involved by asking plenty of questions that you know they can answer or figure out easily. Don't just stand there and lec-

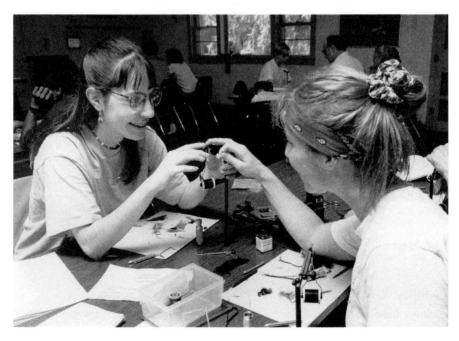

Katie Donahue and friend at the New Jersey School of Conservation.

ture. Kids have short attention spans. The use of props will also help keep their interest. Provide breaks from time to time. Keep it simple. And most of all, keep it fun!

Loaner Equipment

If your community program involves more than a few youngsters, you'll probably need some sort of loaner equipment to ensure that all the kids have the opportunity to practice the skills they're learning. Some of them may not be able to afford fly-tying and fly-fishing equipment, and it's not a good idea to lend out your private selection of fly rods and reels.

In such cases, consider organizing an equipment-loaning program. Support organizations may provide funding and a place to stash any program equipment. A sportsmen's group or community youth organization may also be of assistance.

Label all equipment before it's loaned out (see chapter 5). If the equipment will be loaned for an extended period, make up loan-out sheets. Have the young anglers fill it out, describing the equipment and including the proper numbers. Be sure to inform the youngsters that they are financially liable for the equipment, and how much money is involved. Have the youngsters sign the forms.

SPECIAL CONSIDERATIONS

In any community program, there will likely be a diversity of folks involved as mentors as well as apprentices. As the scope of a successful program increases, there will be an even more diverse population of participants. This section looks briefly at a few groups that may call for special considerations. The same procedures and recommendations outlined throughout this text also apply to these groups. For certain special-needs areas, it's wise to seek the assistance of professionals before proceeding with program plans.

Girls

Even though the fly-fishing industry has been trying to encourage women's involvement in the sport, it is likely you will attract fewer females than males to your program. Young ladies should be encouraged to join in the sport of fly fishing and should always be viewed as positive additions to any program.

At regular group meetings, a mix of sexes shouldn't call for any special considerations. Overnight or extended field trips may present some problems, however. It is always good if the parent is willing to come along. If not, proper accommodations must be discussed with the parents and followed along the way.

Urban Youth

I ran across a comment on the editorial page of the *Syracuse Post Standard* several years ago that made a real impression on me. The author, Chris Campbell, was a bronze medalist in the 1992 Olympics and is a lawyer living in Fayetteville, New York. This is a short excerpt from a speech he gave at a U.S. Senate subcommittee hearing on children, family, drugs, and alcohol:

> "There is no way around it—The U.S. is a predominately white society. Minority children must be involved in positive multiracial activities such as sports. Otherwise, the only interaction they will have with white people will probably be negative.
>
> "If these children are not involved in multiracial activities, you will be allowing a generation of racists to grow. They will hate white people. This hate will severely limit them and doom them to poverty. Nobody responds positively to hate.
>
> "At many crucial stages in my life I have looked into the eyes of a white person and seen someone who wanted to help. When they looked into my eyes, they didn't see hate, but rather the eyes of a loving child.
>
> "These people made it their mission to make sure I was successful. I am an Olympic medalist, a world champion and I have an Ivy League law degree. I believe these people accomplished their goal."

Fly fishing is not part of the cultural background of many minority youth found in urban settings. For this reason, it may be difficult to find any skilled local mentors familiar with the sport. It is, however, vital that the mentors come from areas not too removed from the neighborhoods of the apprentices. For the key person, this will involve added recruiting and training time. Interested experts and concerned facilitators can help start and maintain the program, but the strength must come from within the local community. Discussion concerning any aspect of the sport must be understandable and directly relative to the child. A lot of problems, including availability and affordability of equipment and where and when to use it, must be addressed. This makes it even more vital that local people, with a stake in the well-being of these kids, be involved.

An urban program can be a valuable experience for a number of reasons. Direct contact with the resource, one-on-one work with a concerned mentor, and interaction with interested peers will help build a feeling of community. In addition, it can help youngsters develop a positive attitude toward the outdoors.

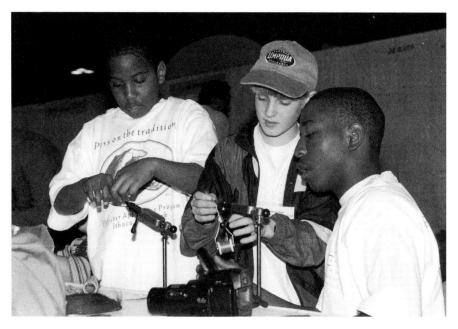

Two young apprentices from the Photographic Center of Harlem learn a few techniques from Patrick Sodums.

I can't pinpoint when I became a fly fisher, and until now, I've never given any thought to why I chose to be one in the first place. Perhaps I should. Fly fishing has shaped the kind of life my family and I live. It hasn't blessed us with all the trappings of a successful business, but it hasn't left us wanting either. What it *has* given me is a sense of purpose, and it has helped me to relate events of personal significance to a calendar made more meaningful by fly fishing. I became a fly fisher without regard for consequence. Like most people, I was influenced primarily by the times, a few individuals, and a family more understanding and liberal than one could wish.

I am a first-generation Chinese-American. Far Eastern culture does not have a history of fly fishing. It is something only synonymous with Western civilizations. It would be safe to say that if my parents had remained in China, I would not be a fly fisher today.

—Michael Fong, angling writer and publisher of *Inside Angler*

As a very young boy of eight living in Chicago, I saw some kids fishing for tiny fish, perhaps 3 or 4 inches long, in a pond in Humboldt Park. They were using bent safety pins, poles that were branches broken from bushes or trees, and bobbers made of just a small piece of wood. Little pieces of bread, pieces of bologna or lunch meat, and various other leftovers served as bait, and a large can half filled with water held a half dozen or so captured fish, some dead and some alive. They were older kids and wouldn't let me help. But I was fascinated and spent the whole afternoon with them. Several days later, I went back on my own, rigged similarly, and caught my share of the little punkinseeds. We lived very near the park, and it was easy for me to go. On two occasions, a policeman made me quit temporarily. I took the fish home but don't recall eating them. I think my mother garbaged them all—almost surely.

—Mel Krieger, master casting instructor

A youth fly-fishing education program addresses youngsters' need to hang out with peers, providing a productive alternative to gangs. Young people who live in difficult and potentially dangerous urban settings often face feelings of emptiness and loneliness. Productive, nature-focused educational activities can help fill the void.

The natural world should be a therapeutic and vital part of the human experience. It is important that youngsters in an urban environment be encouraged and educated in the skills that will help them understand and interact with whatever local ecology is readily available to them. It's okay to look outside the neighborhood for stimulation and to show an apprentice the possibilities; however, chances are that these young people will not venture far from this setting for the remainder of their lives. It's important to help them experience the natural world right where they are.

The Disabled

Fly fishing should be accessible to anyone able to maneuver a fly rod so that it can cast a fly. When working with folks who desire to become fly fishers but have special physical needs, the fly-casting instructor should seek out individuals who have experience with the disabled for guidance.

Professional fly-fishing guide and instructor Philip Krista of Ellicott City, Maryland, has made a special commitment to help disabled folks learn to fly-

fish. His motto is "Fishing belongs to everybody." Phil's dedication is rooted in his childhood experiences with his physically handicapped brother, whom he helped learn to fly-fish. The positive effect the sport had on his brother convinced Phil that this was a significant experience—or as he likes to call it, an adventure—that could be very beneficial to many others.

Phil began working with other physically challenged people and soon became aware that to work effectively with this special audience, the instructor must bring into play two important skills: imagination and creativity. Each individual has unique needs and interests. A standard procedure for teaching fly casting to the physically handicapped does not exist.

First off, no matter what sort of physical limitations a person may have, he or she must be able to get to the water in order to fish. Accessibility is the key to beginning any successful program. The access can be a specially designed, handicapped-accessible ramp or a firm, level beach or stream area where a wheelchair can be safely positioned.

During the actual fly-casting instruction, students with special physical needs should be treated like all the others as much as possible, with a few creative judgments being made as necessary. If the student is in a wheelchair, Phil recommends that the instructor teach casting from a chair beside the student to better demonstrate the possibilities.

Many disabled students will be high in enthusiasm but low in physical strength. Because of their handicap, they may be unable to hold an 8-foot rod and cast 50 feet of line. The tackle and the situation need to be tailored to the individual. A 4-foot rod and 15 feet of line might, with a little creative coaching, be just right for such an angler. Put this fly fisher where he or she can get a cast into a school of bluegills or a pod of trout, and success is sure to follow.

Avoid using terms like "power stroke" or "muscling a cast." Stress timing and balance, not strength. Build the entire adventure around success. Most important, realize that where there is a will to fish, there is a way to do it.

Phil credits much of his success in this special field to his mentor, Art Neuremberg. Art was struck with polio as a young man and has been confined to a wheelchair ever since. From this vantage point, Art attacked life and made the sport of fly fishing his own, helping countless disabled youngsters muster the courage and conviction to follow his lead.

Art's philosophy revolves around his observation that kids don't know the words "I can't." With this in mind, he has worked some minor miracles with youngsters who had the desire to fish but lacked the physical abilities to do it in the conventional fashion. Art tells of youngsters with no arms holding fly rods with their feet, line in their teeth, casting to a pond full of bluegills. One young boy who had no use of his arms or legs cast a fly line by

having the rod wedged under his arm and rocking back and forth to get the line moving and out on the lake,

A few paragraphs in a book in a chapter on fly-casting instruction is not enough to fully cover the special techniques and methods needed to make a handicapped fly-fishing program a success. The inspirational examples of Philip and Art and the courageous efforts of the young people who, in spite of incredible odds, manage to successfully present a fly to a fish show that we can bring this wonderful sport to anyone who will benefit from this direct interaction with the natural world. Our lakes, streams, rivers, and oceans are part of their birthright also, to enjoy and protect.

Senior Citizens

Older residents can be included in community fly-fishing programs in two important ways: as mentors or as students. The chemistry between an old

- I caught my first trout on a fly when I was six years old. My father taught me to fish and rigged a dropper fly about a foot back of a worm on the end. I was fishing a riffle, and the fly was bobbing on the surface and a small (6-inch) brook trout hooked itself. This got me started with fly fishing. From that time, I enjoyed fishing wet flies. Then, a few years later, I started fishing dry flies.
- I started tying dry flies, wet flies, nymphs, and streamers when I was ten years old.
- I taught the first noncredit (in the United States) angling class and fly tying at Penn State College in 1934. I've taught classes every year since.
- I taught the first credit class in the United States in 1947. I taught five sections each spring semester until 1972, when I retired.
- I taught fifty-two angling and fly-tying classes in forty-eight cities in Pennsylvania.
- I've lectured to so many groups I can't give an exact number, but it must be close to 150 at least.
- For the past seven or eight years, I've been teaching angling and fly-tying courses in symposiums in eastern cities for Chuck Fur-minsky.
- I am now eighty-five years old and am going to retire and will no longer teach (I think) after this year.

 —George Harvey, legendary fly-fishing innovator and author

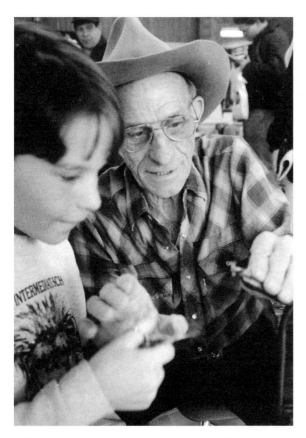

Bud Radigan gives some sage advice to a thankful youngster at the 1997 Ithaca Fly Fishing Day.

Joe Humphreys is the long-time apprentice of George Harvey. Here he is in 1938, age 9.

master and a wide-eyed youngster is magical. Passing along his years of accumulated wisdom and knowledge will give the seasoned old-timer a feeling of worth and personal fulfillment. At the same time, the youngster will revel in the golden tales and treasured tips offered by this colorful fly-fishing sage.

The magic can also flow the other way, when a youngster proudly tutors a senior in the skills and techniques he or she is beginning to master.

CONSERVATION PROJECTS
AND COMMUNITY WATER EDUCATION

Fly-fishing and sportsmen's clubs often go out into the woods and onto the streams en masse to clean and repair the local wildlife habitat. These events are tailor-made for the community youth fly-fishing education group. If the program leaders are involved with the clubs, it will be a simple matter to include the youngsters.

Other sources for finding this sort of project are the local Cooperative Extension Office or the State Department of Natural Resources or Department of Environmental Conservation. The biologists and conservation officers are often willing to help plan and implement cooperative initiatives.

Nothing will build stewardship of the resources in the youngsters like putting some serious labor into the improvement of the local streams. Take lots of slides documenting the process before and after. A series of these photos showing the areas at different times, with a kid holding a trout at the conclusion, is a powerful message as well as great PR.

A youth fly-fishing education program can get involved with the resource in many ways. There are many ways to begin such an endeavor and several programs across the country that can help interested organizations become water-quality advocates through community action.

Kelly Warren is an environmental education research specialist from the University of Wisconsin. I met Kelly at the pilot training for the 4-H National Youth Fishing Project and was impressed by what she had to say. We'll be combining forces along with folks from Trout Unlimited, 4-H, and the Federation of Fly Fishers in putting together the initial pilot project training in the Northeast.

Kelly sent along some guidelines for anyone interested in starting a youth water education project in his or her community:

Why Educate Youth About Water?

According to a recent study, most people believe protecting water resources should be a national priority, and both adults and youth want to know more about how they affect water resources. However, water issues are often over-

shadowed by ozone destruction, global warming, air pollution, and recycling, which receive more media attention. But water is a vital resource, and we tend to take for granted that clean water will automatically flow whenever we turn on the faucet.

To preserve or improve water quality, individuals in their communities need to find ways to build local support and inspire personal action to address local water issues. This can be a big job, and a set of blueprints that suggests a framework to complete the tasks can be helpful. The University of Wisconsin-Extension has developed such a set of blueprints, in a program called Educating Young People about Water. This program includes a video and workshop guide to help trainers set up and conduct workshops for those who will work directly with young people, and a series of guidebooks for the youth leaders to use when working with young people on water resource projects.

Role of the Instigator

To ensure a great program, enthusiasm must be accompanied by leadership and lots of legwork. The knowledge and skills of dedicated youth leaders are needed to help make water issues relevant and interesting for young people. Someone must be the instigator—the one who makes things happen. Here are some key things to get the program going and keep it running:

- Find out who is doing what and using which resources in educating about your topic, whether it be stream monitoring, fishing education, or restoration and conservation work.
- Thoroughly evaluate and understand your community's water education needs and concerns. Don't rely on your personal understanding or local popular impressions. Start by conducting a community water education needs assessment.
- Create or link with a network of partners who have similar community-based water education goals. Find out from these groups what is missing in local water education efforts.
- Provide educational materials. Make sure they fit the audience and the program's goals.

The Planning Process

An organized and thorough approach to planning a program helps ensure that you've thought about what you are trying to do and how you will get there. It provides an opportunity to look at what resources your community already has available, what it needs, and what the youth want and need. Planning also helps ensure that you use human and financial resources wisely.

The Educating Young People about Water training packet suggests that you include other people with similar interests in the decision making. This helps get community members, resource managers, and concerned young people involved and enthusiastic about the project.

References

Water: A National Priority. Americans' Attitudes toward Water Quality and Availability. A 1993 survey conducted for the National Geographic Society by the Roper Organization, Inc. Available from Communications Division, National Geographic Society, Washington, DC 20036, fax (202) 828-6679.

Educating Young People about Water series:
A Guide to Goals and Resources, 2nd ed. 1995.
A Guide to Program Planning and Evaluation. 1996.
A Guide to Unique Program Strategies. 1996.
Planning for Fun and Success! Video. 1996.

University of Wisconsin-Extension, Madison, WI. Available through the ERIC Clearinghouse, 1929 Kenny Rd. Columbus, OH 43210-1080, (800) 276-0462, or from Acorn Naturalist, 17300 E. 17th St., Suite J-236, Tustin, CA 92680, (714) 838-4888.

Kelly J. Warren
Environmental Education Research Specialist
University of Wisconsin-Extension
1450 Linden Dr., 216 Agriculture Hall
Madison, WI 53706

HOW TO GET STARTED

First off, every program should have a mission statement: a concise statement of its long-term goals. The mission statement of the Fly Fisher Apprentice Program is "to identify, encourage, and educate the future stewards of our resources through fly fishing." This one sentence guides us in every aspect of our program and is the reason we got involved with kids and fly fishing in the first place!

Your stated mission will play a big part in how you begin and where your program goes from here. The next few questions and answers provide a variety of ideas for anyone starting a community program.

4-H is the youth education arm of the Cooperative Extension with agents in 3,000 counties across the U.S.

Q. *Will the program be run through a support organization or will it be an entity unto itself?*

A. A key person who is already an active member of a sportsmen's organization, works with a youth organization, or is affiliated with a public or private school will already have a base to work from. The key person may wish to team up with another group in the area that can offer important advantages or perks such as liability insurance, vehicle use, building use, expertise, money, access to camps, or an enthusiastic volunteer base. An individual who wants to start from scratch has a lot of work ahead. It is advisable to speak with an attorney to find out what it will take to limit liability, acquire insurance, become a 501(3)(c) (nonprofit) corporation, and generally take care of the program work.

Q. *How do I identify, attract, and keep qualified mentors?*

A. Many sportsmen's, conservation, educational, and youth-oriented organizations will have folks within their ranks who would be willing to men-

tor. Look for mentors who live nearby. Approach only people of integrity and character. Look for two types of mentors: part-time and long-term.

Part-time mentors will help out when called on or whenever they can. They are valuable assistants for one-time demonstrations, community events, or teaching a class or two. It's usually easy to build a list of folks willing to be part-time mentors. Anyone who belongs to a sportfishing organization or has a few fishing buddies will have no problem stocking the program. Interested non-fly-fishing parents of youngsters are often willing to help in lots of ways.

Long-term mentors form the core of the program. They are willing to make a long-term commitment to the effort and are firmly dedicated to the kids and the program. Long-term mentors must be reliable, ethical, responsible, and above reproach. Choose them carefully; don't just automatically accept anyone who expresses an interest. And don't try to force or shame anyone into helping.

All mentors should be personable folks who have a good record with the community. They must be easy to reach and willing to spend the time it takes to build a good program. Teaching experience and a solid knowledge of the sport are valuable but not necessary. Good character and a willingness to learn are far more important.

The key person should subject each volunteer to a screening process. Organizations that deal with volunteers on a regular basis usually have well-thought-out methods. If possible, meet with a representative of such an organization and learn about its policies and procedures.

Strive to get a commitment for a minimum length of time from the mentors and an idea of what each person expects to get out of his or her involvement. Set standards to give the mentors an idea of *your* expectations.

In determining how many adult mentors you need, always err on the side of *quality*. Once you have the number of mentors the key person can handle comfortable, it's time to have a meeting or two, get to know each other, and plan the future of the program. Keep it simple, and plan for success. Include some form of recognition for each volunteer, and throw in as many perks as possible. It will bring everyone back for more!

Q. *Where do we get the kids?*

A. Finding enthusiastic youngsters should be the easiest part of the whole project. Many programs get started because they have the kids already. Others are begun with the sons and daughters of members. If you wish to enlist other youngsters, it's best to identify the most interested, motivated, and dedicated. Look at each youngster chosen as a potential

instructor who will represent the program at many events for several years to come. The long-term program goals may affect the population of youngsters you will be targeting.

Fly-fishing and fly-tying classes, sportsmen's shows, and related activities are good sources for finding enthusiastic young anglers. Advertisements in the local paper often attract too many applicants and don't allow for personal introductions. Don't try to go out and sell this to every kid. Some just won't care to learn, and other will be too busy and won't make a quality effort. The purpose of a youth fly-fishing program should not be just to fill the streams with fly fishers!

It's important to start with a small, manageable group of motivated, easy-to-teach, enthusiastic apprentices who will show up for each meeting, be ready to learn, and have the eager support of family and school. The program will grow on this foundation. Kids will be sure to include their friends and siblings, creating a dedicated core of future young instructors who will someday take on the main teaching responsibility for the program.

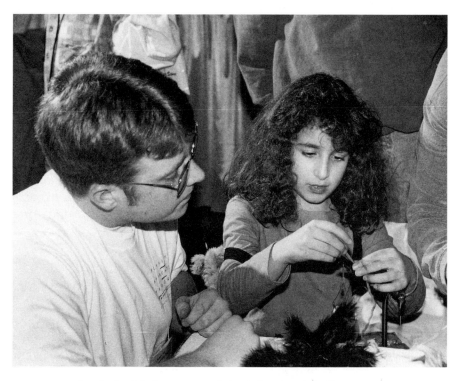

Justin Cook helps a young lady tie her first Woolly Bugger.

If it's your desire to work with a more challenging population, such as troubled kids or children with special needs, it will be more effective to wait until a core group of young instructors is firmly established. Tackling the difficult cases in the beginning will wear everyone out and may only lead to disappointment. Develop the program, become proficient, get lots of experience, and build up a strong team of young instructors. The young instructors will be incredibly effective in working with special cases. *Kids teaching kids* is a powerful concept.

Once the apprentices and mentors are identified, a group meeting should be set and a plan for the year laid out. Allow for no more than four apprentices per mentor, keep skill levels similar, and have a part-time mentor or two per full-timer. Keep the plan simple, and include the apprentices in the planning and implementation whenever possible.

Q. *Where do we get the equipment?*
A. If you stick to working with just a few kids at a time, tackle and materials should not be a problem. Fly-fishing friends will have extras, sportsmen's clubs can help out, and you can hit up the local fly shops and sports stores. Most fly-fishing manufacturers are very generous with their products and many have special reduced-rate purchase plans for legitimate youth organizations. Contact them to find out. Don't be too pushy or beg, however. Most manufacturers get hundreds of requests a day for free donations. If possible, it's always best to work through someone who already has a working relation with the industry and can get what is needed. If they can afford it, mom and dad or grandma and grandpa will likely provide an outfit for the new angler. If none of this works, put an ad in the paper asking for donations of equipment; that should do it.

From here on, the program can take on a variety of different forms, flavored by the people and the organizations who are involved. Stick by a couple of basic principles—keep it simple and don't try to conquer the world—and success is sure to follow!

PROGRAM ELEMENTS
The Fly Fisher Apprentice Program has experienced great success in bringing youth fly-fishing education to the community through many educational activities and workshops that combine several essential elements.

Competition
Although we participate in many different venues and offer a wide range of activities, we've never included any form of competition in our programs. We

Joan Salvato Wulff donning hip boots during this 1939 fly-casting class.

When I was sixteen, my casting caught the eye of William Taylor, a Paterson Casting Club member renowned as both a local bamboo rod maker and a distance caster. Mr. Taylor taught me to form beautiful narrow loops and hover a fly above the target for pinpoint accuracy, while refining my style.

However, it was distance casting that changed my life. I started by gillying for Taylor, retrieving his line between long casts and laying it out in tangle-free coils on the platform at his side. He asked me to watch his backcasts and critique them, and I came to know what truly beautiful casting looked like. When I told him I really wanted to try distance casting, his rod was impossibly heavy, so he made a rod that weighed 6¾ ounces, to cast a 52-foot silk shooting head that weighed 1⅜ ounces. Modern graphite trout rods weight 3 ounces or less.

We didn't know it at the time, but the armed forces later discovered that women have about 55 percent of the strength of men, pound for pound. The "light" rod Taylor made was still so heavy that I could never false-cast it, but he forced me to discipline my moves. I learned to pick up the head, shoot on the backcast, then shoot forward—one complete cast.

In my first tournament event, I cast 120 feet. My all-time record is 161 feet. It was distance casting that kept me interested in the sport. Having been a tap-dancing instructor, I loved the pure physical elements of it: the use of the whole body, the precise use of strength, and the rhythmic feeling that was such a large part of it.

—Joan Wulff, renowned fly-casting instructor and author

believe that there is no place in fly fishing for organized competition, especially in the early stages of learning. The fish, the elements, and ourselves are competition enough. We have plenty of spirited fun and are always one-upping each other. If awards and prizes are desired, we prefer to point our youngsters toward community service and academics.

This is our choice. Other groups hold regular competitive fly-casting and fly-tying events. If you believe they fit the goals of your program and are beneficial to all who participate, feel free to include competitive events.

One-Day Events

We are invited to and participate in many one-day affairs and host a few in our area each year. They can be used in many ways to help achieve the goals of a long-term program:

- To introduce the community to the program.
- To give young apprentices the opportunity to show their skills and to increase teaching skills.
- To provide a threshold experience for many youngsters.
- To build up a mailing list.
- To introduce individual youngsters to the program.
- To supply a large number of participants to keep the number crunchers happy. This may be a very important point if grant money or other support needs to be validated by high numbers.
- To build and strengthen ties with a host or support organization.

Fund-Raising and Promotion

All programs need money to survive. Look to special events and classes as sources of income for the program and wonderful opportunities for publicity, which in turn will lead to better income possibilities. Charge a sensible amount for the services you are offering. Don't undercharge.

Follow state and local guidelines for reporting donations, sales tax, and income. Nonprofit support groups are well versed in dealing with this stuff and can fill you in on the rules quickly.

Always thank contributors in some way. Included in the thank-you for larger gifts should be a slip with information on the tax-deductible nature of the contributions along with a few photos, notes from the participants, or articles about the kids.

Special Events

Following are brief descriptions of four of our annual educational events and a workshop format. They should serve to stimulate ideas in any group just

starting a program. Use these examples as a formula for a basic plan. By tailoring these ideas to fit your long-term project goals, your community program will give youngsters the opportunity to learn and practice teaching skills, build self-confidence and self-esteem, and log extensive community service hours. It will also provide opportunities for old-timers and novices to have meaningful and productive interactions. And perhaps most important, it will encourage and educate the future stewards of our resources.

Learn to Fish Day. This was the first community activity that emerged from the 4-H origins of the Fly Fisher Apprentice Program. The event took place on the banks of Cayuga Lake at the site of the Ithaca Farmers' Market. Learn to Fish Day eventually took a backseat to other fly-fishing-oriented activities, but it still remains a very productive and fun time for us all. It's also

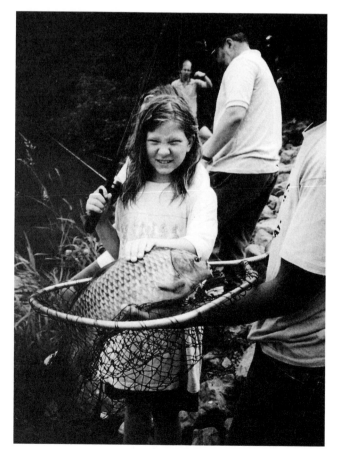

Katie Brown and carp at our 1993 Learn to Fish Day.

a classic example of using an existing resource and wild fish to teach fishing skills, as well as local ecology and environmental lessons, to a large group of youngsters. Hatchery trout stocked especially for an event may be more glamorous but would represent a totally contrived situation. Carp, though an uglier fish and an introduced nuisance species, provide an easy-to-catch, large, plentiful, and powerful target.

Organization
Schedule. Each year at the end of June or the first weekend of July.
Instructors. Mentors, apprentices, and any fishing friends we could persuade to help formed the core instructor group.
Students. Kids of all ages were encouraged to participate.
Fee. None.
Equipment. We use closed-faced spinning outfits supplied to 4-H by the Berkeley and Zebco Companies.
Advertising. We sent an announcement to the local outdoor writer and put up posters several weeks in advance at the market and other selected places in town.

Setup
We laid out four basic stations:
Registration. Name, age, and address were recorded. This became our first mailing list.
Knot tying. New anglers learned a clinch knot and, if there was time, a surgeon's knot.
Casting instruction. Cardboard boxes painted like largemouth bass, with big holes for the mouths were the targets. Small, hookless practice plugs were used.
Fishing. After completing the other three stations, young anglers took turns angling for giant carp, using kernels of corn for bait.

Results
It was a real ball! The new anglers got a quick education on how to fish this local resource and how and where to repeat the experience. Our young apprentice instructors improved their teaching skills. The farmers' market patrons had a great time, and our program received some needed publicity.

Action at times was fast and furious, with these strong fish stripping many yards of line from the reels of the first-time anglers. This basic one-on-one outdoor encounter couldn't have been any better if the quarry had been bonefish!

Lee Multari teaches a nymph pattern during Winter Fly-Tying Workshop.

Annual Winter Fly-Tying Workshop. Six years ago, we began offering fly-tying classes to the Ithaca community. This annual event became an extremely popular and effective tool to accomplish our program goals.

Organization

Schedule. Eight weeks of two-hour classes on consecutive Saturday nights, from mid-January to the third week in March. The classes were held at the Tompkins County Cooperative Extension building, and the rooms were available to us at no cost because of our affiliation with the 4-H.

Instructors. Each class was taught by a different experienced local tier, who presented his or her specialty. Class topics included the basics, wet flies, nymphs, dry flies, streamers, salmon and steelhead, and saltwater flies.

Students. Classes included both adults and youngsters. Registration was maintained at roughly two-thirds kids, one-third adults.

Equipment and Materials. Materials and hooks were provided. Tool kits were available for sale at the class or could be borrowed (with a deposit) and returned the last day of class.

Advertising. Free advertising was done in local newspapers (outdoor columns, community events sections) and with posters and mailing lists.

Results

The classes were an immediate success and produced many exciting and positive results that we had not anticipated. Saturday night became fly-tying night for everyone and gave the young apprentices and mentors a great excuse to get together. The apprentices quickly joined in on the instruction and became assistants to the teachers for the evening, learning valuable teaching skills and becoming comfortable working with others. The winter proved to be the best possible time to fill the classes and helped everyone beat cabin fever.

For many of the adult tiers who taught classes, it was their first experience at instructing others. Every instructor has come back again and again to teach, and most have remained active, mentoring youngsters on field trips, at camps, and in many other venues. This is a marvelous way to introduce young people to the social traditions of fly fishing, expose them to a variety of fly-tying styles, and give them the opportunity to interact on a personal level with older, experienced fly fishers. For the instructors, it was a rare chance to come face to face with teens! The old-timers were delighted to be able to pass on the skills, patterns, and traditions to a group of young people who really appreciated it.

From the ranks of these students emerged our new apprentices. The most enthusiastic and skilled youngsters of the class were asked to join the program and were immediately teamed with a mentor. They eventually became the young instructors for our events. This has proven to be, by far, the best venue to meet and recruit new quality apprentices. Most of the adults who participated in the classes with their kids have also stayed in touch, and many have become active mentors and enthusiastic supporters.

Tuition from the workshop turned out to be *the* significant funding for an entire year's activities. As we grew, the sale of fly-tying tools and materials brought in more money and led us to build a mobile fly shop, enabling us to sell materials at our workshops and appearances. Youngsters involved in the creation of the Community Fly Fisher youth entrepreneur venture, the retail fly shop, and the Youth Fly Fishing and Natural Resources Education Center have benefitted greatly from the knowledge gained here.

Note: It's a mistake to charge too little tuition for a comprehensive fly-tying class. A lot of work goes into the production and implementation

of a class. Tuition lets the students know they are getting something of value, and attendance will be regular. It will give the program a much-needed source of income and pay for materials used throughout the year. Of course, we do make provisions for youngsters who are excited about learning the sport but cannot afford the class. Currently, we charge a $30 fee for youngsters under the age of 18, $60 for participants older than 18, and $80 for an adult and child who come together.

The workshop grew to become our biggest advertisement and event, attracting the attention of folks around the area and across the state. This success and attention eventually led to Ithaca Fly Fishing Day.

Ithaca Fly Fishing Day. Since 1992, we have put on what has become *the* fly-fishing party of the Finger Lakes. We invite fly shops, environmental educators, professional fly tiers, rod builders, fisheries biologists, and youth programs from across the state to join us for a day of fly fishing and natural resources education.

Organization

Schedule. The first Saturday following the last class of the winter workshop and a few days before the opening day of trout season.

Vendors and Instructors. Fly shops, tackle crafters, and hackle farms were invited to participate and set up shop free of charge. An item for raffle was requested from each vendor. Fly tiers, youth programs, educators, and fisheries people were invited to teach, make presentations, and publicize their programs.

Fees. Admission wasn't charged, but donations were accepted and enthusiastically encouraged.

Advertising. We used the same outlets for publicity as for the fly-tying workshop.

Setup

Dozens of vises were set up for use during the day, with materials and hooks provided for both impromptu and organized fly-tying instruction. Ongoing fly-casting classes, with over thirty participants in each class, were held throughout the day. Presentations concerning vital fisheries issues were given by the head of the fishery for the Finger Lakes area and the river keeper of New York's Salmon River.

Results

Once again, the community responded with enthusiasm and support and made Ithaca Fly Fishing Day a greater success than we had anticipated.

Our list of exhibitors has exploded and includes quality retailers, professional fly tiers, educators, and others from the fly-fishing industry from three states. This year's Ithaca Fly Fishing Day was the scene of the only Federation of Fly Fishers' Fly Casting Instructor certification for hundreds of miles around in upstate New York. It has also proven to be a great event for non-fly-fishing parents to get involved in.

Much to our surprise, the donations at the door, combined with raffle donations and sales at our mobile fly shop, eclipsed the funds raised by our winter workshop. The space was given to us free of charge, and final expenses were minimal. Each person who entered registered with name, age, and address, providing us with a valuable mailing list for classes and events.

Local newspapers were informed ahead of time and were happy to cover this exciting community event full of photo opportunities. Attendance by folks new to the sport and coverage by local papers helped greatly in expanding our audience. The very positive response to our classes and community fly-fishing education day led us to our next important step: fly-fishing show instruction.

Fly-Fishing Show Instruction. Taking our young fly-tying instructors to the largest fly-fishing-only show in the world seemed like the natural next step. The young apprentices had taught in many venues before, but this proved to be their most challenging—and successful—venture to date.

In preparation, we had a meeting with everyone involved in the trip in which jobs and rules were handed out and spending money totals recommended. Transportation and accommodations were arranged in advance. Some food was brought along. We learned early that people who received lessons from the young instructors or who left their kids to be instructed while they wandered around the show were very willing to donate a dollar or two to the program, if an easy means for contributing was available. Three large, well-built, and attractive donation boxes accompanied us on all subsequent trips. The collection more than paid for our meals during each of the three-day shows.

Organization

Transportation, Accommodations, and Food. The 4-H provided a vehicle and insurance to cover us. Our accommodations were paid for by the producers of the show, the Northeastern Council Federation of Fly Fishers, and funds from the Fly Fisher Apprentice Program winter workshop. The program picked up the food costs; other expenses came out of our own pockets.

Our cadre of young instructors handles several hundred young tiers during a show weekend.

Parents are usually very supportive at the shows and enjoy the opportunity to share in the experience.

Instructors. Fly-tying instruction was the main activity. We took along eight young people and three adult mentors to handle the expected crowds. The young apprentices were to teach.

Equipment and Materials. We took along twelve vises for use by students. Fly-tying tools were purchased with proceeds from the workshop, and piles of fly-tying materials and hooks were gathered from a variety of manufacturers and local fly tiers. We knew that the cardboard boxes holding the fly-tying tools and materials, adequate for our usual venues, would not be up to this task, so we built three wooden road cases: one for fly-tying tools, one for materials, and one for tools and supplies for the booth.

Results

Once again, both the response to this appearance and the lessons learned far exceeded our expectations. There were seldom any empty seats at any of the twelve vises set up at our booth. Over three hundred students of every age and skill level were given a lesson that weekend—surely a record for three-day Woolly Bugger production! All students were asked to register with name, age, and address. This provided us with a total count, demographics, and a mailing list for future events in the area.

Weekend Workshops. A weekend workshop tailored to take advantage of the fly-fishing opportunities and ecology of a local area is a fine way to introduce youth fly-fishing education and your program to any community. We've run several in freshwater and saltwater venues around the Northeast, and each has proved to be an enjoyable and productive experience for everyone.

When traveling to a new destination, plan ahead. Be sure the place you will be calling the headquarters for the workshop has a good place to do aquatic sampling nearby, a sheltered place to tie flies out of even a mild wind, and a suitable area for fly-casting instruction. Take the precautions recommended in chapter 8.

Send publicity and press releases in advance to newspapers and schools in the area. If your group is affiliated with an organization such as 4-H or Boy or Girl Scouts, contact representatives in several counties around the town in which the workshops will take place. Put together a quality poster explaining who, what, where, and when, and send several copies to schools and groups, asking them to post them and pass them around.

Advance registration is recommended. If that's not possible, plan to

There is seldom an empty vise at our instructional table.

handle as many participants as you can. Charge a reasonable fee to help off-set expenses. Currently, we charge $10 to $20 for such a workshop.

The weekend workshop concept works in a variety of different venues. As many details as possible should be worked out in advance, relying heavily on local expertise, good organizational skills of the mentors, and the information in this book.

Setup

After registration, our workshops are then usually divided into four parts:

Sampling of local waters. Aquatic sampling of the local fishing waters comes first. Collecting various creatures is lots of fun for the kids and always informative. Refer to chapter 9 for more details on aquatic sampling.

Fly tying. After the local fish food has been gathered and identified, we head back to headquarters to create flies based on these real-life models. Every effort should be made to keep the creatures alive and

to return them to their place of origin promptly after the fly-tying class.

Fly casting. Next we hold a fly-casting class. Refer to chapter 5 to help you get this event organized.

Fly fishing instruction. This is the part where everyone gets to use the newly tied flies! Depending on the schedule and time constraints, this may also include instruction in knot tying.

COMMUNITY PROGRAM PROFILES

The following organizations and programs are run through a variety of venues. Not all are fly-fishing centered, but all have a value or connection that will be of interest to anyone beginning a youth-based community education program. These profiles will give the key person interested in youth education a rich resource of ideas, a selection of support organizations, and examples of successful initiatives.

Public Schools

ARROYO FLY FISHERS
Arroyo High School
4921 North Cedar Ave.
El Monte, CA 91732
Director: Frank Kuhn

I've enjoyed speaking with Frank on the phone over the last two years. He's enthusiastic and is dedicated to the ideals of his program. In his words, here's an outline of the Arroyo Fly Fishers high school fly-fishing program:

"I've been a science teacher for the past twenty-five years and a fly fisher for more than twenty. In the spring of '95, a few of my students talked me into starting a fishing club when they saw me tying flies in my room after school.

"We started off by writing over two hundred letters to fly tackle dealers and manufacturing companies, and we had a good response from all over the country. My kids had a great time sorting all the items we received!

"To get our membership started, we put up fliers and ran announcements at our school. We now have thirty-two members. Most students at Arroyo are on government meal tickets. I don't want to turn any youngster away from learning the sport of fly fishing, so all materials, as well as fly-tying, casting, and rod-building classes, are free. Only the students who go on the trips are charged a one-time fee of $5.

"The club has two monthly trips and a general meeting with a guest

speaker and barbecue once a month. After each trip, I have each person give me a one-page report on some aspect of the trip. So the students are learning writing skills along with fishing skills. By the way, in 1995, the city of El Monte was rated as one of the five worst cities in the United States to raise a child. We have a long way to go."

FAMILY TYES
c/o Baldwin High School
4653 Clairton Blvd.
Pittsburgh, PA 15236
Directors: Paul Hindes and Chuck McKinney

I met Paul and Chuck at the Fly Fishing Show in Somerset, New Jersey. We had communicated often but did not meet till then. Among other things, this high school group takes a yearly fishing trip to Montana, has appeared on national TV shows, and is marketing the Downs Fly Box as a fund-raiser.

Family Tyes's stated mission is "to organize programs that influence youth to become positive, productive adults. Family Tyes activities provide lifelong positive alternatives to drugs, alcohol and other challenges facing today's youth and families. We are something to say *yes* to."

Chuck McKinney, his son, and grandson—three generations of Family Tyes.

Paul and Chuck both teach and coach at Baldwin High. About seventeen years ago, they saw the influence of society's problems with families, drugs, and alcohol on the schools. They decided to take action and formed the Baldwin Fishing Club. In 1993 they incorporated and, with the assistance of a grant from a local company, obtained $1 million in liability coverage for the program.

Family Tyes uses a shared interest in fly fishing as the vehicle to organize year-round activities that promote family values, volunteerism, educational processes, and business skills. Purchasing a permanent camp site and expanding throughout the Greater Pittsburgh area is their goal.

Universities

Many fly-fishing programs are available to students at colleges and universities across the United States. George Harvey was the first to make fly fishing a part of academic life in the United States when he started classes at Penn State in 1934. Today some schools offer fly-fishing courses in a variety of locations. Cornell University even offers saltwater fly-fishing trips to the students and the college community through the physical education department. The following three programs are associated with universities but focus on community programs and a younger age group.

JUNIOR FLY FISHER SCHOOL
New Jersey School of Conservation, Montclair University
1 Wapalanne Rd.
Branchville, NJ 07826
Director: Dr. John Kirk

Since its inception in 1992, the Junior Fly Fisher School at NJSOC has set a standard for excellence for youth fly-fishing educational experiences. Dr. Kirk has been a good friend and shows an enthusiasm for life and the sport that inspires all who attend the school. The application pamphlet describes the program as follows:

"The program will be staffed by the Director and other professional staff members at the NJSOC. Instructing the fly casting and tying will be members of the Mid Atlantic Federation of Fly Fishers and Trout Unlimited. There will be one adult instructor for every two children. The program will include basic fly casting, selection and care of fly fishing equipment, techniques for wet flies, dry flies, streamers and nymphs. A session on rod building is also included. Other activities will include stream ecology, entomology and a trip to a fish hatchery to observe breeding techniques for trout. The co-educational program is limited to children between the ages of 11 and 14."

Cornell fly fishing student Sara Bannister with a 25-inch landlocked salmon caught during her physical education class.

LINKING WATER EDUCATION TO COMMUNITY ACTION
University of Wisconsin-Extension
1450 Linden Dr., 216 Agriculture Hall
Madison, WI 53706
Research Specialist: Kelly Warren

Although it's not a sportfishing program, this initiative can be just the foundation needed to build the environmental and community service components of a youth fly-fishing education program. The Cooperative Extension system of the University of Wisconsin has developed a blueprint to help interested educators build support for local water quality issues by working with youth, training youth leaders, creating an efficient network, and planning the entire project.

THE NEW YORK STATE 4-H SPORTFISHING AND AQUATIC RESOURCE
 EDUCATION PROGRAM (SAREP)
108 Fernow Hall
Department of Natural Resources
Cornell University
Ithaca, NY 14853-3001

This is where the Fly Fisher Apprentice Program had its beginning. The
4-H proved to be the ideal vehicle for our interest and ambitions. It remains
one of the premier youth sportfishing initiatives in the United States. The fol-
lowing description is taken from the program brochure:

"SAREP trains and supports volunteers in helping youngsters become
anglers. Weekend long instructor certification trainings take place across
NY State. SAREP focuses on developing a commitment to conserve and
enhance habitat, and to fish ethically and responsibly. The SAREP approach
emphasizes community based, long term club experiences, in which mentor/
apprentice relationships are formed,"

Conservation and Sportsmen's Organizations

THE BROTHERHOOD OF THE JUNGLECOCK
706 Orchard Way
Silver Spring, MD 20904-6232

According to the organization's newsletter, "The name of the organiza-
tion comes from the waxed neck feather of the Indian Jungle Fowl which was
worn as a symbol of the group. In the late 1930s a group of men (the legend-
ary fly fisher Joe Brooks being among them) had formed a tradition of a
Spring outing to fish Maryland's Hunting Creek. In 1939 the meeting was set
for mid April, but on Friday a snowstorm hit keeping the men in their cabin.

"These men were fly fishers. They shared common feelings about their
sport. They wanted to protect it and ensure that future generations of anglers
would be able to enjoy fishing as they had. They were determined to pass on
the knowledge, skill and ideals of conservation to the youth of their genera-
tion. How best to do so was the topic of conservation that Friday night.

"Now, fifty years later, the tradition continues. A seven year instructional
program is currently being used. It starts, for a boy 8 or older, with the basics
of beginning angling and takes him through an opportunity to fish with the
'masters'.

"Attendance is by invitation only. Conservation, reading the water, stream
side instruction, entomology, terminal tackle, equipment maintenance, knots,

Ninety-plus-year-old Frank Smoot, Brotherhood of the Junglecock mentor since the beginning, trades some secrets with youngsters at the 1997 Pennsylvania Campfire.

fly tying, rod building, and net making are just some of the classes being taught."

"Maryland is the parent chapter, with offspring chapters in Michigan, Ohio, Pennsylvania, Virginia and New York."

FEDERATION OF FLY FISHERS
P.O. Box 1595
Bozeman, MT 59771

The FFF is the world's largest organization of fly fishers. Its motto is "Conserving, restoring, educating through fly fishing." It is organized into councils and grassroots clubs that cover every state. Its membership pamphlet describes the organization as follows:

"The International FFF has a common denominator which binds together men and women in the interest of catching and releasing fish on a fly. Many members of the FFF are active in 250 local and regional clubs across the U.S.

"From the maintenance of fishery habitats, to fly casting and fly tying lessons and from socializing to offering expert speakers, the FFF makes its presence known. The FFF is dedicated to teaching today's young people how and where to fly fish. Most clubs have educational events, activities and outings for young people."

THE BOISE VALLEY WOOLLY BUGGERS
2715 N. Hartman
Boise, ID 83704
Director: Clayne Baker

Clayne is one of the most active and dedicated youth fly-fishing educators in the United States. He explains just who the Woolly Buggers, an FFF youth club, are:

"The Woolly Buggers were born in January 1994. The premise of the club was education, conservation, and fellowship. The grand idea was that when the kids reached adulthood, they might join the adult club, bringing fresh new blood and a vitality that the old fishing clubs often lack.

"The club's growth is a product of an aggressive recruiting program, action-packed monthly programs, and enthusiastic officers and advisors.

"The club's motto, 'There is more to fishing than catching fish!' has been an important key to the club's success. Monthly programs explore educational subjects beyond fishing, casting, and fly tying. Any subject related to the environment of rivers, streams, or lakes is fair game."

THE IZAAK WALTON LEAGUE OF AMERICA, INC.
707 Conservation Lane
Gaithersburg, MD 20878
Executive Director: Paul Hanson

The "Ikes" are very active in conservation and sportsmen's rights. They are especially well known for their Outdoor Ethics initiative. The National Wildlife Federation Conservation Directory describes them as follows:

"Promotes means and opportunities for educating the public to conserve, maintain, protect and restore the soil, forest, air and other natural resources of the U.S. and promotes the enjoyment and wholesome utilization of those resources."

TROUT UNLIMITED
1500 Wilson Blvd., Suite 310
Arlington, VA 22209
Executive Director: Charles Gauvin

TU was born in Michigan in 1959. Today, with over 85,000 members in more than 450 chapters nationwide, TU is a true force to be reckoned with in the conservation community. Youth activities are part of many local chapter activities. The following is taken from its membership pamphlet:

"Mission: Trout Unlimited's mission is to conserve, protect and restore North America's trout and salmon fisheries and watersheds.

"Every TU member is automatically assigned to a local chapter. It is here members find the maximum satisfaction of being part of TU. Local chapters meet on a regular basis to plan their conservation and fundraising activities. Meetings often include a speaker on angling or conservation issues. Chapters in each state are organized into councils, which are in turn consolidated into 10 regions."

Environmental Camp

PECONIC DUNES CAMP AND ENVIRONMENTAL CENTER
c/o SCOPE
P.O. Box 604
Smithtown, NY 11787
Director: Richard C. "Griz" Hilary

The "Griz" runs a tight ship on the North Fork of Long Island. Saltwater fly fishing from the camp beach is some of the best found anywhere. This camp is the only one I know that offers saltwater fly tying and fishing as an environmental education activity. Griz explains what the camp is about:

"There continues to exist today a great need to actively participate in and practice environmental stewardship. If we provide custodial care and institute programs that advocate the wise use of our renewable resources, while practicing sound proven conservation strategies, the environmental legacy for generations to come will be a bountiful one.

"At our Environmental Education Center, we are dedicated to transmitting a philosophy and ethic to our campers of respect for and an understanding of our natural resources.

"Our Native Americans had a reverence for the environment, and their sustenance and inner peace came from the outdoor world around them. We

provide our campers with a balanced program that includes many points of view regarding the use of our resources."

Special-Needs Fly-Fishing Instruction

PHILIP KRISTA
730 Pleasant Hill Rd.
Ellicott City, MD 21043

Philip is a professional full-time fishing guide on the Chesapeake Bay and area rivers. He's the only guide I know who wears a kilt when he's fishing! He's also the only instructor I know who offers fly-fishing education and fishing opportunities for disabled anglers.

NEWINGTON CHILDREN'S HOSPITAL
181 E. Cedar St.
Newington, CT 06111
Fly-Tying Program Director: Dr. Philip Brunquell

Dr. Phil Brunquell and members of the Connecticut Fly Fishers at the hospital.

I met Phil several years ago, about the time he was putting together his marvelous book, *Fly Fishing with Children*. It was obvious we shared the same passion! Several years ago, Dr. Brunquell started an after-hours fly-tying program for some of the very ill youngsters at the hospital, most of whom were resident psychiatric patients. He enlisted the help of the folks from the Connecticut Fly Fishers club. Fly tying proved to be just the thing these kids needed, and everyone was impressed at their improved attention spans and the skills they exhibited.

Youth Programs

THE FLY FISHER APPRENTICE PROGRAM
407 W. Seneca St.
Ithaca, NY 14850
Director: Phil Genova

Here's some information about FAP from *Black's Fly Fishing:*
"Mission statement: 'to identify, encourage and educate the future stewards of our resources through fly fishing.' As a not-for-profit educational corporation, FAP has broadened, popularized, and redefined the role of fly fishing in natural resources education. We combine the educational, conservation and fly fishing communities into a unique collaboration that benefits our sport, our resources and our youngsters.
"'Absolutely the finest, most effective youth fly fishing program I have ever witnessed.' Gary LaFontaine.
"FAP relies on private and corporate funding sources and welcomes inquiries."

4-H NATIONAL YOUTH FISHING PROJECT
7607 Eastmark Dr., Suite 101
College Station, TX 77843-2473
Coordinator: Dr. Ronald A. Howard

Inspired by the success of the 4-H Shooting Sports Program and urged on by the American Sportfishing Association (ASA), a nationwide team of educators put their heads together to begin work on the 4-H National Youth Fishing Project. Instructor trainings are being scheduled nationally, and a full curriculum and program design will eventually become available for participants through their local 4-H offices.

The Fly Fisher Apprentice Program—kids teaching kids. Here eight instructors man the tables at the 1997 Northeastern Fly Fishing Expo in Secaucus, NJ.

FUTURE FISHERMAN FOUNDATION
1033 N. Fairfax St. #200
Alexandria, VA 22314
Executive Director: Sharon Rushton

From *Black's Fly Fishing:* "Educational arm of the ASA, provides leadership in the area of sportfishing and aquatic resource education and coordinates the popular "Hooked on Fishing—Not on Drugs" program that combines drug prevention, environmental education and fishing into a powerful package. Instructor and student manuals, videos and other support material available."

Appendix

Much of the following material is based on information found in the Cornell Cooperative Extension publication *Pond and Stream Safari: A Guide to the Ecology of Aquatic Invertebrates* by Karen Edelstein (1993). Paul Roberts and Phil Genova adapted the material for use in this book with permission from the Extension's Publication Office at Cornell University.

The "Quick Reference Guide to Aquatic Invertebrates" chart was produced by Media Services at Cornell University and is used with permission.

Quick Reference Guide to Aquatic Invertebrates

Aquatic Invertebrate	My Distinguishing Characteristics	Where I'm Found
Sensitive to Pollution		
stonefly nymph	2 tails; 2 sets wing pads	cold running water
mayfly nymph	3 tails, sometimes 2; 1 set wing pads	cool or cold running water
caddisfly larva	most species build cases or nets, soft body	cool or cold running water, also ponds
water penny (larva)	round, flat, disklike body	cold running water
Somewhat Tolerant of Pollution		
predaceous diving beetle larva (water tiger)	up to 6 cm long; robust jaws	quiet freshwater
whirligig beetle (adult)	black; congregates in schools	surface of quiet water
black fly larva	small body; small hooks at end of abdomen attach to rocks	cold running water
dragonfly nymph	stout body; grasping jaw	cool still water
damselfly nymph	3 leaflike gills at end of abdomen	cool still water
hellgrammite (dobsonfly), alderfly, or fishfly larva	up to 9 cm long	cool slow-moving water
water strider (adult)	skates on water's surface	ponds or still pools of streams
water boatman (adult)	long swimming hairs on legs	ponds or still pools of streams
backswimmer (adult)	light-colored underside; swims on back	ponds or still pools of streams
crane fly larva	cylindrical body; often has lobes at hind end	bottoms of streams and ponds in algae
mosquito larva	small body; floats on surface	cool to warm still water
aquatic sowbug	flattened body, top to bottom; 7 pairs of legs	shallow freshwater, among rocks and dead leaves
crayfish	5 pairs of legs; first pair often robust; looks like small lobster	under rocks or in burrows in shallow freshwater
scud	flattened body, side to side; swims on side	bottoms of lakes, streams, or ponds in vegetation or sediment
Tolerant of Pollution		
midge larva	small, cylindrical body; sometimes blood red	bottom sediments of lakes, ponds, or streams
rat-tailed maggot (larva)	cylindrical body; tail-like breathing tube	cool to warm water with low oxygen levels
tubifex worms	segmented body; builds a vertical tube from which one end protrudes	polluted or oxygen-poor water

How I Get Oxygen	How I Get Food	Why I'm Special
through body surface; some small gills; does "pushups" to increase oxygen flow over body	predator or herbivore	streamlined body for crawling on rocks; only tolerates high oxygen levels
through gills along abdomen	herbivore or scavenger	only tolerates high to medium oxygen levels
through body surface	filter feeder, herbivore, or predator	builds cases of heavy material (rocks) to avoid being swept away by fast-flowing streams; in ponds, uses grass and plants to make cases
through gills on underside	herbivore—grazes on algae	flattened body resists pull of current
through body surface	voracious predator	special channels in jaw to suck body fluids of prey
from atmosphere	predator or scavenger	has two pairs of eyes to see above and below the water's surface; has a type of "radar" to locate objects in the water; secretes a white odorous substance to deter predators
through body surface	filter feeder	anchors to rocks with silk; only tolerates medium to high oxygen levels
dissolved oxygen, through gills in internal body chamber	active predator	clings to vegetation or hides in clumps of dead leaves or sediment
through gills at end of abdomen	active predator	clings to vegetation or hides in clumps of dead leaves or sediment
through gills along side of abdomen; some fishflies have breathing tubes	active predator	can swallow prey without chewing
from atmosphere	active predator	can stay on water's surface because feet have small surface area and are water repellent
from atmosphere, by carrying air bubble from water's surface on body	omnivore, herbivore, or scavenger	has swimming hairs on legs that act as oars
from atmosphere, by carrying air bubble from water's surface on body	predator	swims on back; sleek body shape
from atmosphere through spiracles (openings) at hind end	active predator, herbivore, or omnivore	species that eat woody, decaying matter have gut bacteria to digest cellulose
from atmosphere through breathing tube	scavenger—feeds on micro-organisms	swims or dives when disturbed
through body surface on legs	scavenger—eats decaying matter—or omnivore	male clasps female under it during mating; female then sheds half of exoskeleton, which becomes a case into which fertilized eggs are placed for development
through gills under body	scavenger or omnivore	crawls backwards when disturbed; males display some courtship behavior to reduce female aggressiveness
through gills under body	scavenger or omnivore	male carries female on its back during mating; female then sheds half of exoskeleton, which becomes a case into which fertilized eggs are placed for development
through body surface	predator, herbivore, or omnivore	some have substance in blood to hold more oxygen in oxygen-poor environments
from atmosphere through breathing tube	scavenger—eats decaying matter and sewage	can survive low oxygen levels fatal to most invertebrates
through body surface, but can tolerate water with no oxygen	scavenger—eats decaying matter and sewage	can survive low oxygen levels fatal to most invertebrates

Nets

COLLECTING NETS

Nets used to capture aquatic life effectively can be simple and inexpensive. Long-handled D-nets can be used, if they are available; however, simple aquarium dip-nets, in a variety of sizes, make the best all-around bug catching tools, especially for smaller youngsters. These nets are economical, easy to find, easy to carry, and easy for small hands to manage.

Dip nets are not the best choice, however, if you are targeting fish. You will be much more successful at that if you use a seine.

A seine is usually operated by two people, one on each side, holding the bottom of the net close to the stream bottom as they move it along. Fish are then herded through shallow water toward the stream or lake shore. Other participants can help with the herding and inspection of the catch.

BUILDING A SEINE

Seines can be purchased at fishing tackle shops or can be easily and economically constructed.

Before making a seine, be sure to check local fishing laws to learn the maximum net area (length times width) allowed. Also decide on the type of mesh you'll need. Fine mesh sizes are useful for slower waters and smaller creatures; faster currents may require the use of larger mesh sizes and more robust materials.

Materials needed:

- two pieces of 1 x 2-inch wood stock, 3½ feet long
- ¾-inch carpet tacks or roofing nails, and a hammer or heavy duty staple gun and staples
- 3 x 5-foot piece of nylon netting or mesh fabric
- heavy nylon sewing thread and a needle, or a sewing machine
- two 2 x 36-inch strips of heavy cloth (canvas), cardboard, or similar material

Putting it together:
1. Hem four sides of the netting for reinforcement and to stop fraying and tearing.
2. Nail each of the two short, hemmed sides of the mesh to a length of wood so that the bottom edge of the netting is flush with the end of the stock, and the seam is attached evenly along the length. Space nails about 6 inches apart, leaving about 8 inches of wood on top for the handle.
3. After both sides are attached, lay the seine on the floor and roll the stock over a time or two. Secure the cloth strip over the doubled netting for reinforcement.

AQUATIC SAMPLING RECORD SHEET

Collecting Site Name:　　　　　　　　　Date/Time:

　　Name of Watershed or Drainage:

　　Nearest Town:

　　Nearest Road:

　　Landowner:

Weather Conditions:

　　Air Temperature:　　　Water Temperature:　　　Water Clarity:

Critters Captured	Habitat Type	Number Caught	% of Total Catch
1.			
2.			
3.			
4.			
5.			
6.			
7.			
8.			
9.			
10.			

Results:
　　How many different kinds?　　　Total number (all kinds)?

　　Why are there different kinds of aquatic creatures?

　　Why are there more of some kinds than of others?

Additional notes:

Each and every person I have mentioned, the famous and the not-so-famous, well-known and unknown, have one thing in common: All have offered help, given direction and guidance, taught and instructed without reservation. No fly, fishing spot, tying method was kept secret. Ours is a sport that someone once described as a school from which one never graduates. I have learned tying tips from those I taught to tie and I have given tips to those who taught me. I am truly blessed to have taken fly fishing and fly tying as passionate hobbies. It has become a lifestyle, life's work, if you will. The friends I have made since partaking of this sport are precious, generous people. Being associated with these individuals is truly a humbling experience.

It is my intention to tie flies and fish with them for the rest of my life. I hope that when my fishing days are over, I will have passed on my share of traditions and information to those who might, in turn, pass it on to further generations of fly fishermen and fly tiers much as it was passed on to me.

—Bill Peabody 1946–1997

Bibliography

BOOKS

Abrames, J.K. *Striper Moon*. Portland, OR: Frank Amato Publications, 1994.

Borger, Gary. *Presentation*. Wausau, WI: Tomorrow River Press, 1995.

Brooks, Joe. *Trout Fishing*. NY: Outdoor Life Books, 1972.

Brunquell, Philip. *Fly Fishing with Children*. Woodstock, VT: Countryman Press, 1994.

Chartrand, Claude. *The Art of Fly Fishing*. Buffalo: Firefly Books, 1996.

Combs, Trey. *Steelhead Fly Fishing*. NY: Lyons & Burford, 1991.

Dunaway, Vic. *Baits, Rigs, and Tackle*. Miami, FL: Wickerstrom Publishers, Inc., 1984.

Greenberg, Martin H. and Charles G. Waugh, eds. *One That Got Away*. NY: Crown Publishers, Bonavea Books, 1989.

Harvey, George, *Techniques of Trout Fishing and Fly Tying*. NY: Lyons & Burford, 1990.

Hughes, Dave. *Wet Flies*. Mechanicsburg, PA: Stackpole Books, 1995.

Humphreys, Joe. *Trout Tactics*. Harrisburg, PA: Stackpole Books, 1982.

Judy, John. *Slack Line Strategies for Fly Fishing*. Mechanicsburg, PA: Stackpole Books, 1994.

Kaufmann, Randall. *The American Nymph Fly Tying Manual*. Portland, OR: Frank Amato Publications, 1986.

———. *Fly Patterns of the Umpqua Feather Merchants*. Glide, OR: Umpqua, 1995.

———. *The Fly Tyers Nymph Manual*. Portland, OR: Western Fisherman's Press, 1986.

———. *Tying Dry Flies*. Portland, OR: Western Fisherman's Press, 1991.

Kreh, Lefty. *Fly Fishing in Saltwater*. NY: Lyons & Burford, 1986.

———. *Fly Fishing Techniques and Tactics*. Birmingham, AL: Odysseus Editions, 1991.

———. *Salt Water Fly Patterns*. NY: Lyons & Burford, 1994.

Kreh, Lefty and Mark Sosin. *Practical Knot Tying*. NY: Nick Lyons Books, 1972.

Krieger, Mel. *The Essence of Flycasting*. San Francisco: Club Pacific, 1988.

Kyte, Al. *Fly Fishing: Simple to Sophisticated (2d ed.)*. Champaign, IL: Human Kinetics, 1987.

LaFontaine, Gary. *Trout Flies: Proven Patterns*. Helena, MT: Greycliff Publishing Co., 1993.

Leiser, Eric. *The Complete Book of Fly Tying*. NY: Knopf, 1979.

Leiser, Eric and M. Vinceguerra. *The Orvis Guide to Beginning Fly Tying*. Bennington, VT: Abenaki Publishers, 1993.

McClane, A.J., ed. *McClane's Standard Fishing Encyclopedia*. NY: Holt, Rinehart and Winston, 1965.

Meck, Charles. *Patterns, Hatches, Tactics and Trout*. Williamsport, PA: Vivid Publishing, 1995.

Merwin, John. *The New American Trout Fishing*. NY: MacMillan, 1994.

Meyer, Deke. *Saltwater Flies: Over 700 of the Best*. Portland, OR: Frank Amato Publications, 1995.

Mitchell, Ed. *Fly Rodding the Coast*. Mechanicsburg, PA: Stackpole Books, 1995.

Morris, Skip. *The Art of Tying the Nymph*. Portland, OR: Frank Amato Publications, 1993.

―――. *Fly Tying Made Clear & Simple*. Portland, OR: Frank Amato Publications, 1992.

Nemes, Sylvester. *The Soft-Hackled Fly*. Mechanicsburg, PA: Stackpole Books, 1993.

Roberts, George. *A Fly Fisher's Guide to Saltwater Naturals and Their Imitations*. NY: McGraw-Hill, 1996.

Shaw, Helen. *Fly Tying*. NY: Lyons & Burford, 1987.

Stewart, Dick. *The Hook Book*. Chicago: Northland Books, 1986.

―――. *Universal Fly Tying Guide*. Woodstock, VT: Countryman Press, 1979.

Stewart, Dick and Farrow Allen. *Flies for Saltwater*. North Conway, NH: Mountain Pond, 1992.

Tabory, Lou. *Inshore Fly Fishing*. NY: Lyons & Burford, 1992.

Talleur, Dick. *The Versatile Fly Tyer*. NY: Lyons & Burford, 1990.

Tryon, Chuck and Sharon Tryon. *Figuring Out Flies*. Rolla, MO: Ozark Mountain Fly Fishers, 1990.

Van Vliet, John. *The Art of Fly Tying*. Minnetonka, MN: Cowles Creative Publishing, Inc., 1994.

Walker, Alf. *Mastering the Art of Tying Flies*. Toronto: Pagurian Press Limited, 1976.

Wentink, Frank. *Saltwater Fly Tying*. NY: Nick Lyons Books, 1991.

Wright, Leonard. *Superior Flies*. NY: Lyons & Burford, 1989.

Wulff, Joan. *Joan Wulff's Fly-Casting Techniques*. NY: Lyons & Burford, 1987.

PERIODICALS

American Angler, Bennington, VT.
Black's Fly Fishing, Red Bank, NJ.
Fly Fish America, Fryeburg, ME.
Fly Fisherman, Harrisburg, PA.
Fly Fishing in Saltwaters, Seattle, WA.
Fly Rod & Reel, Camden, ME.
Fly Tyer, Bennington, VT.
The Inside Angler, San Francisco, CA.
Saltwater Fly Fishing, Bennington, VT.
Warmwater Fly Fishing. Bennington, VT.
Western Fly Fishing, Portland, OR.

VIDEOS

Clouser, Bob and Lefty Kreh. *Fifty Years Behind the Vise—Vol. 1.*
———. *Patterns That Produce—Vol. 2.*
Krieger, Mel. *Essence of Fly Casting.*
LaFontaine, Gary. *Tying and Fishing Caddisflies.*
Lay, Bob and Al Beatty. *Practical Trout Flies.*
Morris, Skip. *Fly Tying Made Clear and Simple* .
Wulff, Joan and Lee Wulff. *The Joan and Lee Wulff School of Fly Casting.*

Index

Page numbers in italics indicate illustrations